Text-Me-Up!

Thank you to everyone who has ever texted me

Tracey Moberly

Text-Me-Up!

Beautiful Books

First published 2011

Beautiful Books Limited
36–38 Glasshouse Street
London W1B 5DL

www.beautiful-books.co.uk

ISBN 9781905636822

9 8 7 6 5 4 3 2 1

A catalogue reference for this book is
available from the British Library.

Design and layout Jonathan Moberly

Printed and bound in the UK by
Butler, Tanner and Dennis Limited

Contents

To Dad

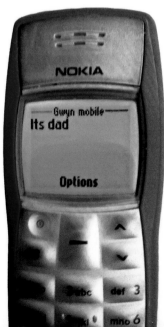

**Message found unopened on a
discarded mobile two years
after my father's death.**

Statistically women use more exclamation marks than men in text messages...

I have saved every text message I have ever been sent since the first in 1999.

Text-Me-Up! illustrates some of those 60,000 texts received.

Received texts from 1999-2010 form the outer casing and occasionally the core of each chapter. The autobiographical narrative which weaves through the book is an attempt to make sense of those texts. They mark time, carving a slice of social and cultural history. A third textual dimension of current-day text correspondences are interspersed throughout in pink and red.

Inevitably we read between the lines...

Tracey's phone > TM
23 Mar 2010 3:02:46
**'There's the art of lines
and colours and there's the
art of words that will last
just the same'
– Vincent Van Gogh**

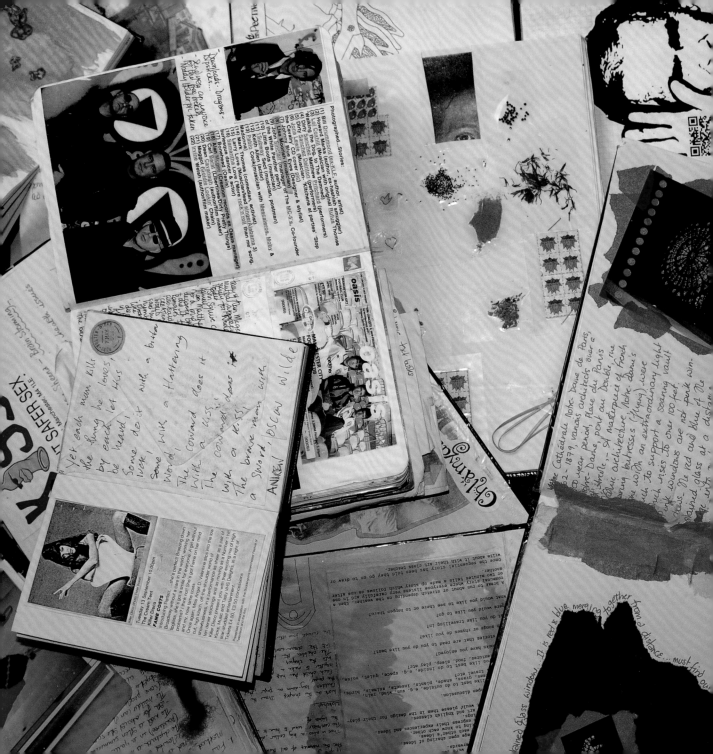

You never gave me pink
But... more to the point
I didn't give it you...
Now I cannot...

Someone gave me red
Deep dark & dirty red
You got your own red
It's just as dark...

I cannot make red anymore
bright, pulsating & vibrant,
If I made that red
I'd give you pink...

You don't want pink
But if you had it,
your senses & emotions
would be knocked senseless

My deep, dark, dirty red
Was being made better
You gave me insight
Giving me purple & green

We started to build
the purple & green
In our own Coronation Street
A purple & green dream...

My inner sanctuary
The divine of shrines
for what we've got
the yellow that came before

It followed the teapot
for the morning sun
that we never ever
shared...

The red of the bed
that's dead, you said,
You said I said
We're both dead in...

The red of our bed
I made it happen
I retained it all
in the red of my head

No pink, no red
A purple & green?
The yellow that's lost
as grey drowns our dream

In the red of our bed
My dreams they scream
Just part of a thread
that belongs to a seam...
You never gave me pink
I mull over... reason
I sometimes sit & think
throughout every season

I mull over... reason
throughout every season
I didn't give it you
Did this make me blue

Now I cannot...
No pink
I try not to think
The End...

17:45 SAW NOEL GALLAHGER 20 MINS AGO & TOLD HIM AAAARRRSSSE! \ 18:06 I dream about U often. Kinky pink thigh-high boots & Pucci knickers suit U best I think......... \ 18:13 Baby was it good for you? \ 19:26 TEXTING TEXTING 123 \ 20:07 You ll always be my Xena, Wonder Woman & cow gal. You are also my bunny girl, strip per & wild woman. \ 20:35 If ELVIS was here in shiny black leather, how could i resist? should i even try? what would Priscilla think? 68 comeback special, I wasn t even born!!! \ 21:12 SUK MY THERMOS FLASK \ 06.46 GISMS? \ 08.07 How u 2 day? the sun carrys my love so stand in its glory and let the light show you who u r xx \ 08.09 Wake up + text me! \ 06.42 You do inspire the cockles of my toe nails- your a lovely, caring, fab + gorgeous no.1 friend thanks for being there + thanks for giving \ 12.37 LISTENING TO RISE AND THOUGHT OF YOU \ 12.47 IM GETTING FLEA BITE WITHDRAWALS \ 18.43 HI IM NOT SPEAKING IM FINDING MYSELF \ 21.29 ARE YOU FKN DED oR WoT? \ 00.08 KIPPERS \ 00.36 Until the colour of a mans skin is of no more significance than the colour his eyes, me say war...peace brother, speak to you soon star. Lips

I have saved every SMS text message I have ever been sent, apart from the very first one, when I was so shocked and surprised to find that such a medium existed. That first text, coupled with the breakdown of a long and tumultuous marriage, launched me into a new body of artwork. The year was 1999, 'The End' had taken a long drawn-out time exhaling its last, violent breath. Then suddenly I was single. I had forgotten how to be single, but with the help of two close friends and work colleagues – Jai Moodie and Nick Fry – I learned how to interact with the opposite sex again. This was via their 'what does it in a woman for us' tutorage, a step-by-step guide to how a female should successfully catch her prey.

There was a barman about ten years my junior, an alpha twenty-something male, intricately daubed with tattoos. On his back he had emblazoned an Aztec solar calendar similar to the artwork found on a Mexican tequila bottle. I christened him *My Object of Lust and Desire* and later, simply, *The Object*. Not in a month of grey, rainswept, air-strangled, low-cloud-laden South Wales Valleys

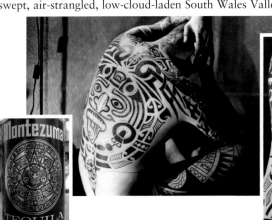

TM > Hel Elvis Jesus
14 Mar 2008 20:10
Wat is the type/brand of tequila 'the object' had tattooed on his back? Can u remembr+do u stil drink it?

Hel Elvis Jesus > TM
14 Mar 2008 21:09
I have no idea what your talking about.

TM > Hel Elvis Jesus
The tequila bottle with the aztec solar calendar image for its label, that we drank. The barman with the tattoos i went out wi wen me+g split up had the image tatod on his back remembr? He became an artwork called, 'my object of lust & desire' It's the only tequila u'd drink. Wat's it called?

Hel Elvis Jesus > TM
Ah! Do you know, I can picture the bottle but have no idea what it's called.

TM > Hel Elvis Jesus
That's tequila abuse 4u! If u do remembr let me know please x

Hel Elvis Jesus > TM
Why on God's earth do you need that? Do a google search.

TM > Hel Elvis Jesus
I'v done a google search its for a book i'm writing. I thought u may remembr?!!? U swore by it at the time x

Hel Elvis Jesus > TM
But you know how fickle and shallow I am...

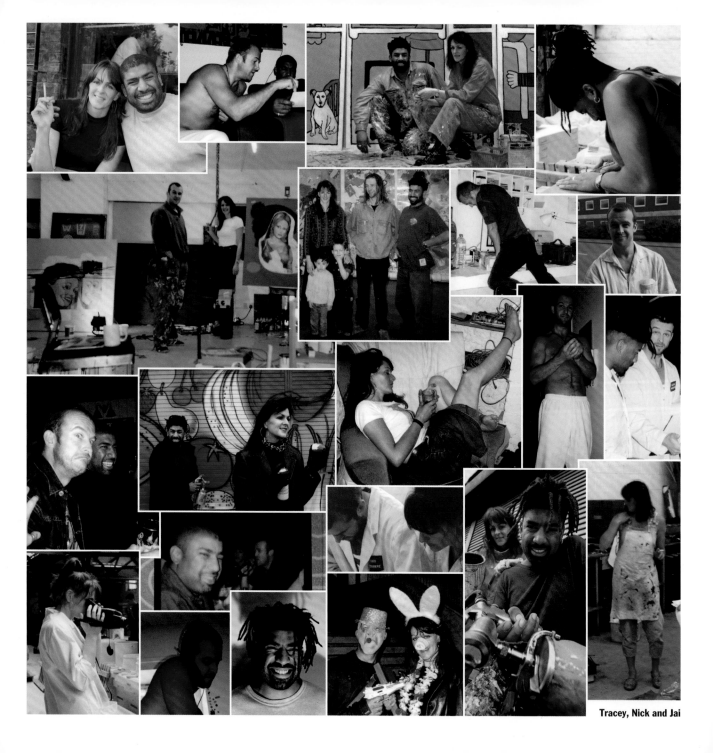

Tracey, Nick and Jai

Sundays did I ever think he would notice me. However with the tuition I had received from my male peers he was in hot pursuit of me all over the city.

With the right look, throwback

laugh and eye movements giving out 'the confidence' when you feel like a pygmy shrew in a world of giant water rats, they had taught me well. If only I could have really been bothered. The Object became mine, but I tired almost instantaneously, bored with a hulk who talked bar work and tattoos. Shortly afterwards, he became an artwork: a photographic exhibition aptly titled *The Object*. And I've not drunk that brand of tequila since.

A few months later I was sat in the same bar in which I had met *The Object* (who was now a friend), when I was sent my first text. The sender was Big Dave, who I'd met whilst touring Brittany and the West Coast of France on a motorbike about fifteen years earlier. He was at a funeral. When people ask me if I remember my first text, I conjure up an unforgettable image of a 6'5" man at an Irish wake, along with

the person being laid to rest. It's a bit like the first band you go to see, it's etched in your memory forever. Mine was Kraftwerk: I found the ticket stub the other day when sorting through some old boxes. I remember the whole experience well, every direction Florian Schneider looked in, convinced he was staring straight at me (they were gods, right?). I remember clearly the full-on banter a couple of hours before the gig, about a TV advert that I'd been randomly stopped to do for Sprint biscuits, and then the chatter on Siouxsie Sioux and the Creatures verses the Banshees in the train journey across into England from Wales and back again after the gig. I remember this as clearly as I recall

TM > Big Dave
6 Dec 2007 19:20
Whose funeral were you at the day you sent me my first text message which I lost? Do u no anywhere that makes things outa recycled bottles?

Big Dave > TM
I think it was old stan, one of my neighbours . Will have an ask round about the bottles. Am just filling in an application form for a job with tra***** council

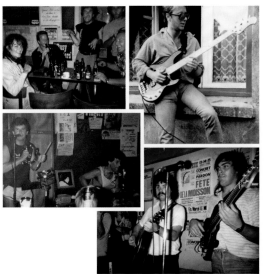

01.07 DO YOU DO MORNING COFFEE, CROISSANT, LUST & INDULGENCE \ 01.09 IF SO CAN I HAVE A PERMENANT TABLE \ 21.01 YOU ARE WORTH MISSING FOOTBALL FOR \ 22.08 ALWAYS LOOK AT ME THE WAY YOU DID TODAY \ 20.49 BEATS ME IT COME OUT DO YOU WANT TO GO TO CUBA WITH ME \ 02.15 I NEED TO BE IN YOUR LIFE FOR A LONG TIME \ 10.41 SLAPPA QUEEN OF THE MOSS I AM ON MY WAY AROUND FOR A COFFEE \ 18.20 IT GETS HARDER EVERY TIME I THINK OF YOU \ 10.09 I NEED YOU TO BE SANE \ 11.03 HAVE YOU DRIED OR ARE YOU STILL WET! \ 17.30 CHECK YOUR MICROWAVE FOR CLEANLINESS \ 20.53 OBSESSION FOR WOMEN BY TSW! \ 00.35 PHDS + DISSERTATIONS ALONG WITH OBJECTS OF DESIRE IS WHAT LIFE IS ABOUT YEA! \ 18.38 Can I do a porno fashion masturbatory installation? It could include dead & bloody ani mals..... \ 20.47 Yea, really filthy but boys will be boys..... \ 14.30 You already I sent that message! Naughty chicklet! \ 19:14 INYK2 U & ME?

the details of my first text. However the Kraftwerk concert was a real event, whereas we fill in the story around a text message by reading between the lines of somebody else's reality, not our own.

I'd met Big Dave in France when he was performing on the same bill as Mungo Jerry. He was an old band member of my motorbiking partner Julian Layfield. After I lost that first text, I quickly mastered the art of SMS text messaging. I love people's words, so I couldn't throw any away and I began religiously copying them into a collection of books which grew into journals. These journals became abstract diaries of my life written in the words of others: random ridiculous, pseudo-sexual, loving, friendly or downright disgusting texts which helped me recall the emotions I was experiencing. The text messages became part of my healing process, a way to show people how I was being knitted back together again. I used to think that if any disaster occurred to my home, I would save my photo albums and sketchbooks first, but since my introduction to text messaging, this has changed to my photograph albums and text journals.

The collection of my first texts culminated in an exhibition at the Castlefield Gallery in Manchester in June 2000, titled *Text-Me-Up!* Following the first *Text-Me-Up!* exhibition I have used my texts in a number of different creations, exhibitions and installations that have crossed a variety of media from print, poetry, embroidery, radio and film. The work and media are constantly evolving, all based around the SMS text message.

22.36 SCUZZY FISH TANKS MAY BECOME THE NEW FASHION \ 09.20 ARE RAWL PLUGS + SPIRIT LEVELS SEX AIDS? \ 09.17 GLAD TO HEAR YOUR GETTING YOUR WIRING SORTED!!! \ 20.53 HOW DO YOU KNOW WHAT A BAG OF SHIT FEELS LIKE? \ 12.08 SEX, LUST, RED, PINK & CHAMPAGNE \ 16.42 ITS WELSH FOR CUNTY SLAPPER \ 21.58 POT THE BLACK BITCH BAG. SORRY JAI – NO PUN INTENDED! \ 20:10 EAT NICE FOOD FOR ME THEN EAT ME \ 20:45 no snook, no pool, but sitting bull + wildmoon like sitty, telly an' drinky \ 12:23 You should have married me-still love you-bitch \ 20:51 Asda massiuf gettin ma eats. Haf pisd. cal u in a bit..xx \ 12:11 KISS MY VELVET HELMET \ 21:13 WHY ARE YOU SO ANGRY? \ 21:16 I CANT GET NEAR YOU! \ 21:41 IF YOU CARE YOU SHOULD HAVE BEEN THERE, WHEN I FACED MY FEAR, BUT IM USED TO DOING THINGS ALONE. \ 23:13 DONT WE NEED TO DISCUSS WHATS HAPPENING BETWEEN US FIRST \ 19:07 DOES CONTEXT MEAN A TEXT THAT IS A LIE?

I organised my first *Text-Me-Up!* exhibition to coincide with my birthday, the first birthday of my singledom. The location had to be Castlefield, Manchester. The Castlefield Gallery were more than happy to accommodate the exhibition and *Text-Me-Up!* was brought to life. Castlefield was so important for the exhibition due to the intertwining of its industrial heritage with my own personal history. In 77AD the Governor Agricola arrived in Britain from Rome. He erected a turf and timber fort near to the convergence of the rivers Irk and Irwell in the place that was to become Castlefield. It became a landmark during the Industrial Revolution with the opening of the Duke of Bridgewater's Canal in 1761. This facilitated a three-way trade – making it easy to import raw

cotton and cheap coal to fuel ginning and spinning mills on an industrial scale which could then be exported as finished cotton goods worldwide, turning Manchester into Cottonopolis. The canal network grew and was later superseded by an intricate network of railways. Castlefield became the site of the world's first purpose-built passenger railway station in 1830. Rail became used for mail services, and this promoted a new widespread interest in letter writing and printed communications. The growth of this literary tradition took us into the latter part of the twentieth century which saw the development of the global system for mobile communication (GSM), followed by the introduction of the short message service (SMS) or text message.

Text messages are like little sugar rushes of communication or as someone once said to me, 'postcards of the peoples cyberspace'. The first month for which figures were recorded (in 1998) British users 'texted' 5 million messages. By April 2000 this had risen to 360 million in one month and by the end of 2000 it was 500 million.

When I graduated from art school in Newport I'd gained the healthy result of a first class honours degree. I thought the world was my oyster and I could put plans for the next phase of my education on hold for a year or two. Since the age of seventeen I had introduced random fatalistic elements into my art practice which I called the 'chicken-wire effect': this still encompasses my whole body of work from then to the present. Delaying my studies would give me time to play around with this strategy. One night just after graduation I was at a friend's flat

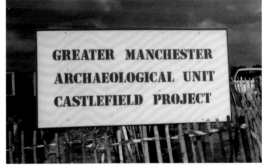

Manchester Evening News

Friday November 15 1996

Wired for chickens

In a shed in deepest Moss Side Tracey Sanders-Wood pursues her distinctive personal and artistic philosophy

whilst halfway through reading Karl Marx's *Communist Manifesto*. I had the book in one hand, a pin in the other, and a map of the British Isles on the floor with a heightened sense of the need to start a new life. I shut my eyes and stuck the pin in the map. It landed on Manchester and within the week I'd packed my bags, left my flat, and relocated myself. I thanked Marx for his influence on the pin and his dedication to Manchester whilst not acknowledging Adam Smith and *The Wealth of Nations* for the pin in my hand.

In need of employment and using the chicken-wire effect as my guide, I had to find a job that connected with my last artwork. In my practice, each piece of art leads on to the next with six possible variables forming interconnections as in a segment of chicken-wire. My last piece of art had resulted from me not doing a scheduled art performance in the Nettlecombe region of Somerset, because the group I was taking to the performance went to see the newly released film *Indiana Jones and the Temple of Doom* instead. The piece of work I produced as a result was an 6 x 3 metre wall-hanging, hand printed onto fabric, using screen print, lino and etching techniques. Within the border of the work I silk screened images of stills taken from the film. One square would read 'Is an archaeologist...' another would show a blown-up section of the young Chinese boy, another of a tomb, and so on.

How I could link this artwork to the jobs I was about to search for I didn't know, but as I walked into the Manchester job centre everything fell into place. I left with several application forms, but the two most prominent interviews were for a Chinese newspaper and an archaeological dig, both corresponding with the illustrations in my Indiana Jones-inspired artwork. My interviews went well and I was particularly taken with the manager of the archaeological dig with his wild, almost black eyes, and long, corkscrew curls tumbling over muscular shoulders.

Being offered both jobs, I declined the Chinese newspaper position and turned up in Castlefield for my first day of work. Greeted by two padlocked iron gates and a snow-covered escarpment near the pillars of a Victorian railway bridge, I felt like I was starting a new job in a Siberian gulag. The work involved excavating, photographing and drawing ceramic and bronze remains from Governor Agricola's Roman Garrison Fort. It also involved exhuming the remains of families from the nearby Manchester Cathedral who had died in the 1840's. Most of the deceased were privileged people, having been buried inside the cathedral. Many had died from cholera outbreaks due to the squalid conditions of the period – that same period in which Marx was in Manchester and was writing about in his *Communist Manifesto*.

Fifteen years and three children later at the end of the 'very long, tumultuous relationship' with the archaeologist who had interviewed me and managed the Castlefield dig, I was getting ready to install the first *Text-Me-Up!* exhibition.

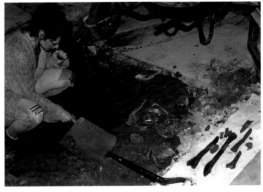

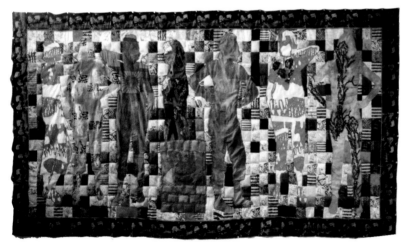

11:00 WHY WILL U NEVER CONSIDER MARRIAGE? \ 23:33 I THINK YOU LL FIND IT WOULD BE A COCK NOT A DICK \ 00:02 WHY DO DOGS BOLLOCKS SWING? \ 00:27 I IS LIVIN IN DA MAINLINE WIZ MI BOOKASH BREDRIN WE IS ROKIN DA SHOK INIT \ 10:08 i d show elvis that bi is best & maybe get Jackie Susann over for a thre some..... \ 09:26 already at studio. woke A 7 hard as hell and ready to win \ 09:30 YES-I-JAPS-EYE \ 00:27 All I want to do is hug you*but not like that i feel huge huge love 4u \ 00:31 BIG AND NEEDY \ 19:08 PS, HAPPY ANNIVERSARY \ 10:53 bit wierd all round wernt it? \ 23:25 coz she obeys the pole pokemon and loves the land of lickitung \ 23:47 I love you even at your unhappiest you give of yourself you are a beautiful person \ 12:17 just had some frosties... deciding whether to have fried dumplings with sausage or ackee & salt fish..... AAHHHH HOME \ 21:28 Dotty! May showed me pic of u & bridge! hope to see u soon, k \ 00:40 have a nice life as u used t say xxx until never..... \ 00:48 bitch xxx

3 In The PINK

00.22 KISS YOR PINK, 2SHOTS 2ME, BACKSHOT, FLIPSHOT NEVER TOUCHED THE WIRE \ 18.50 BIG BOOBED EARTH MOTHER QUEEN OF PINK \ 20.06 I LIKE PINK BITS \ 17.13 SELF ESTEEM V PINK JACKET! \ 18.42 PINK PHEASANTS & STRAWBERRIES JUST CAME INTO MY HEAD \ 23.07 TRACEY QUEEN OF PINK FUCK I JUST DROPPED MY PEN \ 23.18 HEY PINK POSER RU HAVING A GOOD TIME \ 21.01 WHITE RABBITS, PINK ELEPHANTS + TRAFFIC JAMS! \ 21.10 PINK IS THE NEW BLACK THEY SAY \ 10 12.08 SEX, LUST, RED, PINK & CHAMPAGNE \ 20.50 TRACEY QUEEN OF PINK LASER QUEST HERE WE COME \ 20.06 AUTHOR OF MY LIFE. PINK, OUT THERE SOCKS + ALL \ 19.15 Hi pinky how are u mmmm i have a new number please call me \ 21:18 OH WOE IS ME OH WOE IS YOU NOT IN THE PINK BUT IN THE BLUE! \ 22:26 JUST SEEN SOMEONE WITH YOUR PINK LEATHER JACKET MEG MATTHEWS \ 02:39 art n pink \ 00:10 HOWDY DOODY NICE TO SEE U LOOKING BACK IN THE PINK \ 09:51 As her knickers hit the floor, she opened her legs & thrust her pussy into the strangers face \ 14:13 and so did her ample bossom... \ 19:04 MY DIPTHERIA IS PLAYING ME UP SOMTHING ROTTEN \ 20:34 It could last forever... \ 22:32 LETS GO CRAZY MENTAL STUPID \ 23:11 BAGELS \ 18:41 WILL YOU GO TO BED with me? \ 18:48 WHY NOT? YOU NEED ME \ 10:01 Ishall speaky to Franko and send his mind on a mission to find you x \ 14:35 FANCY YOU \ 16:37 IS NEXT FRIDAYS THING CALLED A TEXTABITION? \ 23:57 How ya doin? Still standin soz if i was moody this morn. STILL LUV YA XX \ 01:05 SQUAT-PUSH-&SHIT THEM OUT-NOT THAT I KNOW FROM XPERIENCE \ 01:44 GOODGOOD-U HAVEN1T SAID WHOOSE GOT WORMS \ 17:53 IN YOUR WETTEST FANTASY \ 06:46 GISMS? \ 09:20 PICKLED EGGS

The area where the fort had stood had been regenerated by the likes of Simply Red's Mick Hucknell, who owned one of the first bars in the redevelopment, and had become one of Manchester's key social hotspots. Following the development of transport and communication during the Industrial Revolution and as the textile industry grew, an expanding community of Jewish settlers took over the running of a number of textile businesses in Manchester. Many of the architectural landmarks of the era are preserved today as listed buildings, with the brickworked names of the founding Jewish owners standing proud. In later years an influx of Asian settlers from India and Pakistan began a gradual shift of ownership. In the 1980's, Shami Ahmed began the multi-million family business Joe Bloggs, to appeal to the average man and reflect British working class tradition. The Joe Bloggs jeans and casual clothing were adopted by fans of groups including the Inspiral Carpets, Stone Roses and Happy Mondays – who set the music scene which became known as Madchester. This highlighted once again Manchester's textile heritage and put Manchester onto the world map as a city leading in popular culture, with fashion and music working hand in hand.

It was during this period that designers Helen Littler and Kurt Jones moved to Manchester, lured by the social and music scene, with a feeling that it was growing again as a centre – with acid house and baggy t-shirts the fashion scene seemed geared to 'dressing down' street and club wear.

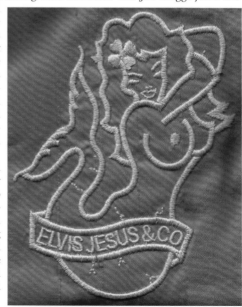

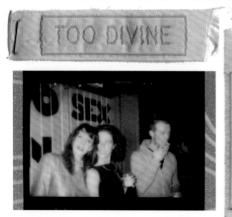

Helen and Kurt formed their working partnership whilst dancing the podiums at the thriving Haçienda nightclub in Manchester. Following a signing by their literary master Kinky Friedman of his book *Elvis, Jesus and Coca Cola*, Helen and Kurt gave birth to the exclusive fashion label Elvis, Jesus & Co. Couture. The duo began their label studying the climate of Manchester's textile industry. Focusing on the Asian influence, they began designing using sari fabric. Inspired by the limitless choice of patterns and colours and controlled by their limited funds they used sari fabric in their initial design manifesto. They could obtain small, 6-metre quantities of sari (instead of the textile trade standard 100m bolts) which allowed no two garments to be the same.

In the lead-up to the *Text-Me-Up!* exhibition, they started a passion with the colour pink at about the same time as I did. At that point, pink hadn't become the new black and not many people were wearing it. I had an obsession with the colour pink and people texting me always referred to my love of the colour. I'd started making the cushions for *Text-Me-Up!* in a variety of pink fabrics and Elvis, Jesus & Co. Couture had offered their seamstresses services to sew in all the zips of half of the collection in time for the exhibition installation.

Prior to this I had been working on a three-part television documentary for Granada TV and Elvis Jesus & Co. Couture had made me one of my all time favourite dresses in purple sari fabric, with silk lining and hidden labels carrying statements such as DIE YOUNG, STAY PRETTY. I'd become a big fan of their label and as they started to manufacture their frocks in pure pink silk I knew what I'd be wearing for the exhibition opening and my birthday celebration. The label has since been taken over by a Manchester street wear company.

Nick Fry had been helping with the exhibition and he called around the evening before in his newly dyed deep pink shirt (a requirement for the exhibition) with the text calling cards he'd printed for me. I had never seen a man wear this shade of pink at this point in time, it looked fabulous.

My exhibition covered most of the walls in the gallery. The mobile phone numbers of the people in the exhibition were taken out, and names of the vulnerable, insulted, or blatantly rude were covered in black gaffa tape. Rainy City record label Irfan and ex-Jazz Defector Franko provided their music for the opening. The centre space of cushions was occupied most of the night by Katie

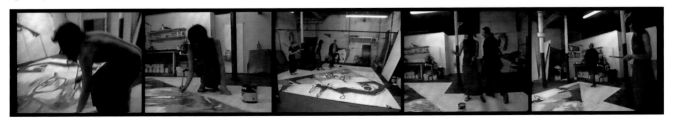

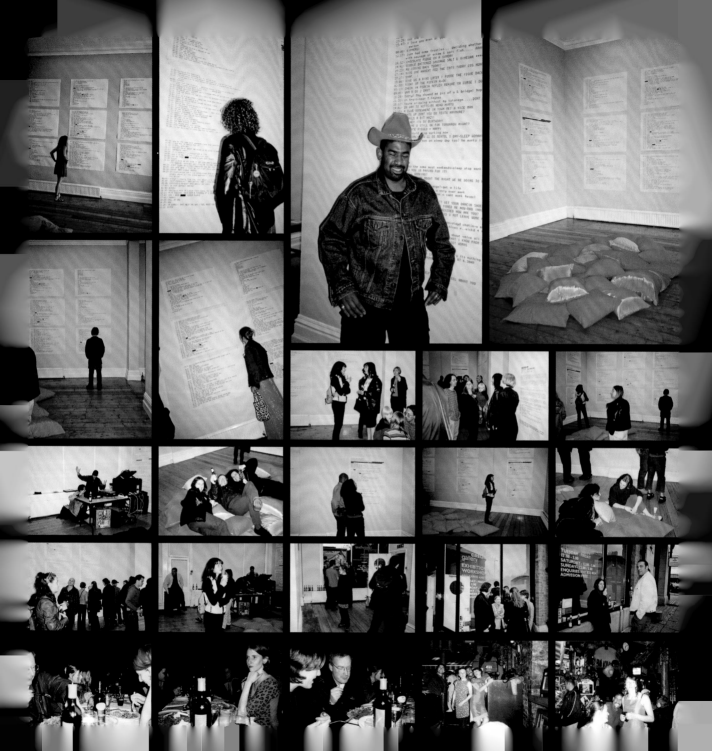

Mountain (co-owner of Manchester's music venue The Roadhouse), my childrens' nursery school teacher (and artist) Karl Harris, and Patrick Fitzgerald (singer-songwriter). Helen from Elvis Jesus & Co. Couture gave me a fantastic pink cowboy hat in the same pink shade as my dress, matching the pink of my texts.

Many of my friends and other artists attended and I was staggered by the amount of time individuals spent reading the texts. Were they looking for references to themselves in texts from or about them? Were they following a similar path to me and just about to break up from their long relationships? Were they happy or sad for me? What did they gain from the exhibition and why did they spend so much time reading the texts? I've always thought that people don't really look at the artwork on the opening night; that the majority of it is spent as a social event, so I couldn't understand what was so gripping about the exhibition. I was pleased…

It was as if I had put my red basque in with my white wash and aired my pink laundry in public to dry. At the same time, my emotional and physical scars were becoming less blood red and healing into a lighter shade of pink. My now old, red silk wedding dress and veil hanging in a discarded open wardrobe had also started to emulate my emotions: drained of its original vibrancy by the sun's rays, it had begun to turn pink. My texts were knitting back the very fabric of my life, confidence, and above all, womanhood, in an electric pink thread that was invisibly whirling through the ether in electronic form and into my limbic system.

A meal in Dimitri's next door to the gallery was followed by a night of Latin dance tunes at The Latin Club; a very special, textual birthday and opening night.

Hel Elvis Jesus > TM
22 Mar 2008 00:24
Mini me!

Hel Elvis Jesus > TM
Crikey charlie! A bit of a coincidence...

Hel Elvis Jesus > TM
I wasn't bought out, he simply took it over

TM > Hel Elvis Jesus
Lovely! I am just writing about u+the birth of ejcc for my book on txts as u txtd! And of course our shared love of pink b4 it was the new black

TM > Hel Elvis Jesus
I no! I had just finished wi the sentence: elvis jesus&co. couture hav since been bought out for their name by a big manchester retail company the couture evidently dropped. It all starts wi the history of u&kurt&kinky&diana vreeland i need more bits off u tho to go in x

TRACEY SANDERS-WOOD

18:35 in dimitris.U? \ 18:38 & ru open? \ 18:45 here \ 18:55 ON THE BUS + ON MY WAY \ 22:25 ALRIGHT THAT END OF THE TABLE? \ 22:50 HE WANTS U LOOK AT THE WAY HES LOOKING AT U NOW STOP FOBBING MEN OFF! & ITS UR B/DAY \ 02:30 YOUR NIGHT LEFT ME ALONE AGAIN USUAL SHIT \ 03:44 WOT DOES THAT MEAN?? \ 16:20 There's hangovers and tracey hangovers! Great show last night. We had lotsa fun..Need 2 sleep 4 days... \ 23:22 SINCE THE TEXTABITION U DONT DO REPLYS \ 13:52 TAFTASTIC PARTY! \ 00:36 CHAICHAI BANT GIBBLE BREATH \ 10:30 having a shit if u must know! sorry its nothing fabulous \ 11:20 IM SORRY-I CANT HELP THE WAY I FEEL ABOUT YOU \ 12:04 WHY DO I WASTE MY TIME? \ 00:52 I WANT U KNOW \ 23:40 She gasped as the sheer black panties fell to the floor and an icy hand brushed her soft, tan thigh. "ooh yeah baby" she whispered... \

16:40 and when he shot a hot load over her face... \ 13:30 No it feels 2 good 2 ever forget! \ 21:25 How do you get to Wales when you cant find Stretford? \ 21:39 DRIVE CAREFULLY POURING DOWN IN MANC \ 19:21 Alert you have a new message. Please dial your retrieval number \ 23:44 Nite nite, hope your world is a happy one. \ 14:36 CI CI-IVE GOT A SWEATY COCK-FAB! \ 16:03 DONT KNOW THEY PROBABLY HEARD YOU WERE COMING DOWN TO THE BIG CITY AND STOPPED THE TRAIN \ 21:25 Message 4 the dirty gal. CU tomorrow in slinky shiny pants (u not me!!) \ 11:51 HOWS LONDON HANGING? \ 15:57 HEY TSW-WELL DUN! SAZ SED LAS NITE WOZ TOP-SOZ HAVNT BIN IN TOUCH TIL NOW-V EARLY START-IN DARWEN WIV MAINSTREAM. \ 20:22 IMPAIRED FUNCTION THROUGH WASTE PRODUCTS.
\ 12:35 Let me know when UR getting here-why not get sat morning train? \ 23:35 - & LOTS OF STEAMING HOT SEX \ 23:38 HOWS EW TWEECH EN? \ 23:36 WHAT WET? \ 23:48 YRU GOING TO LONDON-2C THE QUEEN?

Nine days later I was travelling to London to install my next exhibition with Professor John Hyatt (my friend and boss at Manchester Metropolitan University) and John Gill (from a music background who had worked with The Mekons). I hadn't been to London for eleven years. The exhibition was programmed into the vaults of the Foundry – a bar, exhibition, performance and music space situated on the apex of Old Street and Great Eastern Street in Shoreditch, East London. The area was home to many artists and abandoned properties. I instantly fell in love with the Foundry and this wonderful chunk of the East End. The exhibition we were setting up was to accompany the book launch of *Navigating the Terror* by John Hyatt. The co-owner of the Foundry, Jonathan Moberly, also co-owned a publishing company called Ellipsis and they had published the book due to be launched that evening.

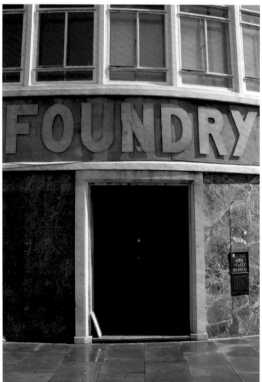

I had worked with Jonathan two years prior to this in a small back-room in deepest Moss Side, Manchester collating all the work I had gained from projects I was running as a lecturer in Fine Art/Interactive Arts at Manchester Metropolitan University. I had never met him, our correspondence done entirely through email. The project we were working on was 'ISEA98 The International Symposium of Electronic Arts', that year hosted between Manchester and Liverpool with the title of *Fear and Terror*. I commissioned Elvis Jesus & Co. Couture to design the delegates' bags from a Manchester textile perspective and the bright sari fabrics they were using in their latest collection. It was a wonderful sight to see Manchester City centre streets full of the symposium delegates, some in suits, some more casual wearing the ornate

and brightly coloured delegate pack bags over their shoulders. I used the Elvis, Jesus & Co. Couture labels that they concealed within their garments, printing them with 'ISEA98' instead of their usual 'DIE YOUNG STAY PRETTY' or 'TOO DIVINE' slogans. I also designed the covers of the books in the packs around a textile theme with labels and a CD-ROM designed by a group of interactive arts and communication media design students. Overall, it added a bit of vibrancy to the grey streets of Manchester.

I had been working on a number of projects with Tony Wilson of Factory Records. My most enjoyable time spent with him were the lectures and seminars he did with myself and groups of my students. These were carried out in the confines of his Castlefield loft-type flat, an amazingly intimate situation that taught my students much about the Manchester music scene, its nightlife and interactive models of operation. With Tony chairing and hosting the ISEA Symposium, I knew the final touches of vocal colour would be added to the patch-worked hues stretching across Manchester.

The ISEA website was a project I developed, titled *Following 1848...* It focused on the immediate history of the location – All Saints, Manchester. I was interested in what lay beneath the tread of my feet in this area: I had grown up in the Welsh mining valleys, constantly wondering about the hordes of miners hacking away at the shrinking coalface below my feet. I had a keen interest in the politics of the working classes and the reformation acts. Elizabeth Gaskell's novel *Mary Barton* was forefront of my mind with its vivid description of a bur-

ial in a common grave in Manchester. I did some research on the subject. On Wednesday 19th April 1820, twenty-one year old Fanny Knowles was the first of 16,572 people to be buried in the churchyard of All Saints. For the poor, the most likely form of burial was a large communal grave around the edge of the graveyard. These graves

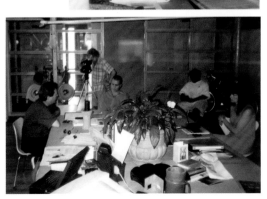

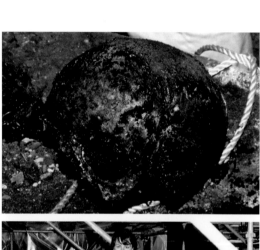

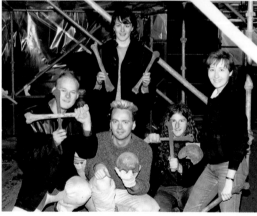

Gravedigging at Manchester Cathedral were only temporarily covered until full to capacity. The common graves at All Saints began to cause complaints. In 1848 their 'offensive effluvia' was brought to the attention of The Manchester Corporation and the Bishop of Manchester, as bodies were only one or two feet from the surface. *Following 1848…* seemed a positive title and I hoped it would deter some of the students from sunbathing face down on the still-consecrated ground that featured as a park with all those bodies still laying beneath. Nothing will ever alleviate the smell of decomposing brain matter from an exhumed skull interned in a lead coffin for me… . Ever.

The website was posted as part of ISEA98 and people were asked to MAKE YOUR STATEMENT using any action or medium. 1848 seemed to be an interesting

Scarcrush with Karl Harris

year for happenings: Donizetti died, Sir Hubert Parry, the English composer was born; Bismarck founded the *Neue Preußische Zeitung*, Marx the *Neue Rheinische Zeitung*; a wave of revolutions swept Europe.

Along with my friend and fellow artist Karl Harris, we exhibited a series of photos we'd taken called *Scarcrush* (to a soundtrack of songs by Patrick Fitzgerald). The body of work was based on Karl's appendectomy followed by peritonitis. The CD-rom was based on the history of the art school and its environs following 1848 up to present time, aided by a creative team of students.

Tom Greenhalgh from The Mekons was also working at Ellipsis at the time; he was the only person I met from the publishing house when the symposium

began. The lead singer of The Mekons, John Langford, was also in a band with John Hyatt prior to his professorship called The Three Johns. As ISEA98 finished, a few pieces from the *Scarcrush* exhibition were selected as part of a staff exhibition at Manchester Metropolitan University to tour Oregon, USA. One of the pieces entitled *Opiated More...* was selected as the cover for the book supporting the touring exhibition. It was at this point that John Hyatt and I decided to collaborate on a project and exhibition.

The teaching project I was running with the students on the Interactive Arts degree course also looked at aspects of Britain's military and technological history. It developed within the structure I was putting together for ISEA98 and the CD-rom I was making for the university. *Following 1848...* had developed into a program of 50-year anniversary time frames. *Following 1848...* then *1898, 1948* to *1998.* In developing the 1948 section I was looking at how we were celebrating the fifty year anniversary of the Manchester Mark 1, the world's first electronic stored-program computer which was built at The University of Manchester in 1948.

The project I devised for the students focussed on computer pioneer Alan Turing, whose research played a big part in the development of the Manchester Mark 1. We looked at various aspects of his life, from a question posed by Apple Computer's logo to Turing's homosexual activity and subsequent death. Shortly after the war Turing was arrested and publicly tried for being a homosexual. It is believed that this drove him to poison himself with a cyanide-laden apple, dying at the age of 41. Was the original Apple logo – a rainbow-coloured apple with a bite taken out – a reference to Turing, with echoes of the rainbow flag adopted by the gay movement at about the same time?

I didn't yet know how the advancement of the mobile phone would change my life and art in the next year when a love of texting succeeded my crumbling ruin of a marriage. I often think of Turing who has influenced so many key developments in technology as I text with my phone. I particularly think of him when I use the forward slash key in a message or as last command when calling up a website address. He chose the forward slash to represent binary zero – which thus became the most common character in his programs and data sequences for the Mark 1. The consequent patterns formed by these ////////// slashes, it is said, was inspired by the incessant rain of Manchester's grey climate.

At the time I was friendly with Steven Twigge, an international arms specialist who also lectured on the subject. I had become totally fascinated by the beautiful names given to different UK missiles and warheads of the Cold War era, like Blue Bunny; Orange Herald; Red Snow; Green Granite; Indigo Hammer. I began using their names to write anagrammatical poems. I wanted to see all the official secret documents regarding these missiles and warheads and soon began collecting them. Inspired by Alan Turing and his decrypting of the vast number of war time messages which had been enciphered using the Enigma machine, I researched into their coding and finally created a body of work on anagrammatical poetry based exclusively on the individual warheads' names.

This poetry formed the basis of a collaboration between myself, John Hyatt, Steven Twigge, and Karl Harris, and was published by Manchester Metropolitan Press as *Give Battle in Vain* under the anagrammatical pseudonym Doria Hemming.

The exhibition was titled was taken from the mnemonic 'Richard Of York

Manchester Evening News
BT NORTH WEST DAILY NEWSPAPER OF THE YEAR

Tracey goes BALLISTIC

BY RACHEL PUGH

How nuclear missiles with pretty names launched a Manchester artistic campaign for peace

RED Snow, Violet Vision and Orange Herald may sound like varieties of garden flowers – but they are the names given to British nuclear warheads that have provoked Manchester artist Tracey Sanders-Wood into launching her own artistic campaign for peace, which is extending its tentacles over Europe.

The 35-year-old Moss Side-based art lecturer at Manchester Metropolitan University created a creative storm in Bulgaria, when she talked at a digital art conference in Plovdiv and showed work she'd produced in Manchester inspired by her disgust at the naming of the weapons of mass destruction. She has now set up an art project with artists from England, Switzerland, Macedonia and Finland to explore the way that military events are viewed by different countries.

The show, called Where The Pheasant Hides, will be shown in the Holden Gallery, Cavendish Street, Manchester, and in Macedonia and Bulgaria during October and November.

"It was the names of these nuclear warheads that really got to me," says Tracey. "I had been talking to a friend who works for the MoD in the bar one night and he started telling me some of them."

Fired up by indignation at the ironic beauty of the British weapons' names, Tracey put together a show at the Cube gallery called Give Battle in Vain (the last part of the mnemonic "Richard Of York Gained Battle In Vain" for the colours of the rainbow). Each of the seven British warheads is named after one of these.

The new show Tracey is co-ordinating with work colleague John Hyatt and nuclear historian Dr Steve Twigg, is named after the Russian equivalent of the memory aid "every hunter needs to know where the pheasant hides".

Macedonian artist Natasha Dimitrievska, who worked on the Cannes award-winner Before the Rain, is filming the concrete tunnels and underpasses of eastern Europe.

Amos Taylor from Finland is tracking stray dogs in the streets of Sofia, drawing the analogy with missiles which

have a homing instinct. Other artists will produce photography, digital art, paintings and prose.

The group will work under the name Doria Hemming – a pseudonym already employed by Tracey for her Cube Gallery show earlier this year. The name is an anagram of Indigo Hammer – another of the seven innocently-called atomic weapons. Doria's identity is one of the devices Tracey uses to highlight the duplicity and fear that surrounded the events of the Cold War, and the appearance of peace between nations that can easily erupt into war.

She says: "People accept that these weapons are here and they stop questioning it. It's only when Pakistan drops its bomb and things get nasty in India that it all comes back to memory."

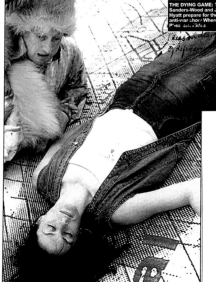

THE DYING GAME: Tracey Sanders-Wood and John Hyatt prepare for their anti-war show Where The Pheasant Hides

MUSIC

■ **Buxton Festival**, ends Sun. Britten The Rape Of Lucretia, tonight, 7.30. Double bill of Donizetti's Il campanello di notte and Suppé's The Beautiful Galatea, tomorrow, 7.30.
■ **Clonter Opera Farm**, Congleton (01260 224514). Opera Studio double bill, Puccini Il Tabarro/Jaques Brel On A Carousel. Tonight/week tonight, 7.30, tomorrow/week tomorrow, 7pm.

Alan Hulme

Gave Battle In Vain...' a learning tool in schools for children to remember the colours of the rainbow, based on an historical rhyme. Richard = r =red; of = o = orange; York = y =yellow and so on. I concentrated on seven warheads/missiles and the rainbow colours that matched their names and subtitled the exhibition *Indigo Hammer*. Anagrams of the warhead were Doria Hemming and Radio Hemming. We created seven stations based on the colours of the warheads/missiles at the Cube Gallery in Portland Street, Manchester. After all my research, I now wanted my own missile. It was easier than I thought; I asked around and had one in my possession for free by the end of that week. I began feeding John Hyatt various anagrams on the warheads for his book *Navigating the Terror* and took the book to London for a launch with an accompanying exhibition.

Copy No. 1 of 5 copies

TOP SECRET ATOMIC

E.D.

FB/219/57

How long will be the intervals between tests? D.S. 14/5

MINISTER

The technical requirements involve an interval of 17-20 days. This may be increased if the weather turns nasty.

As your office has already been informed, we have had the all-ready signal from Christmas Island. This means that, if the weather remains kind and everything goes well, the first test will probably be carried out on Thursday.

2. You will like to know the final test programme. It is as follows:-

Test No. 1 - GREEN GRANITE II

This is a 30" diameter weapon weighing 2 tons. Until recently this was expected to be the best approach we could possibly make to a free falling bomb.

Test No. 2 - ORANGE HERALD

This is a 45" diameter weapon weighing 2500 lbs. and was intended to be the prototype for the development of a head for the intermediate range ballistic missile. It is extremely expensive in fissile material.

Test No. 3

There are two alternatives for this test depending on whether or not Test No. 1 is really successful.

(a) If GREEN GRANITE II is really successful, Test No. 3 will be a weapon known as BLUE GRANITE which is a 20" diameter weapon weighing 2500 lbs. This is an extremely forward looking weapon designed at a very late date. Its principles are based on the success of GREEN GRANITE II and the use as a trigger of the initiating mechanism intended for use in the defensive weapon, and if it comes off it will provide an extremely light and cheap solution for the free

/falling

TOP SECRET ATOMIC

A brief extract from it sums up our entrance into London:

> It was a complex story. Indeed so complex that it seemed a deliberate smoke-screening device. An arts project by the internationally renowned artist, Doria Hemming had been unveiled to unanimous arts press applause down in the city centre. The trans/bisexual Hemming had announced that he/she was teaming up on the project with a rising new art star, the AISCARP. Doria Hemming teaming up with anyone was unprecedented. He/she was a superstar; a household brand name. Hemming was the sort of artist a city bought in to create some buzz about the fact that the city was a city, a real place rather than just a site through which information and data was switched and shifted.

I never read the book predominantly because of my fabulous accreditation in the acknowledgement section with my then surname Sanders-Wood, which read: *Tracey Sanders-Wood, William Shakespeare and Mary Shelly*. In no piece of literature could I ever again be included or defined in this way.

Give Battle In Vain

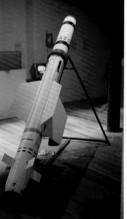

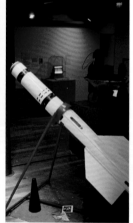

23:40 YOU R MISSING JERRY SPRINGER \ 00:14
YEA U 2 ROCK ON \ 23:37 THE SONG REMAINS
THE SAME \ 22:08 I BET U DIDNT MAKE IT TO
BED YET! \ 12:45 ARE YOU IN MANC YET? \ 21:36
NEW ONE FOR U TRACEY QUEEN OF HAPPY \
00:16 GGGRRRREEAA8IT \ 06:26 Stavros say he
no need for get strong, I big strong massive sorted
+ clear see. Ciao \ 06:33 YEEEEEEEEEEEEEE
EEEAAAAAaaaaaaaaaAARRRR! \ 23:01 DID
U SURVIVE TALKING TO YOUR EX TODAY \
21:10 ...and the first message reads: welcome to
my mobile world... \ 21:33 in ellipsis...en route to
foundry *^*/^* did you get a phone? \ 22:16
BIT SLACK WITH THE TEXTS ARNT YOU \ 00:05

IF I TEXT U AT NIGHT WILL U STILL RESPECT ME IN THE MORNING? \ 01:47 pink is a better colour
than brown \ 16:44 so u never got my texts? lovingly handcrafted, especially the one about the
cramp in both feet... \ 05:10:44 alarm call 11.00? codeword? = accountant

05:20:32 ...then later in somerset... \ 20:22:14 Can i meet him? maybe kidnap inte$ogaith & torture in a remote part of englain <unspecified> \ 22:20:40 I am an aleien and i have teleported into your phone right now i am having sex with your thumb i know you like it Cos your smiling . Now Pass Me On \ 16:43:03 FUKN CLAYTN IS FINSHD – IT IS DEAD NO MORE – DECEASED – \ FUKN DEAD...HIPHIP FUKNHOORAY!XX \ 15:05:10 Still on hope, the cathedral graveyard canyon on your right, you pass gambia terrace liverpools own royal crecent (but it is not royal or a crecent) \ 16:55:13 I THOUGHT YOU WERE USING POETIC LICENCE...besides havent you heard of the merseys famous basking sharks? they eat plankton not people... \ 17:44:17 amazingly we got away with it! \ 20:44:16 EARTH CALLING MOTHER MADNESS \ 22:42:39 rang u to go to play \ 23:01:13 No way! completely phased by texterity \ 23:07:01 LOST IN THE SWIRLING MISTS OF KUBLA KHAN \ 00:19:49 I WILL BE IN DESERT SOON GOING TO LIVE IN MUSCAT...FRANCE FIRST WITH ANDY \ 00:23:10 FLY OUT–PLEASE \ 13:23:42 in a cornfield... \ 20:28:16 YOU CHEEKY THIEVIN BITCH I WAS READING THAT, IF ITS NOT BACK BY SATURDAY JAI LOOSES A BOLLOCK \ 23:09:18 TRY TO AVOID HIM AS MUCH AS POSSIBLE \ 00:25:58 I LUV U ALWAYS THERE FOR YOU. XX

The *Navigating the Terror* exhibition opening night and book launch at the Foundry had been a success. I soon found myself on the train back down to London the following weekend inviting more friends to the exhibition. That week I had met several people who would have a positive impact on both my children's lives and mine. Five of these were Jonathan Moberly, Jaime Rory Lucy, Daisy Asquith, Pete Doherty and Gavin Turk. I instantly bonded with Jonathan, who I'd worked with two years prior to this but had never seen, spoken to, or met. The textual revolution didn't seem to have taken hold there as it had in Manchester. I was soon urging people to get the Nokia 3210. From that point, my messaging boxes were filling themselves as soon as they were emptied. I soon needed more journals to transcribe my new friends' texts into.

On the night we first arrived in London to install the exhibition, the two John's and I had dropped off the work, been introduced to the Foundry and then went off to meet the Pro-Vice Chancellor of Manchester Metropolitan University with his son and colleagues from Wallpaper magazine. We went out for Japanese food and drink and had a lovely evening. As the evening concluded we went our separate ways and I was left to hail a cab, soon learning the London cab's 'yellow light – for hire' rule. I eventually stopped a cab in the middle of an overbusy somewhere: climbing in I found myself in the midst of an assault, the victim receiving a serious facial beating, oozing blood, his assailant trying to escape by commandeering my cab. The assertive cab driver ejected him and hastily diverted our route as I gratefully accepted a texted invite back to the Foundry.

When I arrived at the Foundry, Jonathan was out with Jaime flyering the local area for a book launch by Jeremy Cooper, published by Ellipsis with an accompanying exhibition by Gavin Turk. The book was titled *No FuN without U: The Art of Factual Nonsense*. I picked up a copy of the book, reading the inside sleeve as I waited for them to return. *No FuN without U* chronicles the life and times of Joshua Compston, a pivotal figure of the Shoreditch art scene of the 1990's until his death at the age of 25 in March 1996. His lasting

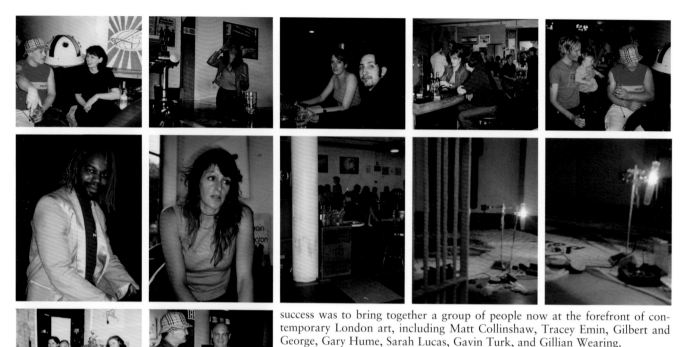

**Navigating the Terror
exhibition and book launch**

success was to bring together a group of people now at the forefront of contemporary London art, including Matt Collinshaw, Tracey Emin, Gilbert and George, Gary Hume, Sarah Lucas, Gavin Turk, and Gillian Wearing.

I was instantly attracted to this dead artist's ideals and wondered why I'd not heard about him and the sentiments he carried prior to this. I love people in any profession who act as catalysts, bringing people together and making things happen. Jonathan and Jaime returned from their mission and I later asked how Joshua had died. They said it was 'from the ether…' ether poisoning. The ether to me was a cable that connected me to the rest of the world with the ethernet, just as my mobile and text messages were out there in the ether without an umbilical cord attached, it could go anywhere and bring all the information back to me. I am still perplexed today by this artist and his untimely death. As I turned the page to the two artists who had painted his coffin, Gary Hume and Gavin Turk, one of them walked into the Foundry and a shiver wove down my spine. I was introduced to Gavin Turk as Jaime and Jonathan relayed their night's activity. The following evening, we were all stood in the same formation next to the bar when Gavin brought my attention to an invitation scantily secured to a space above the bar. It read:

The Foundry is going to Moscow. Dom is coming to London. Dom is a place in Moscow with a bar, a stage and walls for sticking art to. From August 20 to 27 we are giving the Foundry to Dom. In LATE September the Russians are giving Dom to the Foundry. If you want to come sign here and tell us what you want to do. We have a few quid (thanks to the British Council) but money is tight. So the more people who can pay for themselves, the more of us can get there. Flights are cheap. This is the application form. Make your own job title, make your own dream job and tell us why you are the best person on the planet to do what you want to do.

Gavin, Jaime and Jonathan urged me to put my name down saying there was a budget to pay for it, but I dismissed it telling them it would be too difficult for me to get away.

The train commute from London to Manchester became a strategic part of my life. My friendship with a woman called Heidi Wynter in Manchester grew as we started sharing school pick-ups for the children, which helped if ever my train was delayed on the days that she collected the children from school (on other days they stayed with their father). It became easy to be transient between the two cities. With a mobile phone I was constantly contactable.

On my following visit to the Foundry I stood in the same spot next to the Russian invitation. This time I was introduced to a young Pete Doherty and we hit it off immediately; he hosted the poetry night every Sunday and was a regular barfly and personable creative soul. He was handsome, almost pretty for a man. As our friendship developed over the coming months he was added to my phone contacts as Prity Pete. Pete explained he was definitely going to Russia and looking forward to hosting the Russians here in the Foundry. He urged me to go and I told him it's almost impossible. We spoke about Moscow and my love of shooting and the area I come from in the Welsh Valleys where there used to be nothing to do on a Sunday, and how shooting became an activity which many people adopted. I told him how quickly I can skin a rabbit, moving swiftly from one to another, chopping the head off so it cannot look at me for my sins, snapping the bones with a crisp break to each leg. A deep insertion to the stomach from top to bottom with a bucket for the innards. Then, a gentle levering of my fingers and flat palms between where skin membrane touches flesh; a gentle suction noise emanates as the skinning processes nears completion. He looked horrified and

told me how he frets about most things. We talked about mine and John Hyatt's exhibition in the Foundry and he told me I couldn't use 'Missile and Warhead Collector' as my Russian job title as I'd never get into the country, but more importantly I may not be allowed to leave – if I did there'd be a gulag with my name written on it. He asked if I'd shoot bears there suggesting maybe if I did I could stuff them instead of skinning them and then go as a taxidermist. Then he laughed saying he should go as a fretter. And as things developed over the coming months I did go to Moscow as 'The Taxidermist' and Pete went as 'The Fretter'. There were an amazing assortment of job titles from 'The Sax Man', 'Miner', 'Geek', 'Doctor', 'Supernova', and 'Red Belle' to 'Being Che Guevara' and 'The Disinformant'. I found out that a mnemonic similar to 'Richard of York Gave Battle in Vain' was used in Eastern Bloc countries using the Cyrillic alphabet, which translates as 'Every Hunter Needs To Know Where The Pheasant Hides.'

That same weekend I started talking to Daisy Asquith. Daisy is a filmmaker and her career was just formulating then. She had made a few interesting documentaries, but most intriguingly both her and Jaime were always walking around the Foundry filming everything and anything. They introduced me to the film camera. Daisy often helped out behind the bar, but up until this weekend I'd not spoken to her very much until I noticed a tattoo on her arm of two red dice. I knew from the dice tattoo, and then from her explanation, that we were going to become good friends, the dice bonding us.

TM > Daisy Asquith
5 Oct 2009 21:08
What are the numbers on each of your dice?

Daisy Asquith >TM
sorry honey, was doing some emails… my numbez are 4 and 6 facing out, 3 and 2 facing up. I rolled dice to get em. Whatyou up to ?X

10:30:22 WHAT TIME IS IT? (broke the clock) \ 11:22:47 gavins on his way to get me out \ 12:57:44 GONE TO FOUNDRY \ 10:05:01 right Ur SNUGGLED up it is! \ 12:25:07 HOW LONG U IN IRELAND FOR? \ 12:46:06 SOUNDS LIKE A FAB PLACE FOR A HOLIDAY EVEN BETTER TO LIVE \ 11:15:33 AT A FESTIVAL NR OXFORD, RING ME! MISSED U LOADS TWAT BITCH. XX \ 57:27:20 SAW THE FUCKWIT LAST NIGHT + CALLED HIM A SELFISH WANKER \ 15:35:14 I NEED TO FUCK TILL I DONT KNOW WHAT DAY IT IS \ 19:19:55 YOU KNOW I CARE ANYWAY WHEREVER I END UP \ 20:44:37 farb message luv u – always there 4 u but we need to do full on missions n adventures \ 23:44:05 PS HES GOOD IN BED TOO \ 11:14:43 I HOPE IT DONT FOLLOW THROUGH REMEMBER ITS PUSH, THEN SQUEEZE, OR ELSE ITS GRAND PRIX SKIDDING \ 00:51:00 IM SO SORRY I HAD NO IDEA THATS WHAT THIS MAD LIFE PUTS US THROUGH THATS WHY WE NEED TO GO. LOOSE SIGHT OF REAL SHIT \ 01:16:40 LUV U TAKE CARE OF U \ 11:12:34 DOES IT GO ANY BETTER TODAY? \ 19:05:37 CUNTBITCH

Daisy Asquith >TM
8 Oct 2009 15:44
I miss you and love you Tracey xxxx

Daisy Asquith >TM
On way to Yorkshire for filming. Have fun baby x

TM > Daisy Asquith
Aww baby me to! I'm writing about you at the minute and will have to check things with, details like. Jonathan is going to phone you re film stuff. I'm in a car with Mark Thomas at mo going to gig with him in hastings. Where are you?

TM > Daisy Asquith
And you chicklet xx

02:20:01 HOW U? DONT B LONELY, DONT B SAD..ONE END A NEW START + FRIENDS LOVE YOU NO MATTER WHAT...sleep easy..xx \ 00:56:50 IN BED IN CHORLTON OR MOSS SIDE? \ 01:23:49 paaC.ABAARR T T T T Y Y Y I I E E !!! on roof of town hall \ 16:52:36 BEEN ARRESTED YET? \ 10:00:40 HaVE U ERECTED YOUR RUSSIAN METAPHORICAL PENIS YET? \ 13:54:38 GINTFLAPS \ 18:05:58 HAVE U HAD WIDGETS + WIPPED KIPPER? \ 23:50:03 BOB DYLAN GAVE US COKE LOU REED GAVE US SMACK BOY GEORGE GAVE US A CUP OF TEA \ 07:05:05 GOING BACK TO MANCH ON TUESDAY IF U WANT MISSILE MOVED \ 01:38:45 ZEPPLIN RULES... \ 21:36:21 IM GOING TO START A ROCK BAND CALLED THE DRIBBLING COMMODES \ 09:09:10 Dont forget to call me so we can sort out Moscow \ 00:20:32 MANEZHNAYA PLOSHAD 1ST stop to gather the hunters... fur royals & vodka... the pheasant NEED grows...grain soaked in whisky makes them drunk& easier to catch... \ 23:47:03 IM SOOO GLAD I VOTED 4 CRAIG! \ 23:17:02 YOU GO GIRL GO WITH ALL MY LOVE + SUPPORT (+ENVY) \ 21:19:01 N N S T D L T B B B A I T D G Y S A H T T T B A B CLUE E G B D F \ 18:08:00 fakirs most welcome...can s/he do passports? \

Gavin Turk and his partner Deborah Curtis collaborated with Jonathan and decided to throw a welcoming party for the fifty Russian and fifty British artists, musicians, film makers and performers on the rooftop of their home in Shoreditch Town Hall. I was unable to go due to commitments with the children at home in Manchester. I was, however, busy plotting and planning a spin-off exhibition from *Give Battle In Vain...* based on the warheads and missiles I had now become totally obsessed with which would form a new section of my work in the UK and in Moscow. It seemed ironic as I sat working on this new weapons project and the texts were coming in, that the missiles and warheads had changed my life for the better. I sat there wrestling with a quote by Simone de Beauvoir from her book *The Second Sex* in relation to the weapons I was working with:

> Here we have the whole key to the whole mystery... In serving the species, the human male also remodels the face of the earth, he creates new instruments, he invents, and he shapes the future... [woman's] misfortune is to have been biologically destined for the repetition of life, when even in her own view life does not carry within itself its reasons for being, reasons that are more important than life itself.
>
> For it is not in giving life but in risking life that man is raised above the animal; that is why superiority has been accorded in humanity not to the sex that brings forth but to that which it kills.

I started constructing a major trail around Moscow based on the nuclear warheads and missiles for our visit there. I then began to think that it would be a good gesture to offer our Russian guests a British missile in the name of art and progress, symbolising how we had moved on from the recent Cold War period. I made a few phone calls and sent some emails the following day and I secured the same missile I had used for the exhibition at Cube, Manchester.

I text my singer-and-bass-player friend from *Toss the Feathers*, who had sent me my first ever text message. It was all arranged: Big Dave would go to collect the missile in his ex-army Chevy and pick me up en route to London with the missile in the back to present to the Russians as a welcoming gift. We decided to look the part, dressing in dark colours with dark shades bordering on the secret agent look. Big Dave pulled up to my house with the missile protruding a couple of meters out of the back window. I jumped in and we set off. My mind started racing, 'what if the police notice us driving this huge object down the motorway and they call a swat team?' I reached the point in my own imagination where a helicopter chase ensues and they start taking shots at us. Big Dave

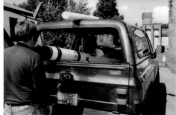

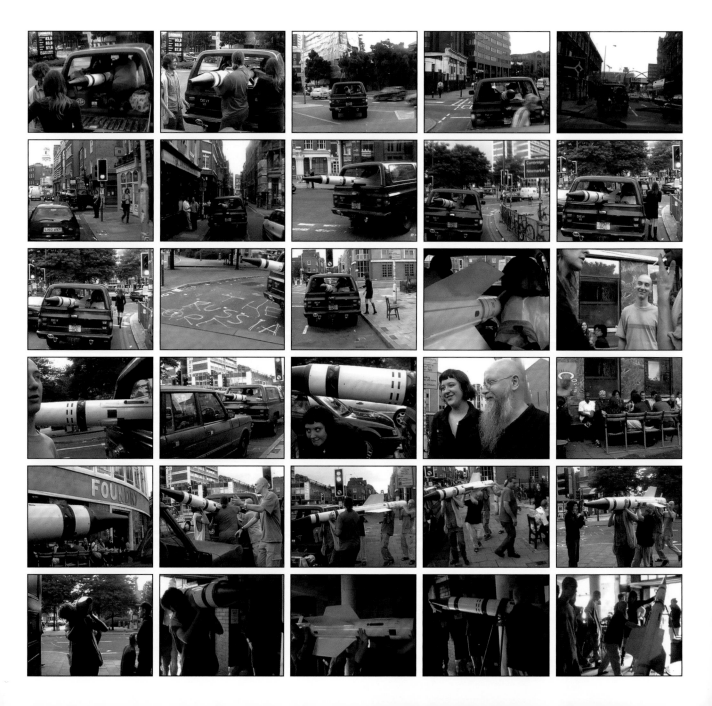

was chilled-out and that alleviated my growing paranoia over the protruding missile and my fears of being gunned down by the police in the name of peace, art, Perestroika, the death of the Cold War and so on. We then hit a large traffic jam. Big Dave had become agitated by the amount of time wasted in this congestion; he indicated left and started driving down the hard shoulder ignoring my protests. He continued driving past all the cars caught up in the jam, not heeding any of my now loud verbal complaints. My paranoia flared and I knew at any second the police were going to stop us for driving down the hard shoulder and then arrest us for carrying an unsecured missile. Thirteen kilometres down the hard shoulder and we were at the front of traffic jam and back into the correct lane.

We drove to the outer edge of London and stopped at a garage to re-fuel. A drunken man took a short-cut through the garage forecourt. He walked for a few meters, turned around and came back to the car. He paused and said, 'I do this walk every day back and forth to work. Today, I left work at lunchtime and went to the pub. I've drunk a lot, but I'm not hallucinating. That is a Firestreak air-to-air missile sticking out of the back of your car isn't it?' Dave and I nod and both say, 'Yes it is.' The man looked at us both and said to me, 'I'm going home to the wife. I'll tell her about this and she won't believe me, she'll just think I'm drunk. No one will believe me and I'll wake up tomorrow morning and think I've been hallucinating. I'm not hallucinating am I?' Again, Big Dave and I say 'No'.

Dave and I set off for the last leg of the journey to present the Russians with their welcoming gift wondering how the drunken man knew the name and type of missile and why no-one had reported us to the police.

The mobile phone became a hotbed of action as Jaime Rory Lucy and Jonathan started calling. They wanted to meet us with a film camera and follow the last leg of our journey through London delivering the missile to the Foundry. I was assured that the Russians were gathered expectantly and waiting for their surprise offering. I became anxious and hoped that everyone saw the humorous and political message in my actions and deliverance. We arranged to meet at the garage on City Road. Jonathan and Jaime turned up in a military green Range Rover with Jaime and his 6'5" frame sticking out of the sunroof with film camera rolling in hand. As I started to introduce Big Dave and Jaime to one and other, I found that the pair had met a long time ago and had shared experiences in Manchester but not seen each other for many years.

We drove the short distance to the Foundry to unload the missile gift to the Russians. The greeting wasn't quite as I had expected. Some of the Russians were interested with smiles on their faces but others viewed it with trepidation. It was moved and positioned by the bar and set on its stand. Soon it was accepted and enjoyed, and a great ice-breaker. The missile was soon scrawled with the Russian word for 'cock', creating our very own Cold War scenario for a short time.

The missile became a centrepiece to the week's events with numerous Russian and British women straddling it, posing for the post-Cold War photo shoot. The Russians were launching the first *Alcofilm Festival* at the Foundry, which attracted an amazing and diverse audience. It had been nine years since the collapse of communism in the Soviet Union. From a nation built from hardship and extreme climatic conditions, a strong and passionate culture had emerged. The art presented at the Foundry that week smashed unreconstructed attitudes and

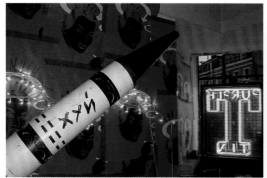

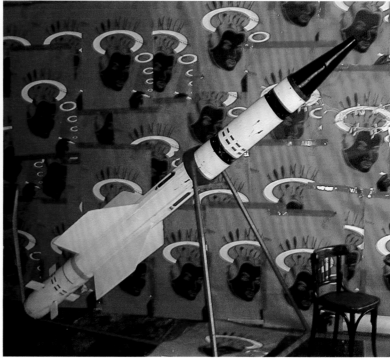

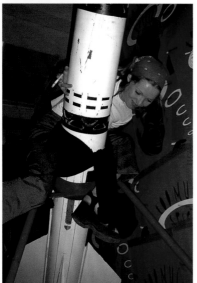

beliefs on both sides. I was proud to be part of this event knowing that elements would be tied up in histories, acting as a catalyst for more things to come. It was the perfect place to be hosted in: the Foundry, a 'non-establishment' intent on challenging unquestioned attitudes of the art world in Shoreditch, in Britain and beyond.

Shoreditch was then an under-developed area, full of derelict buildings, disused warehouses, property bought up from faltering mortgages and bankruptcies. Many empty buildings had been turned into artists' studio squats and there were only a handful of pubs. Along Rivington Street there was a regular Monkey Parade at weekends between the Foundry and the Barley Mow pub, passing the Bricklayers Arms in between. This was before outside drinking was banned in the area. The Monkey Parade being the early Shoreditch walk of fashion, hair, styles, shoes and bags which may have inspired Mark E Smith's ex-wife Brix from The Fall to establish part of her fashion empire there with her second husband Philip Start. On Fridays and Saturdays it was at its most vibrant. On a Summer Sunday it would always take longer for the cars to get through the throng due to the slowness of the wide-eyed drink and drug bender-weekenders lining the street. With their mullet haircuts and indelible fashion style they formulated the Shoreditch hipsters, dribbling as they looked on, fawning everything in their mashed up brain, often finding solace or a bed in the middle of the road.

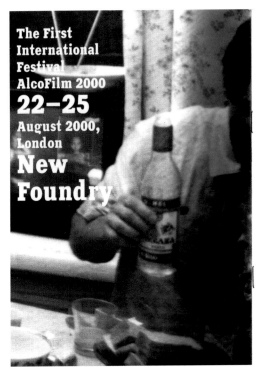

The First International Festival AlcoFilm 2000

22–25 August 2000, London **New Foundry**

Homo homini fellow drinkerest! (Человек человеку – собутыльник!)

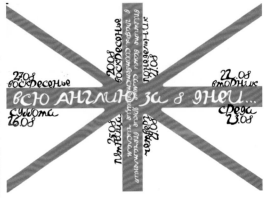

The Foundry felt like a self-contained arts community and the thirty-five Russian visitors soon became part of the building's internal and external fabric. The pavement outside the building became a show area for our guests, where a Russian artist, German Vinogradov, executed an almost naked performance with a metal helmet covering his head and a cup covering his genitalia to which fireworks were set alight. Fireworks and the Firestreak missile were to become a continual thread throughout the week.

The Foundry has three main floors. It was originally built as a bank, and down three sets of stairs the two-roomed bank vault can be found with a huge safe door. On the middle floor the big room is located which houses a concealed

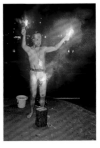

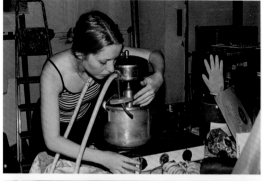

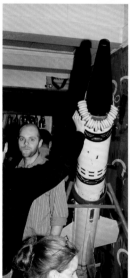

entrance and a huge lift that we use as a storeroom. Much use has always been made of this room in the Foundry for art, music and performance.

A revolving steel bullion turntable approximately 4 metres in diameter was installed into the floor by Francis Theakston (Ltd) 1933, now acting as a huge merry-go-round for many of the visiting artists and audiences. Such discs had been fitted into ferries as a useful way of manoeuvring vehicles. The night after the naked Russian body fireworks performance had taken place, HXA New Art Ensemble put on a performance in this room. They were an experimental musical act from Chelyabinsk (in the Ural mountains), creating music for absurdist theatre and post-modernist happenings.

As the week took shape it geared up for the *Alcofilm Fest* screening with an arts performance including the distillation of 'samogon' organised by Nadya (Nadezhda Bakuradze) and Pasha (Pavel Labazov). The night was aptly titled *Samogon, Samogon!* Samogon is a home-made spirit similar to moonshine. The Russian name literally translates as 'distillate made by oneself' and it's made from the raw ingredients of sugar, beet, corn and

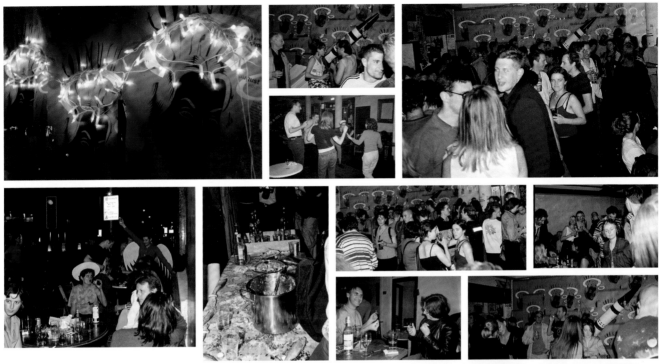

potatoes. As the first *Alcofilm Festival* title started rolling frame by frame so did the drops of samogon from the Russian still. The table surrounding the still was decorated with Russian snacks including small dried fish along with buckwheat blinis with sour cream, pickled herring, marinated cucumber and red caviar. The samogon was tried and tested by a local audience keen to experiment along with the Russians who were used to it. The haze of samogon-clouded thoughts mixed in with smoke is just a small memory for that evening.

The evening was fuelled by fire, from an ignited wheelbarrow and burning bar floor. Fireworks were set off in the big room and the HXA New Art Ensemble did another performance after the films. Just as the performances and screenings had got into full swing, licensing officers walked in and carried out a thorough inspection of the bar, on one of the wildest nights the Foundry had seen. Standing right next to the distilling samogon, the officer asked for the licensee. 'We don't like what's going on here, but we can't find anything wrong,' the officer grumbled. I was oblivious to this, helping with the ignition of a ring of fire we had made around the outside of the Foundry. Just as the licensing officers were asking Jonathan, 'how do you control any situations in here?' Jonathan noticed the fire circle outside on the pavement and simply said, 'perhaps we should go outside and put that out.' I managed to get a few photos before it was finally doused. The night didn't end there.

As the evening's bar events closed and many of the people left, we organised

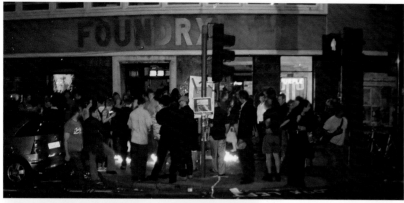
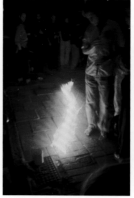
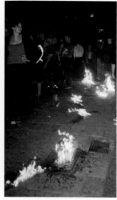

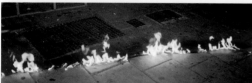

a lock-in party for our Russian Dom guests and the UK Foundry counterparts. Alcohol intake resumed and dancing started. As the party progressed into the early hours of the morning, people dropped like flies, literally where they stood or sat. A hard-core bunch of us got some military flares out and set them off near the far wall of the bar. The ceiling is still scarred with holes in many of the panels. The noise was the most deafening sound I have ever heard. Uniformed officers stormed into the Foundry demanding to speak to the licensee. They took one look at the scene, the lead officer muttered something and they left as quickly

as they came. The party resumed until after breakfast. At this point I was fast asleep and many of us were woken by the laughter of Olga and Nick, organising the Dom members as they had walked in from the street through the unlocked Foundry front door.

The world's first *Alcofilm Festival* was a success. As Saturday moved into Sunday, I took portraits of the Russians after a full English breakfast in a greasy-spoon café. Then we said our good-byes as their coaches left for the airport. Rain-soaked dried fish heads lay strewn around the pavements of Shoreditch as the Russians departed. Lost amongst them my phone and text messages of that eventful fire-fuelled week.

14:30:09 ARE U STILL PACKING + SORTING? \
14:25:52 LET ME KNOW IF YOU NEED ME TO BAIL YOU OUT \ 12:05:48 ABSOLUTE MADNESS HAVE A VODKA 4 ME \ 23:39:56 B WITH ME ATWIXT \ 14:18:13 HAVE U SORTED THE ENSUITE YET? \ 10:16:16 GOIN 4 BReaKFast, call when U R UP \ 21:47:26 UP YOUR ARSE BUM FUCK SEE YOU IN HALF AN HOUR \ 21:31:58 NICK SAYS TO SAY...THATS A ROG \ 20:33:36 WHERE U TWAT? \ 17:49:30 TA 4 DOIN THE FORMS GIZZLESPURT. HAVE I GOT FREE ACCOM. COZ I WILL B MEGA SKINTOS \ 12:10:37 SUCH ELOQUENCE FROM SUCH A POX INFESTED RAT FUCK BITCH \ 21:29:15 I AM NOW LEAVING MANCHESTER \ 10:29:06 BACK IN MANC \ 01:22:31 SHAGGED... \ 23:38:14 KNOW THAT LAST BIT. HOPE THE RUSSIA THING GOES WELL. SAVING THE PARTY TILL YOUR HERE \ 16:35:45 Got y r msg but been u busy with music world. Off 2 work now and lotsa sleep@ w*end and then we 2 can meet!? \ 23:49:22 DID U SAY LAP DANCE ON M25 OR LAP OF M25? HAVE U SUSSED WHO CRAIG IS YET? \

09:30 RUBARB and GRAVY \ 09:39 YOU KNOW YOU REALLY WETTING MY APPITITE \ 23:55 EVERY EGG A BIRD \ 00:23 HEY U LOVE U! \ 23:45 CALL ME \ 11:28 HEY DUDE SLOWED DOWN YET? \ 20:51:59 YOUVE BEEN WORKING FAR TOO HARD YOUVE LOST THE PLOT \ 20:28:16 ???UUHHH??? \ 22:44:41 DID U GET THERE SAFE + SOUND? \ 04:06:16 AS FAR AS I CAN TELL YOUR LIFE IS A WORK OF ART IN THAT YOU HAVE TO LOOK PAST WHAT YOU FIRST SEE (NOW WHOS GETTING POETIC) \ 13:55:51 i KEEP GETTING THE WHERVE U GONE M3ES$AGE...IM STILL HE3R \ 20:44:16 IS THAT GLADNESS OR GLADIOLIES \ 00:23:04 WELL NEARLY WHATS DIRTY ABOUT IT I HAD A BATH \ 18:46:32 ridic i kno bu IT had Xd my mind...n t lesS i strongly $uspect i cannot \ 05:11:31 THIS IS THE ME$SAGE: samogon research required \ 20:00:07 SAW IT WHO HAD ROAD RAGE U OR THE OTHER DRIVER? \ 23:53:20 IM GOING TO NEED MY TATTOO DESIGNED B4 I GO

EVERY HUNTER NEEDS TO KNOW WHERE THE PHEASANT HIDES (OR SITS)

Give Battle in Vain
British mnemonics for the colours of the rainbow; names for British nuclear warheads.

R = Red	Red Snow	Richard
O = Orange	Orange Herald	Of
Y = Yellow	Yellow Sun	York
G = Green	Green Granite	Gives
B = Blue	Blue Danube	Battle
I = Indigo	Indigo Hammer	In
V = Violet	Violet Vision	Vain

This I translated into anagrammatical poetry. I started crudely researching the mnemonics in Russian Cyrillic although I had no Russian friends at that time that could translate. I formulated the colours of the alphabet with a Bulgarian who spoke a little Russian. I was unsure if it was fully correct, but nonetheless started to develop the project around this.

Every Hunter Needs to Know...
The Russian mnemonic translates into 'Every Hunter Needs to Know Where the Pheasant Sits/Hides…'

К = Красный	Red	Каждый	Every
О = Оранжевый	Orange	Охотник	Hunter
Ж = Желтый	Yellow	Желает	Needs,Wants
З = Зеленый	Green	Знать	To Know
Г = Голубой	Cyan	Где	Where
С = Синий	Blue	Сидят	Sits
		Скрывает	Hides
Ф = Фиолетовый	Violet	Фазаны	Pheasants

The project began >> EVERY HUNTER >> as we visit the ex-opposing Cold War country in peace, to create and interpret >>

MNEMONICS << UK >> V << RUSSIA >> COLD WAR >> AND MNEMOSNYE – GODDESS OF MEMORY

Mnemonics – Mnemosnye
The word descends from the Greek *Mnemosnye*, Goddess of memory. Zeus the King of the gods was known as a philanderer of women, spending most of his time seducing the most beautiful of women in heavens and on the earth directly or by means of deception. Contrary to popular belief his affections were not spread equally, with Mnemosnye vying for and obtaining more of his time and attention than any other. Mnemosnye was the goddess of memory. On one occasion he spent nine days and nights making passionate love to her with the coupling resulting in the birth of the nine muses. The Muses represent creativity. Each being the goddess of a particular art…

ERATO	*love poetry*
CALLIOPE	*erotic poetry*
EUTERPE	*lyric poetry*
POLYHYMNIA	*hymns*
THALIA	*comedy*
MELPOMENE	*tragedy*
URANIA	*astronomy*
CLIO	*history*
TERPSICHORE	*dance*

Zeus symbolizes power and energy. So according to the myth, applying energy or power to memory produces a fertilization which results in creativity. This relationship has major implications for mind mapping theory >> and I interpret >> the whole >>

>> A subterranean realm transforms to the face of the surface world like an enchanted vanity mirror >> we each hate our other whilst we fall in love with the image of our other >> *and somewhere over the rainbow skies are blue* >> and there's a land that I dreamed of once in a lullaby >>

The trail begins…
As we enter Moscow we search and find the vanity mirror at the PALACE OF CONGRESS, Kremlin, Senate Square – metro: Alexandrovsky Sad, Biblioteka Imeni Lenina >> the first metro introduction of the trail begins here and will end defining 'the subterranean realm transforming the face of the surface world >> the vanity mirror at the PALACE OF CONGRESS is located in the men's toilets. 'Their curved walls and sheer size, magnified by mirrors, produce a remarkable effect; the women's facilities are far less numerous and only of practical interest'.

PORTRAITURE TIME – WE ESTABLISH OUR OWN IDENTITY IN PHOTOGRAPHIC FORM >> WHAT DO WE NEED TO ACHIEVE THE TRAIL? >> maybe it is that 'somewhere over the rainbow skies are blue' >> but ultimately we need to translate the rainbow into cold war militaristic style >> codebreaking and missile busting >> Every Hunter Needs To Know Where The Pheasant Hides (or is it sits?) >> we group >> and pause and think of Vladimir Nabokov's private language and his interpretation of the rainbow: 'Kzspygv… a primary, but decidedly muddy rainbow…' and I interpret this as media exploitation… I remember the shock I experienced when I found that the news imagery I had been exposed to and saturated with as a child was very far from correct in illustrating the true picture of a country.

>> I WAS SHOCKED TO learn that Russia had sun and beaches >> it was not true that the ONLY attire of the Russian was heavy coat, warm fur hat and scarf >> I needed to counteract this myth and somehow rectify it by visiting their TV station when we were there offering a BLUE for BLUE SKIES that were denied to me by the Cold War >> **The Blue Bunny official secrets document of the UK government being read out live on national tv as I wear pink bunny ears**

Following the digression >> Every Hunter Needs To Know Where The Pheasant Hides (or is it sits) >> The hunters gather to complete a trail of the once opposing country mapped out in accordance with British nuclear warhead missiles >>

The most apt place to meet on this cultural art-bar exchange was the former *Okhótny Ryad*, translated: HUNTER'S WAY. We would meet here for Kir Royales and co-ordinate our mission: ROYGBINV – the rainbow.

R = RED = RED SNOW

'MY OWN BODY BEARS THE CANCER AT ITS RED EPICENTRE'

I will need to find soil to place squares of red poppy seeds; the square, the fixed, the here, the now, the present. I am here now. My statement drawing upon my knowledge; it was Cold War, I state my peace

RED SNOW – thermonuclear warhead for Yellow Sun II and Blue Steel

RED SNOW
anagram poem
DOWNERS...

REND ...SOW
WONDERS
WONDERS
END ROWS
SOW...REND

SOW...REND
WONDERS
WONDERS
END ROWS
REND...SOW

WONDERS_
END ROWS
DOWNERS
END ROWS?

O =ORANGE = ORANGE HERALD

>>The side façade of this building faces a market place...STARY TSIRK – OLD CIRCUS>>

Three clowns juggle three oranges each outside STARY TSIRK – OLD CIRCUS >> three main Cold War power countries, ORANGE as ORANGE

The Top Secret Guard, OR1142 Orange Herald Document >> ORANGE HERALD – British nuclear warhead. A boosted fission device initially designed as the warhead for Blue Streak tested at Grapple. Yield 0.72 MT

ORANGE HERALD
anagram poem
DRAGON HEALER

O GRAND HEALER
A HERON GLARED...
O GLARE HARDER
HARDER O ANGEL

NO HARE GLARED
ANGER O HERALD

REAL DRAGON HE
GOLDEN AH! RARE
NO HEAD LARGER
RARE LONG HEAD

OH! REAL DANGER
HALE NO REGARD
RED HALO RANGE
RED ANGER HALO

NEAR GOLD HERE
HER GOLD AREANA
RED ANGER HALO
HER RED ANALOG

HER DRAGON ALE?
RED HERON GALA
REGAL RED NOAH
A HOLED GARNER
DARN HE GALORE

Y = YELLOW = YELLOW SUN

Pheasants >> what do they eat? What is yellow? >> grain >> WHEAT! A British trick of catching a pheasant is to soak grain in whiskey >> here in Russia we will soak the grain in the traditional home made distilled 'moonshine of Russia' SAMOGON: which will lead us to wheat? >> VDNkH >>we will need to discover wheat throughout VDNkH >> **Take yellow grains soaked in Samogon and enlist the help of Mnemosnye and Zuse's muses to place small structures of alcohol-soaked grain in front of each of the nine pavilions surrounding the 'Friendship of The Peoples' fountain. The nine muses will poetically and musically interpret in each of their categories. We may catch or see the pheasant here. Each muse will be filmed reading their poetry, dancing their dance or playing their music beside nine different symbols of wheat found throughout the area** Yellow wheat: wheat the Russian symbol for abundance and wealth >> the sun shines on all crops for most people. YELLOW SUN I – Interim megaton weapon based on the Green Grass nuclear warhead housed in a ballistic casing, entered service with the RAF in 1960.

YELLOW SUN
anagram poem
NEWLY SOUL...

SEWN...YOU'LL
SULLEN YOW
NEWLY SOUL...

G = GREEN = GREEN GRANITE

The trail leads us to Voskreseniya Vorota, northern gates of Red Square and then to Teatral'naya >> an area regenerated from its construction in 1538. REGENERATING an anagram of GREEN GRANITE. The gates formed the main entrance to the old part of the city and were the ceremonial route taken by the Tsars into Red Square. The pheasant's route may have been this way. **Green hearts left on or around the gateways as we pay homage to the historical route into the city and the last Tsars**

GREEN GRANITE – two stage thermonuclear warhead using lithium 6 deuteride as a thermonuclear component and a Red Beard warhead acting as the nuclear trigger

GREEN GRANITE
anagram poem
REGENERATING

REAGENT REIGN
INTEGER ANGER

ENTERING RAGE
TEENAGER RING

INTEGER ANGER
ENTERING RAGE

EAGER RENTING
TEENAGER GRIN

INTEGER ANGER
ENTERING RAGE

INTEGER RANGE
REGAIN REGENT

B = BLUE = BLUE DANUBE

Now we move on to find an office block >> we need a fax >> how simple will it be to fax a cold war top secret document into London from within this country? We can outline a request to find the pheasant…

Top Secret ATOMIC document – outlining 'the interim free falling bomb in a Blue Danube case'. Faxed to any Government building in the UK.

Faxes should be returned detailing pheasant sightings >> suggested office blocks: 1. KGB Administrative Building, Bolshaya Lubyanka Ulista. Metro: Lubyanka. 2. Sovmortrans Office Complex, Rakhmanovsky Pereulok 4. Metro: Kuznetsky Most.

BLUE DANUBE – Britain's first free fall nuclear weapon, entered service use with RAF in November 1953, variable yield 5-30 KT

BLUE DANUBE
anagram poem
NUDE BAUBLE…

BLUE BAN DUE
BAUBLE DUNE

BLUE BAN DUE
BUNDLE BEAU

BLUE BAN DUE
NUDE BAUBLE

BLUE BAN DUE
UNDUE BABEL

I = INDIGO = INDIGO HAMMER

>> The hammer >> Indigo Hammer >> in abundance with the infamous sickle >> *The Worker and Farmer* sculpture >> **We take indigo – the clothing language of the worker – display in artistic form in the vicinity of 'The Worker and Farmer' sculpture found at VDNkH** 'Hands high in solidarity as they clasped the hammer and sickle…'

INDIGO HAMMER – lightweight warhead for SAGW, yield 5KT

INDIGO HAMMER
anagram poem
DORIA HEMMING

OH! I'M DREAMING

OH! I'M DREAMING
DREAMING HIM O
OH ADMIRING ME
IMAGINED? OH! MR.

AIDING MR. HOME
AIMING HER M.O.D.
OH! GRIM MAIDEN
GO MAIM HINDER
OH! I'M DREAMING

V = VIOLET = VIOLET VISION

Violet Vision >> the last colour of the rainbow. We move onto the Ostankino TV tower where vision of the world is given out >> and of the initial vision >> the newspaper >> the mnemnomist journalist. S. was a reporter for a Moscow newspaper in the early 1920's **We must find the ancestors on S. who will have retained vital information on where to find the pheasant. This will have been passed down through family stories – locate and interview people. Find the mnemnonist reporter grandfather who's name begins with S and interrogate: 'Did he ever tell you where the pheasant hides?' Research to be carried out with Soviet violin playing.**

VIOLET VISION – nuclear warhead designed for use with Blue Water SSGW

VIOLET VISION
anagram poem
SOVIET VIOLIN

VOTIVE IS LOIN
VOTIVE IN SOIL
LIVE TO VISION
VIOLET VISION…

VISION TO EVIL
VEIL TO VISION
VISION TO VEIL
SOVIET VIOLIN…

Food >> hunger >> sustenance >> we move onto TRAM restaurant – theatre restaurant for Moscow actors >> found at Malaya Dmitrovka, Chekovskaya >> 'it has an atmosphere more reminiscent of Paris than Moscow…'

Play a film of Appoliniare's grave in Paris – where Alan Ginsberg is recited in memory of Appolinaire… here conversation poems are constructed from sound recordings and notes … subconsciously people may have already found clues to the pheasants whereabouts >>

Where else can we find evidence? More clues through words? >>

'On the pavement of my trampled soul…

the soles of madmen stamp the prints of rude crude words' Vladimir Mayakovsky 1913… the clue is in the words >> The Moss Elprom Building, 297 Nizhny Kislovsky Pereulok. Metro: Arbatskaya

Three directions >> three ways to go >> once Mayakovsky's words adorned the building can we find any evidence here or in the surrounding area, 'On the pavement of my trampled soul…'

Direction >> can we find the rainbow >> MONUMENT TO THE CONQUERORS OF SPACE at Prospect Mira Metro VDNkH >>

On the pavement of my trampled soul….

00:27:10 IM NOT OTHER PEOPLE THOUGH AM I \ 00:54:19 YEA BUT BACK IN WALES WELL BE BACK TO…BY ERE… + …YACKI DA… \ 00:39:43 HEY DONT STOP TALKING TO ME WILL YOU? \ 17:13:13 FAB LOOKING BLOKE JUST SAT OPPOSITE ME!! \ 17:35:06 HES ASLEEP WITH HIS MOUTH OPEN NOT QUITE SO FAB \ 19:56:58 HOW GOES IT + WHERE RU? \ 00:28:35 FUCKING WORRIED ABOUT YOU \ 17:44:39 ONLY*ON*WUSSIES \ 22:14:07 OK U CRAZY CAT! sk soon \ 14:00:57 FUCKIN FANTASTIC \ 21:04:31 ALRIGHT COCK? MIGHT BRING YOU SOME CAKE AFTER OUR DINNER IF YOURE LUCKY-CIAO BELLA XXX \ 21:43:30 THE SECOND WILL BE DIPHTHERIA + BINS IN PARK \ 22:15:04 MY THIRD WILL B NUNS IN SNOWSTORMS + INCOPADS FROM THE PLANET PINK… \ 19:41:08 No loneswordsmen 4 me. Tmw night is 4 sleep \ 20:13:46 Did yu grt petrol? \ 00:54:22 THE EMPERORS CLOTHES IS WHAT IM WEARING. THE MUSE THAT IS WITH ME IS 4AD CURSING AND SWEARING \ 23:02:49 IM IN TRAINING 4 THE OLYMPICS DRINK BEER + WATCHIT ALL NIGHT SLEEP ALL DAY BY THE CLOSE I SHOULD B GOLD MEDALIST \

8 Give Me Joy - Manchester, London, Moscow

14:11:54 stars old moscow circus edinburgh 2.x-7.x (!) \ 14:11:54 10-12 clowns being organised Filming 28.1x - 1x/meet Dom pm 27 $ (foxes, sheep, rabbits, playboy bunnies) \ 15:05:49 SOUNDS FOUL \ 17:28:20 T-GIZZLEFLAPS J-RUMPLEFORSKIN or is it rumplestiltskin? - N-GUSTYOVSKI \ 22:57:18 COMPARED TO U THE MOST SANE PERSON ON EARTH \ 23:05:19 WHAT SHOULD I DO ABOUT HER TRACE I WANT HER BIG PLSE TALK TO HER 4 ME SHE LISTENS 2 U \ 08:46:37 CANT GET THE FOUNDRY WEBSITE BIT FOR RUSSIA CALL ME WHEN U RISE \ 17:34:05 AAAARRSE \ 18:15:25 AARSY BASTARD, CANT MISS THE DOC. CUNT \ 25:51:34 MISS YOU TOO PINK BUGGAR \ 22:33:31 IM ON THE ROLLIES & CANT USE BANK OR RING U BUT I DO THINKABOUT U. HOW WAS RUSSIA? HOW R THE BOYZ? SPEAK SOON \ 17:21:46 HAVE A GREAT TIME IN RUSSIA GIVE MY LOVE TO THOSE FUR COVERED!!! \ 18:41:45 WHOSE MENTAL VOGUE IS THAT UNDERTOW? \ 21:59:59 i miss you all menthally \ 22:37:00 Tom says im slightly less menthol today \ 22:38:30 Police fire or ambulance \ 09:41:40 in bed with my ut

What followed was a month of Russian recovery in the form of liver regeneration which was helped along by my new-found ability to perform unattractive party tricks with alcohol, the likes of which I never knew I had a talent for. Since the Russian invasion of the Foundry I found I could do several things with alcohol very well. The top of this list was my talent to projectile vomit as soon as an absinthe sugar-burnt solution even touched my lips. The next was followed by the sound of a slamming shot glass and the effect it had on my back; the dense thud as it hits the bar now instigated a tremor from my basal ganglia, flowing down my spinal cord giving my coccyx a pounding more powerful than any drink was ever designed to do. Then thirdly, when a simple sip of vodka passed through my lips onto my tongue, it made me want to scream like a banshee on hallucinogens as the pain of the taste pinged across my taste buds in an order that played the hymn *Give Me Joy In My Heart*:

Give me joy in my heart, keep it burning,
Give me joy in my heart, I pray,
Give me joy in my heart, keep it burning,
Keep me burning 'till the break of day.
Sing Hosanna, sing Hosanna,
Sing Hosanna to the King of Kings!

Appealing to God for deliverance, for what, I don't know… maybe my liver – which sometimes involuntarily joined the chorus with my pained taste buds. It sometimes speeded up to a techno cover version of the hymn.

After this month gap I was ready for the trip of a lifetime. I'd always had a keen interest in Cold War reportage. I was intrigued by the film clips of Russian people battling through their everyday lives, being held back as they hurled themselves into the blizzard and snow drift battles. When Edward Heath and his government introduced power cuts and the three day week, I used to imagine I was living in the Soviet Union and I would write by the lingering smell of the candle and its burning wax, thankful I was indoors out of the Russian blizzard. I used to wonder how so many people could live in a climate like that.

I was, however, very happy to be going to the country and continent of my dreams. Images of the NOYTA CCCP stamps of my childhood were whirling around my mind, evoking strong images of a once mysterious culture. My thoughts spiralled back to my very first day on the archaeological dig in Manchester. I had then been destined by my now-estranged husband to serve

out my time near the convergence of the rivers Irk and Irwell as an archaeological finds illustrator, photographer and grave exhumer in Castlefield. I'd walked to that site on my very first day, navigating the worn out, uneven cobbles, weaving past the Roman garrison fort dig, down through the scrap metal dealers. I'd got to the site's crooked metal gates, which were forced together and held by a thick rusty chain and monster padlock. A sliver of light snow covering the muddy terrain behind the firm metal mesh gates that kept me a prisoner outside of my then soon to be new world and life. I scanned and surveyed that near horizon likening it to starting my first day of work in Siberia and made a vow to myself there and then that somehow, someday, I would go to Siberia; now Moscow was my first step to achieving this. (My travels to Siberia have followed since, more than once in an area that at the time of my vow was closed to the West, the Krasnoyarsk region of Eastern Siberia, and I will one day live there). I felt sad at the thought of standing, waiting outside those gates on

left: Castlefield, Manchester
below: Kansk, Siberia

Nick Fry > TM
21 Nov 2009 16:52
Ps the house is on!..I
Got a reduction!!.. X

TM > Nick Fry
21 Nov 2009 16:53
Very nice. X

TM > Nick Fry
Bargoed swat u get wen u pull ur pants up
too far

Nick Fry > TM
No, that's a Somerset
wedgie

TM > Nick Fry
… & we're off there next week for a few games
of strip poker & a bit of a spit roast whey hey
hey get the cockles out!

Nick Fry > TM
…Ive heard theres
flooding, they had 14
inches in cockermouth

TM > Nick Fry
Wow! That's a lot… I was out with Zinzan
Valentine Brooke the legendary All Blacks star
last night with two of my other rugby loving
friend Jonathan & Jed. I have never seen such
big hands on a man. He's a Moari. He got the
whole pub knocking nails into a plank of wood
to see who would win the challenge & take
him on..

the brink of a new life that came to an end fifteen years later. A text eased me out of my melancholy:

02:02:01
HOW U? DON'T B LONELY, DON'T B SAD.. ONE END A NEW START + FRIENDS LOVE YOU NO MATTER WHAT.. sleep easy.. xx

I was due to meet Nick in fifteen minutes for the train down to London. We had iced plastic champagne flutes and a champagne cork ready to pop out of an iced bottle as we settled in the train from Manchester to London on the start of our epic adventure to Moscow.

A text beeps in from Nick in present time, 21 Nov 2009 16:54 on my iPhone and I contemplate the passing of almost another decade. His 40th birthday is approaching and he's trying to organise his party, a house in Somerset predominantly for the Manc brigade: these are some of the people that I left behind on my journey to London and Moscow. Many who were much a part of my life then are now still embroidered into the fabric of my texts.

As I'm writing the texts down from Nick, the cricket chirps of my mobile ringtone spring Savannah-like into action. It's Jai organising our train tickets to Nick's special birthday bash in the cottage and we've just decided on his present – a bottle of his birth year Port, Pink Pants and a Panama cigar. Anyway, back to the past...

Nick and I hit London and made our way over to the Foundry. I needed to get a copy of a film of Karl, Patrick, my estranged husband and I reciting Alan Ginsberg over Apollinaire's grave in Père Lachaise cemetery in Paris for part of my Russian trail work. Jaime Rory Lucy readily obliged, and then we were off on the coach boarding an old Aeroflot beast of a plane. I sat snug on the back seat with Jonathan. The air host and hostess were a loved-up couple who presented us with a copy of the Moscow Times containing an article about our mission to Moscow. The flight took off smoothly, the vodka toasts begun and I was ready for the ultimate art and culture adventure. For the first time I started wondering how I was going to manage without my frequent textual injections. I had my Russian arts trail clasped firmly in my hand, which was vocally explored with anyone who wished to listen. Nick sat in another part of the plane, exhausted by my enthusiasm for my 'Every Hunter Needs To Know' trail. I couldn't wait to get started on it in Russia.

We touch down in Moscow and strong cigarette smoke fills the passport visa check-in area. Stern faces of beautifully made-up women and rugged men in post-Soviet uniforms stamp our visas. They let us into their country without a smile and we board the bus and are taken straight to an architectural marvel: the Hotel Rossiya.

My arts trail focused on the number seven, the seven colours of the rainbow and seven nuclear warheads/missiles. I purposely hadn't included the

Seven Sister Towers of Moscow as I thought this may be a bad omen: the Hotel Rossiya was initially planned to be the eighth tower and would have been known as the Zaryadye Administrative Building. It would have been one of the tallest buildings in the world if it had been built. Instead, it was decided that it would overshadow the Kremlin. When Krushchev came to power, the only part of the building that was finished were the foundations and an industrial-sized bomb shelter whereupon he gave clearance to erect the Hotel Rossiya in its place, which was large enough to house all the 6,000 delegates of the Communist Party Congress. I had never seen anything like this hotel before and fell in love with it far more than the architecture of the Kremlin or nearby St. Basil's Cathedral. When it was built, it was registered in The Guinness Book of Records as the largest hotel in the world and remained the largest hotel in Europe until its demolition in 2006. I periodically open random draws and cupboards at home now and find sections of the hotel building that we brought back during its demolition. No traditional Russian Dolls, just rubble, foundations and mortar. It had 21 storeys, 3,200 rooms, 245 half suites, a health club, post office, nightclub, cinema, barber shop, as well as a 2500 seat State Central Concert Hall. We ate breakfast looking out over the Kremlin walls and the cupolas of St. Basil's Cathedral.

I was already drawing parallels with the other two cities that now both dominated my life, Manchester and London. All three cities grew up around industrial rivers and had strong connections with the textile trade. The area I was now standing upon, formerly known as Zaryadye, was the oldest trading settlement outside the Kremlin first documented in 1365. The area grew from the Middle Ages alongside the Moskva River. During the 1700s when Manchester's

TM > Nick Fry
21 Nov 2009 18:38
Why you not answering me back? I just spoke to Jai & he thinks you're a smelly shit arse & so we're going out with our friends in London if you don't text me back

TM > Nick Fry
Any updates today Twinkie or are you still covered in paint?

Nick Fry > TM
The place is booked! Just in bath call you in 10x

Nick Fry > TM
Ok let's go!..x

cotton industry was flourishing, the textile trade also dominated the Moscow business world and was located in Zaryadye. At the same period in the East End of London, the French descent Huguenot silk weavers were rioting against the newly ensconced Irish silk weavers. At the time of the Russian Plague the Moscow textile industry's close proximity to the river facilitated the transport of bales of wool and silk from the south, providing easy passage for plague rats and fleas. The Foundry was built in a location historically used for plague pits just outside London's city walls: the area is still marked with hidden plaques. The Zaryadye settlement was finally demolished in 1947 to make way for the eighth of the Seven Sister Towers.

It was late September: in a few days it would be October and I was wearing a green Elvis & Jesus Co. Couture vest. Where was the blizzard? My TV had reported the blizzards throughout every season and I had packed my thermal clothes! The sun's warm rays and the vodka had given me more than a heady mix of Cold War paranoia that would grow over the week. After leaving the hotel, we eventually reached the Dom forecourt and a replica of the Foundry sign hanging over the entrance to the Dom Cultural Centre.

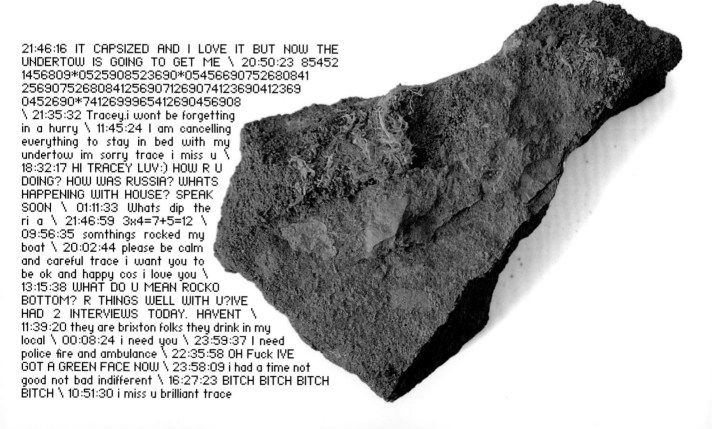

21:46:16 IT CAPSIZED AND I LOVE IT BUT NOW THE UNDERTOW IS GOING TO GET ME \ 20:50:23 85452 1456809*0525908523690*05456690752680841 256907526808412569071269074123690412369 0452690*7412699965412690456908 \ 21:35:32 Tracey.i wont be forgetting in a hurry \ 11:45:24 I am cancelling everything to stay in bed with my undertow im sorry trace i miss u \ 18:32:17 HI TRACEY LUV:) HOW R U DOING? HOW WAS RUSSIA? WHATS HAPPENING WITH HOUSE? SPEAK SOON \ 01:11:33 Whats dip the ri a \ 21:46:59 3x4=7+5=12 \ 09:56:35 somthings rocked my boat \ 20:02:44 please be calm and careful trace i want you to be ok and happy cos i love you \ 13:15:38 WHAT DO U MEAN ROCKO BOTTOM? R THINGS WELL WITH U?IVE HAD 2 INTERVIEWS TODAY. HAVENT \ 11:39:20 they are brixton folks they drink in my local \ 00:08:24 i need you \ 23:59:37 I need police fire and ambulance \ 22:35:58 OH Fuck IVE GOT A GREEN FACE NOW \ 23:58:09 i had a time not good not bad indifferent \ 16:27:23 BITCH BITCH BITCH BITCH \ 10:51:30 i miss u brilliant trace

TOO MUCH SPIRIT TOO

FOUNDRY @ HOME

**Russian poster for the Foundry's
relocation to Moscow
opposite: Hotel Rossiya rubble**

9 An All-out Alco-Anarchic-Art-Assault on Russia

13:07:21 wont be back till after 11 k \ 15:13:56 EN ROUTE TO PRAGUE \ 23:09:33 We are breakfast telly \ 01:27:38 Immediate consumption \ 01:56:36 Miss you \ 18:02:13 I am going somewhere very fucking different tom \ 18:34:12 Ow r ewe butt? Tweech orite like? \ 03:18:27 WHER+ ARE + U + HOW + CALLED + NO + ANSWER + I + HAVE + INFO + RE + NEW + PROJECT + REF + WARRINGTON \ 22:46:04 HEY HONEY NO TEXTS WHATS GOING ON? \ 22:13:36 HOW R U DUDE? \ 20:36:00 WHAT YOU MEAN THE OBJECT!! \ 20:43:55 DONT HAVE A SHORT MEMORY JUST CANT KEEP UPWITH YOURS \ 02:58:21 cant stop thinking about u since we went to the mad country like going back again if u & you'll come with me only temporary please respond \ 13:35:34 MESSAGE RECEIVED AND UNDERSTOOD \ 13:40:25 BITCH \ 10:39:45 MORNING IS YOUR EMPTY SHELL ANY FULLER YET?

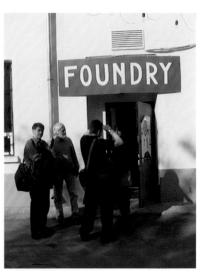

We entered the Dom, now signposted 'FOUNDRY'. I stood by the side of the bar with Pete 'the Fretter' Doherty and Valentina 'the Video Trapezist' Floris. Pete, in another hat looking as freshly baby faced handsome as ever and Valentina, wearing her 'I am a Cunt' t-shirt. I had fallen in love with this range of statement t-shirts by Anand Zenz over the years, but this was the ultimate double negative for a women to wear. As I focused my attention away from Pete and Valentina I noticed the pristine gallery/bar space inviting us. The musical instruments were all set up onstage.

I activated my arts trail and co-ordinated people taking part. I fitted into other artists' and performers' set activities and that of the program whilst realising my own work as the coming days developed into an arts, music and performance-themed adventure throughout Moscow. *The Idler* Magazine introduced it well and it soon became an all-out anarchic Alco-art assault on Russia:

JONATHAN MOBERLY, the man behind Ellipsis the publishers and Foundry the Shoreditch bar, got fifty Russian artists and poets over to London. Then his crew went over to Moscow. Lots of things happened including maggot racing…'

'From this mixture of self-assistance and government propaganda largesse, a mobbed troupe of fifty Foundry barflies mounted an all-out anarchic Alco-art assault on Russia. Storming Russia's Channel One TV station on our first day in the manner

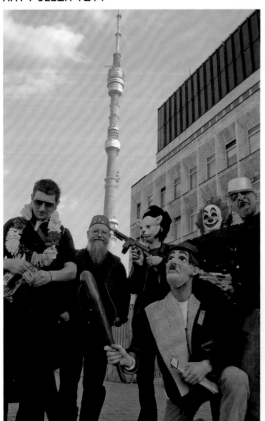

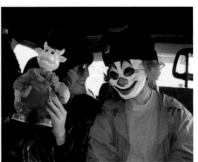

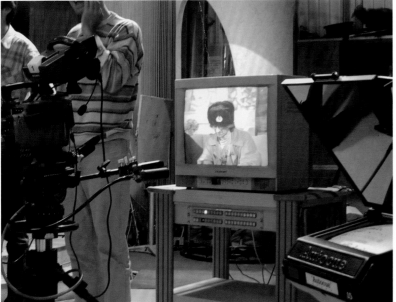

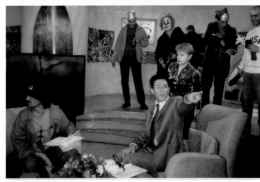

of a Seventies bank raid with plastic guns and clown masks set the tone for a week of chaotic intervention that brought Foundry-inspired noise, geeks, circus and opera to the DOM, out onto the streets of Moscow and into the homes of a million Russians for primetime breakfast TV.

Jonathan was initially invited by Nicolai Dmitriev (director of the Dom) to go on the primetime breakfast TV show and they invited me to go on with them to speak as Jonathan's partner on my contribution and involvement in the arts programme. I gladly agreed and we waited for the car to arrive that was going to deliver us there. In fact a large minibus turned up so we crammed it with as many Foundry-ites as would fit. We were off. It was mid-afternoon when we arrived at the TV centre, and were offered alcohol in the green room. We were allowed to take this into the studio where the interview was to take place: vodka and beer bottles wrapped in brown paper. At this point I was wearing a multi-coloured flower garland around my neck, a pig's nose, a pair of pink fluffy rabbit ears and holding a grey life-sized plastic rat. Jonathan was in his Russian fur hat and our counterparts were decked out in all manner of masks carrying an assortment of props. As the interview began I noticed a live rabbit on the coffee table directly in front of us. Perhaps it was the breakfast pet of the week, I wasn't sure. I wasn't really sure of anything as I didn't understand Russian. However, what happened next needed no explanation, Russian or otherwise. Fireworks were ignited by our cohorts. The rabbit started urinating on the glass coffee table, and then bolted across the studio floor in fear of its life. This put us in a compromising situation with

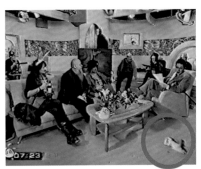

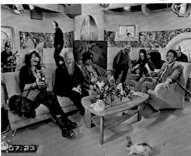

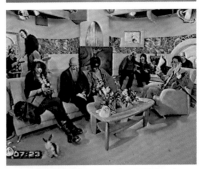

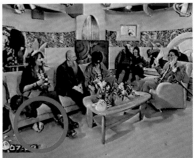

the youngest pet loving viewers of the early morning show. It was later reported that the rabbit had died of fear, an exaggeration on true events.

On the minibus journey in, I had already decided when wearing my pink rabbit ears that the blue section of my Moscow trail would be completed on national TV. Instead of faxing now-defunct official secrets documents from the KGB head office, I would ask Jonathan to read out the Blue Bunny Cold War Top Secret government memo live on TV, reaching millions of Russians in the comfort of their homes. The Blue Bunny is a nuclear landmine that used the Blue Danube warhead; it was developed from 1954 with the goal of deployment in the Rhine area of Germany. When Jonathan did this, it was probably the most romantic thing anyone has ever done for me and it beat finding out by ripping petals off a flower saying 'he loves me, he loves me not…'.

As we left the building we took the presenter of the show, still wearing one of our plastic Viking hats, to the massive staircase outside the TV station. Here we all recreated the Odessa Steps sequence from Eisenstein's classic silent film *Battleship Potemkin*. It's a famous scene in movie history; the Tsar's Cossacks march in machine-like order, rhythmically firing volleys of shots at the crowds. A mother is shot and as she falls to the ground, her baby is sent on a bumping, rolling journey down the steps amidst the fleeing citizens in its pram. A very powerful scene and although fictional it was a propaganda tool to demonise the Tsar and the Imperial Regime. After we all completed this I felt fully ensconced in Russian culture.

My accent and dialect had started to become a focal point of the week. Hailing from the South Wales Valleys I use many colloquialisms attributed to the Welsh, usually based on a hybrid of the Welsh and English language called Wenglish. There are words relatively unknown to most of the UK but specific to Wales, and others quite local to the Valleys. One of my favourite of such words is 'cwtch',

TOP SECRET
ATOMIC

Tracey Moberly

Copy to:　Sir Richard Powell　(3)
　　　　　　Sir Frederick Brundrett　(2)

17th May, 1957.

We had a word on the telephone this afternoon about the report which Plowden had given Brundrett of his discussion with the Prime Minister this morning about the further shots in the current series of tests in the Pacific.

As I mentioned to you we have assumed that, in the light of Sir Anthony Eden's reply of March 1st last year to Sir Walter Monkton's minute of January 9th, it was unnecessary to consult the Prime Minister about arrangements and timings for the individual items in the present programme.　You will, no doubt, correct me if this assumption is incorrect.

The present programme provides for the following tests:-

Test No. 1　-　"Short Granite"

This is a 30" diameter weapon weighing 4,480 lbs. from which could be developed a free-falling bomb. (This is the test which has just been completed.)

Test No. 2　-　"Orange Herald"

A 45" diameter weapon weighing 2,500 lbs. intended to be the prototype for the development of a head in the intermediate range ballistic missile.

Test No. 3　-　"Blue Granite"

Since Test No. 1 has been a success it is intended to use the opportunity to test out a very forward-looking weapon, the design of which has only recently become possible.　This is a 20" diameter weapon weighing 2,500 lbs.　The principles of this weapon are based on the success of Test No. 1 and the use as a trigger of the initiating mechanism intended for use in the defence weapon.

meaning cuddle, but suggesting a deeper warming embrace than a cuddle and which also alludes to a sense of being when one is 'cwtchy' or 'cwtched up'. Sayings such as 'now stop starting' and 'whose coat is that jacket?' had been adopted by members of our group. 'Whose coat is that jacket?' soon transposed to the sublime and ridiculous in a myriad of sayings: 'whose toe is that stairs?', 'whose food is that cigarette machine?' This lasted much longer than our visit to Russia; people still address me with comments of a similar pattern.

I was also speaking a lot about a large hospital bed I'd bought from a famous furniture chain. I know Gavin and Debs, Daisy and others actually bought the same bed when they got back to the UK as I'd used its imagery as a place of sanctuary throughout the week. Hospital was also a key word along with Menthol Vogue, a long, slim, elegant menthol cigarette I fell in love with. No escalators, especially on the underground, were used unless we broke into song with 'Give me joy in my heart keep it burning' covering all verses and ending well after we'd left the underground. John Spencer, one of the British artists from the Foundry, was exceptional in promoting this song with me throughout the trip along with the many less-sensible variations on 'whose coat is that jacket...' When we returned home, I was leaving Russia with a much stronger Welsh Valleys accent than I'd ever had when I'd lived in the Valleys, and a few with English accents were also using Welsh variants on words.

That evening we were introduced to two places, called Pirogi and Ogi. We collected Valentina, Pete, and a few others to sample vodka with the full head of a rose submerged in the glass, before the Noise Night that was due to begin in the Dom. In a live video link-up at the Dom, saxophonist Lol Coxhill was projected onto the walls as Big Mike 'the Music Attaché' Walter improvised with him. Daisy had been talking all day about the need to explore Moscow and its bookshops in order to find the ultimate Russian word that she could transfer directly onto her body regarding this period in time. And it needed to be very Russian. I promised I'd accompany her in the morning as we made our way back to Hotel Rossiya. As we trekked the long corridors to get to our rooms, they seemed endless as we were watched over by a matron who collected

keys from the guests as they left. We passed more of the long, horizontal mirrors that we presumed were probably two-way, and suddenly came face to face with a naked middle aged man in his doorway making no attempt to hide his semi-erect penis as he was bidding farewell to a young and very beautiful tall slim brunette. I realised that prostitution must have been part of the service within the hotel. Were the matrons the pimps or madams? This was not doing my Cold War paranoia any good at all and by the time I reached my room I was sure all the mirrors were two way and we were being spied on, even in the toilets. I was to learn some years later that after the collapse of the USSR, areas of the Hotel Rossiya were rented for a reality TV show similar to Big Brother, called *Za Stekolm* or *Behind The Glass* – where contestants were filmed from behind the mirrors – so maybe my paranoia was slightly justified. I began thinking that the tannoy system in the room was used to listen to the people in there.

The next day, I met up with Daisy and her film camera as we set off on a mission to locate the Russian word to be tattooed Daisy's back. Three of us boarded the Moscow underground with the Cyrillic alphabet offering no clue in pictures or text as to where we were going. It felt like everyone was staring at us. It wasn't until some children were giggling, babbling Russian and pointing at us that a person standing near to them said to us, 'Morning TV'. I realised then that we had been aired that morning across Russia and the children were probably holding us responsible for the apparent death of the rabbit. I wanted to curl up and be transported straight to a hospital bed that offered asylum to my remorseful soul. Once off the underground we found an amazing ancient bookshop. Daisy got a few ideas sorted and knew that she wanted a single word that was life-affirming. The word was 'pharmacon'.

When we eventually arrived back at the Dom, Jaime's visuals of me delivering the missile to the Russians in London were playing around the room with Lev

TM > Dasisy Asquith
12 Feb 2010 09:48 PM
Daisy is your tattoo pharmacon in English? How is it spelt in Russian?

Daisy Asquith > Tracey
hi love Im just down town with Lenny...pharmacon is an English word with Greek origin. It means both poison and remedy. It is spelt in Russian only phonetically, due to the concept reaching me while in Moscow, and misspelt due to the vodka reaching me while in the tattoo shop. X

TM > Dasisy Asquith
I do love that tattoo so much x

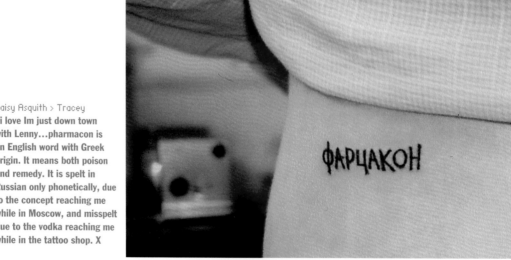

performing his improvised electro-acoustic music. Following Lev came Alexi Shulgin, a contemporary artist and musician performing with his 386DX – an antiquated computer with Microsoft Windows version 3.1 and an Intel 386 processor with a MIDI interface and a synthesized text-to-speech voice which actually sang the lyrics of hit music tracks. He called it 'The World's First Cyber Punk Rock Band'. The first UK debut had been performed in the Foundry. I believe a decade later Dasha Zhukova (Roman Abramovich's partner) purchased it for her new contemporary art space in the Bakhmetevsky Bus Garage known as the Garage Centre for Contemporary Culture.

We all grouped together at the finale and made our way to The Third Way nightclub, a building not too dissimilar to those in Shoreditch at that period which housed some of the best rave squat parties. There was going to be a wedding ceremony. All artists, performers and musicians were instructed to attend The Third Way as James 'the Conductor' Harpham (who looked like a vicar due to his white beard, but was actually a music composer) would be conduct-

ing the ceremony for the marriage of a random Russian bride and Foundry Barfly John 'the Bachelor' Spencer. They were married on the rickety rooftop overlooking the Moscow skyline, and no-one managed to fall off.

When the swirling of my brain subsided some hours later, a few of us headed to the Hotel Rossiya, taking the route through Red Square and past Lenin's Mausoleum. Vladimir Lenin's embalmed body has been on public display there since his death on January 21st 1924. Every time we had tried to enter the mausoleum it was closed, and we joked that he was out or just didn't want to see us. But he was in there and real, his body preserved at a temperature of 16 degrees centigrade. Every eighteen months his corpse is removed to undergo a special chemical bath. Soldiers with huge rifles were keeping guard over Lenin's tomb day and night. They spoke no English and we spoke no Russian. As we approached them I knew that this was going to result in the completion of the Orange

TM > Lynne J
Oh no... Poor you, i'll speak to you tomorrow then,. Cwtch up warm & get some hot wine with spices in down you or a lem sip the first does better I think like a mulled wine xxx

TM > Lynne J
aww! I'm just writing those similar words in my book from my friends tattoo she got done when we were in russia... Poison or remedy her tattoo means.What's the score?

TM > Lynne J
Great I don't need to watch it with a friend like you. When I go out tonight I can just say...'it was bloody hard work wasn't it with Shane Williams scoring in extra time' and add a tsk!

TM > Lynne J
Me too .. get well in your victory & when you hear the words tonight hailing up the valley, being sung of "Wales forever we shall support you ever more..." from downtown Bargoed you knw it'll be me by proxie of course xx

Lynne J > TM
13 Feb 2010 04:07 PM
Sorry love am not so good have flu but should be ok if u want to come up tomorrow

Lynne J > TM
Oh don't worry I'm taking a combination of both. Kill or cure is my moto I just wish I could hve got ill after rugby season!!!

Lynne J > TM
Wales won 31 24 but it was bloody hard work and Shane Williams scored in extra time

Lynne J > TM
You go girl you r a Wales rugby fan by proxie and u chanel my energy when I am too weak to hold the mantle!!! Love to Stacey tonight and I hope we can get together soon

Lynne J > TM
I knew I could rely on u love have a good night

15:59:58 SORRY MATE WILD HORSES WOULDNT GET ME THERE \ 23:33:59 i am glad i met you \ 21:08:34 COOL I THINK IT WILL LOOK GROOVY \ 09:00:15 STUCK IN TRAFFIC BORED AS HELL \ 16:24:37 Enjoy the knots – its time i felt like that again. i love you and j together – it restores my faith \ 16:44:40 im at work say hi to nick for me ill call in a bit \ 19:20:31 ill tell him bout mekons and party \ 18:09:32 GO GIRL GO ILL JOIN U JUST FOR THE EMPATHY OF COURSE! \ 22:19:15 I am eating some olives and talking about going mental. \ 17:02:52 HEY SCOOBY DOO WHERE RU? \ 18:44:01 JUST ANOTHER NORMAL DAY THEN \ 18:53:20 U R NOW PRONOUNCED BRICK + WIFE \ 02:14:19 would u do another mot o o r byking excursion in hot climes 4 xmas supplying shit hot enduros 750+ no problemo \ 02:24:02 HONDAs – was it the elsinore u started off on and then red rocket did u ever do trials? \ 02:31:20 WHY? \ 02:36:34 everything would b in place 4 u \ 03:30:21 TEXT ME!

Herald section of my Moscow trail. Lenin should have probably been buried a long time ago I thought, and it really felt like a circus to me, an almost sinister freak show. As one of us juggled with some of the circus props we were still carrying around, I started doing handsprings the length of the mausoleum and its entrance where the guards were patrolling back and forth. We lit fireworks, sending them off into the bluish-black Moscow sky. The guards were embracing the moment and enjoying our circus and celebration of Lenin, and this went on for a while with many laughs, smiles and an eased atmosphere. That was until Andy 'the Sax Man' Knight started playing a beautiful tune on his saxophone to accompany our circus activities. Instantly and with rapid speed, the guards' guns were raised and pointed directly at us. We all froze in suspended animation. My epitaph was looping around my brain… 'Tracey died with Vladimir Lenin (only the 'seventy six years apart' was deleted from it). The guards were highly disturbed by the saxophone, but not by the fireworks, handsprings, somersaults or juggling. We all finally left without any gunshot wounds.

It was dawn when we arrived at the hotel, passing no prostitutes or their naked clients in the corridors. We sat for a while experiencing the grace of the Moskva River dancing in the dawn light. I knew I had to move quicker with my Cold War trail. I still needed to plant Red Square with red poppy seeds without being caught.

00:53:16 Trace Casey is here and she hates me cos all i talk about is u and j and k and i cant cope \ 00:56:33 Casey says im an asshole \ 17:37:20 Daisy Guy Fawkes Bonfire Leeds party Pakistan exit Party Party (-go – go) \ 21:59:06 Do you have the ingredients \ 22:03:09 We are having a pharmacon moment of great intensity \ 22:03:49 We need your help with the recipe \ 22:05:51 White help but pink do fine \ 22:21:20 What are the ingredients for the foundreme? \ 23:09:33 We are high and we want to watch breakfast telly \ 23:14:22 Yes me and j are missing you & i think who knows Tom is here and we love you \ 23:31:50 I am after hours \ 23:38:45 Bar management IS a pharmacon \ 00:14:14 Where are you now its very important \ 00:06:24 The wine is on its way \ 04:57:59 Tequila slammer + + \ 14:52:45 My heart is in your body beating up your undertow \ 18:21:48 HAVE U JOY IN YOUR HEART

We made an early start, heading off in a coach in the direction of Yuri Bakhchiev's dacha (a Russian summer house) just outside Moscow. It was in a wonderful woodland area and soon a party in the woods swung into full flow. Daisy and I had to look after a seriously vodka-ravaged Nick 'the Gigolo' Fry, who had narrowly escaped with his life from a testosterone-fuelled Russian business meeting the previous day.

We were, I was informed, celebrating Chekhov day today as Joe 'the Disinformant' Banks took an axe and proceeded to chop off a plastic doll's head on a sawn-off tree trunk. We were all wearing circus masks, with Deborah 'the Supernova' Curtis in a white bobbed wig, and Gavin 'Being Che Guevara' Turk being Che. The coach back was a 'sing song' coach. Jonathan and I exited to Red Square with hundreds of packets of poppy seeds and randomly sprinkled them. No paving crack or tree earth base was without them – accomplishing a victory on the Red Snow section of my Moscow trail.

It was Circus Night at the Dom. Upstairs, Charlotte 'the First Bodyguard' Cullinan and Jeanine 'the Second Bodyguard' Richards debuted their art action performance piece 'Shooting

Nick Fry > TM
21 Feb 2010 03:49 PM
Hello Shadwell, what's the commotion?.. are you well?.. Or has your visit to the homeland twisted your taffy chromosone?..

Nick Fry > TM
Yes I am a lumberjack 'and I'm ok'. I may also be officially bald, with more hair on chin than on head, but I can do an epic impression of a boiled egg that's been dropped on the carpet and crammed back into an unsuspecting eggcup. How was Tony Benns' party?

Nick Fry > TM
I believe you mean "who were you with in London with?", welsh grammar doesn't do this side of the border. I was in London with no-one as I wasn't there either. I was actually in deep dark Somerset with Nino and Hayden. "We was 'aving a butchers at 'owses".x

TM > Nick Fry
That's better I thought I'd drastically lost you there… 'I'm so twisted I ain't ever gonna fix it… I'm just waiting for the light to shine on a brand new day… There's gonna be peace in the valleys tomorrow but tonight Im gonna throw it all away.' What's been appertaining in your life? Are you now a wurzel lumberjack in deep wurzeldom Bristol? You must be well missing me!

TM > Nick Fry
He was doing a talk at national theatre which was good but didn't go for food with him afterwards. What have you been up to? Who was you in London with the other week?

TM > Nick Fry
That sounds very good and very progressive & what I want to hear… Did you see any? Which bit of Somerset? The weekend before that I meant when you said you were coming down the foundry & singing red dragon radio theme?

TM > Nick Fry
Well?

Nick Fry > TM **Twot**

TM > Nick Fry
When are you seeing me next? You must be in a bit of a state missing me & all…

Nick Fry > TM
Not sure I was sick and shat myself at the same time earlier, was that something to do with you?, some kind of sympathetic osmosis ?…

TM > Daisy Asquith
13 Feb 2010 05:13 PM
Did we slaughter the womens toilets in the Dom with red paint? On the night of Circus in the Dom when you switched from miner to porn star?

Daisy Asquith > TM
can't remember honey! X

Range'. British and Russians firing side by side with an assortment of air rifles and pistols as the vodka flowed. Layers of cardboard protected the wall behind. I loved the target practice and the conversations it inspired from Russians and British alike. I stayed on this most of the night, gorging myself on the psychology that the construction and activity evoked. Midway through the night a massacre occurred in the toilets with red paint strewn across the mirrors, cubicles and doors. The slayers shall remain nameless.

The flea circus entranced much of the audience, who were then enthralled with the maggot racing. Steven 'Archeo-Engineer' Haines, responsible for the maggot racing track and organiser of this prestigious event, had hastily relocated the annual Shoreditch maggot race to Moscow, as detailed in a press release:

> A last minute decision was made to move the annual Shoreditch maggot races to Moscow in an attempt to escape the heavy handed racketeers of London's East End, although the frantic wagering was quick to attract the attention of the Russian Mafioso.

Pete Doherty, Nick Fry and I huddled around forming a strategy for the race. A throng gathered around the maggot racetrack as people scrambled to view the maggot release. Russian currency had changed hands and the commentator was almost delirious as the maggots were being highly receptive to the atmosphere. As they speeded on, little slack was cut for the winning prize maggot known to the trainers as *The Wiggler* and he only just forged ahead in the remaining seconds of the race. This was repeated for several more races and at least three good racing maggots were lost and one eaten. When the final race concluded there was a mad flurry of reporters, journalists and photographers eager to interview the winning owners and trainers, the breeders all promoting their maggots.

Out of the three breeds of yellow, white and red maggots, the red seemed to be the quickest off the post and the favourites to win. In his last statement to the surge of sports journalists, Steven Haines summed up the maggot racing business: 'From a stable of nearly one thousand maggots, building up a close relationship with individuals is rather difficult. The trouble with racing three-day-olds is that after a week they start to pupate which makes it very difficult to build up form. The real enemy of the maggot race is maggot tampering.'

Haines concluded: 'They are on their best form if they haven't eaten for at least eight hours beforehand. People often try to sneak in with the odd bit of bacon before the race. If you give them a hunk of bacon it is more likely that they will eat and then go to sleep and change their skin, before you know it you've got flies.'

(A full version of these events can be found in *The Idler – Everybody Loves a Fool* issue 27 with Welsh Valleys comic Tommy Cooper on the front cover).

The week with my new friends was rapidly coming to a close in Russia, with the highlight performance yet to come. I knew that I had to finish my trail on the week's finale: the Opera Night. Tam Dean Burn, the Scottish actor, was flying in for one night only to host and lead the Opera Night. Red Square security was out in full and I needed to conclude my Cold War missiles and warhead trail. There was a Communist Party rally in Ploshchad Revolyustii and the anti-cap-

italist demonstrators were mainly pensioners. There was a panic as Tam Dean Burn had not appeared and it was declared that he'd gone AWOL. It hadn't occurred to anyone that despite flying him into Russia to be on time for the start of the opera with only minutes to spare, no one had given him any details of where to go from the airport. A meeting was called regarding the missing lead. Pete Doherty, Jonathan, Nicholas Bloomfield and James Harpham literally re-wrote the opera (a year in the making) in half an hour. As they completed the re-write, Tam turned up courtesy of Aeroflot, speaking not one word of Russian, with no phone number or address or any sense of direction to where he was heading, all he had was one word… DOM. However, Dom is also the Russian word for home. It was incredible that he actually arrived there at all.

An intense night of theatrical operatic mayhem ensued with Gabriel of

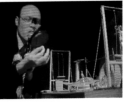

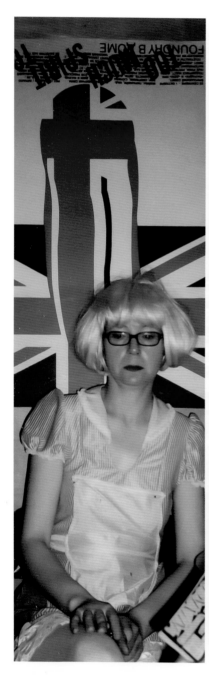

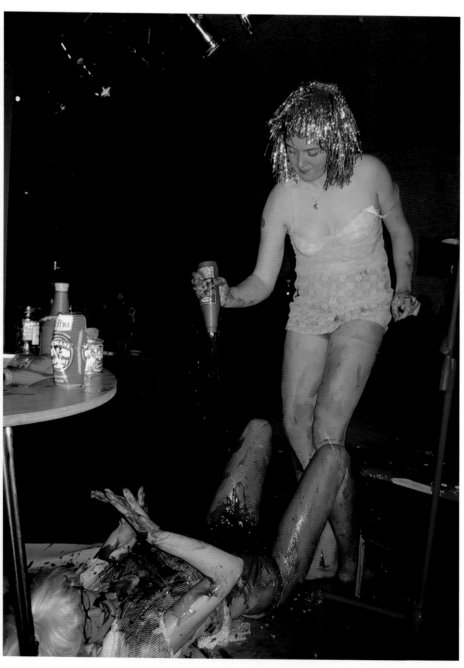

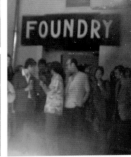

Evercreech 'the Second Pianist' performing with James 'the Conductor' Harpham; Leila 'the Diva' Adu did a few arias, which raised the tone of the evening. There were three men on a Grand, Nicholas 'the Third Pianist' Bloomfield, Gabriel and James. Paul 'the Digit' Chauncy integrated with Hugh 'the Stringer' Metcalfe and Big Mike 'the Music Attaché', whilst the Opera looked for direction as Tam Dean Burn's rant brought that section to an end. The lights dimmed with an introduction to Julia 'the Porn Star' Moore and Daisy 'the Miner' Asquith indulging in baked bean, mustard and tomato ketchup erotica live on stage with Daisy in lingerie and Julia in a short nurses outfit. The Dom was now bursting with people and the pristine white walls became stained with Julia and Daisy's actions; they had bean juice, ketchup and mustard seemingly pouring out of every orifice. For the final act, Tam, wearing tights, came on in his glowing anti-paparazzi coat with Germ 'the Strategist' as the Queen of England, wearing a basque and plastic see-through ball gown petticoat. Germ was carried out flat in a funeral ceremony and laid to rest on the British Glass Flag that Sarah 'the Glass Gardener' Staton had engineered. The flag was ignited and burned, Germ making a quick escape, Tam dancing on the embers. A few verses of 'Give Me Joy in My Heart' later and we were back inside witnessing Pete Doherty and Hugh Metcalfe screaming music out and smashing guitars and instruments into fragments, Big Mike shaking the stage down, Gavin Turk and John Spencer pogo'ing joined by all of the Foundry eventually bringing the

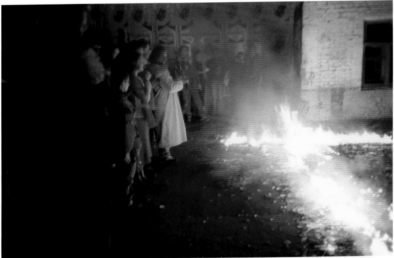

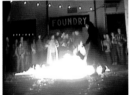

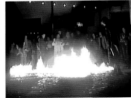

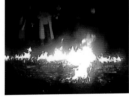

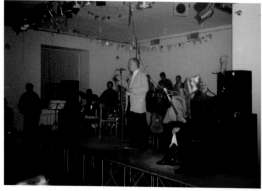
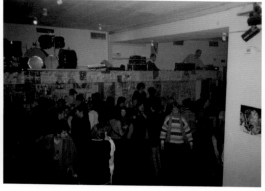

stage crashing to the floor. The audience were going mental and soon fireworks were going off indoors adding to the elated pandemonium. Olga the Russian co-coordinator of the Dom with Nicolai was screaming, 'No more damage to the building!'

As night passed into day we walked to the northern part of Red Square; the gates here formed the main entrance to the old part of the city, which was where the Tsars took the ceremonial route into Red Square. We scattered green paper hearts here as part of the green section of the trail, paying homage to the last Tsars along with the historical route. Again we tried to visit Lenin but he really was having none of it. We then attended a farewell dinner in a closed off section of Ogi. Speeches were delivered, more vodka consumed and I could feel it physically slicing through my liver.

The final night remains etched in my memory almost as an intricate painting. Walking through a park that seemed to be the halfway point between where we had been and where we were going I experienced my first ever David Lynch moment. It felt like I had walked into one of his films. I was steering people and baying down vodka-induced rages with some male participants of our group. Suddenly characters emerged from the darkness of the park, some appearing from behind trees, others already leaning up against them in contorted, exagger-

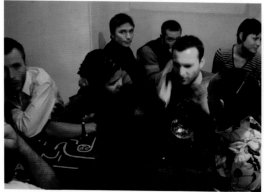

ated angles and some wearing period costume sailor suits. A mist from the vodka had started to cloud my own vision, whilst a mist that sometimes comes with dusk also seemed to be hanging low in the air, like that of the visual effects created by a smoke machine. A totally surreal experience shared by all.

As we bade farewell to this wonderful country, I left part of my heart there and most of my Cold War paranoia, as Daisy and I began planning the next event and our joint birthday party which would be in a few months time. In our white Russian hats Daisy and I decided to make a small film on the ease of smuggling Smack out of Russia and into the UK (Smack is a snack similar to a Pot Noodle). We had now completely developed our own language.

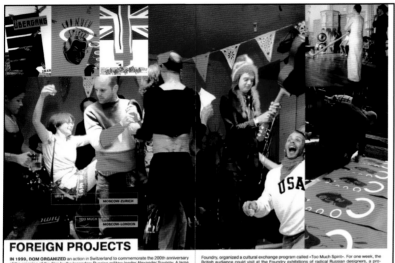

FOREIGN PROJECTS

IN 1999, DOM ORGANIZED an action in Switzerland to commemorate the 200th anniversary of the crossing of the Alps by the legendary Russian military leader Alexander Suvorov. A large group of musicians, artists, designers and friends of DOM staked their cultural territory on Swiss soil and repeated part of the Russian army's path. Along the way, the group organized concerts and other Russian cultural actions, actively engaging the Swiss inhabitants.
IN SEPTEMBER 2000, DOM, together with the British Council and the London club

Foundry, organized a cultural exchange program called «Too Much Spirit». For one week, the British audience could visit at the Foundry exhibitions of radical Russian designers, a program of independent video art prepared by VideoDom, and audio-visual performances of Russian artists. The British did not wait long before paying a return visit and a month later sent a British delegation to Moscow, turning DOM into a real Foundry by organizing a series of thematic evenings.

People everywhere were bursting into song with 'Give me joy in my heart keep me burning', 'whose passport is that breadboard?' or 'whose Russian hat is that fried egg?' There ended a wonderful experience with my new friends, some of whom would make up a large part of my new life whilst becoming an extensive part of my one woman Textual Revolution…

00:38:33 OH GREAT MAD ONE IT WAS IN THE PAPERS KNEW IT HAD TO BE YOU\21:43:22 Dirty girl wot ya been up 2?\16:23:58 stop starting im in the tate with jon langford and co\20:31:55 Are you here? are you with j? I think im in your body again\13:50:11 TRACE IM HAVING A PARTY CAN U MAKE IT?\13:29:27 FLY OVER HERE ILL GET THE FLIGHT...PLEEEEEEEAZZZZZE\14:20:15 HMMM!...ITS A MATTER OF RESOLUTION & HOW MANY TIMES OR THE INEVITABLE.....\19:17:55 IM STANDING INFRONT OF A BONFIRE AT THE BLACK COCK. WISH I WAS WITH SOME OTHER C*** IN FRONT OF A FIRE!!!\22:33:51 TAPING RISE THE ALBUM WHILST PAINTING THINKING SO MUCH OF U\21:51:56 I LOVE YOU TO BITS AND I LOVE NICK BUT THERES A PARTY GOING ON IN MY HOUSE WISH U W²HERE\21:22:42 I AM IN THE HOUSE OF COMMONS DRINKING BEER (1.50 PINT) JACK STRAW AT NEXT TABLE!\13:56:00 He can keep his wellies on i think i get back 5th boo.\14:33:53 Due to high usage since your last payment was recieved your service may be interrupted. To avoid this please dial 121 7am–10pm\13:52:21 i am sitting in the Pakistan embassy trying to stay calm. thinking of u. my car was involved ina stabbing and the police have taken it away\13:54:37 They are examining it for forensic evidence. I thought it had been nicked.\20:51:19 Y DONT WE LIVE NEARER I COULD CUM UP & HELP U EAT & DRINK THEN – saw your mum\18:05:07 HEY MATE U OK?

20:55:12 Hi baby i came home early! \ 16:25:37 TLK2U
CU C \ 21:42:10 BARGOED - SWAT U GET IF U PULL U
PANTS UP 2 FAR! \ 08:51:14 CALL ME \ 15:14:38 Is my
house ok? \ 17:51:52 Throw petrol on the fire hot stuff \
18:12:08 I can feel the heat through your skin \ 18:14:00
information technology. Do you know the definition of
utopia? \ 18:16:49 I am in the air and in the ashes \ 18:18:49
Have you read the wanderer it is full of ... 3 dots \ 18:26:16
Utopia is 'a place that doesnt exist' - is IT a pharmakon or a
foundreme? \ 18:47:41 I love IT \ 19:27:22 "0" "0" "0" keep
these 4 little ANGELS for a WEEK do not delete
them. Send them to 4 of your BEST FRIENDS,
then make a wish, GOOD LUCK. Do it NOW! \
21:54:34 28 dec-TRACEY is TEXT-ME-UP-
TOO! exhib @nFOUNDRY = Xo+TEXTME UPmaS
Party +r2dj.garcia +gavD.J.-WAP +andySAX w/
jimmyFINGERS +U+EVERYONE TEXTmeRSVP!
\ 22:03:15 Yep there obviouslyxx \ 22:31:09
OK YAR. THE TOD \ 22:34:50 YO BE THERE
4U.MERRY XMAS

As autumn rolled into winter, I was finalising my marriage separation. However, my new friends from Russia with love embraced me in the large bosom of their Shoreditch community, especially some of Jonathan's closer friends. One of these was YBA artist Gavin Turk, who had two children of his own with partner Deborah Curtis and a third on the way. Gavin offered his services as a child minder for odd evenings when the boys were down with me. This opened a support network which every single parent will know is quite important to have. I was making the most of any spare moment I had. I was still lecturing at Manchester Metropolitan University and travelling between London and Manchester whilst falling in love with one of the sweetest souls and kindest men I had ever met in my life.

When I'd first entered the Foundry for the exhibition that accompanied John Hyatt's *Navigating the Terror* book launch, there was huge interest in the recent *Text-Me-Up!* exhibition I'd just held in Manchester's Castlefield Gallery. As texting was really just starting to take off in the UK I found that people who were embarking on new relationships were especially interested in my choice of artistic medium. Tam Dean Burn had been intrigued by how I'd saved all my messages and wanted to do the same. I remember him being very disappointed when I told him that I copied them all down by hand into notebooks and journals. He desperately wanted there to be a computer program that downloaded them automatically but this was of course the year 2000: back then my Nokia 3210 phone only saved a maximum of 10 texts and a text download program hadn't yet been developed.

Christmas was rapidly approaching and I booked an art show in the large exhibition room in the Foundry over the festive period. The evenings I was in London would be spent sorting out the exhibition. We sourced 20-metre long paper rolls that I was going to print my bright pink text messages onto. This was going to mark the intersection point in my life between London and Manchester with old friends and new coming together at the exhibition from both cities, where they could read their own words interacting with others', in the order they were received from my phone.

```
            TEXT-ME-UP-TOO!
22:20:40  I am an aleien and i
          have teleported into
          your phone right now
          i am having sex with
          your thumb i know
          you like it cos your
          smiling Now Pass Me
          On
16:43:03  EVKN CLAYIN IS
          ENSHO - IT IS DEAD
          NO MORE - DECEASED -
          EOKN DEAD  HIPHIP
          FUKNHOORAY!XX
20:44:16  EARTH CALLING MOTHER
          MADNESS
13:23:42  in a cornfield
20:28:16  YOU CHEEKY THIEVIN
          BITCH I WAS READING
          THAT IF WAS READING
          BACK BY SATURDAY JAI
          LOOSES A BOLLOCK
13:54:38  GINTFLAPS
02:20:01  HOW U? DONT B
          LONELY DONT B
          SAD ONE END A NEW
          START + FRIENDS LOVE
          YOU NO MATTER
          WHAT. sleep easy  xx
10:00:40  HaVE U ERECTED YOUR
          PERSIAN METAPHORICAL
          TENT
18:05:58  HaVE U HAD WIDGETS +
          NIPPED KIPPER?
22:15:04  UN TEIRD IM B NUNS
          INCUBUS FROM THE
          PLANET PINK...
17:34:05  AAAARRSE
18:41:45  WHOSE MENTAL VOGUE
          IS THAT UNDERTOW
23:38:45  Bar management IS a
          pharmacon
```

For *Text-Me-Up-Too!* I sent invites to the exhibition out to a wider audience so they could interact with my anonymous conversation responses in texts. I had effectively recreated my virtual home, complete with scroll-like wallpaper depicting the intimate responses to my life. *Text-Me-Up-Too!* began in the big room of the Foundry, with the World's First Vibrating Phone Tone Orchestra. Kimble Garcia came to take the position of *Text-Me-Up-Too!* bouncer and minder for the night. His brother Chris 'the Cement Mixer' Garcia held the position of the World's First Vibrating Phone Tone Orchestra DJ. Chris kicked off the tunes with my favourite sounds of local band Chicks on Speed as I began spraying long pink arrows on the wall with *Text-Me-Up-Too!* sprayed between the arrows until the can ran out. The stairwell, corridors

and toilet doors were pristine and white at this point; it would be another two years before street artist Banksy would fill the corridor with his epic installations closely followed by New York Street artists Faile, which in turn established the Foundry corridor as a free space for street art.

Daisy Asquith was filming me as the can of spray paint ran out just inside the ante-room leading into the main exhibition space. The room had been white prior to this, but I painted it completely pink subsequently to mark the emptying of the can. It stayed pink for a number years. Watching Daisy's film, I had a flashback involving Pete Doherty and my joint birthday party with Daisy.

Todd 'the Costumier-pencil Rubber Specialist' Hanson was in the exhibition with Jonathan and both had their mobiles in hand discussing the abbreviated text 'talk 2 u lata'. I explained

TM > Daisy Asquith
5 Mar 2010 06:42 PM
What year did we do our joint birthday party in the Foundry with cake, your Irish uncle & the Celtic shirt with le Bruce on it?

Daisy Asquith >TM
5 Mar 2010 09:14 PM
blimey uncle Declan...! Was it 2001?

TM > Daisy Asquith
That's it uncle Declan who liked a flutter & a whiskey! I can't remember if it was 2001 or 2002 pete was with Francesca but how long had you been with Dunstan? You were playing dice. Will Dunstan remember?

Daisy Asquith >TM
Yeah it was 2001 cos we were both in brixton flat and only together about 6 months x

Daisy Asquith >TM
Pete and john were loving the dice game. John was wearing a hi vis jacket.pete sang happy birthday and we were on tequilas x

Daisy Asquith >TM
Ps you know dunstan can't remember a thing before last week

that it's a friend who's only just started abbreviating and how I have some friends who write long hand text, but others who've always abbreviated and how different dialects are becoming prominent in many of these compressed texts. Little Mark, one of the mainstays of the Foundry bar handed me more pink spray paint. I thanked him as he headed back upstairs

We started discussing the different ringtones people use on their mobile phones. Todd scrolled through the ringtone menu on his mobile and played them all in an unbroken sequence: Three tone, Siren tone, Quick tone, High tone, Music

tone, Standard tone. Jonathan looked on in awe as our phones wouldn't play the sequence: each tone had to be played individually. John Spencer and a couple more people gathered around, some who didn't know that there was a ringtone section in their phone to change in the first place. We all started struggling through (what seemed at the time) complex phone menus to find our ringtones. Menu – Phone book tones – Ringtones. I found the Jingle Bells tone. Todd says, 'It's like a small mobile phone orchestra.'

I explained, 'We're going to have a larger mobile phone orchestra later.'

John Spencer asked, 'How many mobiles does it take to fill the Albert Hall?' This became his theme for the evening. As we compared ringtones at different volumes and tempo, a person walking through the show shouted, 'What's that terrible noise?' John Spencer explained, 'It's us having a phone party.'

The woman piped up in a frightfully middle class English accent, 'Oh gosh Jonathan, I want to join in but I haven't got a mobile phone.'

John Spencer said, 'Well you can leave now can't you... or you could get a mobile phone.'

Jonathan said he had a special ringtone that he made for me. 'It's supposed to be Shoreditch on my mind'. I thought that the sentiment was nice. There followed a 'Love Ringtone Moment' between Jonathan and I. I tried to explain that when the 'entertainer' tone starts playing on my phone, it is the sound of him. He looked blankly at me and I realised that he probably would never have even heard this ringtone as it was set exclusively to his number. I played it over and over and the noise lit up my stomach, bringing much happiness.

The bar room upstairs was now full and John Spencer, in his classic MC voice, enquired how many people owned mobile phones. A girl whooped a cheer in the background at the diverseness of there being twelve mobile phones in one room. John shouted out 'can the twelve people with mobile phones make your way

TM > Daisy Asquith

So it was the beginning of the love dice episode in your life before cirikee?! Whisky was uncle declans tipple wasn't it? Was my jonathan in a high vis jacket? Can't dunst really not remember anything before last week? Is that because of Chumbawumba or his Vegas life or something else? Does he remember on our birthday night being naked & having a piggy back off pete Doherty around the block of the foundry & trying to light a firework up his own bum or is his memory that bad?

Daisy Asquith >TM

I'll remind him about that when he gets in. no it was the other john wossisname whose coat is that jacket john..... and the dice thing started when I was bout 17. kerickie, and any other dice to gamble. Declamn a whisky man yes. Xx

TM > Daisy Asquith

Yes but I meant wasn't it the 'true love dice' episode in the first year of yours & dunst's union? Where has he gone out to? Are the children good? As in happy & well & up to lots etc .. X

Daisy Asquith >TM

They are fine, still up watching lemony snicket and dunst in the handbury and me totally knackered from too much editing and flying about the planet like an idiot with feathers

TM > Daisy Asquith

I hope the feathers are pink or red! I miss you & when I'm back in London I'll call you & we'll meet up when you have time re foundreme filming & catch up coronas with full details of your adventures xxx are the twins of the gay dads in the Uk now? Are you following them by film? Your baby grow profile status made me broodie the other day x

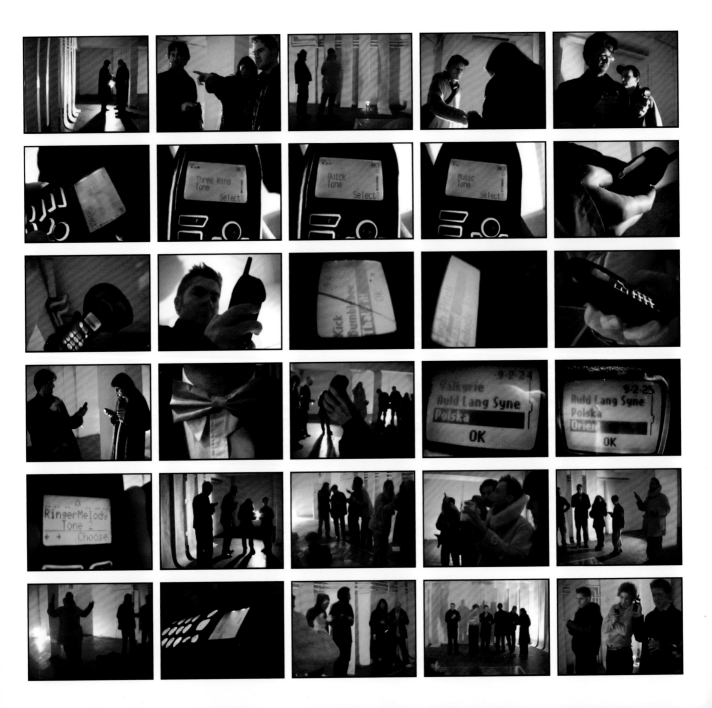

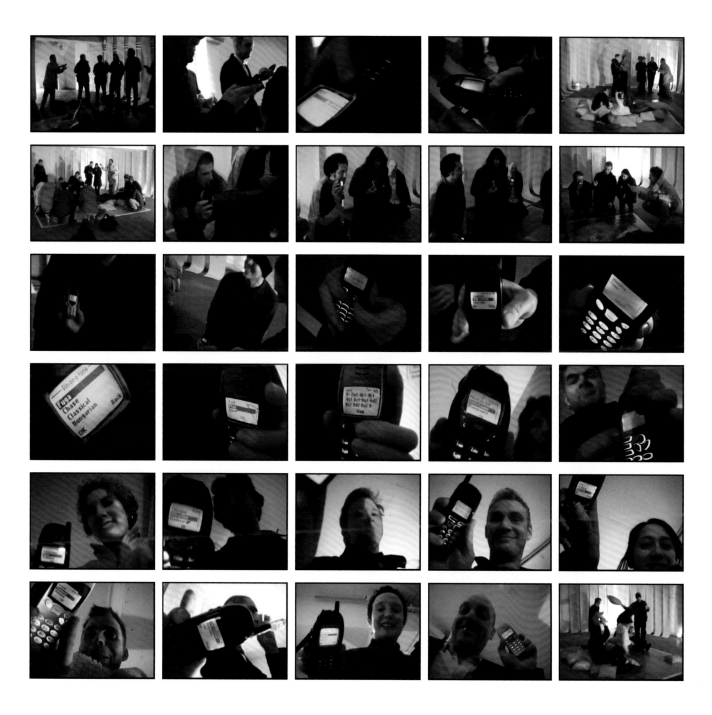

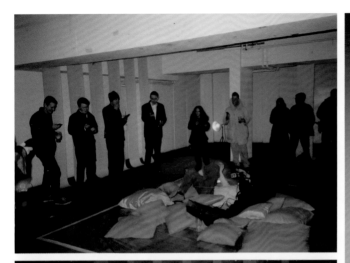

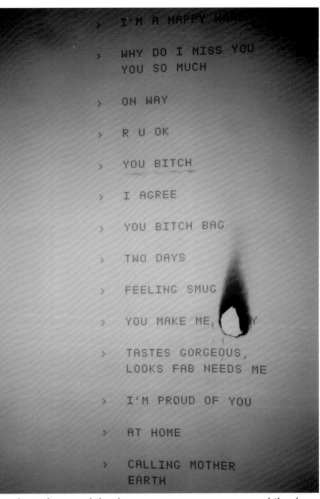

> I'M A HAPPY HAP

> WHY DO I MISS YOU
> YOU SO MUCH

> ON WAY

> R U OK

> YOU BITCH

> I AGREE

> YOU BITCH BAG

> TWO DAYS

> FEELING SMUG

> YOU MAKE ME Y

> TASTES GORGEOUS,
> LOOKS FAB NEEDS ME

> I'M PROUD OF YOU

> AT HOME

> CALLING MOTHER
> EARTH

downstairs now please for a mobile phone tone extravaganza… mobile phone users and tone dialers please make your way downstairs immediately.' They all obliged. As word spread upstairs that anyone with a mobile phone was required downstairs to partake in a mobile phone orchestra, the numbers grew – the final total being eighteen.

Only eighteen people in the full bar then had mobiles. The newly formed orchestra gathered around Jaime and Amy on the circle of cushions. They had positioned themselves there taking over the filming of the event from Daisy. All eighteen were practicing with their ringtones and then the conductor took charge. He shouted, 'Everyone get together, wind, brass and percussion.' We divided up six people into the wind section, placing six people to the right of them to form the brass section, next to percussion, then the string section. The cacophony of

what represented the percussion section in the pinkness of the room created an almost womb-like environment, until I started complaining and asking, 'Whose phone is really loud?' because other phones were louder than mine and I wanted to be heard. I looked around at what was probably the world's first mobile phone orchestra made up of pre-Shoreditch trendies – although there were a few mullets present – and a couple of hoodies. We put the vibrating phone tone orchestra into its first rehearsal starting with the percussion intro. One of the orchestra members threw his phone on the floor but Kimble, now in his creative bouncer role, decided this to be too avant-garde. People couldn't stop laughing. John told the orchestra that we were booked in the Albert Hall next week. We devised a new strategy where each person played a ringtone following on from the next. People played their tone facing the audience. They started dancing while their tone was playing. As the Vibrating Mobile Phone Tone Orchestra concluded, people picked up the cushions from the centre, displacing Jaime and Amy and started a huge pink cushion fight.

TM > Dunstan Chumba Bruce
No I'm in Welsh Wales why?
Are you in London?

TM > Dunstan Chumba Bruce
Im in my friends house in
s.wales we were in nursery
school together catching up

Dunstan Chumba Bruce > TM
6 Mar 2010 09:46 PM
trace, are you t the foundry
tonight?

Dunstan Chumba Bruce > TM
bugger! We're at some 40th
do but we're going to go for
a meal instead coz you're not
around!

18:21:54 5. on the A303 at 80MPH \ 20:28:08 6. THE VAULT ("massive") \ 21:40:06 I need a firm hand \ 18:20:22 Do not run out of talk time! You have less than £1 left. Buy a voucher today. 121 \ 12:52:17 i bet you'll be glad to get some good solid information \ 13:53:18 I might go to the lux to see the gleaners \ 15:20:40 sorry distribution lists are not available on this service \ 09:14:15 CUNT ≠ C \ 18:13:40 text me up BABY! \ 02:42:19 GOeD SAFE'N'SOUND. SLEEP TIGHT IN THE KNOWLEDGE U R V. SPECIAL + R LOVED DEARLY \ 02:16:30 HEY TRACE – jus noticed yor text – jus bin chilin at hme – now bedways is bestways \ 23:02:56 if u ear daisy tell er i found er phone (HARD FAST INTO U) \ 16:06:11 BORING W.END EXCEPT 4 MY WESCHLER BURGER ON C'PHILLY MOUNTAIN! WHAT'S HAPPENING W. BORIS– RU IN LOVE W.IT? IS HIS GIRLFRIEND CALLED DORIS? \ 20:31:30 message box is cleared waiting for all the new ones to arrive fr out the ether but nothing yet also phoned u but no answer \ 01:08:06 HEY DUDE U STILL UP OR R U SLEEPING THE SLEEP OF THE RAT MURDERER? \ 23:24:54 GET DOWN TEXT ME UP EAR 2 THE GROUND NOSE 2 THE GRINDSTONE FINGER ON THE PULSE FOOT ON THE PEDAL ROLL UR SLEEVES UP PUT UR BACK INTO IT. SEXUAL POSITION 125 \ 00:57:41 I'M GOING TO FIX WHEELS ON MY COMODE SO IT BECOMES A PORTALOO!

12 Text-Me-Up-Too!

22:54:40 Sorry your text messaging service is currently unavailable due to insufficient funds please top up your account and try again \ 00:16:25 FRIENDS ARE FOR XMAS NOT FOR LIFE! \ 23:17:42 YOU ARE NOT HERE \ 00:39:48 HAB I NUR FUR DI GERUPFT! \ 21:35:56 ...HELLO...HAVE U LEFT YET...? \ 21:58:59 im now in a dodgy pub in warrington. why...? \ 16:53:13'do not eat, the worm lady..... \ 19:38:01 Pharmakon: going severe to good, wind speed 90 miles an hour; shannon dover dogger cromity foundry, stay calm + noone will get hurt \ 19:55:00 I am in your body keeping things under supervision. I am administering the parmakon foundreme 100% \ 19:55:41 Merry christ my ass \ 20:20:44 How are things on the ward? \ 00:22:56 HAPPY HANDCUFFS + CHAMPERS 2 U \ 22:07:52 LIMBO BABY ITS CRIMBO I DON WANNA DANCE \ 23:15:16 FURRY PINK HANDCUFFS A GIRLS BEST FRIEND MERRY C XXXXXX \ 20:21:22 Well what can i say @ such short notice? wanna text me up all nite baby? \ 20:41:16 Race me over the bridge away from the houses of law towards saint tommy's where we will find the cure for the last unspoken malady – the last act is done. \ 20:54:18 IN JAMAICA THEY DOIT LIKE DIS BUT WID DE OKRA & SUM CRAKRS.. OH YES ITS EVRSOONICE. \

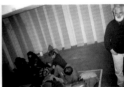

The opening night launch of *Text-Me-Up-Too!* was approaching. In six months, my life had radically changed. I was juggling between two places, still doing the same work, but now in two cities, picking my children up from school on time and enjoying their busy social lives and activity commitments as well as my own.

I was in London on my own for the next couple of days and fully focused on the exhibition. Just like the opening night of the Castlefield exhibition in Manchester, people were spending long lengths of time reading through the texts. I had already decided to have a lock-in at the launch party when the bar was closed; this launch would be for friends who were part of the show, as a way of saying thank-you. Daisy had spent most of the night on the bar floor and as she ventured down into the underground gallery room, she was more than freaked out by the overwhelming number of people already enjoying the after-hours section of the night. I knew I had to somehow re-evaluate the free drinks part.

The visuals and film Jaime had done of the mobile phone orchestra was playing in a packed exhibition against the back wall. He was explaining to me how well the previous night had been received when I was still in Manchester.

Many of the fifty artists who had been part of the Moscow experience had turned up for the official launch. Pete Doherty had surreptitiously taken over the main pink silk cushion area, leading the musical entertainment with his mouth organ. He was playing really well and stopping every so often to come out with a witticism in an Irish-American accent that had the surrounding people in hysterics. He was very quick and very funny. He would then resume with the mouth organ captivating more people in his hypnotic performance. John Spencer joined him on the cushions.

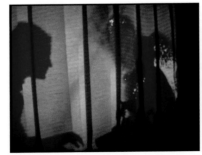
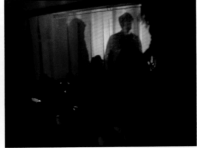
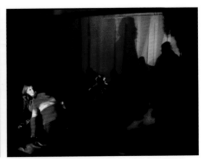

As people mingled, Jaime goes back to filming the text messages…

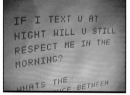

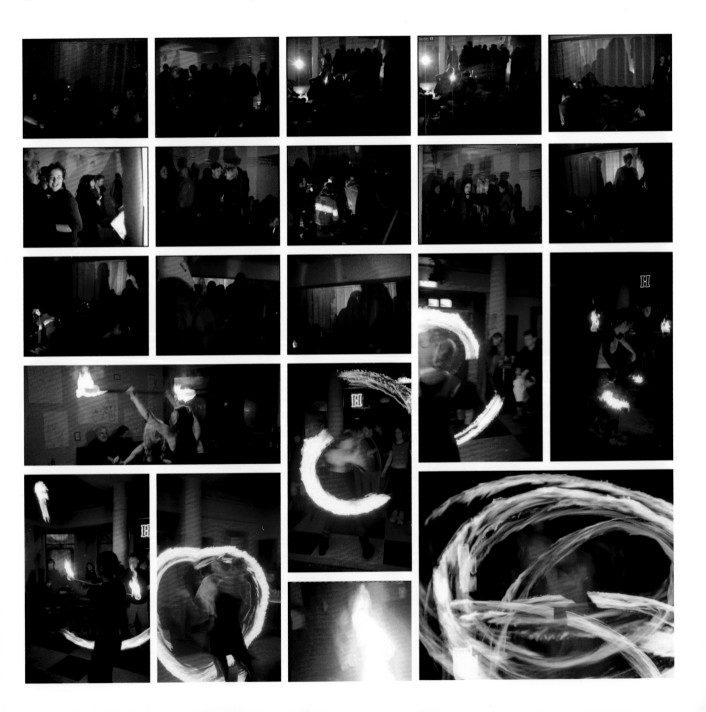

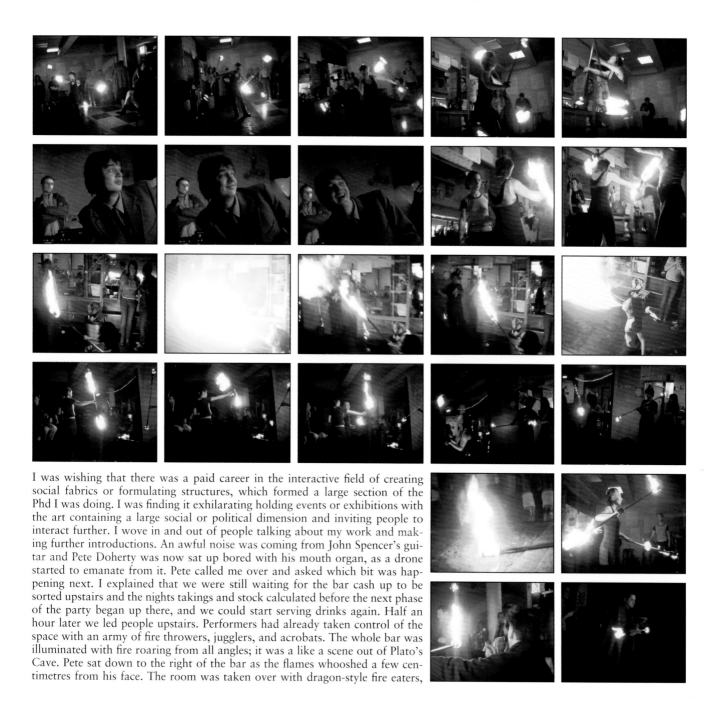

I was wishing that there was a paid career in the interactive field of creating social fabrics or formulating structures, which formed a large section of the Phd I was doing. I was finding it exhilarating holding events or exhibitions with the art containing a large social or political dimension and inviting people to interact further. I wove in and out of people talking about my work and making further introductions. An awful noise was coming from John Spencer's guitar and Pete Doherty was now sat up bored with his mouth organ, as a drone started to emanate from it. Pete called me over and asked which bit was happening next. I explained that we were still waiting for the bar cash up to be sorted upstairs and the nights takings and stock calculated before the next phase of the party began up there, and we could start serving drinks again. Half an hour later we led people upstairs. Performers had already taken control of the space with an army of fire throwers, jugglers, and acrobats. The whole bar was illuminated with fire roaring from all angles; it was a like a scene out of Plato's Cave. Pete sat down to the right of the bar as the flames whooshed a few centimetres from his face. The room was taken over with dragon-style fire eaters,

ball and chain implements manically swinging around and hot music playing in the background. Miraculously, the flames narrowly missed people in such a confined area but the apparent danger only added to the heightened adrenalin. More people were joining in with the flame-throwing. It was now reaching epic proportions erupting across the whole length of the room from floor to ceiling. After a long period Jonathan and Jaime extinguished all fire and concluded the night's pyro-tastic entertainment until the next time.

Gavin Turk's DJ'ing begun with *Goldfinger* on the turntable as he deliberated over whether to play a sound effects album next, but then opted for The Jam's *That's Entertainment* with a very excited John Spencer running over to the decks saying, 'For fuck's sake turn it up'. A projected slideshow on the right hand side of the Foundry's far wall was displaying Soviet era agitprop posters, whilst most of the wall lit up with Jaime's film projection. Gavin put Jimi Hendrix's *Fire* on then and the bar floor area became a packed dance floor. The bar wall had become a huge screen and all the monitors were playing Jaime's film, which had slowed down and was focusing on the delivery of my missile to Russians at the Foundry. At precisely that point, Blondie's *Atomic* came on and a synced magic moment ensued, Blondie's words emphasising the unloading of the missile on screen. I went downstairs to see who was doing what in the warm pink glow of the room. Pete had once again resumed his place on the centre of the pink silk cushions with his mouth organ, talking to a blonde girl, so I went over to find out who she was. Two guys called Geo and Dave along with Russian Alexey had been doing an improvised poetry session with my text messages and I had missed it. I pleaded for them to do one last performance so that I could hear it.

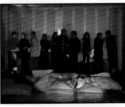

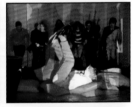

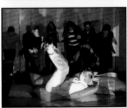

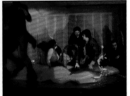

The poetry text message reading commenced, with an audience of five. Pete tried to get up and join in, but the girl kept him talking…

Geo	**You bitch**
Dave	**No answer**
Dave	**You ok I lust you**
Geo	**Strawberry Slappa**
Dave	**Stoke –On-Trent**
Geo	**I will let it get to u**
Dave	**Yes**
Geo	**Sittin on Reading station bored shitless**
Dave	**yep u?**
Geo	**SPEAK**
Dave	**all so normal**
Geo	**I MISS U**
Dave	**YES SMITHFIELDS**
Geo	**Wots new?**
Dave	**Im now livin in Manchester**
Geo	**IM FUCKING 37 TODAY!**
Dave	**Hope u ok call me**
Geo	**Do u read wots happnin?**
Dave	**13 lucky for me. I don't think that easy**
Geo	**FAB**
Dave	**Who is it?**
Geo	**FAB. WISH I WAS THERE**
Dave	**Faster than coffee**
Geo	**with who**
Dave	**R U at home?**
Geo	**what u thinking?**
Dave	**Hows London hanging?**
Geo	**Where ru?**
Dave	**Fagels**
Geo	**Ok I didn't realize & went back**
Dave	**Cool I've got some so I'll bring em round**
Geo	**why would u cancel 2morrow?**
Dave:	**what NO ANSWER frm miss SEXY?**
Geo	**YES**
Dave	**WHAT DO U WANT FRM ME IN UR WETTEST FANTASY?**
Geo	**well done darlin-lovely arse**

In Unison as they meet up at the last text

KIPPERS!

Geo and Dave joined Pete and the blonde girl on the cushions and began a conversation about kippers. I was talking to Russian Alexey about the improvised poetry performance when Jaime, from behind his film camera, decided to round up all the people in the room. He instructed us all to line up against the wall, saying we were going to do some performance filming. Pete was balancing a

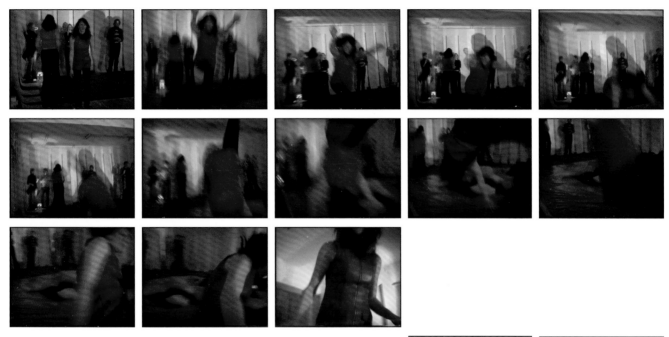

wine glass on his head, as Jaime told us to fold our arms.

After ordering us to smile and put our hands in the air a number of times, Jaime shouts out, 'Ladies and gentlemen, we will commence with diving onto the cushions…'.

So we did, and I still don't know why.

Jaime: 'and again, starting positions'.

We all forgot the purpose of why we were doing it, but dived onto the cushions over and over again. We lined back up against the wall, took our glasses, sipped our drinks and got our breath back. Pete did a short interlude in a high-pitched, Irish-American accent, 'Hello, didn't I meet you in a lift in Kansas City once?'

Jaime: 'I think you did. It was going down'.

Pete: 'You were wearing a hat, a funny black shape'.

Jaime: 'Squiggly bits on the side'.

That was it, all I remember of it as I went into somersault mode, dive-bombing into the pink silk cushions. Jaime had one minute left on his film camera, and that was how my *Text-Me-Up-Too!* opening night ended, as did my memory of it at the point the filming cut out.

The exhibition had become the focal point of the Foundry on New Years Eve. I'd called in briefly that evening, leaving before midnight. As I was walking along the streets to where I was staying, my mind was focused on leaving the year 2000 and how I'd entered into the new millennium I'd been so very sad, doing somersaults then to an audience in Manchester's Albert Square whilst

TM > Nick Fry
7 Mar 2010 02:23 PM

Really, are you ok fousty lardy arse…? Even more hours have past by… a lot of hair roots & skin cells have died, wrinkles sinking deeper and death's shadow nearing the very last corner that we are running headlong towards, hardly stopping for air… as I wonder why No texts from my old mucker wurzel limpet Nick Frybentos? Did you eat all the poison fly agaric mushrooms in your new forestry signage job?

Nick Fry > TM

Hello arse munch. Bows the fanny batter farm? Are you over producing your quota

TM > Nick Fry

It's gibblebatter you urine chrystal and it doesn't have a bow on it! Do you have an image of it being like a Banksy 'have a nice day' helicopter with a bow on the top? Where are you & do you farrrrrrncy a drive over the seven bridge to see your best friend?

Nick Fry > TM

Could, do where you at?

TM > Nick Fry

I'm at my marmmy's in da varlies we could go owt tonight? If you don't want to I don't mind but I'm having a missing nick fry episode. We could meet up in London next week otherwise x

Nick Fry > TM

I'm working tomorrow isn't it see… But see, like I could have last night butt..who's coat is that jacket?… eisteddfodd, pobbl-y-com, es pedweechh

Nick Fry > TM

Call me taffy

TM > Nick Fry

Less of the taffy its Shadwell of the hooowver will ring shortly FreyBENTos x

Nick Fry > TM

Ok bubby, my tuffy Taff.x

15-01-01 12:41:27 HOORAY U CAN TEXT AGAIN \ 16-01-01 04:10:12 mpc network message please delete £t4g¥åå¥åå¥e æ ð#V√%√,So,XΣIAe- Cq2è¥xpnå ååååååååååååå ååååååååååååå ååååååååå \ 16-01-01 01:32:11 HEY HO U MAY BE BACK ON TEXT BUT U SLOW WITH MESSAGES \ 17-01-01 01:17:59 …can we sleep together on your cüshions asks amy \ 17-01-01 01:47:10 he's jaime… she's amy! \ 17-01-01 11:29:38 gavin has daily column in the times this week-how about u TEXT him something 2 say? coded msgs? Jaime gets a mention in todays. \ 18-01-01 00:38:01 STEADY ON WITH THOSE LONG TEXTS I CANT KEEP UP \ 18-01-01 15:04:31 Cos they have fucked up my plumbing and i like a fight with a big corporation! \ 18-01-01 21:56:12 I am at home eating ice cream and dreaming of a nice big Northern man with a beer belly \ 18-01-01 22:00:56 Yes - where you going animal? \ 18-01-01 22:05:35 You are up to no good!? \ 19-01-01 18:06:29 PLEAS CAN I OPN MY PRESIS? \ 20-01-01 20:16:51 On train safe & sound Kiz u upset but u tired! Great w/e babe thanks! Train got 1/2hr delay shit! \ 21-01-01 00:43:13 I am singing give me joy and missing you \ 24-01-01 14:18:25 NOVOBIRISK- BIG HARD AND POUNDING INSIDE YOU \ 26-01-01 11:30:00 COLIN IS A DADDY \ 27-01-01 10:34:49 The baby has landed 26.01.01 7lb's happy healthy & beautifull love gavinx

trying to hold a plastic cocktail glass filled with champagne upright to a clapping audience.

I was now entering into 2001 in a new city, thinking how so much had changed. Happy texts began pinging into my phone with wishes of love, luck and happiness for the coming year; they lifted the spring in my steps through Shoreditch. Then I received another kind of text, but this one from someone I didn't want to be contacted by. First the text and then the phone call, bringing up all the turmoil of everything I'd been trying to forget about and move on from. It boomed and droned on until I'd reached my destination and climbed the four flights of stairs to the top floor flat. I opened the door with my other hand, let myself in and walked into the kitchen standing in the dark. The voice now thick with abuse increased in intensity as the countdown toward the New Year approached. I didn't want to listen to it anymore. I wanted the sounds and sentiments of the abuse out of my head, the rant to finish, end, and stop immediately. In a state of panic and fright I threw the phone against the wall. In the darkness of the room I hadn't aimed well and it crashed through the Georgian window, flying out into the street four floors below. It had landed on someone. I could hear the cry of pain from below. The New Year was not beginning well for me at all and certainly not for the person who had been injured by my action. I was mortified and expected retribution from whoever I had injured. I couldn't see properly, my eyes blurred from the tears. I felt for the corners of the small kitchen table and sat under it like a child, wondering what to do next, not daring to move. It went quiet and I built up the courage to emerge from beneath the kitchen table and peer down onto the street below, being careful not to move any of the broken glass left in the frame. There was no one there, but I couldn't make out the shape of my smashed phone either. I wanted my invaluable, lovely texts. The phone would be irreparable but hopefully I could retrieve my SIM card with all the phone numbers. I crept down the four flights of stairs to the quiet street below. There was only glass on the pavement, and I feared that the remaining shards of phone would now surely be in the hands of the police.

I was left without my faithful companion for over two weeks. Thankfully, there were no repercussions and no one was reported hurt. I had learnt a lesson and would never throw a mobile phone again.

14-02-01 09:52:54 hooray!! going to funeral on way will call later \ 15-02-01 18:20:20 __NEWSFLASH__ A LORRY DRIVER WHO CAREERED OFF THE ROAD and KILLED A MAN WHILE WRITING A TEXT MESSAGE ON HIS MOBILE PHONE WAS JAILED FOR FIVE YRS YESTERDAY \ 15-02-01 18:26:13 i have no further information - she's turned the page - we're on TEST-TUBE FATHER LOSES LEGAL FIGHT now \ 16-02-01 16:36:10 Answer is WANG!i \ 17-02-01 14:01:45 at the doctors! \ 17-02-01 14:08:16 dr dunst! \ 18-02-01 14:27:01 georgia is on her way to spitalfields mkt to meet Z so look around for her \ 21-03-01 19:04:57 ok lover! k xxx \ 01-04-01 15:26:54 IM GOOD BUSY STRIPPING AT THE MO WHAT U UP TO \ 04-04-01 21:19:31 Are u a galloping homosexual, or am i the ugliest bird in your phone book? \ 06-04-01 17:14:46 HEY DUDE BACK ON LINE TEXT ME UP GOING GLOBAL THEN? \ 10-04-01 02:49:36 ... hi trace just finished work ... its béen quite f/on ... did u know it is the 40th aniv of uri gagarin's F.M.I.S. on thurs? party @ roket h/way rd dj/vj. stuf \ 15-04-01 11:11:23 OW'S THE NO SMOKING GOING? RU AVING GOOD TIME WITH LYNNE? I'M STILL FEELING LIKE CRAP :-S \ 18-04-01 15:14:37 BIG FAT COCK DRIZZLED WITH FANNY BATTER, THROBING \ 18-04-01 17:56:34 RIGHT IN THE FUCKIN HOLE \ 19-04-01 15:56:20 ... hi trace had 2 successful meetings in mcr max & video guy r cool, stil lots 2 do but i think its going 2 be ok jaime x \ 19-04-01 16:08:06 oh joy! a sink unblocked

One of the other jobs I'd been doing between lecturing was helping to organise the launch of the soon to be refurbished Zion Arts Centre in Hulme, Manchester. The 2001 launch was to highlight its refurbishment and newly structured arts centre focusing on 16-25 year olds. It was a good project for me, where I could split my community arts skills (I had been Vice Chair of Community Arts North West for ten years), work I did within local schools and my own practice – whilst bringing onboard students from my lecturing posts. The opening event was in April 2001, under the umbrella title of *Blast-Off* which included many performances and arts events.

I had framed and exhibited beautiful black and white photographs from a project Karl Harris and I had done with the children of an undeveloped Hulme and its infamous Crescents. The photographers for the pieces were aged between twenty-three months and four years of age. Beautifully centred imagery, people wanted to buy what they thought were professional, adult prints.

I started devising and organising a spectacular procession comprising of stilt-walking drummers, giant mythical figures, dancers, musicians and circus artists. It would weave from Moss Side into Hulme and continue in front of the Zion where I would release a thousand pink balloons, each carrying an individual recycled mobile phone text message and each individually numbered, with contact address and mobile number to respond to.

I based the processional theme on regeneration and celebration using four mythical creatures: the phoenix, the Minotaur, Triton and Pegasus. The Birley Adult Education Centre was demolished as part of the regeneration program. The symbol for the centre was the phoenix.

The phoenix is a mythical bird, the size of an eagle with similar features to a pheasant. The legend of the phoenix tells of the bird's premonition of death drawing near. From this insight, the phoenix makes nest of resins and sweet

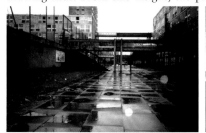

Martyn Ware > TM
11 Mar 2010 11.15 AM
1pm at groucho tues 16?

TM>Martyn Ware **Mx**
Great see you there x

Martyn Ware>TM
16 Mar 2010 08:46 AM
Hi tracey
Come down with a heavy
cold so staying in bed today
– sorry. Can you do thurs or
fri? Let me know you've got
TM>Martyn Ware **message**
Get yourself well. Am not here
thurs & radio shows on fri
sorry. What days do you have
next week? Martyn Ware>TM
Thanks t
I'm on tour til 5 April from sr
That's why I'm trying to get
better asap
TM>Martyn Ware **Mx**
I can do thurs evening. I'm
working in Birmingham in the
day with bill but know he has
to be back for his kids in the
evening can you do this? Or a
day next week? How long you
on tour for? In the UK?

TM > Martyn Ware
Sorry just re read last text I
thought you said from 5 April.
Thurs evening any good? Or Martyn Ware > TM
do you fancy coming on radio **I could do 6pm thurs I'm**
show fri morning? **away from sat for 2 weeks**
Mx

Martyn Ware > TM
Strike thurs eve Just
remembered I cant
TM > Martyn Ware **Mx**
Fri radio then?

TM > Martyn Ware
We could talk & get something
to eat after the show?

smelling wood. The phoenix exposes itself to the full force of the sun's rays until the nest burns. It is then consumed in the fire which it has created. From the ashes, a worm-like creature emerges, growing into the form of a magnificent regenerated phoenix.

The Minotaur, a legendary monster, half-man and half-bull, was confined in a labyrinth, where he was later slain by Theseus. Then there was Triton, the son of Poseidon and Amphitrite, living with them in a golden palace in the depths of the sea. Triton is represented as a merman, having the body of a man and the tail of a fish. He carries a twisted conch shell, upon which he blows either violently or gently, to stir up or calm the waves. And finally Pegasus, the fabulous winged horse which sprang from the blood of Medusa after Perseus had severed her head. Medusa had been made pregnant by Poseidon, who is thus considered the father of Pegasus.

We were all set to go as the artists completed the brief I'd devised.

In 1996 I had completed an Artist in Residence post at St. Philip's Church of England School. The work was a ceramic mosaic covering the entrance of the school. It was based on the story of creation. Although predominantly Church of England, the school attracted children from a broad spectrum of faiths. The story of creation is similar in many religions, albeit told in a slightly different order. I had fun making the mosaic, working with the children and their designs. The order the creation story was put together seemed to be less relevant to them than what colour God would be. A young Malaysian boy said, 'purple, of course.' So God was purple and this was approved of by the general consensus of children in other classes. When it came to Adam and Eve most of the girls, despite their ethnicity, painted Eve with blonde hair and a pink dress and Adam in a red top and blue trousers. Very Barbie and Ken. I decided to place Adam and Eve's faces on the mosaic at the average height of the children in the school and mosaic their faces with mirror glass. This proved successful so all the girls looking into Eve's face saw their own face and skin colour represented, as did the boys looking into the face of Adam. A successful residency was completed and a grand opening saw an Olympic athlete cutting the red ribbon across the artwork.

The school held a balloon race. I've always had a great fascination with balloons. The Albert Lamorisse film *The Red Balloon* 'with the participation of children from Menilmontant and all Parisian balloons' is at the forefront of my

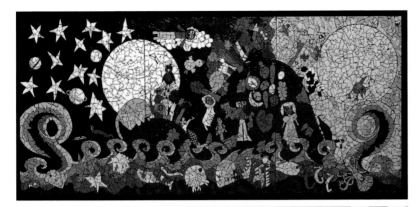

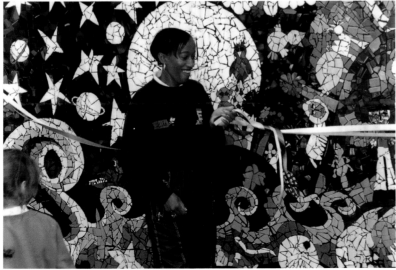

Martyn Ware > TM
16 Mar 2010 09:17 AM

TM > Martyn Ware
11.35am at the foundry
Friday it goes out live at 12
lunchtime on 'the foundry
late late breakfast show' on
resonance 104.4fm or www.
resonancefm.com that'll be
good I think the guy who
does acid jazz records, actor
Jonathan Owen are on this
weeks show and pos opus
3's Kirsty Hawkshaw (or she
maybe nxt week) & artists.
Look forward to seeing you
then & food after. Get well x

Ok What time and where?
Mx

Martyn Ware > TM
See you then (Assuming I'm
better)
Mx

TM > Martyn Ware
Hope you are x

TM > Bill Drummond
19 Mar 2010 08:44 AM
You get them ok?

Bill Drummond > TM
Got them all thanks. Have
not had time to go through
them all as I have been doing
childrens breakfast and about
to get F to school

TM > Martyn Ware
19 Mar 2010 08:50 AM
See you 11.30am at the
foundry x

Martyn Ware > TM
Ok Mx

Drummond > TM
The photos a re brilliant. Is
now a good time to phone you
about them

TM > Bill Drummond
Yes now good time

TM > Bill Drummond
19 Mar 2010 11.38 AM
Will you please text me all you
said about you getting a pink
suit & your quandary over
lining colour? Thank you xx

Bill Drummond > TM
What pink suit?

TM > Bill Drummond
Don't forget please. It takes ages with photos doesn't it!! It took 4-5 hours doing and sending to you last night

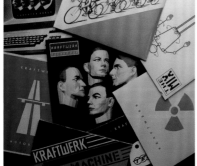

TM > Bill Drummond
19 Mar 2010 03:29 PM
The photos look good on the catalogue page.. The colours & the differences. What are you doing that you've not updated your events page... Hmmmmm have you been out for a long Friday lunch or lying in bed watching tele again?

TM > Bill Drummond
By domestic issues I tke it you mean cleaning your toilet after your wind & bowel issues yesterday...?!

Bill Drummond > TM
Oh that one.Yeah but will have to do it later. As it is taking time getting the photos up.

Bill Drummond > TM
I promise that I will have a pink three piece suit made for myself to wear at the launch of your Text Me Up! Book, if you promise that the cover of the book is pink based. My only problem is what colour should the satin lining be-dark crimson? Or pale blue?

Martyn Ware > TM
19 Mar 2010 01:55 PM
I'm going to give you my newly remastered collection of vinyl Kraftwerk albums as it's such an important part of your musical development – heavyweight vinyl and gorgeously presented LoveMartyn x

Bill Drummond > TM
Had to get to the bank down in Dalston. I am still there now. It has taken all day getting those photos up. Mind you there were some domestic issues I've been dealing with as well. Will let you know when events updated.

TM > Bill Drummond
19 Mar 2010 04:40 PM
Are you going anywhere nice tonight? I am meeting up with a group of male fanatical Liverpool football supporters (all scousers) in a run down pub with 2 pool tables in Aldwych. This is the start of easing into the HAG not WAG tele role. The next one is Cardiff city or west Ham. I can't wait. You home with your clean toilet? Xx

TM > Bill Drummond
Text me when they are up x

TM > Bill Drummond
20 Mar 2010 10:08 AM
Are you at football? Just been looking at your website. Do you know what shade of pink & what fabric you want your suit to be?

TM > Bill Drummond
Oh please don't start me off thinking about hanging directions & things it's early on a Saturday morning & will be too much for me. Sorry you are out in the rain.

TM > Bill Drummond
Did you know Julian Cope was doing the laugharne festival the same time as you?

TM > Bill Drummond
Are you getting my texts?

TM > Bill Drummond
Will you please take a pic & zap it to me on phone. I woke up thinking of you in a pink suit. I don't know what I'd been dreaming about. The shade is important

Bill Drummond > TM
Back home. Domestic situation resolved. Back at the computer. Will be here all evening. I still love the photos and look forward to others seeing them and they being used at some time in the future. Have a great night out.

Bill Drummond > TM
At football in the rain. The relationship between a gentleman and his tailor are a private matter.

Bill Drummond > TM
Yes but I'm trying to concentrate on the job in hand. Will respond later

Bill Drummond > TM
I am now drawing pictures of myself in my pink suit so my Tailor (a Greek Cypriot on Green Lanes) has more of an idea of what I want.

mind as is the migratory path of the black swan as I construct this next paragraph. As a child I wished for remote controlled cameras that would plot and record the journeys of the balloons I set free, wondering what countries would be their final destination or even if they would get beyond the coal slag heap or fire station half a mile from the childhood house I grew up in.

I always entered balloon races but never heard anything again once the balloon gained its freedom. That was, until the St. Philip's School balloon race. My balloon had entered a vast net with hundreds of others literally jostling for air space. The other balloons bearing the names and addresses of pupils, staff and parents alike graced the sky in an immediate burst of colour. I waved goodbye to mine then forgot about it. Several weeks later I received a letter from the school along with a cheque and my balloon tag with Netherlands stamps. I had won! I had actually won a balloon race!

The fact I was no longer a child didn't matter. I was as ecstatic as I would have been at seven years old. It felt like a childhood dream had come true. I knew then that I would introduce balloons into my art projects and exhibitions.

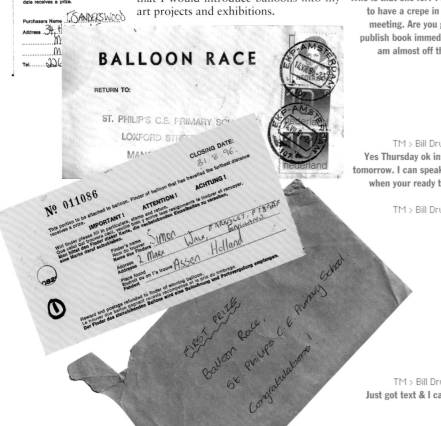

Bill Drummond > TM
23 Mar 2010 10:48 AM
I am on a school trip with F. He is in a cricket tournament at Lords today. I have brought my note book so I can get on with writing. I forgot to listen to my Cake Circle thing on Radio 4 yesterday.

TM > Bill Drummond
I remembered to listen to it last night. I enjoyed it & you very natural & informative. I'm going into town for some meetings on my book/ performances then to see Van Gough exhibition. Tell F I hope he wins & if he doesn't to have a good time. What are you writing today?

TM > Bill Drummond
Who is that one for? I'm going to have a crepe in my first meeting. Are you going to publish book immediately? I am almost off the bus x

Bill Drummond > TM
Answering four questions on Haiti.

Bill Drummond > TM
These four questions are for a producer at the BBC who is interested in pitching a programme about The 17 in Haiti. I told him instead of us having a meeting just email four questions and when I answered them maybe have a meeting then. Any chance you could swap tomorrow for Thursday. Something has come up this morning to do with KLF's container. Will explain on phone. When would be a good time to phone?

TM > Bill Drummond
Yes Thursday ok instead of tomorrow. I can speak now or when your ready to phone

Bill Drummond > TM
Will phone in a bit. F team have just started a new game.

TM > Bill Drummond
Ok

Bill Drummond > TM
23 Mar 2010 08:56 PM
My phoning in a bit has stretched some what. It has been a full on day. Now in the BBC about to do Nightwaves for Radio 3. Will maybe phone when I am on the bus back home. Hope your day has gone well. I now know what all my 100 Questios are to be . Sort of.

Bill Drummond > TM
23 Mar 2010 10:43 PM
Job done. On the bus back home now.

TM > Bill Drummond
Just got text & I can speak

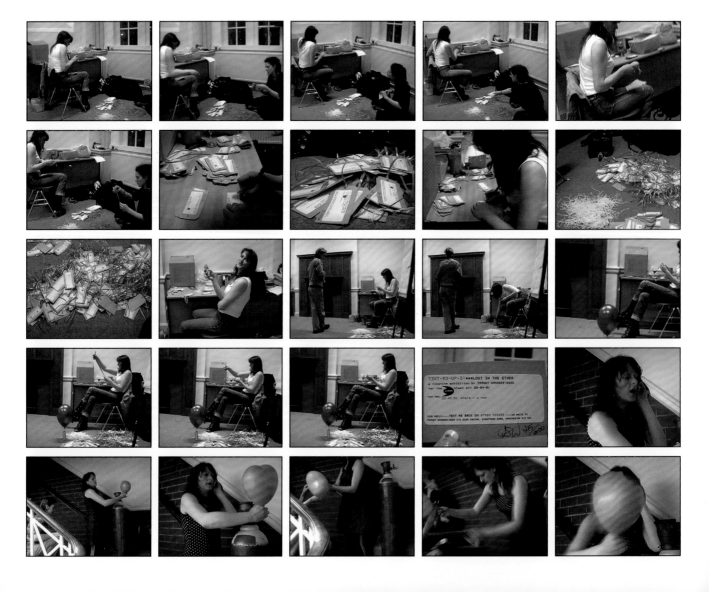

It was now several years on from my victorious balloon accomplishment. The random pin-prick into the map of the British Isles that had first brought me on my journey from Newport to Manchester was about to finish its circuit here. The Manchester roller-coaster journey had taken sixteen years to complete. It had given me memories ranging from horrific to ecstatic. I would be leaving with the greatest thing in life though, the children I had given birth to in the city.

The wind's direction was turning from North to South. The incorporation of balloons into my artwork had been formulating and now I was about to put it into practice. All the words that had been my support system and helped rebuild my life through text messages, I now wanted to set free. The Zion re-launch was just the right occasion with its mixture of re-birth and regeneration. I would launch a thousand recycled mobile phone text messages and if the wind truly was changing direction in Manchester and a move out of the city was right for me and the children, they would be carried in a clockwise direction, indicating change and time moving on.

In a poetic moment, I thought I would incorporate some red and pink balloon hearts. I bought a new SIM card to give out another number on the tags of the balloons that would display the recycled text messages and be a contact number for people who may wish to respond if they found a balloon. As I was incorporating a flash of red colouring with the pink balloons I decided to buy an orange SIM card to put in place of my regular One-to-One. I love the colours red, pink and orange together. I was talking about this and the colours, saying I wish there had been a pink company (this was before One-to-One became T-Mobile with its pink branding). Someone once suggested I approach the Orange phone company to see if they were interested in any form of sponsorship with the balloon launch. I did, but they politely told me that they weren't interested in the project of recycled text messages or balloons. The Orange television adverts using balloons would not start until a while after my proposal to them.

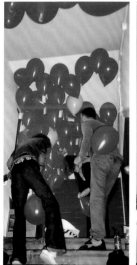 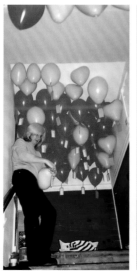 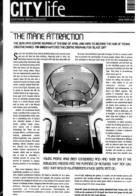

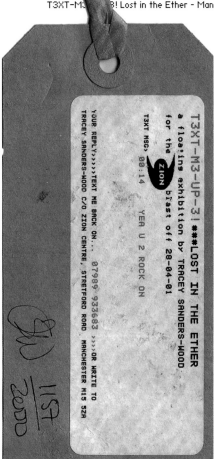

T3XT-M3-UP-3!***LOST IN THE ETHER
a floating exhibition by TRACEY SANDERS-WOOD
for the blast off 28-04-01

T3XT MSG› 00:14 YER U 2 ROCK ON

YOUR REPLY›››››TEXT ME BACK ON... 07989 933683 ››››OR WRITE TO
TRACEY SANDERS-WOOD C/O ZION CENTRE, STRETFORD ROAD MANCHESTER M15 5ZA

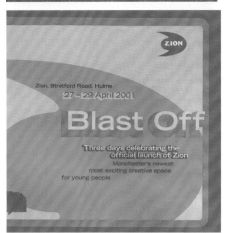

Zion, Stretford Road, Hulme
27 – 29 April 2001
Blast Off
"Three days celebrating the
official launch of Zion
Manchester's newest
most exciting creative space
for young people

When I approached The Zion with the idea of including my floating art exhibition in the *Blast-Off* launch festival, they really loved it and *T3xt-M3-Up-3!* was born. I invited a few London artists to help work on the project for the launch as there were so many costumes to make, even down to things like fifty pairs of silver trousers for the children forming one of the mythical beast characters. I underestimated the amount of hours and labour needed for the artwork, tagging, ribbons and helium-filling of the balloons for *T3xt-M3-Up-3!*

I spent the evening before the launch placing blank pink and white 'message received' cards along the walls of the room. Jaime came to film the event and we started that evening. A couple of us began by fixing recycled text message tags onto pink ribbons. The following day large bottles of helium gas were manned constantly as friends and colleagues turned up to help: this included part of the Elvis Jesus & Co. Couture team, as well as staff and students from Manchester Metropolitan University where I was lecturing. It was non-stop but we eventually reached our quota of 1,000 filled balloons. The recycled texts were bustling in nets as we manoeuvred them onto the old Victorian rooftop.

On the count of three, the balloons were released from the net. Within seconds, the mass of pink floating into the sky depicted the short life of the Japanese Sakura cherry blossom – the delicacy of the flower is a symbol for the fragility of life. The work I had created in the sky symbolised the transience of the blossoms, the extreme beauty and quick death that has often been associated with mortality. Cherry blossom was coming into bloom in the streets of Manchester and all across the UK. By nature's calendar, I knew my old neighbour's tree in their Moss Side garden would be budding into bloom, exactly a day before my

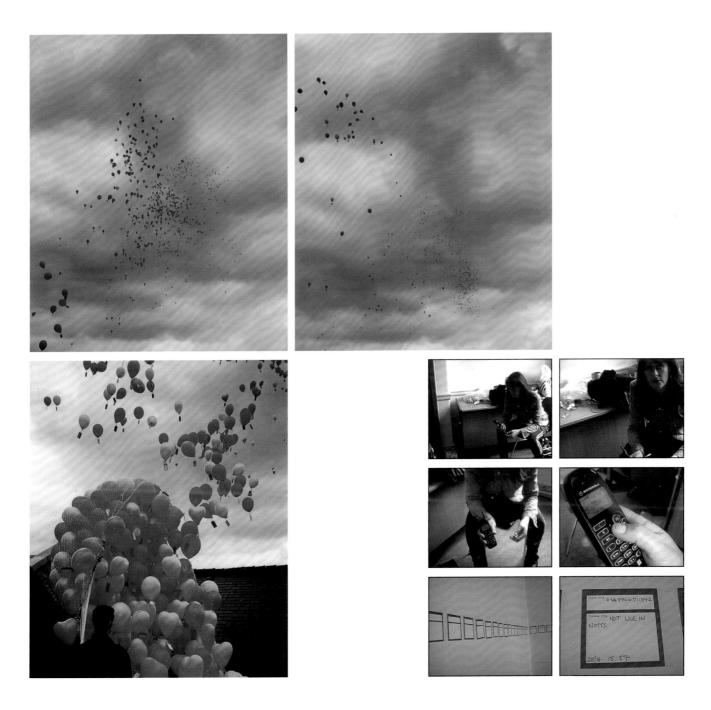

Kirsty Hawkshaw › TM
8 Apr 2010 05:34 AM
There are no blossoms in Osaka : however ULRICH and I found a small park on the roof of a high rise Building. Ulrich got arrested for smoking on the pavement and fined a thousand yen. I find the consumerism here very disturbing.

Kirsty Hawkshaw › TM
Yeah it's ridiculous that u cannot smoke on the street and I have to Breath in everybodys smoky shit in the club! I can't breath… Reminds me of the 80's

Kirsty Hawkshaw › TM
10 Apr 2010 08:21 AM
At last I found a beautiful park with sakura blossom galore and Tokyo crows. ULRICH and I saw some in a cage which was cruel. It's a lovely day. I really needed to see some trees today x

Tonight we r playing at this height at mada lounge amazing place

stepson's birthday. It did every year without fail – even if the MET office stated differently, saying spring was slow in coming or global warming had altered nature's plant cycles. My stepson would not be getting his usual fallen cherry blossom petals made into a birthday card by his brothers this year, as we had long since moved. I wondered if my balloons would fall like the blossom within a short space of each other or if they'd continue on longer journeys as I'd hoped for as a good omen influencing and directing me on leaving Manchester.

The procession had gone well. The costumes were amazing and the other launch activities had now gone into full swing. All the text words good, bad and indifferent would be riding high on the tail of the wind now. They were given a new freedom, repeating themselves and were no longer trying to punch and pull themselves out from the closed pages of the text journals I'd meticulously kept. They were also free from trying to jump down from the gallery walls, where some had admittedly made it into peoples minds or been poetically transformed coming out of peoples mouths. This however was different and I didn't know who the next audience were or what the outcome would be…

TM › Kirsty Hawkshaw
8 Apr 2010 10:34 AM
Hope all going brilliantly sorry to hear about Ulrich's fine scary!

19-04-01 18:29:08 … just leaving now on coach, back home 4 midnight… enjoy TWITS and I'll speak 2 u soon.jx… \ 20-04-01 20:44:42 … hi trace just finished filming a dance performance in an old/recently disused nuclear bunker in essex … \ 21-04-01 22:55:57 Sorry your text messaging service is currently unavailable due to insufficient funds. Please top up your account and try again \ 23-04-01 13:57:29 YAVOL! \ 22-04-01 09:10:34 HAST=WAST BUT MADE BASIC PAATERN - AVRIJ PAIR = NO MORE THAN ONE METRE FABRIC (MOR FR BIGA LESS FR SMALL) ALSO CORD FOR WAIST. GOT WORK AT FOUNDRY FRM HAF 10 \ 24-04-01 16:27:05 long tome nooo text but babes i been a busy guy & my head is mashed. need a holiday in da sun :) see ya soon krazy lady grr r r r r r r \ 26-04-01 18:46:01 WOT FUKTUP FUKEN FUK INVENTS FUKEN CUNTY SLIPPY SILVA STUF T SEDUCE US? CY TOMORO \ 26-04-01 19:10:13 im at ome - jus got in frm collyhurst - u ok? \ 27-04-01 11:19:35 iluvu+ireallywanttobewithunow ;-j \ 27-04-01 09:40:01 LOOKN FEELN LIKE BUFFY XTRAS (DRAINED N SLAYD) WIL B ON EVE TRAN.? WEN CHEAP AGEN? HATE SILVA (AL VAMPIRES DO) \ 27-04-01 20:43:17 HELP ME TXT ME BAK THE INVITE I DELETED IT \ 27-04-01 16:39:17 how many now \ 27-04-01 13:44:37 iluvu + iwontgoaway \ 28-04-01 13:45:17 + i wont go away \ 28-04-01 13:49:27 never \ 28-04-01 16:39:27 how many now \ 28-04-01 19:51:40 DID U GET HOLD OF THE FUCKWIT?

28-04-01 20:01:25 GAS IS HERE \ 29-04-01 13:10:27 T3XT-M3-UP-THR33 FLOATING SHOW LAUNCHES FROM THE FOUNDRY SUNDAY 3PM 1000 PINK BALLOONS SMS T3XTme BAX via t.TRCY SANDERSWOOD+FiLMmeUP V Jaime RORY LUCYE \ 29-04-01 13:12:47 frm the guardian pls, stop sendg msgs2 this no, i am not linda, i hv not slept w/yr sis + i wd nvr call any 1's ma a slag. Gd luk w/viag. luv, yr wrong no. xxx guardian \ 29-04-01 13:2:47 DID MY WORDS HIT THE SKY? \ 29-04-01 15:39:26 hi trace, whats the latest on t3xt me up 3? ...jx \ 30-04-01 17:15:39 ...wow thats great...whats the furthest foundry balloon text so far?... \ 30-04-01 17:08:25 ...wow thats on the south coast 20 odd miles from france what time did that come in? \ 30-04-01 18:09:49 any new msgs? \ 30-04-01 19:05:59 im hungry \ 30-04-01 22:32:08 DO U WANT ANYTHING FROM PARIS? \ 10-52-34 10:00:10 Excellent to the ballons and to you coming down. I need a blast of you! : -) \ 01-05-01 14:02:57 ...hi trace, whats the latest on the text replies. Jaime x. \ 01-05-01 16:17:36 ... hi trace, how many replies so far & furthest distance.. jx \ 01-05-01 20:43:57 agressively vigorously desending... \ 02-05-01 12:15:30 LUVU . . . CANT CALL, THIS MSG USES M LST PENNIES \ 02-05-01 17:45:31 DO I HAVE A BEER? \ 04-05-01 07:26:21 YES SEND MORE DETAILS 079799****

We enjoyed the rest of the Manchester launch and messages had already been texted through to my new Orange SIM card. It was like the blossom had started to fall, dismembered from the buds' epicentre, whipped up by the forked tails of the wind to be scattered into the yet unknown. It was the following morning and Jaime and I set off for the next instalment of *T3xt-M3-Up-3!* and the London branch of it at the Foundry.

On the train down, my phone continued to beep with messages:

29-04-01 13:15
**-FOUND YER BALLOON
IN A FIELD OF BARLEY!
& I M SUCH A LUCKY MAN!**

I kept swapping the SIM cards and messages were pinging in throughout the journey. Jonathan sent a text invitation for that afternoon's balloon launch in the Foundry:

29-04-01 13:10:27
**T3XT-M3-UP-THR33
FLOATING SHOW LAUNCHES
FROM THE FOUNDRY SUNDAY
3PM 1000 PINK BALLOONS
SMS T3XTme BAX via t.TRCY
SANDERSWOOD+FiLMmeUP
V Jaime RORY LUCYE**

29-04-01 13:2:47
**Pls, stop sendg msgs2ths
no, i am not linda,
I hv not slept w/yr sis,
+i wd nvr call any1's ma a slag.
Gd luk w/viag.
Luv, yr wrong no. xxx**

I thought this was fantastic. Showing that last message to Jaime I explained how it came from the Guardian newspaper which had realised a new creative element in the text messaging revolution. The brief was to write a poem within the constraints of the 160 characters on the mobile phone screen. I had heard about it a

TM > Ellie Owen
12 Apr 2010 06:28 PM
An hour I dragged my shopping out for in Asda Merthyr & nothing…Zilch… I almost resorted to 'do you know who I am when people were walking past the veg area fresh from coming in from the carpark… A 'non Svengali pap day' should go in my diary. Tomorrow I will do tescos Ystrad…!

Ellie Owen > TM
13 Apr 2010 06:27 AM
Haha-we'll have to create a hat for you that says don.t you know who I am! Heading off to Vienna. Back this evening. Am loving the fact that it.s now light for these hideously early starts! Xx

TM > Bill Drummond
13 Apr 2010 06:36 AM
For 2 nights on the run you have dominated my dreams. Last night I was over half an hour late to meet you in Shoreditch house which had a different form in dream. You were dressed up & had a wig on. When you saw me come in you jumped a barrier switched all the music off & played the intro to the beginning of 70's radio 1 chart show with presenters voice of then. Then stopped it & jumped back b4 bouncers cud get u/ recognise you, u changed back discarding wig & covering clothing…

Bill Drummond > TM
That sounds like me

Bill Drummond > TM
That was a photo I was trying to send you yesterday of my lunch in response to your curry and chips one.

few weeks ago and started telling everyone. At this point I also became interested in the huge differences in the writing systems and structure that made up over 6,000 of the world's languages. I began to realise that phonetic-based languages would develop far quicker textually. I liked the idea in the 1990's when Japanese girls devised number-strings as codes for their pagers known as 'pocket bells' and how this, in text messaging, was progressing into 'girl-talk' – a mixture of Japanese symbols, numerals and emoticons (facial expressions pictorially represented by punctuation and letters). This would be another book.

06-04-01 17:14:46
HEY DUDE BACK ON LINE TEXT ME UP GOING GLOBAL THEN?

08-04-01 13:41:32
NOT SURE I KNOW ANY CLEAN POETRY

08-04-01 18:57:19
OK I'LL DO IT IN YOUR NAME + SEND A DISGUSTING ONE!

08-04-01 19:06:20
ALL THE MORE REASON ZO DO IT LET ME KNOW WHEN YOUR IN IT

It took me a week or so to sign up via text

21-04-01 14:02:24
The Guardian Thx 4 entrng, votin strts 2 mrw We send 1 pom a day @ 1pm 4 a wk Rply wth vote out of 10 (10=v.gd - 1=v.bd) U must rply 2 gt all poems C site 4 info Guardian

And after receiving the above, I enjoyed receiving a selection of the selected poems to vote on:

23-04-01 13:14:00
bed, u have seen some action, doors, some slam. Landlord, u may remove every chip, scuff, stain: who knows what reflections old mirrors project in the dark

26-04-01 13:26:56
WATCH DOG Watch me, or i'll be prowling my way round your house of a body: licking at windows, stealing through doors, trying beds out for size.

27-04-01 [13:07:43]
txtin iz messin,
mi headn'me englis,
try2rite essays,
they all come out txtis.
gran not plsed w/letters shes getn,
swears i wrote better
b4 comin2uni.
&she's african

Then the day before The Zion launch, *Sheffield* bounced into my phone…

28-04-01 [13-07-17]
SHEFFIELD
Sun on maisonette windows
sends speed-camera flashes
tinting through tram cables
startling drivers
dragging rain-waterfalls in their wheels
I drive on

It culminated in 7,500 entries from 4,700 mobile phones. The judges, Justine Jordan (editor of *Guardian Unlimited*), Ursula Askham Fanthorpe (poet published as UA Fanthorpe) and Peter Sansom (poet), were given one hundred of the poems selected from the overall total to judge from, choosing seven to be texted out to participating phones over a seven day period. It later emerged that first prize was won by Hetty Hughes with *Textin is messin'*, second prize was *Sheffield* by Steve Kilgallon and third was my favourite: *Pls, stop sendg msgs2ths* by Charlotte Fortune. There was also a special prize awarded to Julia Bird for the most creative use of SMS 'shorthand' in a poem.

14: a txt msg pom.
his is r bunsn brnr bl%
his hr lyk fe filings
W/ac/dc going thru.
I sit by him in kemistry,
It splits my @oms
wen he :-) @ me.

Translated:

14: a text message poem
His eyes are bunsen burner blue,
His hair like iron filings
With AC/DC going through.
I sit by him in chemistry,
It splits my atoms
When he smiles at me

Peter Sansom commented on the judging process using an example of the

TM > Bill Drummond
13 Apr 2010 06:45 AM
That puts me to shame doesn't it! But today is a grape, melon & cheese day & I become a vegetarian for a minimum of a year. What is the darker orange stuff on the plate, not the carrot?

Bill Drummond > TM
Carrots, radishes, red pepper, olives, cherry tomatoes & cucumber. Take your pick. And the spunk as an anti aging skin cream stuff I was telling you about is true. Anyway enough of the idle banter and back to work. These books will not write themselves.

TM > Bill Drummond
I've not got out of bed yet. I will at 7am I have the boiler men coming around to drain the system & solder a leak. I like that… 'these books will not write themselves…' text me as you go x

TM > Ellie Owen
13 April 2010 06:49 AM
Have you set off yet?

Ellie Owen > TM
Just going through security! Taking my boots off as we text!

TM > Ellie Owen
Haha! Have a nice Horney & get lots done on the flight & don't forget pic any point you can. It'll be a break from the boiler men from Tredegar. Last time I saw them one was going to watch a pirate copy of 'a bit of tom jones' as Jonathan said it'd not been released on DVD then x

Ellie Owen > TM
I see your predictive text picks up on the word "horny" more readily than "journey"! Goes to show how much usage each word gets ;) will try and take a photo but it may be of an office block! Hopr the boiler man liked a bit of Tom. Text you when I arrive xx

TM > Ellie Owen
Ha! Ok enjoy the breakfast if there is one…

Ellie Owen > TM
Fingers crossed! Xx

Bill Drummond > TM
13 Apr 2010 07:07 AM
I have F from 9am and then have to do a BBC 6 Music interview at some time early afternoon.

TM > Bill Drummond
Enjoy both xx

TM > Hel Elvis Jesus
13 April 2010 11:53 PM
How's everything going love?

Viv Albertine > TM
14 April 2010 10:57 AM
Hi Tracey great to see you unexpectedly at Laugharne! Be lovely to come on the show sometime. Here is Will Hodgkins email. He is djing at Tobys Je Thames soon. Email address Xxxx

TM > Viv Albertine
Thanks that's great. I quite enjoyed his concept. Its something like Bill is working on. It was lovely bumping into you to. When I am back in London I will text/caller the show & it'd be nice to go out for a long lunch etc after x

Dunst Chumba > TM
14 April 2010 01:44 PM
T, still away but done some more writing. Something about you (!) and something about my text me up piece and gethyn (who's the person who unbeknownst to him became bono.) having an amazing time freeloading on the back of daisy's work. Hope you're fine n dandy! xxx

TM > Dunst Chumba
That is brilliant… I have just been putting bedining texts in about dr.Dunst (daisy) glad you're all having a brilliant time. It is something the children will never ever forget growing up. U used fine'n'dandy in 2001 xx

shortest poem which didn't reach the final seven as it parodied a Philip Larkin line and apparently became a catchphrase in Peter's house. 'They phone you up, your mum and dad,' he explained, 'It is post-modern (though admittedly isn't bollocks), because of the self-referentiality, recasting (and therefore commenting on) a famous line of poetry while at the same time talking about mobiles, or at any rate about a generation independent but always because of the phone being in shouting distance.'

UA Fanthorpe's favourite unselected poem was also *They phone you up, your mum and dad*. Sansom described how a lot of Haiku poems were submitted, explaining how in Chinese, Haikus use neighbouring words to alter each other's meanings, 'allowing texts to open in the mind like paper flowers in a tumbler of water.' I thought that this was similar to what had happened on a larger scale with myself, Pete Doherty, Geo and others at *Text-Me-Up-Too!* where randomly juxtaposed text message replies were read out in date received sequence. I would develop this further in new shows, events and written format – in some, keeping to the Haiku character format. On the train my conversation paused for a while with Jaime as I wondered why Geo sent me a text message which read :

09:14:15
cunt ? C .

I should have texted him back immediately and asked him. I didn't know him well so it would not be a form of endearment as it is with closer friends. I got my camera out and started taking photos of Jaime and the text message journal in which I'd be saving all my *T3xt-M3-Up-3!* received messages. I started changing my SIM cards over frequently as texts started coming in from where some balloons had landed.

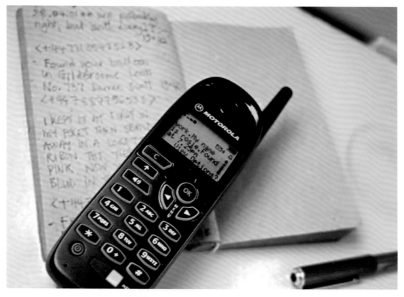

We arrived in London and headed straight for the Foundry. The helium gas was propped up near the bar waiting for me to start filling another thousand balloons. The prospect of doing this again seemed daunting with my fingers and hands bruised from the day before, but the fact that the tags were already made up with an individual text message on each made me feel slightly more excited about the finished vision.

Quite a few people were gathered at the Foundry, readying themselves for the traditional Sunday poetry night. The Wormlady was experimenting with a new all-in-one hand puppet with fingers forming worms. The Wormlady originally trained and practised as a barrister, but then circumstances forced her to stop. She dedicated a number of years of her life to the earthworm which she expressed in the form of poetry and radio appearances at the Foundry.

Fortunately, there were several people in the bar area on hand to help me and we started filling the balloons. There were new people in the bar, Bill Dwyer and his partner Eileen who were immediately roped into helping with the event and completely fell in love with the place. Bill went on to have some excellent exhibitions in the Foundry until his untimely death a few years later. Foundry regular Kimble made an appearance with Liv whose parents had a pub across the road. Pete, Carl and the other Libertines came in. They were all suited and booted for their first Shoreditch performance, which Pete had been really busy organising. Both Pete and Carl were hosting the regular Foundry poetry nights around this period for a couple of years. I was so pleased that this was happening tonight and we could go over to see them after the balloon launch. Pete had mentioned several times that he had wanted me to manage them. He'd met

Bill Drummond > TM
14 Apr 2010 07:11 PM
B and T are laying into me about the pink suit. This one is going to run.

TM > Bill Drummond
Just tell them it will be uber stylish & I wouldn't let you go out looking daft anywhere with me & we'll try & get into the September vogue issue… Surely that should suffice…?

TM > Bill Drummond
Or it might make things worse for you… I hope your not having second thoughts…?

Bill Drummond > TM
I have a feeling that B and T may never speak to you again.

TM > Bill Drummond
Oh no…Really…? Or is this you trying to back out blaming your children?

Bill Drummond > TM
You ask them. I am not backing out. Just letting you know. This is a big thing. They have even dragged S into it.

TM > Bill Drummond
What did S say?

Bill Drummond > TM
Wasting money that could be spent on B, T & F and generally being a shallow attention seeker with multiple late mid life crisis syndrome. Or something.

TM > Bill Drummond
But it's art… I don't want to cause any trouble with your family…!! Shall we compromise? I will photograph you in a pink dress for the book & include all the texts with it & you can wear whatever you like to the launch then. What do you think?

Bill Drummond > TM
I am now back home but F and I have gone to bed. We went to see Laurie Anderson at Barbican. Of course the girls will talk to you. It's best we do not mention it for some time. It will blow over. Talk in the morning.

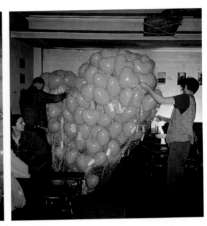

Porno Paul > TM
14 Apr 2010 11.13 PM
23:03 hrs. Location : Close proximity to a drain, just off the Farringdon road. Currently wearing a leather apron, and snorting lines of Octopus granules.'

TM > Porno Paul
That is more than an utterly truly wonderful text which makes me happy to be alive… Soon we will start praying to 'The Textese Church of Porno Paul…' & all his texting glory. Ah!Men

TM > Porno Paul
I have just put your last text up as my facebook status… Stating from you of course…

Porno Paul > TM
Splendid!

TM > Porno Paul
Viva 'The Textese Church of Porno Paul… & all who worship in it…!

Porno Paul > TM
Praise be!

some of my ex-students who were heavily involved in making music videos for some well known chart bands and knew of my links with Tony Wilson in Manchester. I'd told him tales of my band-managing experiences including a Soca band from Moss Side. I think he wanted this because I was really into their music and thought they had the potential to go far. I loved their music, style, personalities and creativity. I wished I could have done it, but I kept declining as my boys were too young and if they did reach the potential I thought they deserved then I'd have to go on tour with them and so on. I did think about it, but at the end of the day I think I probably would have been shit at it. It was good for them that I'd declined as they soon rocketed into the charts, were signed up to a deal and were never out of music and popular culture magazines.

Tam Dean Burn turned up at the bar for the Libertines gig. He started to help with the job in hand, organising the pink balloons. Rod Stanley, a budding journalist appeared who wanted to do a story on my *Text-Me-Up!* and partake in the exhibition/launch. With Nicholas Bloomfield joining in we started to get a great production line going.

As the balloons amassed in the nets, Tam got into the middle of them to sort out any tangles and loosen up the balloons from twisted tags and ties. The Libertines helped Rod and Tam to manoeuvre the nets outside. Lars Erikson who lived with Jenny on the top floor of the Foundry found his position on the roof to start filming the rise of the balloons with his Super 8 camera. People took their positions

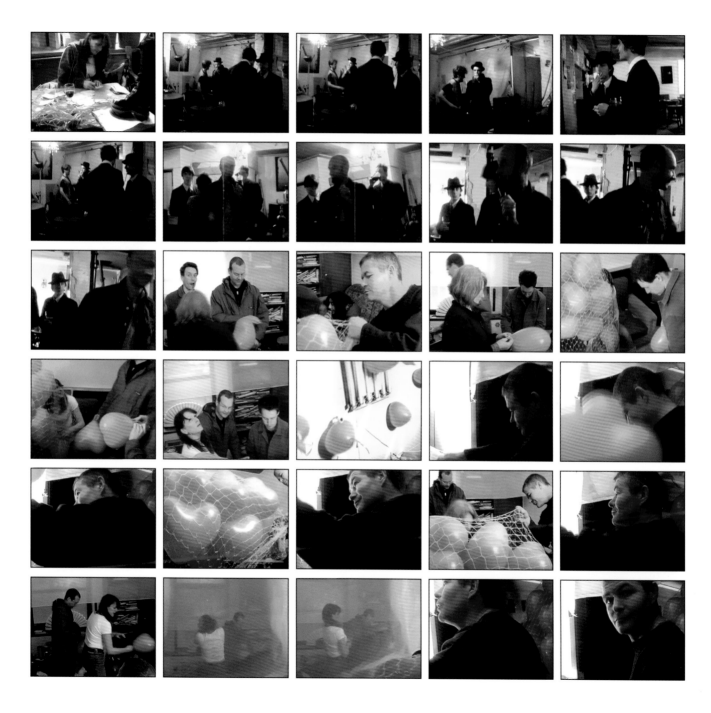

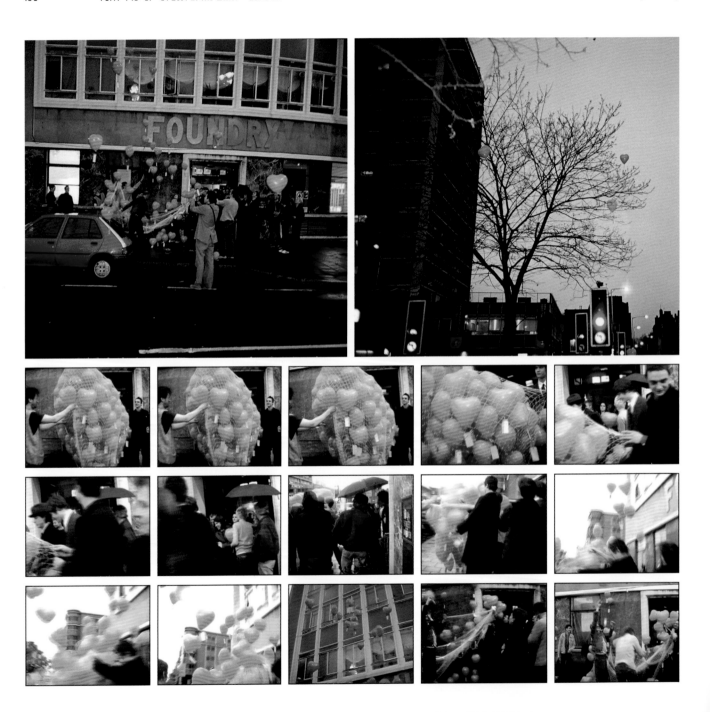

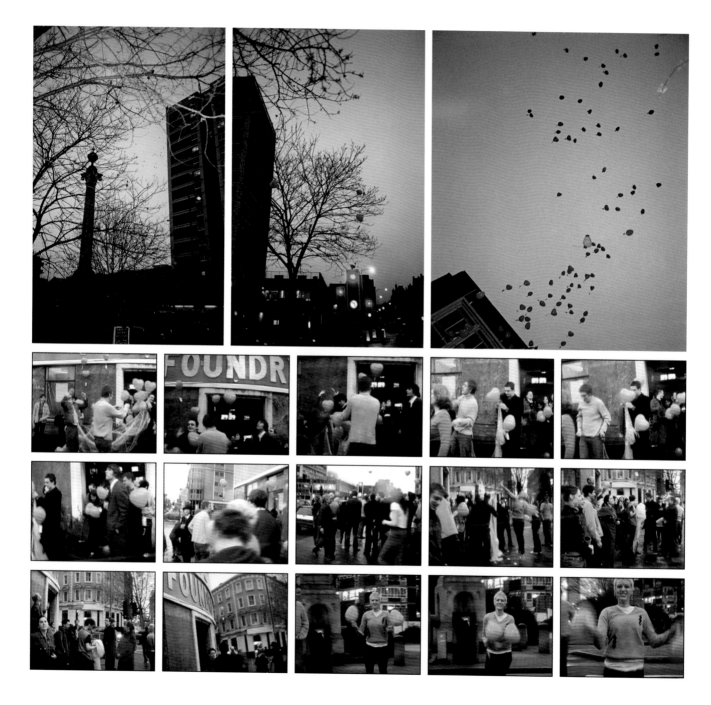

G > TM
16 Apr 2010 09:51AM

Hi Trace, had a fantastic few days with the boys, i so enjoy their company and conversation - they're such good lads, like grown up versions of when they were little :-) hope your mum's on the mend and her op went well and you're good too - av a catch up sooneh-xg

TM > G
16 Apr 2010 09:57AM

Glad you all had a fantastic time. Ha! Yes they don't stop do they they?! They are still like sponges absorbing everything & then questioning it all!! My mum on the mend, early days yet, but she's a strong woman. Catch up with you next time you meet up with the boys x

TM > G
Ha! Or if you meant phone I'm glued to it...

G > TM
Ha - i did ! Off gardening now, so catch u later

Porno Paul > TM
16 Apr 2010 18:26PM

There are people waiting to get on aeroplanes. Can't see any evidence of it whatsoever. Sounds like a load of old bunkum to me.I think it was just somebody's hoover backfiring. Volcano = Schmolcano.

Bill Drummond > TM
16 Apr 2010 19:00 PM

Can you phone me please.

Bill Drummond > TM
I tried to phone you.

TM > Bill Drummond
Sorry was doing the NPR American radio thing. Shall I phone you now?

TM > Bill Drummond
If you do go out I want photos... Please. You have to do a 'canceled poster' for the performance it is brilliant & please could I have one? Drive down for a night out tomorrow?

Bill Drummond > TM
I have the children tomorrow night. Or I would be half way there already. Or something.

on the ground outside the Foundry with each of The Libertines taking a section of the balloon-filled net and with a countdown from Pete, the balloons were left to float for freedom. Again, the pink cherry blossom-like explosion complemented another beautiful blue sky that day. The same Orange mobile phone text response number was on the cards along with information about the Zion launch and of course the recycled text message. When the last balloon was lost in the ether we went back into the Foundry for a drink. The Libertines were fresh-faced and adrenalin-fuelled in anticipation of their first gig at Charlie Wright's. As soon as we arrived to see them I changed my SIM cards over ready to receive any text messages from balloons that may have started landing around London. The gig was rocking and the texts pinged in throughout the evening. The first texts that came through were beautiful...

29/4/01 20:23
WHAT A FANTASTIC IDEA STAY HIGH, SPACEMAN SAM

29/4/01 20:27
ILUVUXTDBX

29/4/01 20:34
A painter paints on canvas, a musician paints on silence, u paint on air! from across the road chloe le fay

29/4/01 20.34
FLOATIN HEART SEEN BY AN OGRE

29/4/01 20:35
Truth shines thru but fades like pink balloons in a grey sky xxx

29/4/01 20:40
MANAGING. Smiles. Luvya T. U wil B xxx

Several of the texts received introduced me to people who were to play a large part in the Foundry community for a period of time. Tam Dean Burn was one of the people who started working behind the bar for a while, in between his TV and theatre roles. One particular evening was hilarious. He started a shift at the Foundry, and the previous night he had been in a major primetime drama where his character was a barman who was also a serial murderer. Many of the people who came into the Foundry that night had watched it and some really freaked out, confusing fact and TV fiction.

T3xt-M3-Up-3! gave me an introduction to so many new people through the recycled texts.

30/4/01 02:09
 - JUST found your balloon in Highbury fields at about 3am. Was feeling confused and lost; it cheered me up. Thank you.

30/04/01 15:56
I would like to hear the persons voice of the heart that flew in my front door

30/4/01 19:55
baloon 1115.2000 floating safe & well on the outer regions cu soon! big green al

02/05/01 20:33
-Earth calling mother madness.Hello i ve found somethin of yours!

02/05/01 22:50
-HEY TRACEY RECEIVED ONE OF UR LOVELY B LOONS JUST 2 LET U NO IT WAS GOT BY OLDFIELD FROM A GUY ON OUR 1ST DATE HE THINKS ITS DESTINY

Currently as I write, disruption has affected hundreds of thousands of travellers since Wednesday when Iceland's *Eyjafjallajökull* volcano began erupting for the second time in a month. This is 14th April 2010. As I stare out to a clear sky thinking of the balloons, I start to wonder again who owns the airspace above our heads in the sky.

TM > Aaj
17 Apr 2010 06:25 PM
Have you photographed the sky today? No white aeroplane lines it looks surreal...

TM > Aaj
Can you email me the pics tonight when you get in xxx I can't believe that as I've just finished balloon chapter...

xluvux

TM > Aaj
It doesn't matter... it was there, it's a love thing x

Aaj > TM
Taking pictures of a cloudless sky. A solitary pink balloon just floated by

Aaj > TM
Its probably smaller than a pixel

02-05-01 23:02:23 Good talking. Sorry I had to rush off – live miles away. Am i being recorded? :) \ 04-05-01 09:45:17 WAT WILL I HAVE TO DO? \ 04-05-01 22:02:18 I found the balloon just wandering wondering what art thing is about \ 06-05-01 01:24:07 it's a hard life being a knob – u have 1 eye that's blind, 2 neighbours that are nuts, another is an arsehole and friends are cunts)powered by lycos. co.uk) \ 06-05-01 12:50:22 I LOVE U PINKEY \ 06-05-01 16:17:37 Yo_ uR THe BeSTI PiNKe ! \ 06-05-01 18:10:02 NO SNOW DROPS AND DEATH AT SAME TIME SNOWBALL \ 07-05-01 22:55:04 im coming to get you \ 09-05-01 00:00:00 I'm in the outdoor cactus bar in Singapore airport. It's 7pm here and there is a beautiful blood red sunset. Which foretells me much beauty and adventure, me thinks \ 10-05-01 14:07:30 HOW RU LUKE HERE. JUST THOUGHT I WOULD SAY HELLO 2U. LUKEX PEACE 2U. \ 10-05-01 18:42:04 Hope you enjoyed dowlais top. Are you travelling back now. If so gaze good journey and see you soon 07977******* \ 10-05-01 23:16:55 FKD UP CANT HELP IT SORRY. B ALRIGHT \ 10-05-01 17:37:19 I'm having a beer now!! \ 11-05-01 21:56:31 GOeD _NIGHT LOVE U ******* xxx XXXXXXX XXXX xxxxxxxxxxxxxxI LOVE U MWA, MWA, MWA, MISS U BYE SEE YOU MONDAY PHONE ME LATER BYE XXXXXXXX \ 13-05-01 11:48:20 GOING TO BLACKPOOL

05-05-01 21:29:27 Turn your phone upside down now 370HSSV 0773H

05-05-01 21:35:27 HOLD IT! SMILE!! *CLICK* <>" .. "(> ((..)) PICTURE OF U... U UGLY BASTARD PASS IT ON

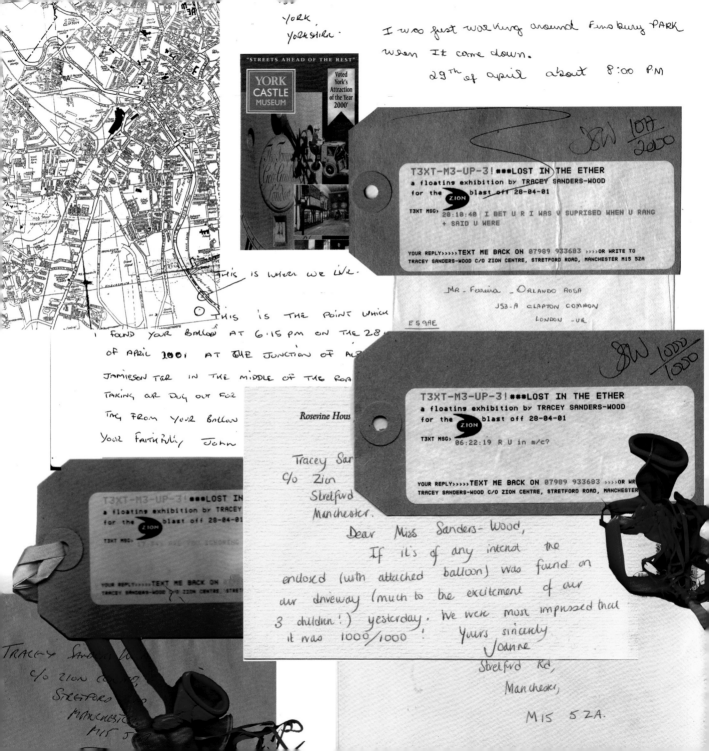

YORK.
YORKSHIRE.

I was fust walking around Finsbury PARK
when It came down.
29th of april about 8:00 P.M

"STREETS AHEAD OF THE REST"

YORK CASTLE MUSEUM

Voted York's Attraction of the Year 2000

JSW 1011/2000

T3XT-M3-UP-3! ###LOST IN THE ETHER
a floating exhibition by TRACEY SANDERS-WOOD
for the ZION blast off 28-04-01

T3XT MSG> 20:10:40 I BET U R I WAS V SUPRISED WHEN U RANG + SAID U WERE

YOUR REPLY>>>>> TEXT ME BACK ON 07989 933683 >>>>OR WRITE TO
TRACEY SANDERS-WOOD C/O ZION CENTRE, STRETFORD ROAD, MANCHESTER M15 5ZA

MR. Ferreira _ ORLANDO ROSA
JS3-A CLAPTON COMMON
LONDON -UK
E 5 9AE

THIS IS WHERE WE LIVE.

○ THIS IS THE POINT WHICH
I FOUND YOUR BALLOON AT 6:15 PM ON THE 28
OF APRIL 2001 AT THE JUNCTION OF AL
JAMIESON TER IN THE MIDDLE OF THE ROA
TAKING OUR DOG OUT FOR
TAG FROM YOUR BALLOON
YOUR FAITHFULLY John

JSW 1000/1000

T3XT-M3-UP-3! ###LOST IN THE ETHER
a floating exhibition by TRACEY SANDERS-WOOD
for the ZION blast off 28-04-01

T3XT MSG> 06:22:19 R U in m/c?

YOUR REPLY>>>>> TEXT ME BACK ON 07989 933683 >>>>OR WR
TRACEY SANDERS-WOOD C/O ZION CENTRE, STRETFORD ROAD, MANCHESTER

Rosevine House

Tracey Sar
C/o Zion
Stretford
Manchester.

Dear Miss Sanders-Wood,
If it's of any interest the
enclosed (with attached balloon) was found on
our driveway (much to the excitement of our
3 children!) yesterday. We were most impressed that
it was 1000/1000! Yours sincerely
Joanne
Stretford Rd,
Manchester,
M15 5ZA.

T3XT-M3-UP-3! ###LOST IN
a floating exhibition by TRACEY
for the ZION blast off 28-04-0

TXT MSG>

YOUR REPLY>>>>> TEXT ME BACK ON
TRACEY SANDERS-WOOD C/O ZION CENTRE, STRET

TRACEY Sanders W
C/o ZION CEN
STRETFORD
MANCHESTE
M15 5

2ND

Tracey Sanders-Wood

T3XT-M3-UP-31 Wadsworth Court,
ZION Blast off 28-04-01 Pellon Lane,
Halifax
W. Yorks
HX1 4PQ

Dear Tracey Sanders-Wood,
 Your balloon has
ended up here. I thought you
would like to know.
 A resident
 (Anchor Sheltered Housing)

Oldham **NHS**
NHS Trust

☐ Please complete attached and return to me
☐ Please let me have your comments
☐ For your action
☐ Copy as requested
☐ For your information
☐ Plea[se]

Found in the
hospital grounds

The Royal Oldham Hospital
Rochdale Road
Oldham OL1 2JH

Telephone: 0161 624 0420
Facsimile:

Direct Line:........................

T3XT-M3-UP-3! ###LOST IN THE ETHER
a floating exhibition by TRACEY SANDERS-WOOD
for the ZION blast off 28-04-01

T3XT MSG> 03:05:49 TRIED TO RING U HEARD A BIT PHONES R
MAD C U TOM AT 6.15 HARDYS WELL OK?

YOUR REPLY>>>>>TEXT ME BACK ON 07989 933683 >>>WRITE TO
TRACEY SANDERS-WOOD C/O ZION CENTRE

Found in a field on [M]e
at Milestone Farm Seamer
3 miles from Scarborough
Y.N.S

HARINGEY COUNCIL

Environmental Services
Recreation Division
Contract House, Park View Road, Tottenham, London N17 9AY
Tel: 0208 489 Fax: 0208 489 5642
- 348-6005

2/5/200

Dear Tracey — your balloon arrived on 30/4/2001 - still partially inflated! Do we
...? We are a small nature reserve called Railway Fields
... Park in Haringey (N. London) where was the balloon l...

T3XT-M3-UP-3! ###LOST IN THE ETHER
a floating exhibition by TRACEY SANDERS-WOOD
for the ZION blast off 28-04-01

T3XT MSG> 00:36> CHACHI BANT GIBBLE BREATH

YOUR REPLY>>>>>TEXT ME BACK ON 07989 933683 >>>OR WRITE TO
TRACEY SANDERS-WOOD C/O ZION CENTRE, STRETFORD ROAD, MANCHESTER M15 5ZA

SW 528/1000

T3XT-M3-UP-3! ###LOST IN THE ETHER
a floating exhibition by TRACEY SANDERS-WOOD
for the ZION blast off 28-04-01

T3XT MSG> 00:14 YEA U 2 ROCK ON

YOUR REPLY>>>>>TEXT ME BACK ON... 07989 933683 >>>OR WRITE TO
TRACEY SANDERS-WOOD C/O ZION CENTRE, STRETFORD ROAD, MANCHESTER M15 5ZA

SW 1157/1000

T3XT-M3-UP-3! ###LOST IN THE ETHER
a floating exhibition by TRACEY SANDERS-WOOD
for the ZION blast off: 28-04-01
T3XT MSG> 16:27:** R AGE

YOUR REPLY>>>>>TEXT ME BACK ON 07989 933683 >>>>OR WRITE TO
TRACEY SANDERS-WOOD C/O ZION CENTRE, STRETFORD ROAD, MANCHESTER M15 5ZA

SW 459/1000

May 3 2001

Dear Tracey,

The pink, or was it cerise, balloon attached to the enclosed label f_____ get _____ "Ether"; if that was ever what it was intended to do!!

~~The balloon came to rest in a small stream running through a Local Nature R_____ — Eccup Whin — for which I_____~~ am general factotum, warden etc. It was found at around 0640hrs on May 2 2____, b___ can_____ had not arrived on a previous day.

Eccup Whin is in North Leeds and close to Eccup reservoir, which I think you w_____ motoring atlas that covers this area.

I trust you enjoyed your exhibition and that all went well.

Regards

© I kept it at first in my poket. Then okt it away in a poket. The ribon that tied it was pink. (NOW so is th Blud in th sink)

SW 922 TOUD

T3XT-M3-UP-3! ###LOST IN THE ETHER
a floating exhibition by TRACEY SANDERS-WOOD
for the ZION blast off 28-04-01
T3___ MSG> 01:16:40 LUV U TAKE CARE OF U

YOUR REPLY>>>>>TEXT ME BACK ON 07989 933683 >>>>OR WRI___
TRACEY SANDERS-WOOD C/O ZION CENTRE, STRETFORD ROAD, MANCHESTER___

Dear Tracey

__ts you can see your
bo____ ___as landed in North Yorkshire!!
Our house is attached to a field
__urti 3 acres, and my father-in-law
__as cutting the field today and came
across your deflated balloon!

Please be kind enough to drop me
a line and explain why you decided
to do this.

Hoping to hear from you
P.S. Hope you have had luck elsewhere.

YORK
is a mechanised
letter office
PLEASE
USE POSTCODES

Tracy Sanders-Wood

TRACEY SANDERS-WOOD
C/____ ___ CENTRE

T3XT-M3-UP-3! ###LOST IN THE ETHER
a floating exhibition by TRACEY SANDERS-WOOD
for the ZION blast off 28-04-01
T3XT MSG> 21:06:07 I THINK SO NEED YOUR ADVICE

YOUR REPLY>>>>>TEXT ME BACK ON 07989 933683 >>>>OR WRITE TO
TRACEY SANDERS-WOOD C/O ZION CENTRE, STRETFORD ROAD, MANCHESTER M15 5ZA

SW 66/1000

19-05-01 14:03:12 Mary had a smelly minge with pubes as dark as charcoal. So most men go round the back and stick it up her arsehole! \ 22-05-01 16:09:18 BOARD IN BRADFORD PLEASE GIVE ME SOMETHING TO LOOK FORWARD TO THANKYOU P.S. MY NAME IS TONY BYE \ 25-05-01 10:51:03 Sorry was on blower, in trouble with taxman, buz u L8rs. ta for yor words – u r special taffy. x \ 25-05-01 14:52:02 I've just had one of those amazing "sugar overload" puddings like u made when I came 2 urs the other day. I feel totally fat, yet happy, ain't life great?!!! \ 25-05-01 15:39:08 Sarah is playing Ukelele with Kiri te Kanawe \ 25-05-01 16:04:26 tommy is playing banjo + singing \ 25-05-01 16:10:59 I'd chill & think bollo x 4 as long as possible until real life beakons, I'm bac in that HELL HOLE called Kwik save this weekend... I can't wait !!! \ 30-05-01 00:19:06 MENTAL, MENTAL + MENTAL = TEL U WEN I CU, x \ 01-06-01 13:55:03 Are you Veronica? \ 01-06-01 19:28:51 Think i have a mag to take it. Hope all is going well: Will be in touch soon. Rod. \ 04-06-01 12:41:47 Veronica = held the shroud girl. Burt x \ 06-06-01 16:52:35 HAPPY BIRTHDAY IN NORWAY WITH TTF \ 07-06-01 19:11:03 Hi darlin! Kwik save were having non of it. I'm rostered on my own on Sat morn. We'll have to have a night out in Manchester. I'm fucking gutted! Have a great time xx \ 08-06-01 13:11:09 Use one 2 one to join in THE JOY. OF. TEXT this Saturday 9th June on BBC1 from 7.25pm. Text your jokes & thoughts to 07949 100 100 & you may see them live on TV! \ 11-06-01 12:52:00 STUDIO, THOUGHTFUL. TOUCHED DOWN 'BOUT 1.30am hope you filled with love + friendship coz u the queen of hearts + we the fireflys. Big luv sis +xx \ 11-06-01 12:55:17 Bouquet de monmartre * tel? * ruth? *just about to board a plane* Kx \ 11-06-01 13:43:01 Ooooooozzzzzin with it... lets do somthin this week x Answer is YES

Several weeks had passed since the balloons were launched and replies were still coming in from the recycled text messages. One of the text messages was actually retrieved from a sewage works, another from a nature reserve and the list continues...

Dear Tracey,
The pink, or was it cerise, balloon attached to the enclosed label failed to get itself 'Lost In The Ether' if that was ever what it was intended to do!!

The balloon came to rest in a small stream running through a Local Nature Reserve – Eccup Whin – for which I am general factotum, warden etc. It was found at around 0640hrs on 2nd May 2001, but I cannot guarantee that it had not arrived on a previous day.

Eccup Whin is in North Leeds and close to Eccup reservoir, which I think you would find on almost any motoring atlas that covers this area.

I trust you enjoyed your exhibition and that all went well.

Regards KC

I'd received hundreds of replies by letter, text and phone call. The Manchester launch had been the most successful, and the majority of the balloons had journeyed safely over the Pennines. They were carried on the tail of a Westerly wind when they popped and began scattering like seeds. I wish I had put seeds in them, but I would save that for another project. The West Yorkshire area was the main hit as they landed in areas including York, Halifax, Malton, Pool-in-Wharfedale, Scarborough and Leeds, amongst other places. The London ones were around Stoke Newington, Tottenham and Finsbury Park.

There was as much interest – if not more – in the recycled text landings as there had been in the balloon launches. For the last couple of weeks, Daisy and I (who share the same birthday month) had been busy plotting and planning a joint birthday party in June at the Foundry. Daisy had fallen in love with Dunstan Bruce, the lead singer on the *Tubthumping* track with Chumbawumba. The song was quite close to my heart, often playing on my internal jukebox.

'*We'll be singing when we're winning, we'll be singing... I get knocked down, but I get up again, you're never gonna keep me down... she takes a whiskey drink, she takes a vodka drink.... she sings the songs that remind her of the good times...*' This was the only Chumbawumba song I was familiar with, unlike my Mancunian peers. There was reason behind this. One of my friends had been highly politicised when he was younger and imprisoned for a number

TM > Sarah Thompson
17 Apr 2010 06.34 PM
What was the name of your friend who I was chatting to & emailing re: airspace when I was doing the balloons?

Sarah Thompson > TM
18 Apr 2010 10:36 AM
Hello hello!! Are you free to catch up ont phone later tday? X x hope your mum is recovering ok? X

TM > Sarah Thompson
Yes will be... Can you text me your friends name? He was either going out with a bloke who was your friend or he was. I need to find an email for the last chapter I've just written, thanks. Hope your enjoying weather... xxx

Sarah Thompson > TM
18 Apr 2010 10:36 AM
Hi, his name isJack Wellthorpe. Went to his fathers memorial on Friday in Sussex. Im sure he would talk to you again at some other point in the future. Speak later x x x

TM > Sarah Thompson
I'm sorry to hear that. I don't need to speak to him. It was just his name to find the email he sent me about 9 years ago… On who owns the air space immediately above our individual heads. Thanks. Love to u jai & the childers & look forward to catching up with you latooor xx

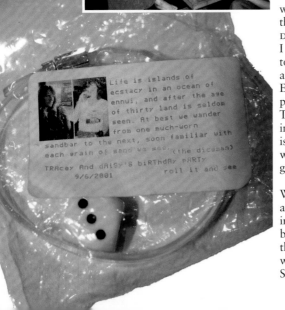

of years for attempting to blow up a bank in Leeds. Chumbawumba was one of his favourite bands and they had offered him support during his incarceration. I've never really been a music-loving person, just liking an odd track of a few bands, with Alabama 3 topping the list over the last decade or so. I was therefore happy to do the babysitting duty for friends when Chumbawumba were performing. I would always be given some of the paraphernalia from the gig. For a number of years in my daffodil-yellow kitchen in Manchester, with my daffodil-yellow teapot on my daffodil-yellow notice board that housed my daffodil-yellow wall phone, I had pinned to the notice board a postcard of the band with a Salvador Dali-type iron.

At this point in time Daisy was often seen around Shoreditch wearing a white t-shirt with a large portrait of Dunstan in a Celtic shirt on the front. Things were getting serious with them. In early May, we met up at the Foundry and hatched a plan to have a joint party to celebrate our birthdays. Pete Doherty was with us that night with his then-girlfriend Francesca. They had been going through a bit of a difficult and stressful time. We had been discussing this, saying a party was much needed. Francesca was wearing a lovely pink leopard skin wristband, so I came up with a wristband and dice themed party. We decided that the afternoon would be spent listening to chilled DJs whilst playing Daisy's favourite dice game Kiriki. I made small clear packages which contained wristband invites with two photos on, one of Daisy in her white 'Celtic Dunstan' t-shirt and one of me with an Eddie Stobart lorry in the background. Why an Eddie Stobart lorry I do not know. I presume the person who had taken that photograph must have. The words of the Dice Man, 'Life is islands of ecstasy in an ocean of ennui and after the age of 30 land is seldom seen. At best we wander from one much worn sand bar to the next, soon familiar with each grain of sand we see…' made up the invite.

At the age of seventeen the current body of work I am still working on began. When I start to explain it, people would often ask if I had read *The Dice Man*. I avoided reading it for many years because of the analogies made and not wanting to be influenced by it in any way. Much later I was given *The Dice Man* books as a present and loved them. I could understand why people always made the reference to my work as I choose a totally random element which sees my work change direction, medium and subject. The Foundry had become like the Sandbar was to me in Manchester, what El Sico's (now T.J.'s) had been like for

me when I lived in Newport. (I still missed El Sico's and John and Trilby the owners).

Pete was first to be added to our list of performers, followed by Dunstan who wanted a DJ slot. We'd decided on an all-day party and Pete had me writing and doodling things in his sketchbook saying he'd auction whatever I'd written years down the line and make money; he made me laugh. Talking through some of the things that had been happening with him and Francesca, an Edith Piaf song started playing on my internal jukebox and it still reminds me of them. It sounds like a contradiction, not really being a music-loving person but I have hundreds of songs that remind me of all sorts of people and events. Although one does not imagine anybody else doing this and if they did have a song reminiscent of me I would want to know exactly what song it was and why.

> TM > Bill Drummond
> 19 Apr 2010 11:23 AM
>
> **Do you have any songs at all no matter how random that you think of me when you hear them? Or a time or a event to do with me? If the answer is no then that is fine too...**

> Bill Drummond > TM
>
> **No. But I will come up with one. On the whole I try not to think about people when I am not with them. That way I can stay focused on the here and now and not on the past.**

> TM > Bill Drummond
>
> **No you don't have to come up with one it was just something I was writing about & thought I'd ask you.**

Following this text reply I thought maybe I should pick another nine people from the list of contacts in my mobile phone who know me quite well and text them the same thing:

> Aaj > TM
> 19 Apr 2010 01:47 PM
>
> **Tracey in the sky with Diamonds**

> TM > Aaj
>
> **Fibber are you serious?**

> Antman > TM
> 19 Apr 2010 01:47 PM
>
> **Hazel oconnor Will you – think its called that The 1 with the sax solo in the bar area in emlyn st**

> Antman > TM
> 19 Apr 2010 01:47 PM
>
> **Send your mum my luv X**

> Nick Fry > TM
> 19 Apr 2010 05:16 PM
>
> **Michael Stipe losing my religion.x**

Wayne Perkins > TM
19 Apr 2010 05:23 PM
Tracey there are two records that remind me of you ... First ... Yellow magic orchestra. z theme from the invaders !!! We (me you Stacey and Lyn danced to it whilst at fleur de lis institute ... I can see it as plain as day ... Just us on the dance floor and everyone else looking at us like we were spazzers from outs space !!! Secondly would be pocket calculator by kraftwerk cos when we saw them in Bristol ... You were convinced that florian schnieder was looking at you all the time ... it wasn't you it was me !!!!! Lol if I hear dark side of the moon by pink floyd that always reminds me of stacey cos she would always play that song Money !!! It's a drag when I went there on a Sunday !!! Mad how these things stick isn't it ??? Will that do for you Mary ann lou with no knickers ??? Xxxxx

Iz at Reading> TM
19 Apr 2010 05:23 PM
3 songs: Cher – Do u believe & Strong, Gewn Stefani, Wonderful Life, I wonder if this 1 is about u & Jeff

Jai Moodie > TM
19 Apr 2010 10:20 PM
Heya Trace. Soz not to txt bak sooner but 1st day bak at skool t'day.. The are a cupla songs that I always think of u wen I hear... Do you remember that song Sunscreen? Mostly talking in beat rather than singing but the words were great. We both buzzed off them! Also Manic st preachers – Tolerate this. That one becoz of the clay bricks and the trip to the brick factory, There are other songs from beehive days but need to unpik brain. Events are pizza xpress, the builder cant remember name, Robbies 50th, marmite & toms on toast loads of times in my kitchen @ millbeck st, jubilee at foundry, numerous greg moments, our first meeting at Helens house, our first exhibition, that butchers on prinny prkway, the montego, that day with sarah at the studio, my tattoo... Theres loads gurl. How do you sum up a greatfriendship? I've known you most of my adult life! We need to do this over a load of drinks! Xxx

TM > Jai Moodie
Ha! That's great thanks babes xxx

TM > Jake New Norwich
A specific trex if you were pushed & had to say?

TM > Jake New Norwich
Awe... I love you x I said a specific t-rex one ??? not track. How was first day back? Waiting for district nurse to ping nan's wound staples out. Been thinking of a really nice holiday, we need to go xx

TM > Kurt
Thankyou lovely, it's going straight into my book x

TM > Kurt
Your words & texts illustrate that honey x

TM > Dan Pox Mb
Why?

TM > Dan Pox Mb
Did I ever tell you that I hate you?

Jai Moodie > TM
Lots of love to your mum too! X

Jai Moodie > TM
I think becoz a long txt it prob came in parts...? Nice one. Fangs for the memories! Spk soon x

Jake New Norwich > TM
20 Apr 2010 09:16 AM
Believe by cher and anything t-rex. This womans work by kate bush x

Jake New Norwich > TM
Believe by cher nicest part of childhood, then Song in hinsight sums up ur situation at time x

Jake New Norwich > TM
Children of the revolution. First day was gd and where u thinking of going for holiday> Name me some candidate countries x

Kurt > TM
20 Apr 2010 11:22 AM
Shake shake senora – makes me think of getting wasted at the foundry with you on tequila. Tom Jones – whats new pussycat makes me think of you –also peaches – tent in your pants.

Kurt > TM
Do you mention how sexy I am?

Dan Pox Mb > TM
20 Apr 2010 12:00 PM
Monkey man by the Specials.

Dan Pox Mb > TM
20 Apr 2010 12:00 PM
It makes me think of your long hairy arms

A week before the party I was in The Bricklayers Arms near the Foundry on the Monkey Parade walk with Michael Curran a local Shoreditch face and his friend Trish who lectured at one of the London art colleges. Trish was the lead singer for the band Viralux who were going to perform at the party and Michael wanted to film Trish and I in there, shooting my reflection in Trish's huge designer sunglasses. That day was full of extreme fashion excess, with people bordering on the mentally feral from the weekend of alcohol and chemical induced partying. There were about two hours left before the casualties and alcoholic drama would begin. It looked like a cult divided between those wearing sunglasses and those displaying their saucer shaped chemical weekend eyes to the public. If there isn't a song called *Chemical Weekend Eyes*, there should be. I have always hated Sundays in Shoreditch after 5 pm for this very reason.

It was time for the birthday party. This one was going to run for about three weeks. The three words instantly conjure up a visual representation of Harold Pinter's play of the same name. Since being introduced to Pinter's work, I've loved it. It was funny being in Hackney, London organising *the Birthday Party* although it was only the title that was the same, and Hackney was where Pinter grew up, wrote, and was educated. The day was going to be music-heavy with DJ'ing and live performances. I knew there would be a fair share of real life contradictions and ambiguity stirred into the mix due the nature of the many characters that would be performing. I was really looking forward to the open-ended interpretation of events as they were due to unfold. Daisy and I were also inviting friends from different areas and times of our lives, even Dominic, an old friend from my first Art School was coming.

->THIS SATURDAY 9 June 3pm - 11 pm>>>>>>>......
TRAcey/dAisy/biRth-dice-Roll sATuRDAy pARTy

<<<<<(84-86 great eastern street)　the foundry

"Life is islands of ecstacy in an ocean of ennui, and after the age of thirty land is seldom seen. At best we wander from one much-worn sandbar to the next, soon familiar with each grain of sand we see..." (THE DICEMAN)>>>>>>>>

Time	DJ
02.30-03.00	d.j. Lars
03.00-03.30	d.j. Tony
03.30-04.00	d.j. Tony
04.00-04.30	d.j. Dunstan
04.30-05.00	d.j. Spencer
05.00-05.30	d.j. Jai aka Mike Hunt
05.30-06.00	d.j. Valentina
06.00-06.30	d.j. Mitch
06.30-07.00	d.j Nick aka m.farmer
07.00-07.30	d.j. Tony
07.30-08.00	Binge & Racket
08.00-08.30	Virulux
08.30-09.00	True Love vs Ramon Ramon
09.00-09.30	d.j. Dunstan
09.30-10.00	Libertines Pete
10.00-10.30	d.j. Keith
10.30-11.00	d.j. Keith

TM > Jonathan Owen
19 Apr 2010 03:23 PM
Are you about tomorrow night usoho? Lots of press going etc... I'm still in Wales looking after my mum but had promised to go and round up a few of my friends. It's Alabama 3 new album. I need to give numbers if can

Jonathan Owen > TM
I'm in Cardiff filming tomorrow Trace alas..: (

TM > Jonathan Alabama 3
19 Apr 2010 03:51 PM
I've left messages for people to see if they are around like Howard Marks (& he's working with hooky new order), waiting to hear back from Angie Bowie & her 2 music mates in bands, viv albertine the slits, mark Thomas can't is away, people from tv program shameless waiting to hear back from & other actors. Gaz mayall will have a number for mick jones I saw him at his studio the other month...have said it numbers sensitive so they'll get back to me.

Jonathan Alabama 3 > TM
Pls ask Andrew, I have tried Alan McGee he can't make it,he is in WalesGaz is coming as he is Djing the rest all good,oh and Holly and Paul cook are already on the list.xx

TM > Jonathan Owen
19 Apr 2010 03:23 PM
Never mind... Don't say I don't invite you to parties... I wish I was going myself. What are you filming?

Jonathan Owen > TM
Ah a thing for Cardiff City... corporate

TM > Jonathan Alabama 3
19 Apr 2010 09:30 PM
Everyone seems to be in Wales (shameless actor) McGee etc, can't get hold of Andrew loog oldmans number, but try alan for it they were out last week, his details locked in my archive in London. Waiting to hear back from Angie & Jude & others. Also lots of people stranded abroad I wish I was x

Jonathan Alabama 3 > TM
No probs, thanks for trying.x

TM > Jonathan Alabama 3
I just found this email address that should get to Andrew if you send it now maybe his Colombian one or his agent <email address> randomly found it in a Steve Van Zandt email contact he was in the sopranos I think. Do you want his? He may be in America, he tours with bruce Springsteen. He may be interested anyway & Bruce x

Jonathan Alabama 3 > TM
I have been in touch with Steve he is going to be playing on a single we will be releasing soon, its all fine now Tracey

TM > Jonathan Alabama 3
Ok speak soon and I'll let you know when Angie Bowie etc gets back to me. It would've been different had I been in London. Have a great Launch night x

Jonathan Alabama 3 > TM
Thanks love

The Foundry was looking good. Maf'J Alvarez, one of my ex-Manchester students, made soft sculptures which snaked the two columns inside the entrance. Michael Curran's film ran on the far wall. Dunstan's DJ'ing session went well, then Pete took over and began playing a lot of live music. As it got later in the day, I grew bored of playing dice. Daisy and Dunstan played off and on into the evening and Francesca gave me the pink leopard skin armband I'd really liked for my birthday and we got on with listening to Pete's introduction as he dedicated his performance to our birthdays. It was a surreal event as he started off with:

Fee Fi Fo Fum I smell the blood of an Englishman…

The main pomp and ceremony of the birthday party began. John Spencer shouted, 'ladies and gentlemen, can we have Daisy please?'

Daisy yelled 'let's eat cake – I don't do speeches.'

Pete brought out a huge fresh cream cake and started singing Happy Birthday.

John Spencer boomed, 'Tracey and Daisy, make your way immediately towards your cake which awaits you and is looking delicious if I do say so myself. Just plunge into the middle and the cherry centre.'

We did. Daisy cut the cake and began feeding it directly into people's mouths straight from the knife as Pete resumed the Happy Birthday song. John Spencer strummed away on the bass as Pete started shouting, 'Find me a bass player and I will play all day'.

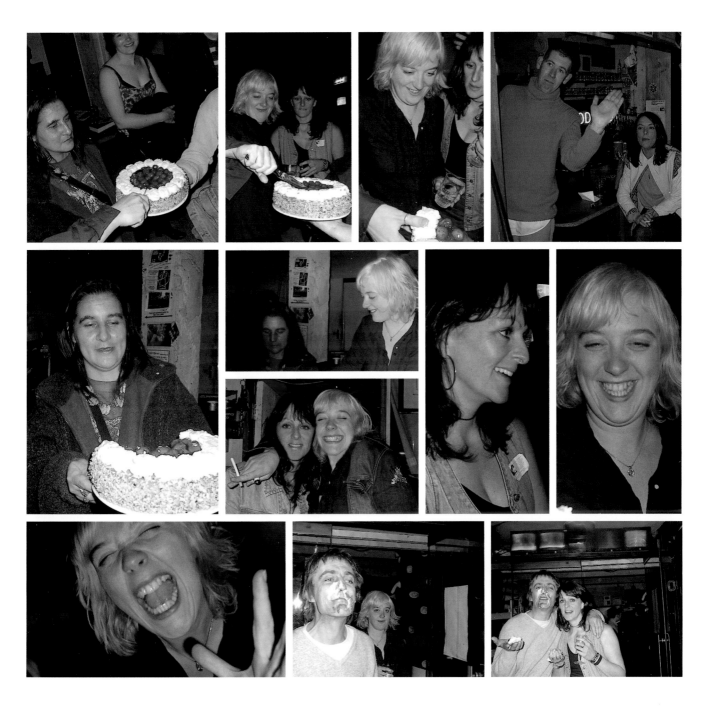

The Wormlady was left holding half an eaten cake. Pete shouted out again, 'Can anyone play the guitar?'

John Spencer seemed totally oblivious to this as he was strumming away. Being none too musical myself, I'd not known if John could play the guitar or not. But I was now concluding that he couldn't from Mr. Doherty's pleas and requests. Then John piped up, 'It's the right place at the right time.'

Pete begun, '*Ladies and gentlemen, we are going to take you all way back to 1937 when Harry the champion was King of the Bethnal Green Road and all your old time music hall stars. But it's commonly known they don't like a song that everyone can sing. But if Rudyard Kipling made them think when he comes out with a quotation, he says music halls are a necessary part of our civilisation. But Harry was a champion in their eyes even with his old green tie on, when he sang about hot meat pies and any, any old iron. He was King of 'em all at the music hall and down at the Old Britannia*'.

Pete takes his new trilby off, fluffs his hair up and replaces it. He continues singing, '*Stick a little treacle on your pudding Mary Anne and you can't help laughing can you? Now little Old Dick was two foot six and his name still now means small. He wore funny suits and big boots as long as he was tall. He'd give himself a clout, chuck himself about and ends up on tip toes. And then he'd stand on his head and the people always said well-done little Dick, good show. But Harry was a champion in their eyes with his old green tie on, when he sung about hot meat pies and any, any old irons. He was king of 'em all at the music hall and down at the Old Britannia, singing stick a bit of treacle on me pudding Mary Ann and you can't help laughing can you?*'

People cheered out, shouting for a bass player. Pete turned around, saw Tony and said, 'We've got a one-armed bass player. *Now sing of some a sweet song about love that moved them all to tears but ol' Harry said, I ain't never in a mile of crying in their beers. He says those love songs are all very nice but I think that it's all been said. So he sung about pubs and ponies and clubs…*' Then Tony the one-arm bass

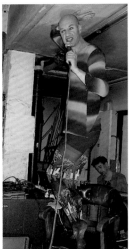

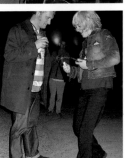

player appeared behind Pete and they began playing together.

I'd received my slice of birthday cake during Pete's performance, hadn't liked it and squashed it immediately into Kimble's face. He paused for someone with a camera then did the same thing back to me only twice as bad. Binge and Racket took to the stage for the next performance, Tam Dean Burn performing in a dress, walking tightrope, prowling over the thin edges of furniture, accompanied by Nicholas Bloomfield on piano. The night was awash in performances, which were all radically different with Viralux complementing True Love vs Ramon Ramon and so on.

Jonathan and I left for a secret gate in the car park with Pete, Francesca, Daisy, Dunstan, Jaime and a few others, where we let off some huge army flares. Our Birthday Party ended with a big bang that would have been heard all over Hackney.

11-06-01 14:37:44 Hi Trace! Did u get my text reveiling my "object of lust" ... etc? \ 11-06-01 14:59:20 R the nutters sstill with u? and yeh! He is gord isn't he? I'm not sure asout London Dread cos I've not met him! \ 13-06-01 03:58:10 U CAN FUK URSELF. DONT ABOTHER RINGSFUK OFF \ 13-06-01 17:10:58 U weren't the only one! Nic apologised 2 me again! Wants 2 go out again! Bless him, he's v cute \ 14-06-01 17:36:00 Ez Trace. tattoo a gogo! Stings a bit but feels grreat... no video tho wish ude bin there nurmind! \ 14-06-01 21:59:56 Not stingn now, got sum piles cream 2 sort it! Nik, Nav & this bloke in halfrds who had a tat dun 2day aswel.. looks wckd \ 14-06-01 23:16:53 Who the fuck nos, but knowledge is power Trace & u know what u HAVE 2 do! ! ! \ 16-06-01 18:40:53 Hey darlin' do u feel as disgusting as i

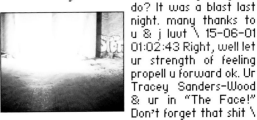

do? It was a blast last night. many thanks to u & j luvt \ 15-06-01 01:02:43 Right, well let ur strength of feeling propell u forward ok. Ur Tracey Sanders-Wood & ur in "The Face!" Don't forget that shit \

16-06-01 01:02:43 shaggin sheep \ 16-06-01 15:46:59 Yeh! it was really nice! Ended up watching Billy Elliot & didn't leave until 11.30 Nik has got me flowers 2 apologise again 4 other nite! Hows u? \ 19-06-01 21:43:21 Buy a guide book! la Coupole is on boulevard de Montparnasse wear Kiki bangle when u get back send the presscuts for Scarcrush/doria etc. asap \ 19-06-01 21:44:21 Text me from Paris \ 20-06-01 19:18:12 One 2 One welcomes you to France to use your phone, call #33•1234# and answer the ring back. Per-minute roaming rates apply \ 20-06-01 21:46:56 A flat in paris sounds nice! And I don't have a # 4 ruth ... Hope U2 have fun *** \ 21-06-01 01:31:26 Oops Ceasar needs a passport we can't leave in morn it's 5:45pm now boo hoo sob sob speak later G&D&C&F&C \ 23-06-01 15:42:09 Avez vouz un tele-signal?

22-06-01 19:05:37 TRACEY! I'M AFTER JON'S EMAIL ADDRESS. CAN U HELP? HOPE ALLS FINE + DANDY \ 25-06-01 13:26:07 Sounds fabulous * hope u photoed everything * I just got trashed on whiskey in Dublin ... \ 27-06-01 10:18:25 WAKEYWAKEYILUVU!!! \ 27-06-01 15:25:57 I'll Wank everywhere in protest \ 29-06-01 22:00:46 ...FRIENDS are like stars ... you do not ALWAYS SEE them but you know they are always there \ 04-07-01 14:18:12 Yes 2 paris ... when? & can i write the book 2? Am on a train to dublin 2 see joan of arse play live... \ 05-07-01 19:02:48 off to dogs. d's dog running \ 07-07-01 09:19:52 Hi Trace, just got ur text! Yeh I was nervous, but we had a really good time, at Nik's flat now, very hung over! R u enjoying urself? \ 07-07-01 15:43:55 We went 4 a meal in v posh Italian restaurant. Went on 2 Funkademia & Punana, had a really good laugh! Out again with family 2 nite. Good 2 hear u enjoying self \ 13-07-01 21:05:51 Sing a song of anal sex, arses full of cum, 4 n 20 penises goin' up ur bum, when the orgies over ur arse begins 2 sting, wasn't it a silly thing 2 take up the ring \ 14-07-01 09:38:41 I can't fuckin remember! Don't care eiter! R u hung over? Had a really good time, Helen is great, Fred tried 2 get my no. \ 14-07-01 12:52:34 TSK - me no mak up- Just 4ward! but here goes.....

UR CLITTY IZ SO PRETTY< UR CUNNY B VERY FUNNY \ 15-07-01 01:14:19 Bloody hell! Its all gone bloody welsh here! We're all pissed! xxx \ 15-07-01 21:45:02 I want purple ones! \ 15-07-01 21:59:49 Yeh, I've heard of that place, lets do it. If we bump in2 Robbie W can I snog him? \ 18-07-01 13:09:22 WAS DISAPPOINTED THERE WAS NO PHOTO OF U! D + C WOULD'VE INC A PHOTO OF U. ID OH WELL... \ 18-07-01 13:13:37 PHOTO OUTSIDE THE FOUNDRY + BALLOONS I THINK. NO TRACEY THOUGH

18-07-01 13:33:58 OOOH! RIGHT - SORRY! YES - LOTS OF PINK \ 19-07-01 16:29:55 Trace! Where r ya? Jai's here now! \ 19-07-01 22:39:43 REAL BOMBS \ 20-07-01 15:01:17 <battery low> \ 20-07-01 00:24:27 Where are u im now on my own in some crapshit place i hate \ 21-07-01 09:32:44 Hi Trace, hope u'll sort out stuff with Helen. Hope u ok, Nik is a tosser, chats so much shit! Fone me later pls, loads of love, H xx \ 22-07-01 17:51:52 Hi trace, hows u? Had gûd time lAs nite, Wolfie foned agen wanted 2 meet up, but was out & didnt get mess til got home. Got u drunk! \ 23-07-01 10:11:49 Don't forget to take yr phone abroad this Summer. You could win £1000 if you use it overseas before the end of Aug. For details call 121 or visit oneZone.co.uk \ 23-07-01 20:23:25 I am in London in b+b feeling much better and the devil has crawled back under his tiny pile of poop. Is it alreet if i giz u a ring tomorrow. Thanks 4 \

Manchester 0
London 1

We said goodbye to Manchester and headed for London. Everyone came to help us move. The strong smelling Red Bull kept us awake as we did several motorway journeys in the process. Friends stored a lot of our possessions in their houses. A decade on and it is all still there.

24-07-01 22:36:29 Jus foned Big Brother 4 Brian 2 win!! \ 25-07-01 14:03:21 < screams > my heart lurched ... :) \ 25-07-01 15:00:52 Its in Trace & u luk fabulas! Its the foto he liked of u lying down, Its great hon! \ 27-07-01 10:46:52 U R TALKING NONSENSE. THE WICKER PHALLUS BURNS TONIGHT. U R CRAB - I AM TOXIC GAS \ 27-07-01 14:50:54 Yes Tê! The tings r good man! Got u stoned 2 d_y! ^'ll b bAc 4 môré of this! There's a festival in Hulme Park 2 môz! \ 30-07-01 08:16:10 T thinking about u all nite.... ring me if u r awake. \ 31-07-01 22:22:58 DID U SAY BIG TiTs? - corrr how cud i forget, ive always loved u! \ 31-07-01 22:26:13 yeah - flabby buttocks!

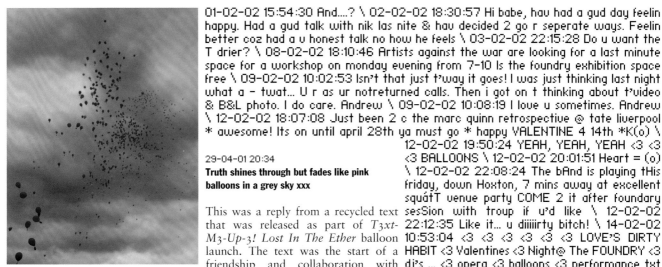

01-02-02 15:54:30 And....? \ 02-02-02 18:30:57 Hi babe, hav had a gud day feelin happy. Had a gud talk with nik las nite & hav decided 2 go r seperate ways. Feelin better coz had a u honest talk no how he feels \ 03-02-02 22:15:28 Do u want the T drier? \ 08-02-02 18:10:46 Artists against the war are looking for a last minute space for a workshop on monday evening from 7-10 Is the foundry exhibition space free \ 09-02-02 10:02:53 Isn't that just t'way it goes! I was just thinking last night what a – twat... U r as ur notreturned calls. Then i got on t thinking about t'video & B&L photo. I do care. Andrew \ 09-02-02 10:08:19 I love u sometimes. Andrew \ 12-02-02 18:07:08 Just been 2 c the marc quinn retrospective @ tate liverpool * awesome! Its on until april 28th ya must go * happy VALENTINE 4 14th *K(o) \ 12-02-02 19:50:24 YEAH, YEAH, YEAH <3 <3 <3 BALLOONS \ 12-02-02 20:01:51 Heart = (o) \ 12-02-02 22:08:24 The bAnd is playing tHis friday, down Hoxton, 7 mins away at excellent squátT venue party COME 2 it after foundary sesSion with troup if u'd like \ 12-02-02 22:12:35 Like it... u diiiiirty bitch! \ 14-02-02 10:53:04 <3 <3 <3 <3 <3 <3 LOVE'S DIRTY HABIT <3 Valentines <3 Night@ The FOUNDRY <3 dj's ... <3 opera <3 balloons <3 performance txt 07989933*** ************* <3 <3 <3 <3 <3 <3 \ 14-02-02 14:36:01 Is it true <3 14-02-02 11:01:02 Electronic top-up is the fast easy way to top up your airtime. To get your free Electronic top-up card call 121 today. \ 14-02-02 17:45:20 Hi babe! Hope u ok, hav a wicked time in foundry 2nite, will cu u soon xx \ 14-02-02 11:23:54 is it true that when you're horney about me your phone locks \ 14-02-02 11:43:18 YOU EXIST AS A DESIRE FOR AN ORGASM

29-04-01 20:34

Truth shines through but fades like pink balloons in a grey sky xxx

This was a reply from a recycled text that was released as part of *T3xt-M3-Up-3! Lost In The Ether* balloon launch. The text was the start of a friendship and collaboration with Johny Brown, author and front man of the Band of Holy Joy. I like the fact that people have become part of my life from random recycled text messages from balloons, found and then responded to by people (such as Johny). Spaceman Sam was another recipient, who I had not met before but became part of the initial fabric of the Foundry for a period. My friendship with Johny Brown grew and soon he would be coming around

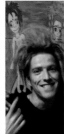
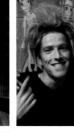

watching TV and having meals with Jonathan, the boys, and myself. He also began working part time in the Foundry. We started collaborating on ideas for work projects. *Love's Dirty Habit* was the first.

Johny loved the concept of the recycled text messages on the balloons along with other ideas I was working on. He was a vibrant, upbeat character and quite inspirational to be around. He was also keen on an alter-ego character I'd been developing called 'Moira Minguella' (known at this point as 'Minging Moira' or 'Moira the Minger'). I think Johny came up with her surname. I'd started a large portfolio of work as the character Moira and writing her off-the-wall biography. With her tussled long blonde curls, her part toothless grin and protruding gold tooth she was a sight for eyes, or sight to make eyes sore.

Sam Alabama 3 > TM
20 Apr 2010 01:26 PM
This month ok-wi gavin charlotte on cover. Page 138 pic of rob and I ! Te he x

TM > Sam Alabama 3
Ha! Fantastic I'll get it. Well done for gettin in there again! Have a great time tonight at launch. I wish I was coming but not in London. My mum out of hospital. Angie Bowie going, speak to her she's lovely. She was on my last show xx

Sam Alabama 3 > TM
I thought u in wales. When u back? the forum gig-the 15 cumin?x

TM > Sam Alabama 3
Yes I'm in Wales looking after my mum. Yes I will def come to the forum gig. It's in my diary now I need a bender of a night out with you! X

Above: Moira and her friend Myfanwy leaving the Groucho club after an unseemly fracas with head waiter and television personality Marcus Mabiline. Moira said afterwards, "i just seem to have this strange affect on men, they become uncontrollable and blue in the face".

MOIRA MINGUELLA
NEW BRITISH ARTIST ON THE BLOCK

THE GORGEOUS ARTIST'S FIRST NIGHT OUT IN TOP LONDON HOTSPOTS

Moira's dazzling debut has stunned the London artworld. Her literary reputation was already secured – in advance of the current interest in her artistic endeavours – when she established the word 'minger' in its modern English usage. The blonde Welsh beauty is soon to release her latest works of art in a number of top London galleries. Our '5' photographers snapped Moira and her brunette friend Myfanwy Evans as they followed the night lights from East to West on their hot nightspot tour. The gnashing duo sipped champagne and chomped on nuts into the early hours at London's most famous bars and restaurants. Our intrepid photographers caught up with them flitting through China Whites, the Colony Rooms, the Met Bar, the Foundry, Zilli's, Groucho's and The Ivy. Hailed by a storm of Paparazzi snappers and film-makers the unsuspecting duo then set off to an undisclosed destination after a threat of

migraine from the incessant dazzling flashes of the cameras. Moira's feminist conceptual prowess and vibrancy has kindled more than a passing interest by most of London's prominent art collectors. Her new show entitled 'Moira's Male Muses' opens in the Library Gallery of the Foundry on February 14 2004 followed by a discreet show in Lovecraft, one of Soho's most prominent accessories shops. Meanwhile Moira's new beer, 'Moira's Malt' is launched at the Foundry this month. A unique Pitfield brew using Welsh ingredients to a recipe her mother taught her. 'We were always drinking this stuff back home, I thought it's time you English got a chance to discover the brew that inspired my best work'.

Tracey Sanders-Wood tracey@foundry.tv
Photos: Jenny Nordquist, Anna Arendar
Foundry 84-86 Great Eastern Street London EC2A 3JL
Lovecraft 46 Cranbourn Street London WC2

Moira Minguella appearing in Gavin Turk's 5 magazine

As front man of the Band of Holy Joy he wrote his own lyrics, many of which are sensual, deep and poetical. He had been working on a new album and was also a prolific writer. The new album was called *Love Never Fails*. He was also writing a play for theatre called *William Burroughs Caught in Possession of The Rime of The Ancient Mariner*. He had a great friendship with Tam Dean Burn and they formed a company. Tam acted to Johny's words in plays, dramas and projects. I was first introduced to author, filmmaker, and director Irvine Welsh by Johny. Irvine had first entered the public psyche when in 1996, Danny Boyle directed a film called *Trainspotting* based on his novel of the same name. Johny and Irvine were good friends with Johny being best man at Irvine's wedding.

Working with Jonathan I had found my true soul mate, he was similar. We enjoyed bringing different individuals and groups together: watching them work and knit together, bond and create. Around this time we moved upstairs, inhabiting the old bank offices. Our time spent living there was one of the best for myself and for the children. The Foundry works on the premise of giving out free space on a first-come-first-serve basis. The requirement for the recipient of the art space who puts on an exhibition is that they leave one piece of artwork for the Foundry collection. This doesn't necessarily apply to performance works – music, poetry, literature – but in most cases people will leave a CD or copy of a performance and the like.

At the same time Bill Drummond came into my life in a solicitor's office in Whitechapel. I didn't know then how our friendship and working relationship would grow, but he has become my best friend and work colleague. We soon begun collaborating and working alongside each other in our individual and joint practices. Jonathan and Bill were friends. Ellipsis, the same publishing company that Jonathan had co-owned that had brought me to London with the launch of John Hyatt's book, had also published two of Bill's books. One of these was about how to have a number one hit. I also learned that Chumbawumba followed the process for this as did other bands that have gained number one chart hits from following *The Manual*.

I have mentioned that I am not really a big fan of music, but there is one band's lyrics and music I do enjoy – Alabama 3. Since going to their gigs in Manchester, I had wanted to walk down the length of Market Street in my first wedding dress with one of the lead singers of this band. The dress was vibrant red silk in a fish tail design with a long red veil, and the Alabama 3 singer was to wear a long grey suit jacket, with matching trousers and Stetson. I have even forgotten why I needed to do this now or what project I had been working on, but it is still on my 'to-do' list. When I had first met Daisy, it had come up in conversation. She liked the music and knew one of lead singers very well and told me that he was Welsh. This surprised me, as I'd thought their Alabama

Kurt New > TM
20 Apr 2010 09:11 PM
My tummy hurts! Bastard noodle king! He makin me FAT! Can I join the Moira Minguella Fuck For Fitness programme?

TM > Kurt New
Haha! Yes we should start a group up on facebook the moira Minguella Fork For Fitness... I need a couple of months being moira non stop. Forwardsh & backewardsh & siiiiiide to siiiiide xx

TM > Johny Brown
21 Apr 2010 05:56 PM
I'm just on the Love's dirty habit chapter of my book & there are a few names & things I can't remember is it ok if I text you a few questions as I go through this chapter? Xtracey

Johny Brown > TM
21 Apr 2010 07:11 PM
Of course xx

TM > Johny Brown
The rhyme of the ancient mariner was about Kathy acker, Burroughs & who else, who played the parts aswell & what was the theatre called? Was this your 2nd thing with Tam? Have you & Irvine worked together on anything? Did you come up with the surname for moira & why?

Porno Paul > TM
21 Apr 2010 08:25 PM
For the past two nights I have been employing a greased weasl as a masturbatory aid, and I have to say, it's fucking well ace!

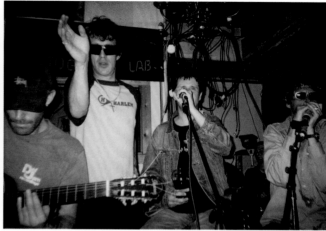

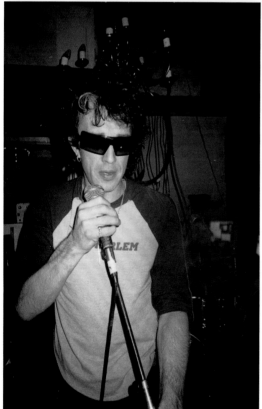

drawl had been quite distinctive. I later found that his parents live two miles up the road from mine in the Welsh Valleys. It was years later that I discovered that they weren't singing about Dallas, but Dowlais Top, a place in the Welsh Valleys where the next stop is the sky. It turned out that Johny was also a good friend of this lead singer and had invited him and his partner to the night's event at the Foundry. Even though Johny was working in the bar and didn't exhibit there he was always bringing something to it and to me on a personal and an artistic level.

Love's Dirty Habit was going to consist of filmed visuals I'd been working on for a while and another balloon launch. Louise Kleboe, an opera singer, was going to perform with her band. The balloon artwork was simple and effective: my large thumb print heart signature, the words 'Love's Dirty Habit... Text us yours' with the generic mobile phone number +44 (0) 7943791599. Each tag had a single suspender belt strap in red attached to it. A few hundred of these were made and tied to the balloons.

It was Valentine's Day. 57.5 million text messages were sent on Valentine's Day 2002 in the UK – the most that had ever been sent on one day.

Socio-politically, I had always been interested in the origins of the High Court of Love, which had been established in 1400 on February 14th in Paris. It dealt with domestic violence against women and infidelity, amongst other issues. The judges were selected by women on the strength of their poetry reading. What I most loved about Valentine's Day was the lost art of people composing their own verses in their own handwriting, along with the hours of effort, skill, design and sentiment they put into this. Then introduced was the anonymity of sending them. This became more popular after 1797 when a UK publisher issued *The Young Man's Valentine Writer*. It contained suggested verses for young lovers to create their own Valentine's Day verses.

Love's Dirty Habit, in its initial concept, had taken me back to my first text messages and the reasons why I started saving them. It also fitted in with where it had all began for me in Manchester and the history of the Castlefield area. I have already described how there was a major program of improved transport

Johny Brown > TM
21 Apr 2010 9:40 PM
Her partner is Alfie. Don't know who her musicians were

TM > Johny Brown
Had you performed with Alabama 3 before or was that just in the foundry? How did you meet rob & the Alabamas ? What influenced many of the Lyrics on love never fails? Do you still have the balloon tag you responded to when we 1st met? Can you remember what the recycled text MSG on it said? This was the night in 2001 that the libertines performed Charlie wrights do you remember anything about that gig?

Johny Brown > TM
I saw the first ever Alabama 3 gig in a town called Bosama in the Italian alps. It was Rob and Jake in G strings and purple afro's doing this crazed white black guys routine. Ultra offensive and very funny. I was tripping on a microdot Rob gave me. It remains one of the most dangerous… And beautiful gigs I have ever seen. As good as Iggy the pistols Sun Ra orkestra. Immense. It was a one off. I knew them from DJ ing in a Brixton night called Bump and Grin. Eddie… Beautiful cat.

Johny Brown > TM
Love never fails was just about London at that particular time. I was really ill with the tumour and didn't know it and madly obsessed with someone too and was trying not to show it and had lots of scorn for society at that time but enough faith dreams and wishes still that I was dying to get across. That's basically what went into Love Never Fails.

Johny Brown > TM
21 Apr 2010 10:01 PM
I still have the tag I showed it to Inga the other night, damn I can't remember the message but I can get it out of the box. I can… Vaguely… Remember the Libertines gig at Charlie Wrights. I remember a few nights there but not really that one. My drummer Bill was telling me about it two days ago mind.

TM > Johny Brown
Ha! What was your drummer bill saying about it? Love the fact that you have kept the tag… Could you get it out of the box & see what the message was? Thnks for all the answers

Johny Brown > TM
I mean I remember everything about the ceremony early on. But you know how it is… When it gets to Charlie Wright time… Woah…

Johny Brown > TM
Well…fill me in…

TM > Johny Brown
Yes I just wished it hadn't been filmed over. Jock Scott was there I remember on loves dirty habit that is. As for the libertines night I just remember dancing loads & tam being uber excited

Johny Brown > TM
He said they were good. But mainly that we were mortal. Hold on I will retrieve box and rummage x

TM > Johny Brown
The text you sent me was… 'Truth shines through but fades like pink balloons in a grey sky x x x'

Johny Brown > TM
Aye, Tam was and is very enamoured of them…

Johny Brown > TM
And how did I come up with the minguella surname

TM > Johny Brown
It opens the loves dirty habit chapter and I'm right back there in my head…

Johny Brown > TM
Wow… Nice

Johny Brown > TM
Did you see the pink balloons in Inga's film?

TM > Johny Brown
You told me Moira needed a bit of class & she might be a minger but minguella would be good and there was a film maker with a different spelling of minguella that would be great for moiras film & acting career you liked something a lot he'd done. Can you remember what it was? Yes I thought Ingas film was lovely.

networks with mail train services throughout the country. As this developed, there was a fall in the price of postage costs bringing about a less personal delivery and increasing the easier practice of mailing services. This made it possible for Valentine's Day cards to be exchanged anonymously. Racy verses were becoming popular in an otherwise prudish Victorian era. I loved the development of the lace, cutwork, appliqué and embroidery cards that were starting to be produced then. I remembered the Valentine's Day cards of my parents' courtship which they kept and stored safely. I had grown up learning traditional Valentine's Day verses from them as a child. These gradually became more corrupted the older my peers and I became. My father's handwriting was beautiful and hours of love and care had gone into putting verse to paper and crafting them.

I had began to speculate whether the growth over the last century of the greetings card industry, specifically for Valentines Day, would be superseded by the text message. There was also another element to this… In the immediacy of sending a Valentine's text message within the privacy of the phones of the sender and receiver, would the racy now-traditional verses become more suggestive and more pornographic? I began to wonder what effect would this have on society and relationships, marriage and the family not only on Valentine's Day, but all year around.

Over the years, friends have jokingly sent me extreme Valentines messages, even heterosexual female friends marking the day. Why? Because with the ease of a text, they could. It was this aspect of texting I would explore in Love's Dirty Habit.

> I NEED YOU
> ALWAYS LOOK AT ME THE WAY YOU DID TODAY
> IF I SAID I LOVED YOU & WANTED TO RUN AWAY WITH YOU, WHAT WOULD YOU SAY?
19.17> FANCY CHAMPAGNE?
19.18> 23.50> ROSES ARE RED VIOLETS ARE BLUE IM GETTING A ****
21.35> I THINK YOUR WONDERFUL ++++GORGEOUS, BE MY BABE!
22.48> ROSES R RED VIOLETS R BLUE.....
20.12> WHY DO FOOLS FALL IN LOVE?
20.14> WHY DO BIRDS SING SO GAY?
22:57> BROKEN ANY HEARTS LATELY?
08:54> IF I'M A WITTY BITCH DOES THAT MAKE YOU A PINKY BITCH?
15:56> HAPPY VALENTINES DAY SWEETY
23:42> ROSES ARE RED, VIOLETS ARE BLUE, I WANT TO FUCK, ONLY YOU
21:18> OH WOE IS ME OH WOE IS YOU NOT IN THE PINK BUT IN THE BLUE!

21:49> WHAT GOES UP MUST COME DOWN WHAT GOES DOWN MUST COME UP!
10:29> What's new pussycat woorr woorr woh?
[00:23:16] ->>LUVU2XXX<<-
[00:50:09] HAPPY piston - packed VALENTINE ILUVU!
[13:00:17] roses are red violets are blue you can suck me + i can fuck you
[16:24:19] hey trace - jus sayn hello seems like havnt spoke 2u in ages ...
[17:48:33] PISSED OFF - FEEL LOW. DON'T KNOW WHAT I WANT & IT BEING VALENTINE'S DAY DOESN'T HELP ...
[09:41:50] CALL ME IF U STILL NEED ME
[07:41:18] I bet u nevr got the flowers either!
[12:22:43] Did u like the boujkee of flowers & wine I sent?
[14:36:01] Is it true <3
[16:51:58] <3
[01:04:09] is it true that when you're horney about me your phone locks

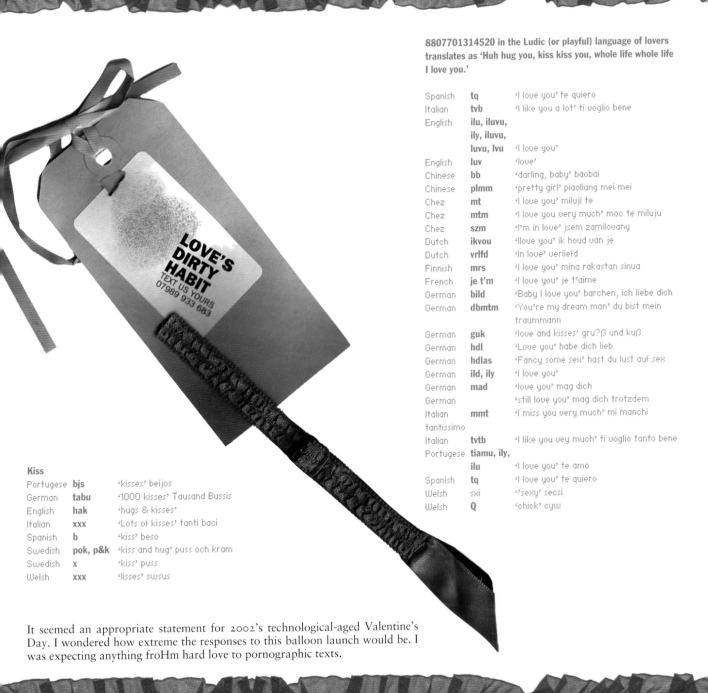

8807701314520 in the Ludic (or playful) language of lovers translates as 'Huh hug you, kiss kiss you, whole life whole life I love you.'

Spanish	**tq**	'I love you' te quiero
Italian	**tvb**	'I like you a lot' ti voglio bene
English	**ilu, iluvu, ily, iluvu, luvu, lvu**	'I love you'
English	**luv**	'love'
Chinese	**bb**	'darling, baby' baobai
Chinese	**plmm**	'pretty girl' piaoliang mei mei
Chez	**mt**	'I love you' miluji te
Chez	**mtm**	'I love you very much' moc te miluju
Chez	**szm**	'I'm in love' jsem zamilovany
Dutch	**ikvou**	'Ilove you' ik houd van je
Dutch	**vrlfd**	'In love' verliefd
Finnish	**mrs**	'I love you' mina rakastan sinua
French	**je t'm**	'I love you' je t'aime
German	**bild**	'Baby I love you' barchen, ich liebe dich
German	**dbmtm**	'You're my dream man' du bist mein traummann
German	**guk**	'love and kisses' gru?ß und kuß
German	**hdl**	'Love you' habe dich lieb
German	**hdlas**	'Fancy some sex' hast du lust auf sex
German	**ild, ily**	'I love you'
German	**mad**	'love you' mag dich
German		'still love you' mag dich trotzdem
Italian	**mmt**	'I miss you very much' mi manchi tantissimo
Italian	**tvtb**	'I like you vey much' ti voglio tanto bene
Portugese	**tiamu, ily, ilu**	'I love you' te amo
Spanish	**tq**	'I love you' te quiero
Welsh	**sxi**	''sexy' secsi
Welsh	**Q**	'chick' cyw

Kiss

Portugese	**bjs**	'kisses' beijos
German	**tabu**	'1000 kisses' Tausand Bussis
English	**hak**	'hugs & kisses'
Italian	**xxx**	'Lots of kisses' tanti baci
Spanish	**b**	'kiss' beso
Swedish	**pok, p&k**	'kiss and hug' puss och kram
Swedish	**x**	'kiss' puss
Welsh	**xxx**	'lisses' swsus

It seemed an appropriate statement for 2002's technological-aged Valentine's Day. I wondered how extreme the responses to this balloon launch would be. I was expecting anything froHm hard love to pornographic texts.

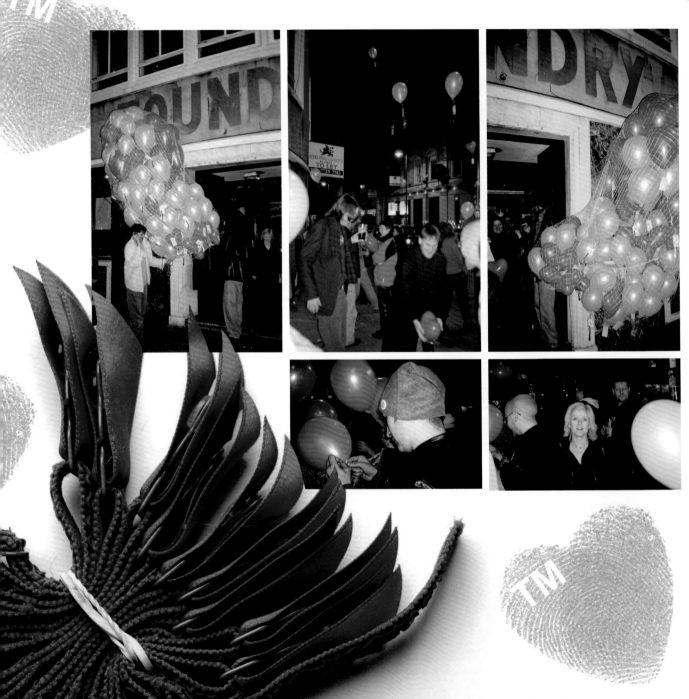

Carol, one of my secondary school friends, was coming up for the evening. Johny was still working on his new album *Love Never Fails*. Johny organised the musical entertainment, asking Louise Kleboe to perform with her band. Louise was the partner of Alfie who was a member of the Band of Holy Joy. She had an operatic voice-which was beautiful.

Many people helped with the balloon nets, but my main worry was that too many suspender belt straps were getting caught up together in a tangled mess. I jumped into the net several times to unravel the ones getting caught. The launch went successfully with hundreds of suspender belt clasps bobbing above us in the sky, before shooting off on the gust of the wind. For years after, the same tags and clasps hung from beer pumps in the Foundry. That night I was introduced to Rob aka Larry Love, one of the front men of Alabama 3. We partied into the night along with Samantha, Rob's partner, who wore a huge red ostrich feather hat. Jock Scott, who had taken over hosting our regular Sunday poetry night at the Foundry and his partner joined us, along with Johny and some of the Holy Joy band members. We danced at Sean McClusky's new Water Rats venue in Shoreditch, anticipating the return texts from tonight's launch. *Love's Dirty Habit* would run in the Foundry from 14th February until 12th March, and then the exhibition would change from 12th March until 31st March with *Love's Return*.

15-02-02 07:41:18 I bet u neur got the flowers either! G \ 15-02-02 12:22:43 Did u like the boujkee of flowers & wine I sent? Andrew \ 15-02-02 18:28:22 NICE ONE TRACEY WILL LOG THEM NOW HAVE GOOD JOURNEY \ 15-02-02 19:43:29 He was nice. Im fkd too. Hope your journies in better than expected. Thanks for having me. It was a great night. Impa i didnt show you up too much \ 17-02-02 22:21:04 WELL THEN I GUESS WE ARE GOING TO HAVE A NAUGHTY BOOK! \ 18-02-02 11:21:12 WE"RE GONNA GET SOME GREAT STORIES HERE \ 19-02-02 15:44:13 UR MENTALIST FASHION WK, SHMASHION WK! Dunst \ 20-02-02 09:46:50 T COULD U DO ME A FAVOUR & NIP OVER 2 CAB OFFICE & RETRIEVE ROBS PHONE JX \ 21-02-02 21:31:42 SINGA SONGA SYPHILIS A FANY FULA CRABS 4N 20 BLACK HEDS TWICE AS MANY SCABS WEN THE SCABS POP OPEN HEDS BEGIN 2 SING WASNT IT A MINGIN CUNT 2 STICK UR PENIS IN. ROB \ 21-02-02 18:09:03 I <3 U \ 23-02-02 17:43:18 INVITE ONLY PARTY TONIGHT? McQUEEN OR RIBERO? OR McARTNEY EVEN? OR RU WORKING AT FOUNDRY? Dunst \ 25-02-02 09:24:19 frank has written music 4 Faustuslite, play at the Steiner Theatre, 35 Park Rd (Baker St tube) for 3 nights wed 27th-Fri 1st tickets £5, starts 8pm. Lou & Frank \ 25-02-02 13:44:57 DID STELLA GET A COPY OF CANT GET U OUT OF MY 24HR PARTY? +ALEXANDER Dunst \ 26-02-02 12:20:13 FILM PREM LAST NIGHT WITH ED IZ + CHRIS ECCLESTONE. GROUCHO 4 NIGHTCAP ETC. I WANNA DJ AGAIN AT FOUNDRY CAN I? Dunst \ 26-02-02 11:12:42 LUWVU LUWVU DO VULUW X 100 NIK \ 27-02-02 01:07:20 Hey trace, soz its been soo long.. Nt avoidn u, jus gt my hed up me arse .. Wil call u tom 2 catch up .. xx \ 01-02-02 00:12:18 MISSED U! WE WERE AT SOHO HO W G NORTON + M FAITHFUL ME + D + ALICE EATING OUT EARLY FRI DUNST

18 Love's Return

13-03-02 12:57:46 LET ME IN PLEASE \ 13-03-09 14:31:54 KNOCK KNOCK \ 15-03-02 15:27:18 GONE VIA YORK. PACKED. PASS ON NO 2 BANKSY. HOPE J DIDN'T EXPLODE \ 16-03-02 13:27:30 Its almost 4 years ago 2day almost 2 the hour that sazz walked into the studio... Me & u were painting those window boards. Call u tom. Love u trace xxx \ 26-03-02 23:20:12 Hey trace, glad evrything is trning round. Ur soo strong. Lots of love 2u & all espec your dad & mum xxx \ 29-03-02 22:40:44 GOOD NIGHT Σ> \ 30-03-02 14:57:22 Saz now ont train bk Lndn Im gnna go2 brist til mon/tue, but mayb in Lndn nxt w/e. Hope everything is cool wiv daddio lots of lve xxx \ 01-04-02 22:16:31 CHAR WRIGHTS NOW \ 02-04-02 15:26:58 Hiya Tra.Sooo good 2 tlk 2 u gain. Op u ad nic scot+welsh chat nit. Im rcoverin frm Manc.Sors frm heels, welis bac on. F on Init 2cat up + arang u stayn.LuVadubs Saz XX \ 05-04-02 18:24:22 HI TRACEY IM DOWNSTAIRS J \ 05-04-02 00:53:50 Hey trace.. dnt be mad wiv me, im stil at the studio, thought id be hme by now. If ur up then gis a call otherwise ill call u tom. Promise! Xxx \ 06-04-02 16:33:29 m6 jct 17 \ 06-04-02 17:56:54 WORKIN @ FOUNDRY WHO THAT? \ 09-04-02 11:27:53 I'm still pretty feelin pretty low but gettin on with daily routine.. wana hide under duvet! I'm fightin that feelin tho! Watchin queen mum funeral & makin me feel sad \ 12-04-02 00:29:45 I kep meanng 2 fone u. Aving nother spot of large life. I keep thinking bout u. Im sory if u felt fckd over wid me. I mis yr friendship + wod like long chats wid u bout \ 12-04-02 00:56:39 U were a special + good friend 2 me. I hear from H bout shit u been throu. Im sory dat i wasnt dar 4 u Tracey. \ 10-04-02 22:04:57 LOVED U ALL BEING HERE XXXX

The responses to *Love's Dirty Habit* started coming through. Although we anticipated some of them being suggestive and rude, they were actually quite extreme. We thought that we were going to use them to begin the next project with, but we would only be able to use them in pornographic literature which neither of us intended on doing. There were less than a handful of text messages that were not outrageous.

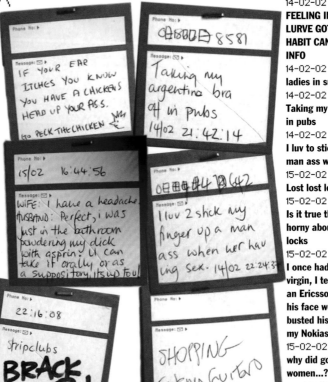

14-02-02 19:08:56
FEELING IN THE MOOD FOR LURVE GOT TO GET A DIRTY HABIT CAN U GIVE ME MORE INFO
14-02-02 21:30:47
ladies in suspenders
14-02-02 21:42:14
Taking my argentina bra off in pubs
14-02-02 22:24:37
I luv to stick my finger up a man ass when we r having sex.
15-02-02 23:17:31
Lost lost lost
15-02-02
Is it true that when you're horny about me your phone locks
15-02-02 22:51:40
I once had a One2One with a virgin, I teased him til he got an Ericsson, Sucked him till his face went Orange then he busted his load of Siemen over my Nokias!
15-02-02 16:44:26
why did god invent thrush for women...? so they could get used to living with an irritable cunt before marrying one.

15-02-02 16:44:56
**WIFE: I have a headache.
HUSBAND: Perfect, i was just in the bathroom powdering my dick with asprin. U can take it orally or as a suppository, it's up to u!**
15-02-02 22:57:03
<3
15-02-02 19:21:02
Lu$IN AFftør yEr L3gs en ÅRße oRgo oRgo eN sWMTim3s yEr Tits
19:27:41
LICK'N MY DOGS DICK
20:02:14
DIRTY HABIT I NOT WASHING THONG AFTER 3 DAYS WEAR
21:40:19
group sx ndr canal briges
21:48:39
F.....g men + married t a woman
22:16:08
stripclubs
22:37:23
Shagen wtsi a prite checks
19-02-02 14:06:02
PUMP UP THE VOLUME
19-02-02 19:36:39
What do u want me 2 do? .. Lvs dirty habit *=*=*
20-02-02 07:27:54
3 in a bed with loads of cream!!!!!
19-02-02 19:29:17
Oh, I lvd it wen he went down on me 2day, I get tingles.....
20-02-02 12:10:43
In my house i am the general. i want him.

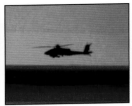

Love's Return started to hold less interest for me as
the texts started coming in from *Love's Dirty Habit*
were so pornographic. The Foundry started to get
increasingly busy over the week that the show was
on. This was due to a surge in different friends and
colleagues of ours booking more art, poetry performance, and music events.
Jonathan and I decided to change a few things around on the bar floor and in
particular we needed a more secure DJ space. A small room at the back of the
bar floor was ideal for this and it would be made into
the DJ Discotheque booth, a term I have always loved.

Paul Mulraney, who was a regular in the bar as
well as being in various bands (which included Primal
Scream for a short while) offered to do the job. With

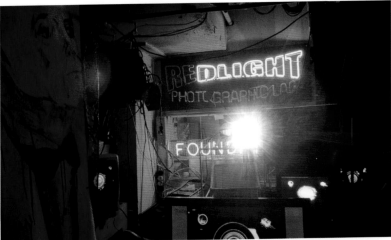

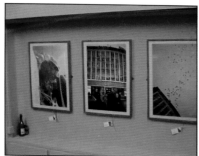

Jonathan Owen > TM
22 Apr 2010 12:29 PM
Dose was 2003 I think?
Not sure about the story
about PS… what was
that now?

TM > Jonathan Owen
Maybe it wasn't you that
told me?? About Paul primal
scream out in a wedding party,
as soon as he gets pissed he
tries snogging people infront
of their partners? There was
more to it though & I wasn't
sure if he'd tried to do that
with the bride… Did you tell
me the story?

Jonathan Owen > TM
Ha! No it wasn't me…
sounds good though.

Howard Marks > TM
22 Apr 2010 12:50 PM
Still on tour Tracey. Cardiff
on Sunday if you fancy it. X

TM > Howard Marks
Yes I do brilliant…
Please text me details

Howard Marks > TM
Peter Hook Unknown
Pleasures Tour Cardiff Glee
Club April 25 at 7pm x

TM > Howard Marks
Great, Stacey might be
up for it too so I not
on my own xx

Howard Marks > TM
Guest list. I'll text you
mid-afternoon for social
stuff xxx

TM > Howard Marks
Ok all sorted so I'll wait
for the mid-afternoon
social stuff text…
Looking forward
to it xx

Howard Marks > TM
Ok of course x

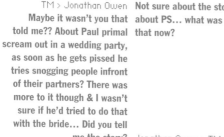

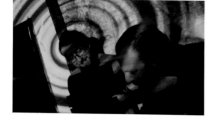

TM > Mark Thomas
22 Apr 2010 01:28 PM
I sent it so you should see it now & I put another request at the bottom as you fly off the phone when your on it. I'm only interested in word counts, syntax & paragraph lengths now nothing else interests me. Can you see if you have a date free for dinner with me the week or two after?

Mark Thomas > TM
Darling I do miss you. You just call at the worst times. I have to see you soon, I am getting withdrawal symptoms. So GLAD your mum is doing better. Call me in the evening and we can chat. Lots of love your friend Mark x

TM > Johny Brown
22 Apr 2010 02:33 PM
What month & year was 'william burroughs/ancient mariner' put on in Glasgow? I'd not realized it was quite Haiti loaded. Did I tell you I did a small part in a 'Kathy Goes to Haiti' film in Haiti?

Johny Brown > TM
2001 I think though may have been 2002. Yes very Haiti inspired not just cause of Kathy but Basquiat was of Port Au Prince lineage. That story about Paul hilarious.

TM > Johny Brown
Yes I know re Basquiat need to watch his biopic... Apparently via mcgee paul was like that all the time...Did the same thing in a wedding & I'm not sure if it was the bride or not! Where could I find out date exact?

Johny Brown > TM
The breath of a drunken ladies man. February 2002

TM > Johny Brown
I can't remember who told me the story passed on from mcgee but I like it being passed on from the breath of a drunken ladies man... There are a few about x

Johny Brown > TM
Hmmm I probably had my moments!!!

TM > Johny Brown
Haha! But he was something else!?! The children were quite young too & II thought WTF he doing?

Johny Brown > TM
Like a Mike Leigh film

TM > Johny Brown
Exactly!

this new self-contained DJ area, more requests were coming in from DJs and bands alike. We didn't have an entertainment licence as we were in a building on a rolling lease. In order to obtain this licence we would have had to make significant changes to the building which we didn't own and could be asked to leave at short notice (in any case a council officer had once said to us, 'don't bother to apply, we'll never give you one!')

There was a clause in the licensing law – known as the 'two-in-a-bar' rule – that allowed up to two people to perform without a licence. This applied countrywide and enabled the likes of Pete Doherty and Carl Barat to take to the stage, play guitar and sing, and one of the Hot Chip boys to do his first DJ set. Complying with these rules, events at the Foundry usually involved no more than two performers, with no dancing and free entry.

A year and a half later on 24th November 2005, a new law came into force replacing a number of different licences, including the Alcohol Licence and the Entertainment Licence with a single 'flexible' Premises Licence. After that date we were able to continue with our existing licensed activities such as selling alcohol – but none of the following could be hosted without additional police and council permission: 'performance of a play; an exhibition of a film; an indoor sporting event including boxing or wrestling entertainment; provision of live or recorded music; performance of dance'. Additionally our piano, DJ decks and PA system now required unobtainable licences so became illegal objects.

It was not clear whether any form of background music was legal without a licence, even a jukebox. Poetry and art were not

Aaj > TM
22 Apr 2010 11:26 PM
There's LARD in the Foundry

TM > Aaj
For fucks sake is there much? Can you photograph it all? Every bit of lard? It won't be normal, some will be garlic other ig & so on…

Aaj > TM
23 Apr 2010 12:06 PM
Did you get the lard pic? They are blaming the Ukranians

TM > Aaj
Ni I didn't get lard pic.. Was it sent to my phone? I accept that it may well be the ukranians… Bloody ukranians and their lard. Did you tell them I got larded out on more than one ocassion in Russia?

Aaj > TM
23 Apr 2010 02:07 PM
The lard pics will be sent in due course

TM > Aaj
24 Apr 2010 11:56 AM
Can you ask Alexey & Maja to come on next weeks radio show to talk about lard aswell as their show & more facts on how the Russians eat it to enable them to drink more vodka & how no substitute snack has been found? Maja's dad is also an Olymic endurance diver in extreme conditions with huge weights on him. He learnt this as a child when he moved to Siberia & in winter at −50 c could onlt keep warm swimming in the nearby lake.. Vladimir Kutz Norilsk. Alexey's dad is Andrey Kovalev wrote Moscow Actionism. Is respected Russian art critic xx

TM > Aaj
Is it right that by eating lard & drinking the vodka it allows the vodka to seep more slowly into the system, thus enabling one to drink more & for the vodka to have a more prolonged effect on the body as in drunken euphoria?

on the licensing list so we could continue with those activities unhindered. This law is currently in operation around the UK and severely restricts low-key pub-scale entertainment. I wonder how many bands, DJs, performers, dancers and musicians now ever get beyond playing in their bedrooms or living rooms. How many that will never get to make it as the next raw underground talent.

There was an omission within the law that seemed to allow music to accompany art exhibition openings. This is how we were able to accommodate singer/ songwriter Kate Nash some years later. One of Bjork's producers was in the Foundry that night and whisked her off to Iceland to record her first single and the rest is history.

Upstairs and downstairs in the Foundry every part was buzzing, from the childrens' lives to ours – with old and new friends playing a part in it. As a Foundry regular the artist Banksy brought with him and built up a nice team of

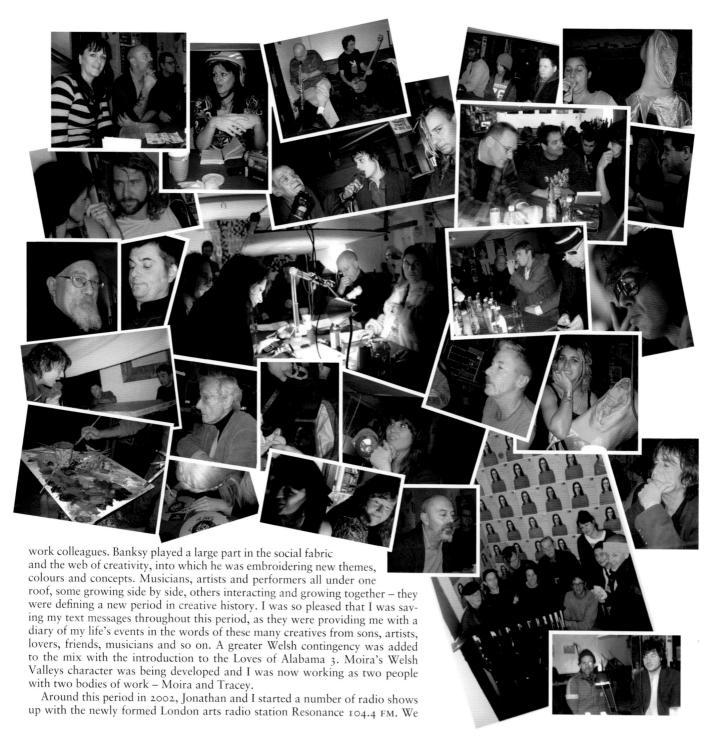

work colleagues. Banksy played a large part in the social fabric and the web of creativity, into which he was embroidering new themes, colours and concepts. Musicians, artists and performers all under one roof, some growing side by side, others interacting and growing together – they were defining a new period in creative history. I was so pleased that I was saving my text messages throughout this period, as they were providing me with a diary of my life's events in the words of these many creatives from sons, artists, lovers, friends, musicians and so on. A greater Welsh contingency was added to the mix with the introduction to the Loves of Alabama 3. Moira's Welsh Valleys character was being developed and I was now working as two people with two bodies of work – Moira and Tracey.

Around this period in 2002, Jonathan and I started a number of radio shows up with the newly formed London arts radio station Resonance 104.4 FM. We

had a regular hour on Friday lunchtimes called the *Foundry Late Late Breakfast Show*, broadcast live from the Foundry. I presented the show and we gradually introduced a format, developing a theme around three randomly chosen words which provided a framework for the hour-long show, with Foundry creatives improvising the live content. We formed the template for a successful show, which ran concurrently for more than eight years until the closure of the Foundry. Each week, Foundry regular Porno Paul, a purveyor and manager of a number of London Sex Shops, sent in random and often perverse text messages to the radio show, based on the show's changing three words. Outside of London, Resonance FM can be sourced on www.resonancefm.com and all our archives on www.sanderswood.com/radio or www.foundry.tv/radio. The archives detail everyone from the newly emerging Libertines; the story of Kate Nash in her own words and music; former MP and ex-Secretary of State for Energy Tony Benn in debate with Banksy; bloodletting artist Franko B in heated debate with MP for Vauxhall Kate Howie and many more artists, politicians, musicians, comedians, performers, poets, authors, and film makers.

As *Love's Return* ended, we had a small closing party. The Libertines had a new manager and they stopped by. The following exhibition was to be by Spaceman Sam and he wanted the room left pink. We retired to the library room in the Foundry. Dunstan had a DJ slot booked in for the night with his friend Griff. They had made a good mash up version of *24 Hour Party People* and Kylie Minogues's *Can't get you Out of my Head*. Afterwards, we were sat talking about life and the world, when Dunstan asked us what we were doing for the Queen's Golden Jubilee. 'We're going to have a street party!' Jonathan replied.

Howard Marks > TM
We stayed up for about another 2 hours, then I crashed. The White Hart is always mental. Great to see you and Stacey. Give her a snog from me. xxXXxx

Howard Marks > TM
X

TM > Howard Marks
26 Apr 2010 12:48 PM
Enjoyed last night, thanks for putting us on list. Wish I could've come to the vodka bar but was staying at Stacey's & she had to be up for work early. Hope you met up with people there. We left not long after you. I LOVED the White hart pub it was like the Jockey on Shameless! So funny how Eileen the landlady won't even enter my local in Bargoed where I grew because she thinks it's too rough! Enjoy Oxford x

TM > Howard Marks
Urgh! It'd be like snogging my sister or mother! Be good & see you soon xx

12-04-02 22:13:39 BOYS KEEP SWINGING \ 19-04-02 18:03:31 Gettin in Euston at 8ill and we'll get the tube 2 urs babe, Feélin ded tired! ready 4 sum champagne! Wat we doin foodwise? \ 21-04-02 00:31:29 TRACE COULD U DO ME A FAVOUR & PUT DAINA IN A CAB WHEN U LEAVE I'LL PAY DONT WANT HER WANDERING STREET IVE LEFT FRONT DOOR OPEN LOVE 2 ALL U BEAUTIFUL GIRLS U LOOK \ 21-04-02 00:32:15 LOOK SENSATIONAL J X \ 26-04-02 15:15:00 Icant believe it! I just told u i needed sex & phil jus txted the no of his finlay quaye lookalike mate to me! Things do happen at rite time dont they? \ 27-04-02 15:30:44 YEP MAJOR MAD LAST NIGHT TAM WAS BRILL \ 27-04-02 15:30:44 IN BAR WITH IRV \ 28-04-02 10:13:28 Mornin u daft cow! Was play gud? I had grt time workin y/day! Wen2 Herbal after wid D, dayna, mafjai, spoon & his flatmate. Had a really gud chat with spoon x \ 01-05-02 14:33:07 Where my toolimibob? \ 04-05-02 14:10:50 Hello trace – no credit... hope you get this. Am v. ill today. What gives as sid james used to say.. \ 06-05-02 12:14:26 Absolutely! Fuckin hell! I had him in my bed kissin my neck & holdin me in the most gorgeous way & I was gaggin 4 it! It was luvly tho! As 4 K...!? \ 07-05-02 12:54:21 SORRY TRACE NIGHT OUT WITH IRV JUST SURFACED J \ 08-05-02 09:26:31 Baby girl at 630 this morning. Nearly 9lbs. Both fine! \ 08-05-02 11:17:35 I have been told to Pester you for art work for street party – Fiona London \ 08-05-02 12:43:44 Mondo on way, glad u hapee miss u butt crust \ 09-06-02 10:30:08 hi trace, cud u text me jon spencers mobile no.. thanx jaime. \ 10-05-02 10:00:07 Jus bort a bra & knickers in hot pink! \

19 Jubilee Party – The Libertines Take Off

10-05-02 10:01:40 Jus séen : ur object tattoo full & beard free! \ 17-05-02 19:12:36 Fuckin hell! Train's jus done a sharp turn & my merlots gone west! Drivin v fast! \ 20-05-02 09:12:08 HI TRACE THOUGHT T STOOD FR TAM! \ 24-05-02 12:45:51 Just seén a poster on wilmslow rd 4 band of holy joy & their new single out on 27th! Finished the assignment, fuck it was hard, meetin phil now C u later x \ 24-05-02 20:21:46 Be a while before t's printed. And yes I did chat to rob, good stuff. \ 25-05-02 12:13:28 AL COMIN DOWN 2 FOUNDRY 4 2 C CAROL \ 28-05-02 00:23:17 ow de b? I do b fucked off writing fing eval/assess reports. Had wierd email from Al! Speak later? \ 28-05-02 16:11:37 WE R ON THE ROAD. WE R COMING STRAIGHT TO THE FOUNDRY. WE WILL EAT THEN WATCH BIG BRO! DUNST XX \ 29-05-02 22:56:39 hi honey! what's happening with the Foundry? Viralux has bee back burning * let me know details so i can consult with others * warm regards * trish \ 30-05-02 15:30:43 Hi babé, wen u foned i was in d moss@t's gettin herbs, has chewed my ear off 4 an hr, god i dont miss him & his out look on life! I'll call u l8r \ 01-06-02 00:23:17 Hello i need 2 speak 2 u urgently (néed a favour) can u call me on 020 793 04832 battery low, ask 4 Elizabeth + she will pass u 2 me \ 02-06-02 00:20:04 Ali g sms translator site www.whoohoo.co.uk still not sure wat i'm doin tomorrow. batty still hurtin. read whoe book today! FREE TEXTS@Whoohoo.co.uk ali-g.co.uk \ 02-06-02 00:28:31 Can yous text back to let me nah yous got dis an' uva masgs. ta bone carol FREE TEXTS@whoohoo.co.uk ali-g.co.uk \ 05-06-02 09:00:09 Hi babé, i suspect ur stil asleep, but wat u doin 2day? U wana go to Lennies 4 breakfast wen u get up? Txt or ring me ok? We need 2 chat bout monday aswell xx \ 03-06-02 09:53:21 hav u got a pair of fishnet stockins i can boro 4 performin? xtam \ 03-06-02 17:09:50 I am in attendance at your street party \ 04-06-02 00:04:22 Hi hope u r havin an ace jubilee time have to talk soon luv fi and jess x x

Dunst Chumba > TM
27 Apr 2010 06:30 PM

"24 hour party people" and "can't get you out of my head" by kylie. Griff from the regular fries was the chap in question who I dj'ed with and who was responsible for the mash up which I released on my very short-lived record label "lenny's record shop". The wamba did a couple of things; a version of beatles "her majesty" with added lyrics which was available as limited edition cd. and. a 12" vinyl version mash up of sex pistols "god save the queen" hope that helps!
Xxx

TM > Dunst Chumba
Yes that was it... Thankyou xx

Jonathan and I started planning our street party. We had only spoken about it briefly, toying with the idea, but now Jonathan had announced it we were going ahead with it. The Foundry, where we were going to be putting the party on also has a reputation for underground politics. Many commented that it was a democratic place where any voice could be heard. Others would call it an anarchistic establishment. We have been graced over the years by numerous politicians, ex-politicians, political activists, artists, comedians, political bands, poets and performers. It was also one of the London haunts of us ex-President Bill Clinton and wife Hilary Clinton's daughter, Chelsea.

Groups like Ma'm (Movement Against the Monarchy) and the Wombles (White Overalls Movement Building Libertarian Effective Struggles) amongst many others regularly held their meetings with us and publicly announced it on Internet notice boards. Only a four minute walk from the Foundry a brown plaque marks the spot where the Guy Fawkes plot to blow up Parliament was uncovered. The police would pick up details advertised on the public notice boards and on the strength of such 'intelligence' deploy police to circle the Foundry with police photographers snapping every person leaving or entering the building. This also continued to happen at the peaceful meetings for the organisation of 2009's G20 protests in London.

During the lead-up to the party, the rest of the nation reminisced about 1977 and the Silver Jubilee. The band The Sex Pistols had brought out *God Save the Queen* which included the lyrics about her 'fascist regime', which was seen as an attack on the Royal Family. Although there was more public support for the monarchy then, there was also discontent. Enough agreed with the song's message that the record got to number two in the UK pop charts, amid unsubstantiated claims that it had been kept off the number one spot on political grounds.

Our street party was to be neither for nor against the monarchy: we wanted to include all-comers. We weren't going to dress up but encouraged others to do as they wished. However we did want to dress the building and sexed-it up in a beautiful gold lamé number emblazoned with the word FOUNDRY. We texted around for help and Steven Haines (the maggot racer) invited an army of us into his Shoreditch loft apartment to tailor the lamé to perfectly fit the three upper floors the building, with the 'Foundry' letters positioned in the correct place on the fabric to mask the original sign.

We graciously prepared for the National Holiday, which would mark fifty years of Queen Elizabeth and her service to the UK and Commonwealth. We

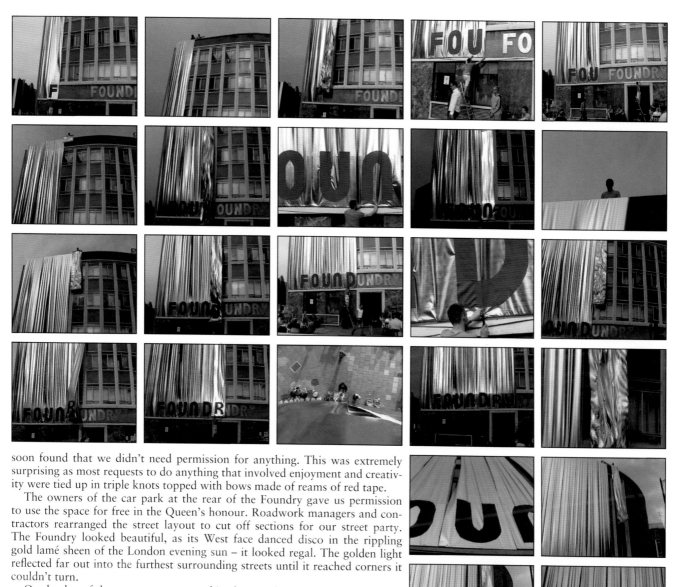

soon found that we didn't need permission for anything. This was extremely surprising as most requests to do anything that involved enjoyment and creativity were tied up in triple knots topped with bows made of reams of red tape.

The owners of the car park at the rear of the Foundry gave us permission to use the space for free in the Queen's honour. Roadwork managers and contractors rearranged the street layout to cut off sections for our street party. The Foundry looked beautiful, as its West face danced disco in the rippling gold lamé sheen of the London evening sun – it looked regal. The golden light reflected far out into the furthest surrounding streets until it reached corners it couldn't turn.

On the day of the street party, many friends turned up and by lunchtime the building was heaving and people started spilling out into the car park. We invited people to come and do their own Golden Jubilee stalls. Chris Grayson and Mike Walter managed one of the sound systems; Fang, a Brixton Foundry friend handed out necklaces bearing an image of the Queen; Gavin Turk and Deborah did a 'Pop Jackson's Pollocks' stall; Heather Niman sketched crowned portraits

Live Stock Management
South Shoreditch Community Association
Audience Appreciation Society
cordially invite you to join us for a

luverlie jubbilie
free shoreditch street party
monday 3rd june • midday to midnight

MORE LIGHT MORE POWER

by an ointment to
her majesty the queen
purveyors of the finest foundry sauce
since local records begun
manufacturers of rub a dub style and
choice jellied entertainment

free for all the family
at the Foundry Palace Gardens
84 Great Eastern Street EC2
Old Street Tube exit 3

bring your party to our street • bring your street to our party
tell us what you want to do
jubilee@foundry.tv • www.foundry.tv/jubilee
020 7739 6900

of people for a pound a piece; Richard Niman performed as a surrealist cloud with many more people running stalls and supplying art. I had built up a good friendship with Larry Love, and he was one of the first to arrive with a friend of his called Rantin' Richie – a baby-faced *Desperate Dan*-looking character with a big personality. I had my film camera in hand throughout the day. I lifted it up to film Larry and Richie, when Larry went into a fast-flowing monologue saying, 'You'll love this I just wrote it, tell me what you think'. Then he started a flow of words, with his face almost on mine until it took up the whole frame of the viewfinder on my camera.

Another psychopath in Iowa, loadin' up another round,
While the NRA in Columbine hunt Marilyn Manson down,
Powder in the pentagon,
Cruel letters in the mail,
Some KKK white supremacist,
Cookin' up a dose of race hate.

I don't need no country,
I don't fly no flag
I cut no slack for the union jack,
Stars and stripes have got me jet-lagged
Stars and stripes have got me jet-lagged baby
Ahhhhh no flag
No flag,
No flag

A baby in Afghanistan,
Cryin for his mama now.
While the bnp scare refugees
In the alleyways' of Oldham town,
Hypocrites in Downing Street
Pouring petrol on the flame.
Satpal cries, asks Paddy,
Why do we always get the blame?

I don't need no country,
I don't fly no flag
I cut no slack for the union jack,
Stars and stripes have got me jet-lagged
Stars and stripes have got me jet-lagged baby
Ahhhhh no flag
No flag,
No flag

do something
or off with your head

I texted more friends to come down and told them how the line-up was shaping itself. Soon, a band with a bus was in tow with Larry Love and they were setting up around the stage. Everyone was performing either for a contribution of alcohol or for free. Mike Walter and Lol Coxhill were doing a number of performances throughout the day. The Band of Holy Joy turned up with Johny,

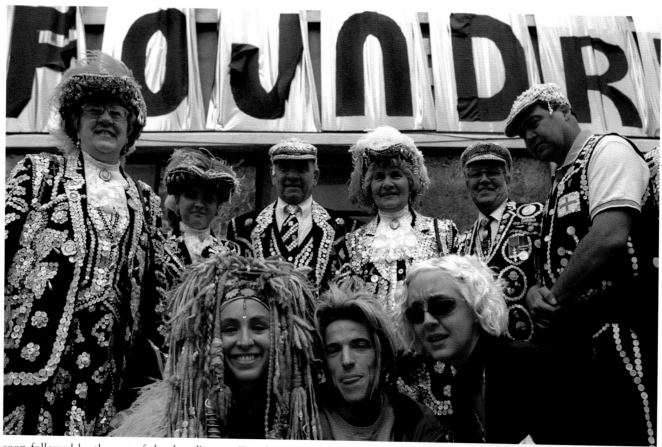

soon followed by the rest of the days line-up. Tam had been travelling down from Scotland and would be hosting sections alongside Vis the Spoon on the main stage. Tam wanted to borrow some of my fishnet stockings and similar paraphernalia along with my lovely blonde curly Moira wig to perform in. So as soon as he arrived we went upstairs for him to get ready to meet his audience. He had brought with him a long maxi length kilt. Spaceman Sam, with his gorgeous bright blue dreads, who I'd met through a recycled text message on pink balloon turned up with a huge sound system. With him came an army of ravers and I met Quarley, with the brightest, wildest knitted multicoloured hair along with Chloe Le Fay, who five weeks prior had sent me the beautiful text reply from a pink balloon:

29/4/01 20:34

A painter paints on canvas, a musician paints on silence, u paint on air! from across the road chloe le fay

the Original and Authentic Pearly Kings and Queens
command performance • regal fun and games
tug of war • egg and spoon
spirit of the blitzed • court jester • *soup and stew*
raffle • *(bring your own) flag competition*
music hall • *mobile phone orchestra*
anthems • *circumstantial pomp*
roundheads and cavaliers • town crier
pie and mashed • *golden balloon launch*
king mob barbecue • *public hanging*
riffraf courtiers • *stocks* • bunting • *tombola*
lucky dip • *donkey tail pinning*
royal fancy dress competition

Irene and Lennie's catered the food. An assortment of Pearly Kings and Queens turned up from different parts of London and performed. Punks, anarchists, disco divas, ravers, hip-hop dancers, Royalists, stoners, hippies and others all danced side by side. We had to make an extra bar outside. Pete Doherty was going to play intermittently throughout the day and The Libertines later in the night. Pete with Carl Barat, John Hassall and Gary Powell were now The Libertines and they turned up for the day looking really good in nineteenth century red military jackets with black trim and shiny gold buttons, for what I believe was their first big interview. The following day, they were going to release their first single which was a double A-side of *What a Waster* and *I Get Along*, produced by former Suede guitarist Bernard Butler. They were also going to feature on that week's cover of NME. The single that was due to be released however was getting very little airplay due to its 'liberal use of profanities'. They looked great and all really handsome in their red jackets. Germ who had performed as the British Queen when Pete was with us in Russia sold this type of clothing on his Spitalfields market stall and I wondered if they had got them from there. I thought I'd seen Germ walking around watching the bands earlier.

The Libertines decided to do their filmed interview down in the Pink Room when it was relatively quiet. I asked if I could film their first interview and they

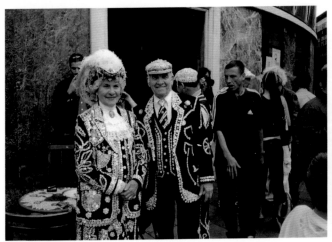

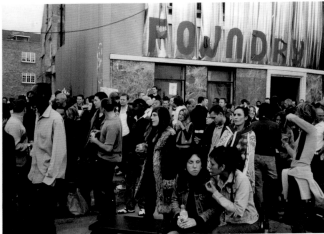

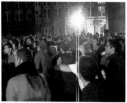

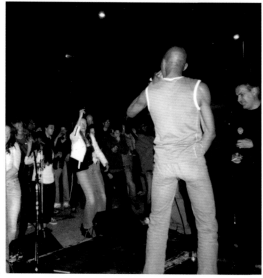

were more than happy for me to do this. I also got someone to keep guard on the door so they wouldn't be interrupted. I was enjoying filming them and hearing them talk about themselves and the band and their journey so far. Midway through the interview, the Mosquito ring tone of my phone went off and I had to quickly leave the filming and the room to attend to getting new bottles of tonic water for the bar; before attending to someone who had mislaid their shoe. Then, one of the bar staff had their first involuntary nose bleed and no one knew where to pinch the nose to stop the blood flow. This was the start of what was to be a long day with a constant tirade of random events that would not cease. After several texts from Pete I caught up with him after the interview had finished. He was apologising, saying they had to continue with the interview and do another gig which would be important career-wise. The film-maker also wanted to continue filming throughout Shoreditch. He left saying how he really wanted to come back and perform that evening with The Libertines as well as a couple of slots on his own. Many of his friends had now started turning up at the Jubilee party. He was so happy that things were starting to take off. He gave me a huge hug and a kiss and I stood waving him off through the car park as he kept turning back to wave saying 'sorry, I'll try hard to get back. I'll text you'. The rest is music history.

A censored version of their double A-side of *What a Waster* and *I Get Along* appeared as BBC Radio 1 single of the week the next day. The Libertines featured on the cover of that week's NME for the first time. Their single reached number 37 in the UK singles chart. They completed their first album, which was recorded and produced by Mick Jones formerly of The Clash, and I thought of the series of texts I'd got from him beginning 'Cardiff's Calling...' or 'London's Calling...' The album was called was called *Up the Bracket*. Their second single, and title track from the album, *Up the Bracket*, charted at number 29 and in October they released the album, which charted at number 35. They won Best New Band at the NME Awards, playing over a hundred gigs that year including support acts for The Sex Pistols and Morrissey. The film footage of the Libertines at the Foundry on Jubilee day made up part of the *Don't Look Back into the Sun* video. NME magazine place it fifth in the list of the fifty greatest indie anthems ever.

When Pete left, I became concerned about the growing number of people coming to our Jubilee party, as word was spreading quickly and people were texting their friends to come along. We had no security or door staff, so Jonathan and I had to do it ourselves. This was the biggest party we had ever thrown and it was becoming the biggest headache I'd ever had. All things seemed to be sorted though and there was no trouble. People started turning up in fancy dress, many of London's Pearly Kings and Queens were still performing, then the Ma'm brigade arrived, adding to the colour of the event. They were dressed as members of the Royal Family with masks and wigs. Following behind Princess Diana, the Queen Mum, The Queen and Prince Phillip were vans full of police expecting

trouble. I went over to speak to the police officer in charge as his team surrounded the Foundry for the duration of the day. The police soon began to relax and enjoy the day and equilibrium reigned again.

The Band of Holy Joy and Alabama 3 played to huge crowds. Larry dedicated my favourite song to me and my mantra, the Alabama 3 version of P*eace in the Valleys* as Samantha Love and I danced on. As we geared up for the finale, Tam Dean Burn took to the stage. He was still wearing my fishnet stockings, suspenders and Moira's curly wig. Pinned on the inside of his long kilt facing outwards to the world was a life-sized image of the Queen's face, in readiness for the party's finale. Louise from Society of Imaginary Friends started singing *Land of Hope and Glory*. Tam hoisted up the kilt waiting for the Queen's face to drop down from where it was pinned in readiness for the moment. He shouted over to Gavin Turk saying, 'I've lost the Queen.'

Gavin shouts back, 'just flash your arse, they'll love it anyway.'

With that, the Queen's face fell in place over Tam's bare arse, with the Queen's mouth in prime position. Tam proceeded to use the vibrator he was holding in his hand, positioning it to thrust through the Queen's mouth to his bottom with rapturous cheers and applause from the audience. It was the finest rendition of *Land of Hope and Glory* I had ever heard. It bounced off the surrounding buildings and peeled throughout Shoreditch.

In excess of five thousand people had turned up to the Jubilee party. There was only one casualty at the end of the night, which was self inflicted through alcohol abuse and friends escorted him home. The after-party with the bands continued indoors; the end was hazy. The tidy-up in the morning was, however, in no way hazy. We finished in time to let Lol Coxhill and Mike Walter through the doors to start the next day's celebrations. This was a period in time when I had no respect, understanding or liking for free form jazz. It was like having ones head ripped apart with the nerve endings soaked in caustic soda over and over again. Thankfully, something changed with that over the years and I love their music now; that morning I didn't but I blamed the Queen and thought of Tam.

05-06-02 01:14:26 How u doin? Still knackered afta ya faaab parrrty? Soooo glad it went well fe u. dig somerset. from welsh rank batty bitch 1 FREE TXTS ▯ Whoohoo.co.uk \ 06-06-02 21:53:17 Thats the last time i'll make moira a cup of tea! Cheeky minger. \ 10-06-02 15:44:21 Thankyou! \ 10-06-02 16:00:00 D'ya mean Pretty Pete Libertines? Bless he texted thankyou 4 that U like em lots innit weldne 2 im frm us xx \ 10-06-02 18:00:32 Hi babé hope ur ok. Me & Kiz feelin nostalgic havin a monday nite curry on wilmslow rd, thinkin bout those days wen we all used 2 do it xxh \ 11-06-02 18:18:32 Last s/hero uk show for 2002 next monday 17th at London borderline + K \ 11-06-00 23:23:18 Bum just ever so slightly uncomfortable! Seemed to me that a would be happy to meet anywhere!!! \ 12-06-00 16:09:34 FANTASTIC ITS REALLY SAD HERE \ 12-06-00 16:14:29 CAMDEN ROAD ARTISTIARCHITECT BETN EVICTED AFTER 10 YRS WERE MOVIN HIMOUT \ 13-06-02 21:10:50 Cardiff calling...in sunday london sunday.Libertines xPx \ 14-06-02 11:00:07 ur vid o our show is fantastic-u.inspiring! + the baloons-superb! c u wen i get bak tues xxxtam \ 14-06-02 20:38:37 TSK he in bath! \ 17-06-02 09:36:04 Dunstan dressed up as a sailor and gave me breakfast in bed. He was a sailor all day – at my mum's and at pulp gig. I know u will appreciate this. . . X x x \ 18-06-02 16:03:40 CURDLED MILK? \ 19-06-02 12:01:33 do u kno wher johny is? c u 2nite xtam \ 19-06-02 21:16:57 Still not up for chats but thanks 4 yr txt * pat's sent out emails w/end details * my heart is heaving but is both red&green *kx (X) \ 19-06-02 23:29:29 CAN'T EXPLAIN INTXT.MATES OF JOHNNIES.CALLED FAIRIES.ALL BIRDSWHO WEAR WINGS.24:7!MISSIONARY POSITION IS A NO NO!!A X. \

20-06-02 01:55:13 Thanks 4 voting for Spencer. Reply 2 this msg with NEWS for latest house update. Visit channel4.com/ bigbrother forterms and more detais.l \ 20-06-02 18:35:22 BILL 07956408365 JOHNY \ 21-06-02 01:21:57 Elise shaved off part of her eyebrow last night. As u can guess she was punished ? What do u think? \ 23-06-02 23:43:44 Hey trac, not heard from wayne/barnes. Give me til morn & ill tel u.. I'm workn int studio... much love, laters xx \ 24-06-02 07:58:26 Happy birthday! Thinking of you on the sleeper . . . ! R u around tomo eve. . I will be in west end . . We could go out for dinner? X \ 24-06-02 14:12:44 From streetcreat... hiy a hun, you not forgotten i just been busy wif the usual shit, see you soon my arty darling xxx CU@voicegroups.lycos.co.uk \ 26-06-02 09:11:05 Oh yeh, jus thort i'd tel u that as always ur prediction was spot on! I'm gettin rid of the dreds coz not rite 4 my hair type. Sick of it always bein messy. \ 26-06-02 21:12:02 HAPPY BIRTHDAY TRACEY! <JUST PUTTING THE GRAMMAR BAK INTO JOHNNY BROWN!> HOPE U R FINE + DANDY LUVxxx DUNST \ 27-06-02 15:49:44 The Libertines play Death Disco tonight at midnight, Metroclub, Oxford st. Text back for guest list xP \ 27-06-02 15:51:36 fankufankufanku!+hopuhadaluberly time 4 urs x we r havin a champers picnic in a tent aftr aquamasage-superbsurprezys+tis only tentae4 i luv44!XX \ 28-06-02 17:31:36 Hi darlin. Well not heard from nik as yet. I've really tried 2 extend the hand of friendship. Aah well, c'est la vie! Howz u & urs 2day? All gud i hope. xxh \ 30-06-02 22:44:01 TRACEY MAN WE DIDNT HAVE VIDEORECORDERS IN 1977 NEVER MIND PORN VIDEOS XJ \ 03-07-02 12:39:14 VOTE JADE 83188 \ 03-07-02 19:30:39 Hi darlin, u havin a gud time. Thinkin bout u enjoying urself @ sandbar, wish i was there not Moss Side. Nicola coming round with a bot of wine, cu @ w/ end x \ 04-07-02 11:16:09 TRACE CUD U GET TOGETHER A GUEST LIST OF ANY FOUNDRY BODS WHO WANNA COME TUESDAY XJ \ 04-07-02 12:00:00 Thanks 4 voting for JADE. Reply 2 this msg with NEWS for latest house update. Visit channel4.com/bigbroyherfor rerms and more details \ 05-07-02 02:38:52 crazy:yung guy sitin in fonebox eyes midl distans-i go+c if ok but hafthink hes takn t pis+cameras r sumwer then cops pul up+chek him out+he todls of+yung asian

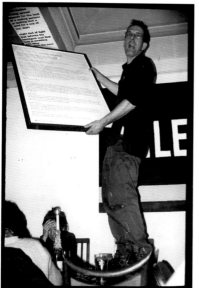

The first time I was introduced to Irvine Welsh was when Bill Drummond was doing a performance at the Foundry and I was collaborating with him on an anti-war theme. Bill was doing a performance based on a pack of playing cards he'd had made called *Silent Protest*. The aims of the game were firstly to go a whole day without speaking and secondly to bring about an end to the war. For my part in the project, I was using the anagrammatical *Violet Vision* nuclear warhead poem I had written. In this instance I was using it to highlight a proportion of the silent victim casualties of war on our streets. I was looking at the abundance of heroin that was flooding the drugs market as a result of the war and the victims sons, daughters, brothers, sisters, mothers, fathers, aunts and uncles that were in some way affected by this the country over. I'd used a Simone De Beauvoir quote from *The Second Sex* in the book I did with John Hyatt called *Give Battle In Vain* which commented on weapons and war.

VIOLET VISION /
SOVIET VIOLIN...

VOTIVE IS LOIN
VOTIVE IN SOIL
LIVE TO VISION
VIOLET VISION

VIOLET VISION?
VISION TO EVIL
VISION TO VIEL
SOVIET VIOLIN......

Life does not carry within itself reasons for being, reasons that are more important than life itself. For it is not in giving life but in risking life that man is raised above the animal; that is why superiority has been accorded in humanity not for the sex that brings forth but to that which kills.
– *Simone De Beauvoir*

Violet Vision: nuclear warhead designed for use with Blue Water surface-to-surface guided weapon.

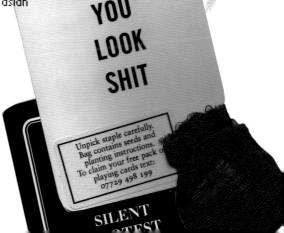

YOU LOOK SHIT

Unpick staple carefully.
Bag contains seeds and planting instructions.
To claim your free pack of playing cards text:
07729 498 199

SILENT
PROTEST

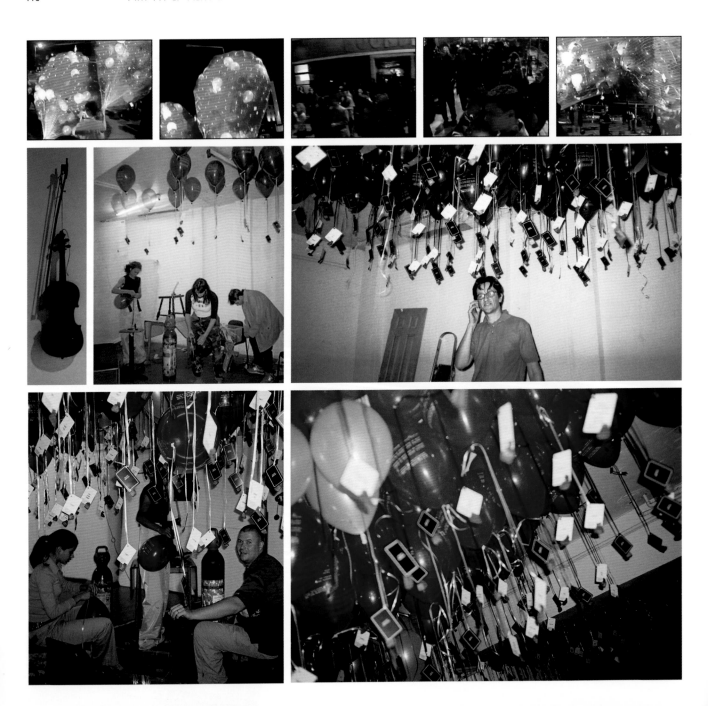

TM > Ellie Owen
5 May 2010 08:28 PM
Not sure if your around on Friday night to pop by, but Jon & I are a live installation at Tate Britain from 6.30-10pm doing radio on politics & art there are loads of things going on in there to look at. I'll be hosting tony benn, mark Thomas, the people who organize g20 demos etc plus radical arts people like blood letting franko b, a tetrochromosy specialist & so on... I'll text Jonathan to. Can you mention to people it's all open to public x

Ellie Owen > TM
5 May 2010 08:51 PM
Sounds brilliant! We might be having dinner with a friend of Jon's from Wales but it.s not 100% so if not then I'd love to come xx

TM > Ellie Owen
Nice one would love for you to see it all in action. Looking forward to a night out with you soon, even if a quiet one in Shoreditch House & book talk!

Ellie Owen > TM
Definitely. Haven't seen you in ages. Lots to catch up on xxx

TM > Ellie Owen
Yes that's how I should be... If you don't manage to pop by Tate on fri lets speak over the weekend & sort out time to meet up. Have had a very welsh day today with Eggsy goldie looking chain & Howard marks filming at the foundry on the shit in cocaine xx

Ellie Owen > TM
Sounds great. Leeks-ahoy! You staying up to hear the votes coming in tomorrow? Yes, lets speak over the weekend.

A lone Soviet violinist played as balloons were whipped up by the wild night wind. They carried opium poppy seeds off to germinate where they landed. The violet balloons symbolised the warhead with the poem emblazoned across each individual balloon. Violet muslin bags carried the seeds which I had attached to an individual 'Silent Protest' card, in the hope of them freeing themselves easily when they landed. This was my anti-war protest and a comment on what I felt was happening directly around me because of this new war. Melancholic music played as a thousand violet balloons launched into the night.

Johny was now fully focused on the *Love Never Fails* album launch as well as adding the finishing touches to his play. I was going to put on *T4xt-M4-Up-Mor4! Love Never Fails* as a balloon installation, this time indoors and using positive recycled love texts. It was leading up to the period where he'd mentioned Irvine having his new book coming out soon called *Porno* which was the sequel to *Trainspotting*. *Porno* described the characters of *Trainspotting* as their paths crossed again ten years after the events of the previous book. The pornography business is now the backdrop rather than heroin use (although numerous drugs, particularly cocaine, are mentioned throughout).

I was getting lots of different invites to this book launch from various people who I'd previously thought had no connection with each other. I really started

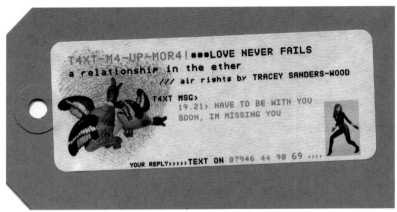

to feel part of a loose community of people.

The album launch date soon came around and Johny was keen to invite me to put on *T4xt-M4-Up-Mor4!* as part of the event. I decided to experiment with the balloon launches I had previously been doing, making this an internal launch. The venue was 93 Feet East on Shoreditch's Brick Lane, where the ceilings were relatively low. I designed appropriate balloon tags with neat bits of artwork, and selected only suitable love texts to fit in with the album launch title *Love Never Fails*.

The launch went well. Tam performed and again requested Moira's wig which he was getting extremely fond of.

As the gig ended, I stayed behind to watch each and every balloon be taken away. As the last one disappeared through the door, I rallied the Band of Holy Joy members along with members of Alabama 3 and Test Department with people who had stayed back after the gig, for a party back at the Foundry to celebrate *Love Never Fails*.

Hel Elvis Jesus > TM
5 May 2010 09:46 PM
Did it all go well today love?

TM > Hel Elvis Jesus
I think so, it wasn't my project or I wasn't involved in it just let them use my toilets at the Foundry. They are filming a programme on drugs & all the crap in cocaine, he was doing it with Eggsy from Goldie Looking Chain. Apparently there is only 15-20% of actual cocaine in the wraps people buy! I thought it was so funny after the text I sent you years ago when I'd first met Howard which translated all wrong. Can you remember it exactly?

Hel Elvis Jesus > TM
No. but we both have good anecdotes concerning Mr. Marks and toilet cubicles! How's the writing going?

Hel Elvis Jesus > TM
My new best friends are my next door neighbours. They came round for dinner two evenings over the weekend and regaled me with lovely tales. Then I had to help them both home…

TM > Hel Elvis Jesus
Haha! You are returning to normal…'sex in Manc city' will beat 'sex and the city' anyday… look forward to a good catch up & 'more tales in the city…' by the end of the week. I just realized I missed this weeks Shameless & now I can't cope… xx

Hel Elvis Jesus > TM
Darling, I lived the dream! Will give you your episode of shameless when we catch up. Love to mum, hx

TM > Hel Elvis Jesus
Xx speak soon

Hel Elvis Jesus > TM
Hold on, Shameless is on channel 4 in half an hour

TM > Hel Elvis Jesus
That's cool I always watch both on a Tuesday. I'll go down & watch it now. Big love x

TM > Jack
5 May 2010 08:59 PM
Just texted your other number. Are you still on either of them? xtracey

Jack > TM
Whats up

TM > Jack
Nothing just checking all ok with you? It's been ages, what are you up to & when is good to catch up to talk?

Jack > TM
Will drop you a line soon

TM > Jack
Better if you text or phone. Are you still in Manchester?

Jack > TM
Any of these going in new book

TM > Jack
No & any that you'll have sent over the years I'll run by you & are nameless. I'm not a cow x

TM > Jack
Can you meet up soon?

Jack > TM
The past is a place I stay away from a reclusive present tense for me

TM > Jack
Does that mean you're a reclusive in the present tense or a reclusive of the past in the present tense & therefore I am the past so you don't want to meet up? How long does a life sentence last?

05-07-02 19:00:24 As a last minute House prank switch the hot water for Jade's shower with cold water, They then turn the hose on her. 'Go for the legs,' shouts Jonny. \ 04-07-02 00:23:16 Cocknet arseface \ 08-07-02 17:49:09 HOWS IT YR END? REHERSAL GUD REALLY WANT JONATHON 2 B THERE 2MORO XJ \ 08-07-02 19:24:43 Need wshng up lqd \ 09-08-02 19:20:27 on my way need ur WIG!!X \ 10-07-02 22:34:19 Ow dew b mun? R ew ok? Did ew njoy the band last night? C. \ 12-07-02 16:14:37 Σ> U \ 16-07-02 18:06:10 iggygig2mro-we-r-past-nucastl. no-camera-wanagocrazee.irvin tryin2get-us-bakstage-EVERYTHIN-XD. XT \ 17-07-02 09:58:13 Two late Roller discos but Tim misses them both. He's removed his contact lenses. Complaining to BB, Tim demands his no shows are void and claims discrimination \ 18-07-02 02:56:51 Alabama r playing in cdf on 3 aug! C. \ 18-07-02 12:33:25 SCRAPIN WALLPAPER OFF TAMS BATHROOM LISTENIN 2 IGGY POP & PLANNIN MY ESCAPE 2 BRIGHTON SAY HELLO 2 BILL \ 19-07-02 10:29:35 Yes

& yes. Weird bus ride & may have damaged dan with the vodka but think he was happy when he passed out :) i'll email u when i've had some sleep LP&H timx \ 19-07-02 16:58:45 You were telling me bout God being a c*** and Dave the Chaplin is sitting (on the phone!) at the other end of my rm \ 22-07-02 14:42:31 HI TRACE IM @ FRANNYS WE"RE GOIN IN STUDIO 2MORO 2 RECORD 1 OF THOSE SONGS WE WROTE BUT I"LL TRY & MAKE IT DOWN 2 CU & BILL IVE STARTED ON YR STORY MY HEAD IS IN A BAD PLACE \ 24-07-02 00:05:54 Hun me offerd interview wif l'Chapelle – u wana b my assistant? Spk l8r k x x ps me fab art critic \ 25-07-02 15:42:08 CHUMBA GIG LONDON JULY 31. ANY GUESTLIST NAMES? \ 28-07-02 16:53:51 Jade makes retching noises on sofa then runs to toilet + hurls. Alex ignores Jade's pleas for help + cleans around kitchen. 'I'm gonna FAINT!' screams Jade

Jonathan Alabama 3 > TM
6 May 2010 12:42 PM
Hi love, did you text me last week about meeting up?

TM > Jonathan Alabama 3
Yes…Can you? Or are you up to your eyes in it with tour coming up etc?

Jonathan Alabama 3 > TM
I'm so up to my tits its not fair but I wanted to acknowledge ur text and say that I will do the meeting asap love.xxx

TM > Jonathan Alabama 3
Ok no probs thought I was going to be back in London for a short time but it's longer now, I'll text you in a couple of weeks and good luck with

Jonathan Alabama 3 > TM
Soon as its over I will be in touch if not b4.x

TM > Jonathan Alabama 3
it all xx

TM > Jonathan Alabama 3
Cool see you soon x

A month later and it was the launch party of Irvine Welsh's book, *Porno*. The invites were great; they were porn industry style DVD cases with the invite inside. The event was organised at the Corona, an old cinema in Elephant and Castle, London. When the launch party closed, a small group of us went back to the Foundry with Irvine to continue the celebration. Poetry was performed and songs were sung and scenes of plays were acted out at random. When Larry Love began singing Acapulco it was stupendous. This continued throughout the night and we all left early in the morning into a beautifully sunny day.

A few months later, Johny was around our flat above the Foundry one evening and I was discussing the fictional autobiography that I was writing based on my Moira Minguella character. Johny said, 'Trace, you have to go online as Moira. Irv is doing a question and answer session around his book *Porno*. You'd be great, go on as Moira.' Johny texted me a few times before the *Talking Porn Room* event. It was the first time I'd ever been in a porn chat room, but I wasn't going in as myself; I was going in as Moira, talking porn with two fictional characters whose lives had developed from the books and film *Trainspotting* then *Porno*. It didn't seem in the least bit surreal at the time, but now reading back over the hour-long *Talking Porn Room* dialogue it does! Moira sat by the computer waiting to enter the chat room at the allotted time. First to enter was one of the main characters in the book, Simon David 'Sick Boy' Williamson, who had been hit by a string of failed business ventures before deciding to embark upon a porn career. DonkeyKnob, Douglas_Fir, and ThrillMeister, all arrived around the same time as Simon and Moira soon entered into the online spirit of the occasion. Midway through Nikki Fuller-Smith enters. Nikki, another main character, is a twenty-five-year old university student. She majored in film studies

TALK SEX with the Talking Porn Room
simon david williamson
and
and nikki fuller smith
9pm GMT
Monday 25th November

moira **i do know a couple of these stories so i think they maybe true**

Douglas_Fir **So Simon - did you ever contemplate asking Mr Connery to be involved in your movie?'**

DonkeyKnob **Simon, can you ask Nikki to hurry up with her kitchen duties so we can get her on here**

Simon **It was nice to talk to you folks. Now i'm off for something to eat, but stick around as Nikki will be logging on shortly.**

james entered at 09:52pm 25 Nov

Douglas_Fir **cya Simon**

DonkeyKnob **Hi James**

Simon **Too finish up, yes, I did think of Sean but there was only room for one arcetypal Scottish working-class success story on the screen. It would have just been the sympathy vote.**

james **hullo**

DonkeyKnob **Simon, b4 you go. Where can we get the dvd**

james **i got told to come here. is it good?**

james **i'm welsh**

DonkeyKnob **Simon had some questions about washed up Skate**

Nikki entered at 09:54pm 25 Nov

ThrillMeister entered at 09:54pm 25 Nov

BigGeorge **Bout time Nikki**

Douglas_Fir **Hi Nikki**

Nikki **Hello George. Why do they call you Big George?**

james entered at 09:55pm 25 Nov

BigGeorge **Its a LONG story**

moira **he's a fucker by nature, he fished for fun, he had angling magazines by the ton, he had a firm rod and he knew how to use it, he'd catch a carp and then abuse it. if the fish were frisky you'd find him there, dippin his maggot where others wouldn't dare he invited my round for a fish supper thats**

moira **when i found out he was a fish fucker, that's from me dad vis the spoon**

Douglas_Fir **So Nikki - how is your uni course going?**

moira **hi nikki**

Nikki **I always find it amusing that men take it**

as such as massive compliment when one gets them all stripped off and into bed and you say 'wow, it's so big'. If a man said that to a woman, you'd go 'darling, well...no.....

moira **what you cock for tea was it hot?**

Nikki **I've decided against academia. I want to do something real, challenging and interesting and my recent experiences have convinced me i'm more of a hands-on person.**

Douglas_Fir **Hands on what though?**

moira **are you in the seven rides film? simon said he could squeeze me in for an audition, will it be hard?**

Nikki **Moria darling, Simon's being rather sexist, a deliberately provocative, if somewhat predictably juvinelle stance on his part and frankly rather dissapointing. I was stuck in traffic coming from Notting Hill. Unfortunately, there was no 'cock' for tea.**

Douglas_Fir **How do you feel about Sick Boy taking all the credit for the movie Nikki?**

Nikki **Well, if Simon's cocaine consumption continues to increase exponentially, then I fear a lot of will be in for a terrible dissapointment.**

james **um. did the conversation stop when i turned up?**

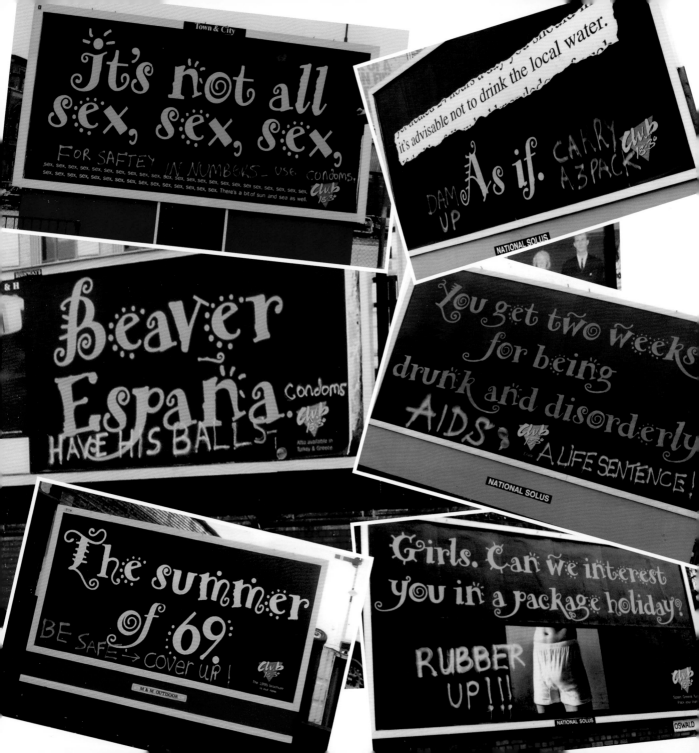

Scene	Breakdown		Pages	Artists
46A	EXT TERRACED HOUSE Antony knocking at a door Mr Joyboy, large Mancunian accent	D	2/8	1,14
46B	INT TERRACED HOUSE, LIVING ROOM Mrs Joyboy late thirties, wearing a baby doll sits on the sofa	D	7/8	
46C	INT MR JOYBOY'S POOL Antony frolicking with Mrs Joyboy and Verity	D		

Unit Call 0800
Est.Wrap:19 00 (reh/shoot)
Costume/Make up 1st call:07 15
B'Fast From : 07 00
Est. Lunch:13 00
Sunrise: 06.51
Sunset: 17.59

and worked at a massage parlour performing minor sexual favours for customers there. She had issues with her body and was bulimic. Attracted to Simon David 'Sick Boy' Williamson she decides to help him with his porn films by starring in it.

It all seemed to work well and then a while later I received a phone call asking if Moira would be interested in a small part in a BBC drama on sexual health. This, of course, was just up my character's street, plus it was being filmed in

the town where I was born but had never visited since my birth. I was cast as a swinger but they wouldn't let me wear my Moira wig. Instead, the hair and wardrobe women gave me a backcombed beehive hairstyle and I was dressed in black PVC and thigh high stilettos. The drama was called *Dose* and aired for the BBC as part of their safe sex campaign called *Come Clean*. I was really pleased to be involved in it, especially after the anti Club 18-30

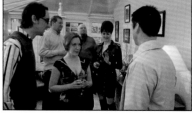

Holiday Campaign I had instigated in 1995 when they had been advertising sex holidays with posters such as 'Beaver Espana', 'The Summer of 69' and so on. I got a team together early one morning to spray paint safe sex slogans over the billboards which I felt should have been put on there by the advertisement company to make a responsible advertising campaign.

Dose was written by Irvine Welsh and Dean Cavanagh and directed by Philip John and told the story of laminate floor salesman Anthony Williams. The press release detailed:

'Despite loving his wife Rhiannon and being committed to Christ, Anthony has a string of adventurous sexual encounters, laying more than just the flooring for his female customers. But despite being ultra-careful and always wearing a condom – the theme of the social action campaign – he catches gonorrhoea from an unexpected source.'

'It's based on something which must, I feel, be fairly archetypal,' says Welsh.

As Verity, I was part of the swingers scene in the drama, where I soon found out I needed to kiss (long and passionately) Jonathan Owen, the main actor. As Jonathan put not one but two chewing gums in his mouth before the scene I just thought, 'shit! what do I do now?' It felt like I was about to be unfaithful to my

partner. It would also be witnessed by a motley crew of actors who were part of the scene. There was the woman playing an American cheerleader who was bent over in front of him having simulated sex and I was supposed to be kissing him while this was happening. I knew I'd have to do this or look stupid, so I kissed the side of his mouth 50's film style and thought I'd never have to see him again. Several years down the line and we are good friends: I've just been acting in internet viral show *Svengali* alongside him (also written by Dean Cavanagh and directed by Philip John). When I first met Jonathan's wife Eleanor she found it hilarious as I told her of my 'kiss' acting dichotomy all for the blink of an eye in a drama.

The moral of *Dose* was… 'always wear a condom and be safe.' It ended with the main character splitting up with his wife and heading off to a 'golden shower' party with Moira. I was pleased they put Moira's name out there, but with half the writing team being Scottish it may have been an obvious name to select. Moira Minguella, real and imagined, is more than a book's worth so I will stop here and start thinking how I will plot *The Men-oirs of Moira Minguella*. The starting point can be accessed here:

http://www.sanderswood.com/moira_minguella/

26-10-02 15:14:45 SAW YOUR NAME ON NME. COM RE BILL D PALYING CARDS! Dunst \ 29-10-02 00:47:28 HI TRACEY I JUST WANT 2 SAY YR A TOTAL & CONSTANT INFLUENCE ON ME XJ \ 30-10-02 12:36:46 HI T WHATS THE LATEST NEWS ON THE BALLOONS J. \ 06-11-02 12:00:00 Free msg: As a former text poet, we thought you'd like to know that Guardian Text Poetry 2002 in association with Orange launches tmrw. See guardian for details \ 09-11-02 13:18:44 Do u have pretty petes no? \ 11-11-02 00:28:41 j strummer on jools h talking bout his art \ 25-11-02 15:58:28 HI TRACE DONT 4GET 2 GO ONLINE AS MOIRA 2NITE WWW.SEVENRIDES.COM XJ \ 25-11-02 16:04:12 ITS PART OF IRVS BOOK PORNO X \ 25-11-02 16:08:50 NINE O CLOCK LOG ON & REGISTER IRV WILL BE SIMON DAVID WILLIAMSON IL B NIKKI FULLER SMITH GO 2 THE TALKING PORN ROOM X \ 25-11-02 22:25:47 THANKS TRACE U WERE FAB \ 12-12-02 17:31:56 Friendship is like pissing in your pants – everyone can see it, but only you can feel its true warmth. Thanks for being the piss in my pants! \ 13-12-02 09:11:31 lluvu my radio babe! \ 13-12-02 11:36:27 You don't know how well timed that was. . .moving 2 brighton is testing all our friendships. . . Some are piss and some are just shit! X \ 23-12-02 14:36:18 Eels slip down a treat \ 20-12-02 15:38:23 Joe strummer is dead! C \ 23-12-02 20:52:23 D'yu no joe strummer died 2day? \ 23-12-02 20:51:29 WOUNDS WEEP WITH A BITTER SWEET TRICKLE

making Svengali

31-12-02 20:02:09
00:03
00:02
00:01
00:00
(((((BOOM)))))
= * = * = * = * = *
happy
NEW YEAR!

JANUARY \ 01-01-03 11:54:35 Cia bello & bella happy MMIII. Lots of love A&C \ 02-01-03 10:54:13 SORRY YOU'VE BIN POORLY. DIDNT REALISE MY PHONE WAS OFF JUST GOT MSGE. WHICH SIDE WAS UR BROW STUD? HAV DONE PRINTS BUT OUT OF PRACTICE MITE B WRONG WAY ROUND! \ 02-01-03 14:11:03 what time work? \ 03-01-03 16:21:50 Do u need me bak 2nite babe? Or will it b ok 2 stay here again 2nite? No probs if u want me 2 cum bak tho \ 03-01-03 17:32:27 Thanx mate! Ur the best! Kiss Ur daughter 4me! xh \ 08-01-03 14:14:30 Hey hey txtn while slidin after mad nite at irus. Thank me and Jacob Marley 4 snowonsnowonsnowon....u around 2nite? X<mas again> xtdb \ 09-01-03 22:57:42 YEP POP DOWN SUN-U OFF ANYWHERE NICE?!-PS-THIS BLOKE-WAS HE GOOD LOOKING? IF SO GIVE ME NUMBER-AL THIS LYIN BOUT ON ME BAKS MAKIN ME HORNY!! X \ 12-01-03 01:09:54 ..txtd2joniwasa wayontues!reasonamawaynowcozlasttimewespokewas23rd! hadlotsaotherproblems 2sortinwiltshire..wont b able 2edit til wedpm... \ 14-01-03 09:28:31 Myself & Saoirse only stayed a few hours Saoirse got on really well with Andrews daughter i can't remember her name that's bad. Saoirse realy wanted t stay \ 15-01-03 09:20:43 Trace, u were rite, it is my thyroid! Glad i no wat it is now & that it can b treatd! Hope u had a gud nite las nite babe. If ur ocin food 2nite i can cum but \ 19-01-03 21:46:26 Helo Traaceeno howr things? What r u planningt do wit stuff of urs i have? Some mould is growing on ur carpet! Uu andrew \ 24-01-03 12:12:07 FUCKIN HELL TRACE THE LEGWARMER IS BACK ON THE STREETS! \ 26-01-03 20:25:26 Rich on loo a min .. \ 27-01-03 16:47:43 .. hi tracey just got ur msg am in mcr spent the aft trying 2sort out vid.. jon h, is gonna find a loop vid 2 morrow.. currently drinking coffee in Kro 2 jx..

01-01-03 01:07:14
. + " " + .
May I be
.+" "+.+" "+.
the first
.+" "+.+" "+.
.
+
2
"
+
. wish u
"
+
.
.+" "+.+" "+.
`. .'
+ Happy +
" New Year
+. ..+
" "
+ +
.

Pass this lucky willy (')
to 7 horny friends & ur //
SEXIEST DREAMS //
will cum TRUE! ())
Warning DONT
ignore or u'l hav
bad sex 4 7yrs!
Cant send back

FEBRUARY \ 05-02-03 16:46:29 TRACE I GAVE MY FRIEND CARL YR NUMBER HE IS PUTTING AN XHIBIT OF DIGI ART@WILDCAT GALLEY & IS GIVING ME A CAMERA FR MONTH BANKSY ETC ALSO INVOLVED \ 04-02-03 21:50:55 Hi – just released from hospital – had a heart attack last friday – big shock but i'm ok – love peace & happiness xxx \ 06-02-03 22:56:30 Hi ya tracey-I'm feelin good despite some pretty significant life changes –lol – mind u i was always safe cos only the good die young :) xxx \ 14-02-03 13:48:46 can we get a shout out 2 sticky nicky crusin round brixton town. . . \ 15-02-03 06:45:41 Are u going to the protest? \ 15-02-03 13:27:38 We r stil nr gower st. where u \ 15-02-03 14:55:20 lat bloomsbury st \ 15-02-03 14:54:16 Whitehall U? \ 15-02-03 15:06:56 hi tracey, we're at picadilly. not much chance of meeting anyone in these crowds though...ant \ 15-02-03 21:05:37 in the middle of nowhere in france txt me soon!! \ 16-02-03 07:05:50 hi mum in Zurich stopped off in the FREEZING weather-15 and snowing hard Get me there \ 16-02-03 11:53:12 just gone through st moritz and all rivers and waterfalls have frozen over!! \ 18-02-03 14:58:03 Someone from bbc wales will be calling you in nxt few days. If u aint heard by Friday call me. x Bob \ 22-02-03 00:53:55 U HAV 2 SNG ME A SONG ON MY VOICEMAIL-THIS IS GOIN OUT 2 ALL MY BITCHES-BEST ONE WINZ \ 24-02-03 14:59:26 Shadwell, are you having a welsh paddy on me? Have you wet the bed and been banished to sleeping in the cat igloo again? \ 28-02-03 23:12:37 Spooky shirt! I'm thinking cheese. Tredegar working mens club catatonia tribute band with all the trappings of valley chique. Lets do it \ 14-02-03 13:40:21 minguella rocks

MARCH \ 02-03-03 18:57:20 I AM DOWNSTAIRS \ 02-03-03 20:15:34 I'm in the bar! \ 02-03-03 22:43:23 Alabamas are about to play \ 04-03-03 18:30:17 How did it go with landlord? When is moira filming? X \ 06-03-03 17:00:32 Wow! U fuckin star! U like fab nobs? Hehe \ 11-03-03 17:12:12 WOT A LET DOWN IM HEADIN FR BRIXTON NOW 2 TAKE MASSES 0 DRUGS \ 11-03-03 14:21:32 Charlie is my darling \ 14-03-03 11:41:39 I Acknowledged u in my dissertation darlin & thanked u 4 all ur support! x \ 14-03-03 14:11:03 Got dr foxes producer to agree to play mwa single on pepsi chart show. Cool. If none of this makes sense ask a child. X \ 20-03-03 01:28:21 TRACEY THIS IS MAD IM IN THE BLOCK WHERE THE FAIRYS LIVE WITH ALL THESE GAY GUYS THERES SOME SERIOUS EGO PROBS \ 20-03-03 15:30:50 ERMM A NIGHT OF MAKIN LOVE & WATCHIN WAR AS IT TURNED OUT! \ 20-03-03 18:52:48 Lost house, not enough money. . .Going 2 rent. . . U up this sun? We r going 2 cannes to see my dad. X \ 20-03-03 17:33:54 IM IN PARLIAMENT SQ AWESOME \ 22-03-03 01:09:03 112a, teesdale street — shall we write lyrics xP \ 23-03-03 19:23:16 Clubbers in Yorkshire have taken to using dental syringes to inject ecstasy directly into their mouths this dangerous practice is known as E by Gum \ 25-03-03 23:26:04 Hello Verity! \ 31-03-03 13:01:24 WOW! CHEK OWT DA SUNSHINE!.. BAK 2 BIZNISS — D'YA WANNA MEET $ CWAFEE THIS WEEK SUMTIME ?...XM

APRIL \ 03-04-03 00:40:01 Sexy mad bitch! Show us ya knickers moira! \ 03-04-03 21:37:39 The more i think about dressing up as bobby crush the more i want to dress up as bobby crush \ 05-04-03 10:30:02 I fancy you? To find out who i am, call Now On 09061702469. POBOX 834 ME208WE150PM \ 10-04-03 21:27:13 Washing up lqd x 2 \ 11-04-03 21:47:43 Me tryin 2 get T 2 go bed : - (i gettin some gud stalky stuf 2gether xx c u mon. Ps no word from Will \ 11-04-03 19:11:01 calvin wants to get started on my portrait tonight... gonna try and sit still for that! play pool another time ok: mucho lovelies to u and all love sal x \ 14-04-03 18:37:46 what's gold teef doing with moira by the bins? \ 14-04-03 14:05:33 am working in the rosy.. fancy a bloody mary? love staggering barmaid \ 16-04-03 22:08:10 feeling like utter poo.. gagging all the way up the road.... could sleep for fifty years in a pool of sick.. err x \ 18-04-03 16:23:57 Moira in telegraph.Fab. \ 20-04-03 18:04:24 Nice, singing moira at bar of the week, well done! \ 20-04-03 20:20:50 AYE MINGA! I B IN SCOTLAND INNIT! WETHERS HERE WISH U WERE NICE! CU WEN I GET BAK YE SLAAAAG!X \ 22-04-03 10:00:23 how was rocking show kist night? writing til 3 am, croatia done. no got cred give me a call when can. love sal ps. read telegraph wot no champagne? \ 24-04-03 14:30:23 NOW A WORD FROM OUR SPONSOR bored? hungover? need a bloodymary? Coffee wit secret ingrediunti special spritzer? sometimesyou wanna go where every body knows your name .. \ 25-04-03 13:43:00 I think we are on about eight thirty. alabama's on after us. do you need guest places? \ 27-04-03 12:55:23 Wud u like 2 b in audience 4 radio 4 recording? today 6.30 @ the manor, all saints rd. off portabello.. no microphone, very intimate. me, john copper clarke love x \ 29-04-03 23:39:52 who is this john macmanus

MAY \ 07-05-03 18:43:36 if you have chewy ears, stinkywax and need a wicked aural fix, this is the one 4U! 11:30 - 1am SALTPETRE RADIO RESONANCE 104.4FM resonancefm.com radio friend x \ 08-05-03 17:25:45 French house, dean street off old compton street. 8-30. MWA \ 10-05-03 00:02:17 I think i just ate your kidney in a kebab. \ 12-05-03 09:48:15 party was pants, one drink and left. We be at foundry at about seven i call you when we outside have a good day. love sal x \ 12-05-03 14:31:05 Globo loco starts Friday on City \ 16-05-03 15:10:17 I woz on a date last nite. He turned out to be the bruv of big dave from toss the feathers!! there is a connection here am i correct? \ 17-05-03 01:59:49 Cwtch is turning Jasmine into a kitten! \ 17-05-03 09:03:49 I am outside where we stayed in the rain with a hangover. need a menthol vogue. X \ 17-05-03 10:30:42 hope it wasn't symbolic! Kirsten is having a 40 birthday party scary people will be there! \ 17-05-03 12:03:38 Kev said his granny is growing cabbages down your back! Wat u gdoing in da varlies? \ 19-05-03 17:31:34 Trace! Went 2 dom but shut. . . All memories coming back so strong. Got u some menthol vogues. Love u and the place we got 2 know each other. Wish u were here x \ 22-05-03 01:24:33 ok so long as we can talk about real things and not farty art?!? \ 22-05-03 01:51:19 Tracey cal Andrew on his mobile wit plAce u'd like to meet. I'd like t c u! \ 23-05-03 11:02:45 Anika got in2 Camberwell! Yeehah! Let the debt begin! \ 24-05-03 19:35:47 am hastings with a bag of live crabs a fisherman gave me.. back in london sun. night got big party wan come? love love x \ 26-05-03 21:18:16 London yesterday, dowlais top 2day, who knows - new york 2 morow?Cx \ 29-05-03 11:37:58 Tracey um having to give my furniture etc. Away t a charity as t space in garage is needed Do u want me t giveur things?

JUNE \ 03-06-03 07:01:51 LOVED SEEING U. J IS V EXCITED ABOUT NEW FAMILY! TNX 4 MEETING UP. WILL RING NXT WK. GOOD LUCK AT CHELSEA. xox \ 03-06-03 14:05:27 Dear Tracey, its akeim the photographer. I think i need 2 or 3 more artists from Shoreditch. I guess you can help me there!? Greeting akeim \ 03-06-03 22:22:36 We r getting it together slowly. . . love it here. . . lola sends love 2 auntie t. . . when will i see u? x much love x \ 05-06-03 09:28:29 Got hosp app 2day 4 thyroid & got 2 go fam plan clinic 2 get more pills, so got a really exciting day ahead! \ 05-06-03 12:18:51 Wow fifty years. . .when r u leaving flat. . .where u going? come and have a summer holiday. miss u as eva x \ 06-06-03 08:09:24 Have u a home yet? \ 08-06-03 21:02:21 a little story. . . 2day dunst bandaged up this young lad outside our house who'd nicked a bottle from the offy, and fell on it and cut his wrist really bad, and later when we got home, he'd left car stereo on the door step for us 2 say ta. . .!! \ 08-06-03 23:11:38 Do u not get good reception living under railway bridges? \ 10-06-03 14:16:20 Will stand by.. I wish you good luck and don't think about your space we are on it. The end. Staring John & Tracey \ 18-06-03 13:29:36 Me has loads of moira stalks! She out 2? Me ache from 2 much gym :-(cu soon Wilbert x \ 21-06-03 14:54:40 Sunday am bbc 2 smile, u get me, basil brush ant take our tu! \ 25-06-03 10:35:56 Thanks 4 voting for Nush. Reply Quiz to play the BB quiz, & win tickts to Fridays eviction party. Each Q costs25p+usual rate. 4+&c's see channel 4.com/bigbrother 85444 \ 23-06-03 19:03:38 Weds 2 july. P view of H=Z map drawings. AKA 18 West Central St WC1 6-8.30 inc. Electronic Elvis @ 8.30 Karen selby pls send e/post address 4 flyer \ 28-06-03 00:11:23 PORN+1 = IMAGINATION. Would like to know what yourself and the others think of this text 0798408****** \ 29-06-03 21:15:25 T* was in wales this dealing with big shit * its not a good time for me to talk so i apologise * maybe by the end of summer i'll be sorted and we can resume \ 29-06-03 21:16:08 I luvu even when im quiet! \ 30-06-03 10:24:36 Is possible to have the video by this friday. Im trying to compile all information about nunca mais to take it home with me. Thanks! Christina

JULY \ 10-07-03 22:14:22 \ Bring them to the wedding. Stuart \ 10-07-03 22:39:46 Who r u? \ 11-07-03 16:04:13 I'm in Greece 4 nxt 2 wks... call call into colony or post flyers to Michael .. 41 Dean St...hope it goes well! Kx \ 12-07-03 21:44:13 that postcard is fuckin disgustin – even i was shocked and nothin shocks me! \ 14-07-03 11:22:30 I just flyered John Charlie Wright in barclays \ 15-07-03 22:54:59 Kevin Williamson needs Big Bobs no. u got it? \ 18-07-03 09:29:24 STILL AS LONG AS YR VICARIOUS APPETITE FOR GOSSIP WAS SATISFIED EH! \ 18-07-03 14:39:02 I thought you would have appreciated the dilemma of needin to resist social events when you are workin hard and not add to the pressure xt \ 18-07-03 17:16:18 Bp! Its fuckin great trac so strong and gorgeous and wot a transformation to the space! And wat a laugh seein the signs opens 8,30 9...5 mins! Must have been mad. Off to banksy wi skye. \ 18-07-03 16:19:34 SORRY IF I UPSET U THIS MORNING WRONG TIME O DAY 2 TALK ABOUT EARS THAT BURN HOPE THE REST O YR SHOW IS A SUCCESS x \ 23-07-03 18:08:16 hey tracey just heard u gettin married...nice x \ 23-07-03 21:04:15 Sitting on my own in sandbar celebrating your engajment! J \ 27-07-03 21:17:33 um yup i fink so y in da aftas tho? wot time wl it b huni? txt m bk babez lu u loads xxxxxzzz \ 27-07-03 21:25:29 larst txt mw K but no i dn fink ee is but u kd b in da dubls? g2g nw txt me in da mornin k ganite x x x x x \ 27-07-03 31:37:19 u shud b marryin me in manc baby x \ 28-07-03 19:54:39 just gt yr txt n im disapointd but pppleeeaas cn we met up 2 mo2 txt ak x x x x x x x x x \ 30-07-03 14:10:00 Jus shown K the flat she loves it! Shes dyin 2 c u all x

AUGUST \ 01-08-03 01:12:17 Maurice is out on the piss up West. Call him tomorrow after 1pm................................. \ 04-08-03 20:13:02 I suppose u find it amuzing ignoring my calls do u? Well thats just about what i wud've expectd from a daft taffy with a cob-on! Buz wen ur bored then. x \ 05-08-03 12:36:05 E ee! My minge is kickin out a rite honk! Crab paste! \ 05-08-03 12:42:36 U fookin bastard! Gona hav a little bit of a fook with me landlord now.. Ola! Thats spanish 4 how do... \ 06-08-03 12:42:36 Listenin 2 The Libertines on radio, nvr heard em b4. Remind me of pulp – Jarvis Cocker xh \ 06-08-03 14:34:29 Can u put sun tan lotion On cwtchs ears, she needs it or her ears will brake \ 06-08-03 20:23:33 Highest ever temp in Central London today at 36°c No joke! Watch the weather tonight after 10 news bbc 1 \ 07-08-03 09:54:05 Hop u enjoying the heatwave in Costa Del shoreditch, gran Camberwelly is marvellous.. do u fancy pimms & tennis soon d'laing? x \ 10-08-03 14:07:29 Weather pissing it down and very windy at lands end :-) went for 3 mile walk at 9.30 this morning! Now off to-late. Wil do senna tomorrow depending on weather. Carolx \ 15-08-03 12:31:12 i am a goat \ 13-08-03 13:43:57 Live debut of my band 8.30pm 2moro (thur 14)@Catch 22 Kingsland rd. nr. Old St + L'pool st + 3 mor fab bands + poets + DJ til 1am £5/£4 if u txt me back SPOON \ 17-08-03 10:54:58 hi Tracey, whats goin on today at Foundry, is this bbq happening? xlaura \ 18-08-03 01:43:38 Eatin microwaved leftover cabbage in garvy \ 18-08-03 01:48:15 With added potato flakes. mmm yum yum \ 19-08-03 20:19:33 JUST FOUND NOTE IN LOFT – IT'S FROM U. ENDS WITH WHEN IM FAMOUS YOU CAN SAY – SHE USED TO DEFROST HER PRAWNS IN MY KITCHEN! XXJ \ 22-08-03 10:12:24 vernen has his van back, but it has no wheels. Sorting them out asp \ 24-08-03 11:01:01 Isn't it your Second loaf of bread isn't as important as your first

SEPTEMBER \ 31-08-03 16:49:25 Hey babe! We're round the corner from rs & theres a sky music channel filming. We're jus about 2 c gareth gates! Mad innit! xh \ 01-09-03 22:17:53 U really r the best mate ive ever had & i love u loads. I cant thank u enough 4 wot u r doin 4 me. I'll cu 2mrw & give Kiz a huge kiss goodnight from me xxxh \ 02-09-03 23:53:23 Giv Kiz a huge hug n kiss from me n tell her ill fone 2 mrw. Thanx pal xx \ 05-09-03 11:28:25 Have u got any ibuprofen? \ 04-09-03 09:34:13 Hello taffyit, tank u 4 loverly message u soppy twat. I will bring my baby down to cu 4 a smashing weekend of drinkypoos soon. Glad u is very bardoed. Luv Niky \ 06-09-03 00:32:55 Hi darlin. Jus had a hour long chat with anne & andrew. im really missin them. Anne sed 2 say hello 2 u. Hope ur ok babe. Ull get through this ur the strongest woman i no! Forge ahead trace with every thing ur doin the rite thing. Lts love h x \ 13-09-03 10:24:44 hi babe lovely 2 cu just sorry we didnt have more time. Can not undstand how u always manage 2 look exactly the same. thanks 4 comin will ring u tonite \ 13-09-03 10:35:53 bout 15 came back they went on till bout 5. i slopd off at 3. up at 7 with alex + found my mate jan asleep in garden in hammock. dad was talkin 2 yr dad tdayx \ 14-09-03 21:25:54 Better still, moira & maureen shud go n show their arses... he'd love that! \ 14-09-03 21:32:01 Naa, id like the daily sport 2 get them, its so much more credable i dont want maureen in the news of the world! \ 14-09-03 04:14:58 U run out of space there. Where's it travelling to? Wanna do pizza show. interested? \ 15-09-03 02:16:38 I THINK ABOUT YOU ALL THE TIME \ 17-09-03 22:35:53 JAMROZY PRESENTS PARASTITIC PROTOCOL PORTFOLIO @ GOLDSMITHS LAURIE GROVE BATHS THURS 18th 15.00-20.00 FRI 19th 13.00-18.00. HEAR SOUND OF ARMS TRADING REAL TIME \ 19-09-03 21:27:49 what is happiness? What makes you happy? Big questions......, am bit pist having left work at 7.45 and nefing gin : -) cx \ 20-09-03 01:05:50 Nice 1 tart face xh \ 28-09-03 02:14:40 Nite Nite then : -) cx \ 30-09-03 18:39:23 Sory 4 getin shirty but a_ bein a complete cow n nasty n im feelin double pisd off so any 1 else putin slightest bit of pressure on making me edgey! Sorry trace jus need 2 clamp rite down on my brat of a daughter. Cu 2mrw nite? x

OCTOBER \ 01-10-03 19:26:04 where the maddies \ 02-10-03 17:07:40 Wil hav 2skip radio show 2 moro 2 sell sarnies - wil try2negoti8 altarn8 weeks (atleast) asap \ 02-10-03 09:41:57 Quite pissed. Went to el passo with hainsey. Bought a hammond organ yesterday. Finishedo and 1 mix. Tutty down plugger comin on radio 2morrow? \ 08-10-03 01:20:57 Did i know m has a stalker? !!! Cx \ 08-10-03 18:58:46 Please dónt forget 2 email me an image of bills at least so i can get it 2 id magazine if uve posted it text me either way 2 let me know the crack ta jo x \ 09-10-03 19:43:34 Cant do radio 2 morrow. Shame cos yes are one of my favourite bands. Speak after. \ 15-10-03 07:44:39 Hey tracey, been thinking about u & the big move... hope it wasnt 2 stressful & u toasted the 1st nite in with sum vodkaxx \ 14-10-03 22:18:52 Aye, more than u fookin no! And a fookin good shagin wudnt go amiss eithr!! \ 14-10-03 22:22:27 Yeah lets go radio rental!! \ 16-10-03 19:12:18 Sorry I haven't been in touch for a while. I was rushed to hospital to have a dangerous mole removed from my fanny. Wont be shaggin one of those again! \ 17-10-03 09:13:56 Good luck in your new home lots of love a&c \ 17-10-03 16:24:44 Live DJ sex at the foundry old street tonight friday. Come and join the musical orgy. No charge. 7-11pm. Snog louise, frank or jim and get a free louise tickle \ 21-10-03 20:31:53 Hi there, you ok? What do you want to do about the stuff at my brother house, he want it out of the way. Anyideas? \ 21-10-03 15:58:57 Please dont forget the alcohol spons ideas & numbers xta jo \ 25-10-03 13:04:31 The number for Absinthe is 011992511*** and ask for George. Cheers karen xx \ 31-10-03 01:25:35 Had to split. That club was really shite. Had several unfavourable flashbacks. Good night, though. cheers. See you soon.X \ 31-10-03 14:03:08 what length?

NOVEMBER \ 01-11-03 23:51:59 Beer can darlin! Yeah i'd b cool 2 hav u here, may c u 2 mrw. Lots of luvio xx \ 06-11-03 19:14:31 Ear dolly bird! Wot street u on 2nite?x \ 07-11-03 19:11:16 JUST ON R WAY INTO CAERDYDD 4 THE RALLY ALL THE SIGNS HAV GOT FUNNY WORDS ON THEM XX \ 10-11-03 16:51:11 hi yep dats fine. so hope u feel beter soon,sounds abit of a scary one. mayb ur'l find some fineart inspiration frm ur tropical poorlynes! take care+let me kno h sn \ 08-11-03 20:32:19 God, poor petal sounds horrible, hope u feelin better soon. I prob wont go up 2 foundry 2nite but wait 2 c it wen u there. Speak 2 u soon XxX \ 11-11-03 18:34:00 GRAFTON DIED YR AGO Y'DAY WE OK. DID U KNO DAVE WRKING AT ASDA? HE S WEL FED UP WITH IT BUT NOT QUITE 2 MOCKRIDGES LEVEL! DID U GET ILL ABROAD THEN? XX \ 11-11-03 20:56:15 R your briks @ poetqy caf ,4 how long & ru better poor love. Sat went great but missd u! \ 17-11-03 19:25:13 Yeah no prob, K askd if uve seen her brown trainers coz she nds em 4 pe 2mrw. Let me no babe x \ 18-11-03 13:06:22 From Dec 1 it will be an offence to use a handheld mobile while driving. Stay safe & legal. Only drive with a hands-free kit. See www.t-mobile.co.uk/driving T-Mobile \ 21-11-03 09:37:30 Yep. I'll bring some fotees of me crispy foot to show everyone. Tee hee \ 22-11-03 00:38:48 No.. Ooot with Nicky Jaix \ 26-11-03 17:27:24 I am sat in Poetry Cafe avin glass of wine! Date went well we went on Eye & 4 meal & grand tour of Lonson. R u at Foundry tonite? \ 26-11-03 17:34:35 He is American livin in London. C in im 2nite will go to Fdry will txt u when on way? I'm with Bob the builder now he luvs ur bricks x \ 26-11-03 19:16:32 1st TONE FREE! Take ur pick, text SELECTA to 8007 and every wk we'll txt u a choice of 3 nokia tones 4u to download: getzed.co.uk 16+ POBox36504W45WQ norm 150p \ 27-11-03 08:07:32 U txt me just as we were Snoggin sayin good bye. It went well again he wud like me to stay longer! Who knows Ldn or L.A.? I will get to CU soon xx \ 28-11-03 15:35:18 Cooja ask laura norda if she wants an invite 2 santas gehto private view? Great show las nite \ 28-11-03 15:54:01 Opefully some 1 will drop em into the bar. I've got lots for u. Mite pop in meself 2 nite.

DECEMBER \ 05-12-03 12:41:02 Bill.s looking very worried today. He knows you.re talking about him \ 05-12-03 17:00:40 Have risen from my rancid sleepless discomfort and mountains of tissues to find myself in a cold art space once. Did show go well? Mr sparkle said he came down but couldn't get in \ 06-12-03 11:17:26 Update: The lungs have turned to cement, throat closed down to a mouse nostril, central nervous system collapsing. It must be the weekend! \ 06-12-03 15:38:27 We just seen yr womb \ 06-12-03 18:00:07 Really need 2 sort this out non aggressivel or horrible but feelin a bad person & wana justify my actions n needin understanding... \ 07-12-03 19:41:12 Ta so much, having lovely champagne x x x cu soon, the bruces x \ 10-12-03 16:31:34 LIKED THE SHOW. BEYOND PORN. GOING HOME NOW LONDON'S DOING ME HEAD IN. C U SOON. PAUL \ 14-12-03 14:04:15 Need u-fallin in-in-in-luv wit u-??! X \ 16-12-03 00:02:42 Why is christmas tree better than a man? It's always erect, stays up for 12 days and nights, has cute balls, and lookk good with the ights on! \ 17-12-03 07:26:39 T I'M EMBARRASSED. BUT LIFES TOUGH HERE AND SOMETIMES I FEEL ALONE. I DON''T KNOW HOW THIS IS HAPPENING. I THINK I-LUV-U XP \ 19-12-03 13:52:55 Hi, really lovely 2 cu. it was jst like old times, so much i didn't gt the chance2 say.bt im so glad we av our friendship bak on course, ur v. special2 me+im sory i.. \ 19-12-03 13:55:05 i wasn't there 4 u wen u went throu al that shit.so lookin4ward 2 meetin up again-wid kids too.lots love sX \ 23-12-03 13:26:02 Electricity Comes From Other Planets live @ 1.30am tonite @ rhythm factory, whitechapel + LIBERTINES + BILLY CHILDISH 8pm-4am £5 entry if u txt me back \ 25-12-03 03:58:19 I miss u t. happy xmas Hope 2 cu soon. love. P \ 25-12-03 09:26:18 Happy Chrissy Shadwell. Luv to everybody.x (i got a hangover and my eyes hurt)! \ 31-12-03 12:10:08 Howz life in th bethnels? Had a grt xmas i hope! Its bin gorg n relaxed here but we're both sad coz sn bak 2 wrk agen! Gona hav 1 las blow out 2nite! Spk l8r xx \ 31-12-03 23:17:59 Slappy New Queer!

As we rolled into 2003, I was receiving around 300-350 texts per month. It has taken me months to transcribe my text messages from my handwritten notebooks to computer. I have chosen seventeen to represent each month by a process of printing them out and and randomly selecting each with a pin. This follows the continuum of the book where I've selected seventeen texts to start and end each chapter. As new people were coming into my life my mobile phone text message box needed emptying at an alarming rate. I did this by handwriting them into whatever selected journal or notebook had been given as a present or bought from the latest stationary shop for that year. Some of these new friends stayed, others left almost as quickly as they came. As testament to some having entered my life, there was a sporadic infusion of text messages into my text books. Some have faces etched in my memory whilst others are only the words they left me with. The journals became diaries in construction made solely from other people's words and sentiments, the perfect place to locate happenings and events entering and leaving my life.

My work revolved around three main exhibitions that year in Manchester and London. Two were group shows, the other solo with invited group activity in the form of performance poetry.

Between January and February, I was part of an arts coalition that exhibited at The Holden Gallery in Manchester, under the exhibition heading of *The War Effort*. My exhibit within the group show was titled *Time Bomb*. The exhibition had been prompted by a speech given by the then US President George W. Bush to the United Nations General Assembly on 12th December 2002. The speech argued that the Iraqi Government of Saddam Hussein was violating UN resolutions by producing Weapons of Mass Destruction. The work that formed *The War Effort* exhibition was devised by a collection of eight artistic responses across media and histories to the culture of war. *The War*

Effort tried to achieve its stated aim, a 'collateral cultural damage' through articulating a human thoughtful intelligent and creative opposition to the spectre and spectacle of war, with the shutting down of dissent as one of its consequences. Exhibitors were Clare Charnley and designer Andy Edwards, lecturers from Hull School of Art & Design; photographer Casey Orr; ex-serviceman 244497531; John Hyatt with whom I'd first entered the Foundry and stayed; Disinformation's Joe Banks; Bill Drummond, and myself.

My work for this show was a continuation of the *Silent Protest* performance I had worked on with Bill Drummond in October 2002 when I had attached bags of opium poppy seeds to poetry balloons, which would self-sew wherever they fell. My rationale for the construction of this activist arts performance began by looking at the early eighties when there had been a huge influx into Britain of high grade heroin from the Middle East; a useful commodity in times of turmoil with it having five times the value of gold. According to the UN Crop survey in 2002, 90% of all heroin sold in Britain originated from Afghanistan. I began battling with the hidden issues surrounding the victims and weapons in relation to the heroin commodity. The balloons were whipped up like missiles launched under darkness until they unloaded their ammunition of little opium bombs over London and into the surrounding countryside, exploding as they landed scattering more of their seed debris.

With documentary photographs of this action I'd constructed a series of twenty-five clocks split into five rows. Each series of five clocks with the same image from the performance was set to the time in a relevant warring city. Kabul, New York, London, Baghdad, Moscow clocks were all running on the current time in their respective countries. Below the clocks a shelf was positioned upon

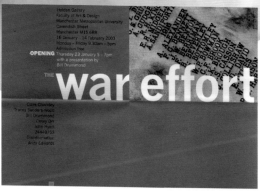

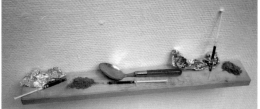

which heroin and the apparatus used for ingesting the drug were placed. The accompanying exhibition text read:

> Then maybe we should count the time on the clock that takes us into Britain's next war with our American allies and ponder in thought on why twelve months after the 1990-1 Gulf War ended it was Britain that sold Iraq Pralidoxime – an antidote to nerve gas which can be reverse-engineered to create nerve gas – and why the US sold Iraq anthrax, vx nerve gas, West Nile fever germs, botulism and salmonella. My factual sources have been supplied by the Guardian newspaper October 26th 2002 edition and the Observer 5th January 2003 edition. Do you believe what you read in newspapers and absorb from television news programs? Is it in the interests of the American government to see mass consumption of heroin on the streets of Western cities? Afghanistan's only cash crop proceeds are from the global distribution of heroin. Do they eventually find their way into the Afghani farming sector which supports 200,000 workers? Does a cut go into the coffers of local Afghani warlords (peace barons)? Will they continue to support Hamid Karzi as long as the money flows in? Is this true? Are British and American dead junkies becoming silent war heros?

> I DON'T KNOW… Do you? . . .TIME WILL TELL …

Public opposition was growing against George W. Bush's speech and the imminent invasion of Iraq. Co-ordinated protests were organised across the world on February 15th 2003. Sixty countries took part in an anti-war rally. The Rome protest is listed in the 2004 Guinness Book of World Records as the largest anti-war rally in history with 300 million people taking part. The airwaves must have been clogged in the many cities where demonstrators and participants gathered, texting friends, family and colleagues of the different meeting locations en-route.

My mobile phone didn't stop bringing me texts from friends who'd arrived from all parts of the UK and Ireland to take part in the London rally. The indirect road to peace was closed after Parliament shamefully rubber-stamped war on 18th March.

Life around me had started to become far more radical and political than usual. Banksy was doing things with us in the Foundry and had started to take the UK by storm. His work was amazing both in artistic execution and socio-political comment, his humour making up a strong part of his genius. He was also joined by Brooklyn-based artists Faile. Towards the latter part of the year, I was introduced to activist and comedian Mark Thomas. Mark had recently completed a documentary for Dispatches on Channel 4 called *Debt Collector* focussing on the creation and profit made from Iraq's world debt. Mark wanted to put on a wrap party following the end of filming and the release of the program the night before it was aired on TV. The Foundry was the perfect location for this.

TM > Mark Thomas
27 Jun 2010 02.24 PM
Text me as soon as you've booked tickets & with times & stations. What is the reason for this specific date?

Mark Thomas > TM
27 Jun 2010 04.20 PM
4th July from Kings Cross to Harrogate, 10am arrive 1.38. Home 6.30 arrive 9.47 pm. Date is Independence from America day. No to the militarization of space no spying and yes to Democratic Control. Tickets cost £80 return. Have got them sorted and Booked

TM > Mark Thomas
That's great & I'm looking forward to it. Do you want me to bring my camera with me for any press things? Did you see my last Saturday times double page spread photo in the Saturday times review section? It's my biggest to date. I'm interested in space ownership from 1 meter upwards… & due to do more balloon projects in September…

Mark Thomas > TM
No mail me links please.

TM > Mark Thomas
Ok will do when I get home looking out on parliament at the moment at St. Thomas' Hospital

**Faile artwork,
Foundry corridor**

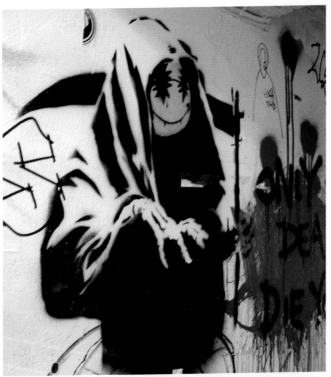

**Banksy artwork,
Foundry corridor**

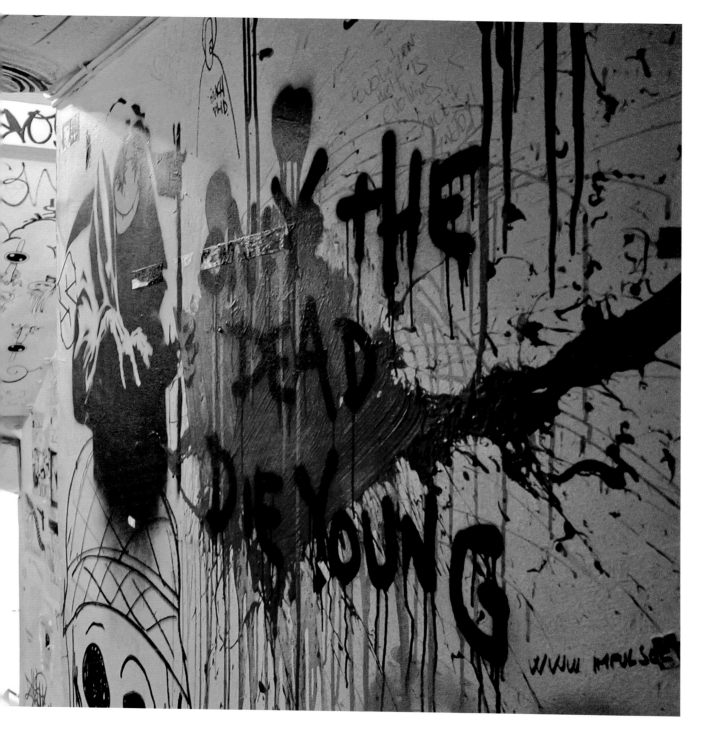

Mark and I got engrossed in conversation and quickly learnt that we'd both used missiles within our respective projects. Mark had obtained a missile and presented it outside Westminster Abbey with the words 'Blessed Are The Meek' written on it. He had paid for his – I had obtained mine free and the word 'COCK' had been inscribed onto mine in Russian. With a lick of my index finger, quickly followed by the finger drawing a vertical line downwards in the air, we became great friends, with the future holding collaborative projects that we would devise and work on together.

The timeless preoccupation with the weather in the UK had started to infiltrate my text messages, as mobile phone service providers supplied packages offering yet more free text messages. Texts grew longer, contained more idle thoughts, statements that would never have been uttered in a phone call or face-to-face.

My alter ego Moira Minguella began a musical collaboration with Ian Thompson (a musician in the Mike Flowers Pops band) and his alter ego, Maurice Potts. It was the rotting and missing false teeth in their jaws that brought the musical collaboration together. Maurice could seldom hold his saliva in his mouth when a whiff of excitement pervaded the dank air. We made a few singles together, one of which – *Jerusalem* – was played on *The Pepsi Chart Show*. Moira went on to appear in the Telegraph magazine courtesy of photographer Boris Bags, and suddenly the new concept of having a stalker was born within my textual encounters. Moira gained a stalker by the name of Wilbert, which was funny and creative, but a month or so later, so did I. This was an alarming concept and something I was unsure of how to deal with. It's worrying when you know the person. It puts one not only into a threatening situation, but also in a position of great responsibility. Especially when the person's mental health state is questionable or fragile, one wrong word or a complete blank could have a catastrophic effect on the perpetrator.

My next main exhibition of the year was called *Beyond Pornography*. This was a project I had been working on for a few years: it was featured in *Flux* magazine in 2000; *Sic Adventures in Anti-Capitalism* by Chumbawumba in 2002; *Five* Magazine by Gavin Turk and other publications. In early 2003, Craig Cooper, originally from Manchester, asked me if I wanted to take part in a group show

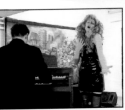

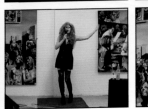

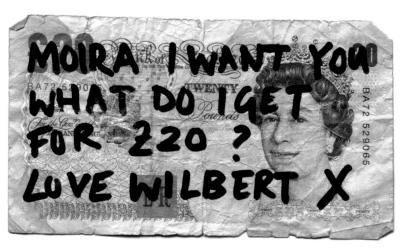

called *Beyond Porn*. I explained to him that as I'd been working on a similar title, *Beyond Pornography*, since the mid 1990's I would love to. I invited Bill Drummond to be part of the show as he had a project running called *youwhores. com* which would fit the exhibition perfectly. Another friend, Nick Reynolds, exhibited along with two new people I was introduced to called Jo Holland and John Logan. This was first exhibited in the Foundry in July of 2003, followed by the Dray Walk Gallery in Brick Lane, Shoreditch and then the Nancy Victor Gallery in Charlotte Street in the West End. My section of the show, *Beyond Pornography – Invasion*, was a slice through a twenty-seven year-old woman. It explored the female form from the inside, with a twist. It told a visual story of new life, love, marriage, cancer and murder. The images were pink X-rays on canvas, showing a healthily developing foetus shadowed by death in the form of a cancerous tumour and the struggle to be allowed to give birth to the baby near to full term. I designed the flyer for the first show, which probably remains the most horrific imagery I have ever used; it was of a weightlifter lifting a weight,

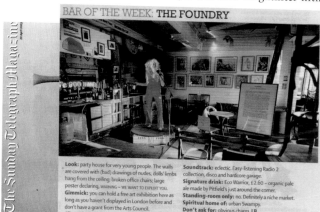

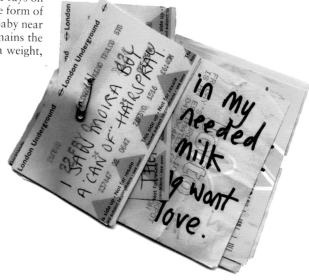

his red leotard torn, his anal prolapse bursting through on full view. It gained much attention and brought more people into the show for the horror factor I think. Moira Minguella had a line of organic beer supplied by Pitfield Brewery and Moira's Arse Ale was launched with the show, selling well. When this show was launched at the Dray Walk Gallery in Brick Lane, it was the same

week that my stalking texts started and he had been to the exhibition, which made me feel very uneasy and unsure on how to deal with the situation.

Channel 4 and other stations had been using texting as a means of distributing information along with a very profitable interactive text service on shows such as Big Brother. The charge for sending a text was far higher than on regular personal phone tariffs. Aspects of popular culture TV shows, especially comedians with their catchphrases, were finding their way into ordinary text language with regional dialects across the UK being incorporated into standard text-speak. The comic character Ali G had his own text converter, translating texts into Ali G speak. The TV comedy show *Bo Selecta* was a prime example of this too, and in 2003 sayings from shows were frequently appearing within my ordinary text messages. These continued throughout the year, the most memorable being, 'Eee! My minge is kickin' out a rite honk! Crab paste!' which was based on the 'Scary Spice' character in *Bo Selecta*. This text came from my friend Heidi who looks uncannily like the real-life Scary Spice. Text flyers were also peaking in frequency. By maximising the numbers of characters in a text message this was a cheap and easy means to advertise bands, parties and events.

I concluded 2003 with an exhibition and night of aural performance at the Poetry Café in Covent Garden. The artwork I was exhibiting was a poem titled *We Breathe Each Other's Breath* that I had written in 1999 for a publication called *Stalk*. A collective based in Manchester called Brass Art had initially commissioned myself along with art critic and poet Sue Hubbard to contribute. Soon after it was published I made a number of bricks at a brick factory in Leicester where I sometimes worked on large brickwork commissions for buildings. I sculpted the poem into bricks, and then proceeded to exhibit the brick artwork across the country. In 2001 I had been invited by Gordon McHarg to take part in an exhibition in London on a tube train with forty-one other artists and exhibited the brick poem and artwork. The hype and publicity for the show was great and it had coincided with the date we'd moved to London. The exhibition posters displayed a photo of each person taking part in the show, and I saw numerous photos of myself along with fellow exhibitors emblazoned on every wall in every tube station; it was surreal. It was a lovely welcome into England's capital city.

Art Tube 01 was billed as 'London's First Rolling Art Exhibition – 42 artists, one Piccadilly Line tube train'. There were several artists exhibiting in each

TM > Martyn Ware
29 Jun 2010 11:49 PM

Are you bck yet? Did you have a good time? Fantastic photo that you sent. I've had lots of problems here from the fallout of the Foundry closing, to it being squatted (I'll send you a link to yesterdays BBC news on it later) my mum falling down a full light of concrete steps/ hospital (miraculously not breaking anything) & other stuff so my book is a few weeks behind deadline. Please could we altar the date for the recording? I will be more together in a few weeks & can then focus 100% is this ok with you? Or have you booked somewhere?

TM > Martyn Ware

Ok when I get back home to my computer I will send you dates (all is pretty open for me once I've finished writing) I'm really, really looking forward to starting this project off with you. Just writing about you now x

Martyn Ware > TM

That's not a problem. Hope you get through this tough time ok New York was mad Over 90 degrees every day Nonstop partyyyyy I now feel like a zombie Give me some dates Love Mxxxx

Martyn Ware > TM

Cool

a poetry in brick exhibition by

TRACEY SANDERS-WOOD

we breathe each other's breath, inhale the dust of each others flesh... in the city...

6 november – 3 december 2003
the poetry cafe
22 betterton street
covent garden london wc2h 9bx

opening thursday 6 november 7pm
with an evening of spoken word, readings and rants (filmed and incorporated into interactive section of the exhibition...)

hosted by Salena Saliva Godden words from Ant the Rant, the Worm Lady, Phil Dirtbox, Grassy Noel, John Chris Jones, Marcus Downe, Richard Niman

We breathe each other's breath
Inhale the dust of each other's flesh
in the city…

Interweaving we follow our personal journeys,
the boy, girl, man, woman, anonymous lover,
brushing shoulders elbow to elbow
office clerk, dustman, murderer, mugger
as we breathe each other's breath
Inhale the dust of each other's flesh
in the city…

Remaining anonymous living only five feet apart
above and below strangers undergo daily life
as we navigate our way through tangential journeys
following the flow and flux of city centre strife
as we breathe each others breath
Inhale the dust of each others flesh
in the city…

ART-TUBE 01 **WE BREATHE EACH OTHER'S BREATH** **Tracey Sanderswood**

The biometric heiress collects, processes and stores as
surveillance techniques follow the complex system of codes
questioning the traveller the observer is observed
as an unknown threat or phobia on most of our roads
as we breathe each other's breath
Inhale the dust of each other's flesh
in the city…

Anonymity surrounding we arrest ethereal presence
as the creator of our narratives - imagined or real
any chosen soundtrack a cacophony of stimuli
we are the authors of our own lives as toe follows heel
as we breathe each other's breath
Inhale the dust of each other's flesh
in the city…

Dissolving into each other like an unknown 'double-life'
transposing private places, gestures and routines
a fetishistic activity from an anonymous encounter
explores our everyday experience of fantasy and dreams
as we breathe each other's breath
Inhale the dust of each other's flesh
in the city…
in the city…
in the city…

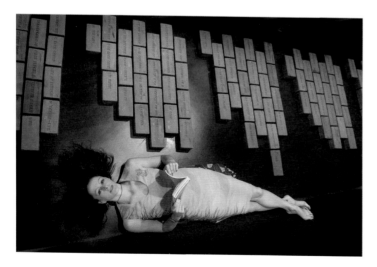

ART-TUBE 01 **WE BREATHE EACH OTHER'S BREATH** **Tracey Sanderswood**

ART-TUBE 01

CATCH US IF YOU CAN

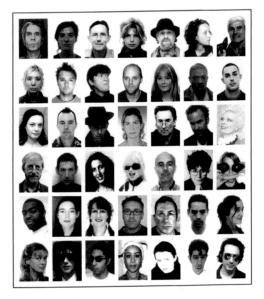

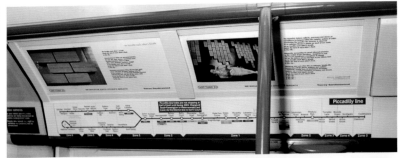

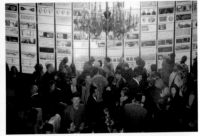

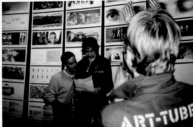

London's First Rolling Art Exhibition
42 Artists -1 Piccadilly line train
Running from 1 November - 1 December 2001

For information on the Platform for Art series, please e-mail platform4art@email.lul.co.uk
For more information about Art-Tube 01, visit the website www.art-tube.com

SMASH Bloomberg UNDERGROUND

ART-TUBE 01

Jamie Reid Fiona Banner Dick Jewell Tarka Kings Richard Niman Beatrice Dillon GT
MissFX Juergen Teller Lucy Jones Gavin Turk Peggy Atherton Richard Muyiwa Chris Landoni
Alessandra Travagliati Joe Rush Paul Simonon Vinca Petersen Colin Self Charlie Baird Vivienne Westwood
John Chris Jones Aidan Hughes Zineb Sedira Pam Hogg John Dunbar Yoko Ono John Spencer
Faisal Abdu' Allah Natasha Laflin Tracey Sanderswood Damien Hirst Mekons Barry Kamen Raksha Patel
Tessanna Hoare John Cooper Clarke Shez 360 Hanan Magou Corinne Day Duggie Fields Gordon McHarg

carriage of the train with artworks occupying the spaces that usually housed the advertising campaigns on the London Underground. I was in carriage number 5 (using my previous name, Sanderswood) along with Damien Hirst, Faisal Abdu' Allah, The Mekons, Natasha Laflin, Barry Kamen and Raksha Patel. The images I used were of the brick poem laid out in stanzas across the floor with me laying flat beside it. It travelled on the Piccadilly line for a month.

There was a grand opening press party for the Art Tube exhibition. I framed and used my images from here, along with an actual line of the bricks, for the poetry Café exhibition that concluded 2003. The opening performance was hosted by Salena Godden and Marcus Downe with many of the people present from *Art Tube 01* who had become a big part of my texting culture and who performed poetry on the night. The poem has since become a bigger project with each line of the poem becoming the banner title for individual projects:

> Anonymity surrounding we arrest ethereal presence
> As the creator of our narratives – imagined or real

As I took down the show and transported it home I kept forgetting about a text I had received on 18-11-03 at 13:06:22 from my network saying it would be illegal to use a hand held mobile whilst driving and that this would come into effect on the 1st December 2003. Nowadays the thought would not enter my head to hold a phone or text as I did whilst driving at the same time, thankfully how quickly I became conditioned.

On New Year's Day 2003, the number of text messages sent in one day in the UK topped one hundred million for the first time. Annual SMS totals: 1999 – 1 billion; 2000 – 6.2 billion; 2001 – 12.2 billion; 2002 – 16.8 billion; 2003 – 20.5 billion.

JANUARY \ 01-01-04 00:48:52 Bo! Peace to y'all in 2004. Sound xxxx \ 01-01-04 14:30:18 KNIVES = LOW LIFE SCUM. HOPE EVERYBODY OK. XP \ 01-01-04 19:25:10 Still up the country the country init, communicate with carrier pigs down 'ere. Love to soon tho. What's the words I may well entertain meself see if i don't. \ 01-01-04 19:29:09 Errol Ayn? That's not proper! You've been watching too much christmas tu you have \ 02-01-04 14:39:53 No prob on witness front. Give cops my details and i,ll do what i can \ 05-01-04 16:06:28 1991? Mobiles didn't even been thunk up in 1991 are it? \ 09-01-04 14:33:31 Charlie has farted on bus. People are looking uncomfortable. What.s morags surname? \ 09-01-04 20:59:05 Excellent my egg slicer makes a pretty good sound like a mini harp ... \ 10-01-04 07:10:03 TRACEY. WOT HAVE U DONE 2 ME. CANN'T STOP THINKIN ABOUT U. XP \ 13-01-04 16:57:56 I'm home safe love young trout \ 14-01-04 02:54:37 I LOVE U xP \ 16-01-04 22:06:17 Aye o' corse! But wot does 'cwtched' mean?X \ 17-01-04 11:32:51 Sorry luv-was on a course-sounded a bit glam - lester sq n'al dat - was tom cruise there?!X \ 20-01-04 13:14:29 Maurice works at the inland revenue in euston. He rents a room in a house in croyden. I have seen him in the lift. \ 23-01-04 20:59:20 Grandew Dad \ 27-01-04 17:27:55 Are u sure u give us the frog? Can't find it. \ 27-01-04 21:08:19 Methinks we never got the frog, linx is double checking at home. Sure it's not still in t'foundry. 'cos we never actually looked at it, and lets face it we woodna woont we?

FEBRUARY \ 01:02:04 03:43:42 Hey trace, ta 4 tha thought darlin... didnt get that far 2nite tho... only as far as nicks! Its bin a real day... loadin van ... nxt time im gettin in the remours! Cu real soon now im almost a ldnr! X \ 01-02-04 15:59:25 All done... Yeeeehah! Nxt... the drive back to manny... Boooooh! Wil txt wen i reach xxx \ 03-02-04 09:12:10 Bloody hell trace you Are the quickest texter i know I just call u SMOKING FINGERS TRACE X \ 03-02-04 13:17:40 Sorry about that will try 2 get it right on your postcard From GOA on the beach in the sun life a bitch init x \ 03-02-04 09:08:21 Hiyah slag bag! Ran out cred las nite jus got more. Hope ur gettin on wi ur phd lady! K still feelin ill stayin off 2 mrw!X \ 05-02-04 15:15:03 I WAS ON 4TH BOTTLE O RED WINE LAST NITE SO INCAPABLE O ANY OBJECTIVE INSIGHT OTHER THAN MAGIC I THINK JR IS GOD & THE EVIL IS STARTIN 2 SEEP THRU JORDANS PORES \ 05-02-04 20:23:14 If ur talking 2 mark can u check bijoy's email address - i havnt got a rply yet \ 05-02-04 20:25:40 Also - thing in guardian re ma"m s arrest at jubilee \ 07-02-04 13:57:48 ARSES! Had fekin hangover al day ystrday - ARSES! How ya doin anyway chikydee? X \ 06-02-04 13:40:48 Think ive got radio show tuned in, u go girl! Hope its' goin well x \ 16-02-04 11:57:11 HI TRACE I LEFT SOME 7 INCH WHITE LABEL REGGAE SINGLES BEHIND CUD U ASK J 2 STORE THEM PLEASE & HAV U SAMS NUMBER? X \ 16-02-04 15:20:12 So far so good lets meet at the vibe bar. Then walk over to the cafe \ 16-02-04 16:29:44 Glad you could make it and with your lovely lads! Will be at daisy,s screening on wed so maybe see you there? N \ 19-02-04 17:44:21 tracey feel awful about deserting you in the loos. hope you had a good time and let me know coca cola details asap xDunst \ 19-02-04 18:26:12 Ok yeah wud b luvly! Always remember ... in my house i am de DENERAL! x x x \ 23-02-04 19:20:35 Ay fanny fart! U stil up 4 that gig? is it this week? Or as i mist it?X \ 29-02-04 19:24:44 Gavin in independent 2day

MARCH \ 01-03-04 14:04:32 Happy st. Davids day xP \ 02-03-04 12:46:57 Hi tracey hope you feel better. If your up to it id like to meet up for quick chat bout resonance exhibition. Jason \ 08-03-04 17:40:55 Happy international wimmins day \ 11-03-04 15:50:57 Hellooo... r u out there down th bethnals? \ 15-03-04 11:53:32 Me got job! Me start my porn career on sat! Kurt. Ta babes xx \ 19-03-04 22:40:16 Gay Indian club ... turbanology a go go xx \ 20-03-04 18:33:22 Shop so funny! Porn seems fun : - D Kx \ 19-03-04 13:56:30 Viva the floridian artichoke x \ 22-03-04 11:06:50 Tues, Weds, Fri & Sat. U want fucky fucky dvd? \ 22-03-04 17:03:24 Something shat in my head and my brain is trying to push it out me nose. \ 23-03-04 23:32:31 Catshit cow fart \ 27-03-04 11:34:27 Hi tracey its laura. I have nearly finished portrait of wormlady, shall we fix a time for the unveiling ceremony soon? Hope you well. \ 26-03-04 08:49:27 Air hair lair darling. Wil deffo b cing u 2nite. Am in pall mall 2day, so wil pop over frm there. 5.45ish ok. MMMWWA X \ 27-03-04 20:12:22 I broke the crane picking up stuffed toy machine. It tried to tear out its own guts! Cool or what!? \ 29-03-04 16:35:45 My grandmother used to say that sarcasm was the lowest form of humour, to which I would rather embarrasingly, reply, and the highest form of wit, at which my dinner rights were revoked. That'll be a yes, then. \ 30-03-04 21:33:33 How many gan your end? All mine backed out, call emselves punks isit? Pah! \ 31-03-04 19:06:19 What name table for? My punkz have forgotton their roots. I'm gonna have to pretend i know your friends. It's hard being an anarchyist sometimes

APRIL \ 01-04-04 13:39:14 hi love havin a nostalgia evening? Can u believe i work with someone born in 1984. i feel so old but am incredibaly sexy so no worries! Give me a ring wen yr hme \ 02-04-04 19:18:02 shitfuckarse wanktitshitcuntbollock pissnippleshitshitshitringpiececockquimwank \ 03-04-04 14:34:23 I liked the bit about radio 4 being fucking insipid tool of middle class indoctorination. Oh, and everything else. Tee hee. \ 02-04-04 19:28:36 HI TRACEY.. have you a rough idea when you think we should do worm unveiling? What time do you think.. late April, early May? XL \ 05-04-04 17:21:41 I just been digging up bits of someones life that the luftwaffe destroyed. Kinda odd. \ 06-04-04 21:15:34 Go 2 you whores.com \ 07-04-04 20:33:23 Someone shit outside my tent at Glastonbury once, but they didn't hang around for me to thank them. It was orange \ 07-04-04 20:35:01 And i put my hand in it. \ 09-04-04 19:56:50 I feel old enough to be a mother to a fifty year old at the moment but i will be ok i know i will \ 10-04-04 01:17:34 Tracey i love you mam \ 10-04-04 19:05:34 Im doing guestlist4libertines and lefthand ifu wanna come on down? The coronet cinema, elephant. Also punk films. 6til4 love Sam \ 12-04-04 15:34:56 Me wif pornopaul sellin filfth 2 perverts... U well? X \ 12-04-04 21:41:06 Welcome to Spain on movistar, our freemove alliance partner, you can easily call using the international dialling code (e.g. +44 to UK), roaming rates apply. \ 14-04-04 14:28:31 Roll 2 dice. Kericke is a 2 and a 1 and beats all. You hide your throw and can bluff if u want. Next player can challenge you. If you throw lowest or get busted u r out. Winner is last in X \ 19-04-04 15:12:59 I haven't caught anything in my sellotape cat trap yet \ 28-04-04 13:21:50 Going margate amorra init. Gona have me some egg'n'chips see if i dont. \ 29-04-04 00:26:00 Jibby moira's nan!

MAY \ 03-05-04 13:56:17 Fuck this, I'm going to asda. \ 03-05-04 16:46:00 To help me prepare for tomorrow can you email details of the mark thomas project. Text me when you have done it. Cheers Stuart. \ 03-05-04 18:28:56 Have an emergency meeting tues at 5.30pm in town. Can we do interview earlier or later? Sorry mark x \ 05-05-04 23:44:50 Also, can we reclaim the word genius and destroy it. It's a facist word, and meaningless. (blimey i sound like penny r!) \ 06-05-04 22:32:58 Luke & Caroline dj'ing at Andi's magic club thurs 15th may. 7-11pm, Bar Aporto. Endell St WC2, opp. shaftsb. theatre \ 08-05-04 14:22:23 Hi, jst wonderin – coud u ask jai about loot 4 me ta, like contact num.+hw2 go about it.ta everso.sx \ 12-05-04 00:35:00 A canard like the bones of piltdown man. Me in mother bar. C rights shut m bar shit. \ 12-05-04 06:57:24 Yeah i was a u gud girl we jus got the tube 2gether. I wudnt do the dirty on r no matter how gorg & lovely mark is. We swapped numbers thats all... was a interesting eve xx \ 12-05-04 18:17:42 Pink cowboy boots in shellys! And we still bootless : – (K x \ 16-05-04 17:44:00 Just bought the observer in durham! How exciting 4u – wish i could b there! Speak soon. Cx \ 17-05-04 07:30:00 Missing you trace! we got to do a girlie day soon x \ 29-05-04 21:02:01 Arse! Wil i ever cu again?! Oh wel av ggood nite hun and hopefully c u soon k \ 29-05-04 17:29:26 A.3 canceld. Nite stil on. Cu there?X \ 25-05-04 14:02:12 Won't be able to be there today – late a good one. Do you want a large orchestra in the basement on friday? Jeremy \ 28-05-04 10:6:17 Hi Tracey. I hope you don't mind me texting you, but last night you mentioned a website that was something like www.schnews.com I can't find it. Could you possibly text me it so i can have a look. No rush. Many thanks Richard. (photographer) \ 25-05-04 15:21:19 Will try. Moira's ale give me the shits init. \ 26-05-04 17:50:04 Don't forget to let me know details for tomorrows cleavage photos! cheers jess :)

JUNE \ 02-06-04 13:45:40 A ripple is the collective name for swimming cats! \ 09-06-04 21:51:28 Ow's ew pussies? Cx \ 10-06-04 13:57:12 Yeah with stethoscope! That what they did 2 Dunst. Then it was gone in 2 days. \ 11-06-04 13:40:29 if u need a photographer in columbia let me know. im hostile environment trained \ 11-06-04 17:51:58 No, denise was a dancer, her stage name was scarlet moonshine or summit, I went to see her show and the man with the torch was there, we all clapped and * some text missing* \ 14-06-04 20:24:58 Thanks tracey Banks \ 16-06-04 18:29:53 I really enjoyed lunch – thanks 4 coming over. Just to mke sure – i'm extremely interested in yr porn peoples, esp t old noman's tale. Also t rape music group and t taxi tale. And i'll look in2 t mobile mast thing. How exciting! Have a good afternoon \ 19-06-04 22:07:21 Thanks so much 4 those lyrics they're disgusting . I'll try to stir up trouble, around them for next week's paper.A \ 22-06-04 08:08:26 hi tracey, wow sounds good.. Columbia. u away4 ur bif? yes Must cu soon.u.stressed at mo, stil dnt kno if we movin.. if e has skol place.dnt kno wat2 do! spk soon xxs \ 23-06-04 13:06:12 We are coming on the 3rd! Are you in Cambodia?x \ 23-06-04 20:25:43 Hey tracey good luck in Colombia! Have you got Bill's e-mail? I'll drop him a quick note later . . . Rod \ 24-06-04 09:39:52 David Beckhams voice is going to be used to make all the announcements at Euro 2004 a spokesman said 'We heard he comes over a PA really well' \ 30-06-04 09:12:41 Dear madam. I would very much like to appear on the radio one day and follow it up eating, discussing and photographing two eggs chips and peas. Would this Friday be suitable as I've got to fucking work all fucking week. Your sincerly. mr. Danny B. Pockets \ 30-60-04 11:44:32 Got tickets 4 patti smith, so will find out time n come b.4 or after? X how was columbia? X \ 30-06-04 12:29:39 Happy BDAY tracey! Hope u hav a great time. Sorry i can make it but am really run down from last wkend and then full week on taggart so got to rest. I am 46 now after all! x tam \ 30-06-04 14:20:41 do you require any disc jockeying on belated birthday night? xDunst \ 30-06-04 18:48:13 Happy birthday! bob be with you! x Church of the sub genius

JULY \ 04-07-04 14:31:16 Thanx 4 last nite! Was great 2 cu and yer lovely arms!X \ 05-07-04 14:04:51 Yep thurs for sure. Ta 4 great nite. Top d.j's n top welsh tottiexx \ 07-07-04 16:29:00 ... and what's more I think I've cracked a random djing style wak wak wow. \ 08-07-04 12:08:18 I've found a copy f the New Statesman, with Mark thomas' colombia article. It's mainly the stuff u text me frm there wen u got the info \ 10-07-04 09:56:34 Are you around? Going to pop into foundry after work. Is coke exhibition still on? Rod \ 09-07-04 14:34:42 Oh, cool. We should chat about Colombia! If bill can do a short story about a song. quickly, that would be brilliant. looks amazing at the moment really good. \ 09-07-04 14:43:02 No! Get the thick twat what told the woman to put her baps away! \ 10-07-04 11:15:23 So far I've found 53 'lucky' pennies this year. works out at just over 8 particularly fortuitous days a month. Cool, huh! \ 14-07-04 13:19:12 How ru How did it all go in Colombia? Fit body guard? \ 15-07-04 07:34:05 In maidstone doing basil brush! \ 21-07-04 18:17:37 Wanna get laid 2nite? Want real Dogging locatns sent direct 2 ur mob? Join UK's largest Dogging Network Txt Dogs to 0778148**** now! Po. 398** WII IWX £1.50/MSG \ 22-07-04 09:34:26 Discussions have led to requesting the tittle baby pussycat stay with it's current family a few more weeks cos the pockets is going away some \ 22-07-04 15:46:51 Had no reply from italy. As dates were 17-24 i guess it isn't happening. Can't check mail but if it was on i am sure i would kno mark x \ 22-07-04 22:11:11 I ok, can talk about the vibrator I got 4 me nephews weddin pressie *snugger* How wus russia? J x \ 23-07-04 13:05:34 'Pataphysics, Rich was factually confused. I am a founder of the LIP And joint organiser of the Hancock show. This will be re-constructed in Edinburgh at the Embassy gallery 8-29 august.' Pataphysics' cal greetings to you all. luv Magnus Irvine \ 24-07-04 16:02:33 Ta 4 lovely TEXT Good 2 C UN Sian. WEL DONE GIRLS GOT 2 DO LUNCH, LAST NITE WAS A DRES REHEARSAL! U LOOKIN GOOD GIRL>XX \ 27-07-04 12:04:34 Wormlady - The portrait by laura Oldfield Ford unveiling 2nite at the Foundry 7pm piano night. with wormlady accompaniment

AUGUST \ 01-08-04 00:38:41 Yep e in oakwood-at jakes at mo! im in canal st. wid new bloke. Conan whose frm wivenhoe! ha ha life eh! i gt myself a ginger boy, tried getin hold of H loads bt no response. am workin mon nite frm 5 cal in day if u can. im 0161 881 ++++ x x \ 03-08-04 20:20:48 Your network has switched to a new payment plan. The cost is determined by your looks – the uglier, the cheaper. As from now on all your calls are free! \ 03-08-04 20:24:35 Thats the fastest reply i ever got off you! thought ya wud like.. Cuntess coochie! X \ 05-08-04 10:35:22 Regrand opening of the BOBSHOP at the Camden Lock Market today. come down and hang out with the POPE! \ 05-08-04 20:56:55 We love pockets the little baby puss cats. When we all return from our various travels we bbq! And next I will have a weekly moment of sharing my pockets with the viewers? \ 11-08-04 14:18:56 Am in the volunteer in lyme regis. They serve treble egg and chips. \ 19-08-04 18:13:03 can't come to London cos cousin stayin.. Or your want shop in Brighton? Good luck tonight anyway Pet. Do you see Pete Doherty these days? X \ 20-08-04 12:25:25 Hi Tracey, really enjoyed last night. sorry didn't make it to Charlies. Maybe see you foundry tomorrow night. xL \ 20-08-04 19:45:12 I woke up with a tongue like 1 of Ghandi's flip flops. I enjoyed the evening very much. Speak to u soon Steve xx \ 21-08-04 13:19:59 I met a lesbian comedian who does her act as a nun... VERY witty wud be great 4 radio or mayb even foundry ... interested?Kxx \ 21-08-04 20:58:54 Is someone going a film with pete for telly? Free monday if you are...Xxxx \ 22-08-04 14:02:53 when is your wedding? \ 24-08-04 17:00:06 I had flower shaped eggs \ 26-08-04 15:31:54 You've got a picture message from +447974307299. View it once within 3 days at http://www.t-mobile.co.uk/pmcollect with your number and the password: zze9w7b +447974307299 \ 26-08-04 21:35:19 Mr. W. Pockets Esq. Seems to be at home, did a poo and a wee in the shitbox and is having a funny half hour with his tail. Purring lots and keeping an inquisitively wide berth of violet. Likes cauliflower cheese! \ 29-08-04 04:59:15 T do u believe in asteral travel? Goin buskin can sing paul 28-08-04 05-27-45 I'd do anythin 4 u t if u were mine xP

SEPTEMBER \ 01-09-04 11:58:50 Mrs Jonathan suits you x \ 03-09-04 08:59:09 Fab went past foundry last night and sent you loads of hospital treatments and menthol vogues x x x x \ 05-09-04 15:10:21 I say is mrsm still in the extremely posh hotel \ 05-09-04 21:01:27 Mrs m, got meeting 2moro... You around 4 lunch victoria area? Mrs b x \ 07-09-04 22:48:49 The whole world is lighting a candle in the window for the russian children. Pass it on. \ 08-09-04 18:59:37 Are you still looking for a gallery in berlin? Steve \ 09-09-04 20:52:48 Yeah all sounds good. Call me when u bac so we can meet. Have a great time in Barca M \ 09-09-04 16:48:12 Oi u married hag wats ur name now? \ 10-09-04 18:17:22 Want free sex tonight? Want the locations of where people meet 4 hot sex sent direct 2 ur mob? Join the hot club by txting FLESH to 698** Opus, in67dq.msg@150p \ 16-09-04 12:44:41 Hitting fox hunters on the bonce and what not. \ 19-09-04 11:49:21 Moo! Workin, filmin, writin, shagin. The usual. C U soon! say hi 2 mr.m! x \ 20-09-04 19:55:43 Show us ye flangita tracey! Paul said he was playin wif j's organ yesterday...x \ 22-09-04 12:41:48 My computer blew up. Pop! it went, with six months work on it. Er... \ 23-09-04 17:29:28 you gone russia? \ 23-09-04 17:44:22 you are so lovely xx \ 27-09-04 21:25:29 texting is genius. Have to find the fucker what invented it. Am wary of the word 'genius', very wary but it does seem to fit in this instance. Init? \ 30-09-04 22:41:51 There was a gal called Tracey, her knickers are red + quite racey, she drinks champers from flutes wearing pink cowboy boots, that's tracey, she's racey our tracey! xK

OCTOBER \ 03-10-04 13:47:52 There's a small foundry story in the independent today if you haven't seen it i'll rave it for you. j \ 10-10-04 15:05:06 Thanks a lot. We had a great time. Maybe do something similar at the foundry some time? Best wishes magnus x ps. I like your fan dancer friend \ 10-10-04 15:15:42 Fantastic party! \ 10-10-04 15:44:24 Thanx 4 lovely party! X \ 10-10-04 16:56:01 OK. Id like to be a chocolate anus millionare. M \ 10-10-04 17:40:50 hi this is Ian from the laundrette hope things weren't too hectic after we left... we kept an eye out from over the road and saw you all leave in one piece! (each \ 10-10-04 21:08:07 Thanks for the invite. It was a great party and the view was amazing. you looked lovely too! Hope you have a honeymoon planned. Lots of love, J and R xx \ 11-10-04 16:14:22 The sex change lady had nice legs – but not as nice as yours. What u exhibiting? You seemed to have gone up a few gears – b careful or they'll have you running the country! Brian x \ 13-10-04 14:50:42 2.35pm standing outside k.f.c. Farringdon road in the rain. How i despise the chicken eating filfth! ... \ 13-10-04 15:20:04 3.12 p.m. location, holborn. Have just observed some miscreant wearing clogs! Where will it all end... \ 15-10-04 16:59:43 I'm off today, but kurt peddling porn till 6.30pm \ 15-10-04 10:19:49 As a mark of respect Mrs. Bigley has asked for all – funeral flowers to be stems only. \ 18-10-04 17:33:23 2.55p.m. lincolns inn fields man spotted wearing cape ! ! Nothing wrong with that .. Ding ! Dong! \ 20-10-04 10:19:31 Only gone and got eggs pickled in cider inni ? \ 21-10-04 00:27:42 Saw u with a pram and a clock \ 27-10-04 12:55:59 12.28p.m. Wardour st. Miscreant spotted emerging from newsagent wearing greenish coloured cordruoy suit with matching cap... a more repugnant specimen you could not hope to encounter .. ugh! \ 31-10-04 20:01:32 7.55p.m. On way to foundry, strong urge to dress up in dangermouse outfit.. oh dear..

NOVEMBER \ 03-11-04 10:05:13 Just see a brilliant thing: woman on the fone walking round a moving bus trying to get a bettes signsl. "hello... hello I cmn't hejr you ... hello ...?" \ 06-11-04 20:36:31 8.23p.m. Old st. Observing various fireworks, on my way home ... marvelous .. Ding ! Dong! \ 08-11-04 17:28:15 Remember to spit when you talk. \ 10-11-04 21:07:18 Hi hol great ta. how was your party. organise us all for a night out when you can fit us in. Will try to get hold of Wayne if you give me a date. See u soon \ 11-11-04 14:44:36 Seriously thinking about starting a Victorian pipe smoking society, port, open fire, lots of scowling.That sort of thing.What say ye? \ 15-11-04 09:24:56 I've just met mr ference's mum and dad. I've known terry for years, but it's the first time i've met terence ference parents. \ 17-11-04 18:44:47 Have just noticed she has an abundance of rather unsightly ear hair yuk! \ 17-11-04 18:49:52 Just saw a tramp wanking near aldgate station. A true art moment ... I wish my wife to be (tracey emin) was here ... \ 19-11-04 11:39:21 Having lunch in Chartier x \ 19-11-04 20:30:00 Tues 23 nov. Larry Love 40th @ The Tardis with Gaz's Rockin Blues & Alabama 3 Acoustic. 8-2. £3 before 10 £5 after. 54 turnmill street EC1 Farringdon Tube. \ 20-11-04 18:47:02 Overwhelming desire to sew inflatable water wings onto my suit. \ 21-11-04 14:08:10 1.59p.m. Lovecraft. Currently munching chive flavoured pringles. 2 very good words there, 'munching' and 'chives'. What do you think ? ! \ 21-11-04 16:28:28 Packed with pre Yuletide Porn Pickers ! Pete works in printing. How about the word 'chortle' ? \ 21-11-04 17:30:26 Shit! My phones upside down! \ 22-11-04 18:36:27 18.27.p.m. Location, gt eastern st. My god what is that hideous giant billboard doing above the foundry ? Yuk ! And quadruple yuk ! ! ! \ 26-11-04 12:07:44 Nipples are designed to be tweaked ferociously! \ 29-11-04 16:27:35 Merry xmas. bit early i know but i know hundreds of rich and sexy people so i thought id start with the poor ugly fuckers first

DECEMBER \ 03-12-04 23:28:13 In the manor anything going on in Tardis tonight love Salena \ 12-12-04 12:09:46 I txtd jon in the week 2 say i cant do wormworld 2 night. didnt get a response so lettin u no 2 just make sure. Spoonx \ 12-12-04 17:33:02 Thanks tracey, glad you like it I'm in Berlin for a few days. hopefully see you in Foundry before xmas! rodx \ 12-12-04 11:41:32 Love the pic of Pete D Darren and moi. Any chance of a copy? x Nic \ 13-12-04 14:55:53 Could well be interested in selling a dead shrew also one of my kidneys. How should I proceed? \ 14-12-04 14:28:29 Changed name to doris, now living in Shropshire \ 17-12-04 12:04:11 When we goin to see you then glamour puss? You def coming to Dunst's party or you wana come another day? On my way home now for 2 weeks!x \ 21-12-04 13:09:52 Pubs fulla cunts. maybe I can sell them some art. Art for cunts. \ 21-12-04 13:20:16 Cunty's too nice. Softening the edges ART 4 CUNTS> NOW! I might change me name by dude pole. \ 21-12-04 15:46:57 Will be in foundry a liberace mode with worm tonight, peddling porn tomorrow p.m. \ 23-12-04 00:32:51 One bloke , when i took the bag of toys around thought i was begging and tried to put money in the bag! Do i look homeless? cock \ 23-12-04 02:13:32 You look beautiful tonight xP \ 23-12-04 02:22:27 Yr a sexy woman T don't forget it .. & remember i told you so ... xP \ 25-12-04 03:41:44 Sorry t i won't bother u again.P \ 26-12-04 14:13:50 Waves of love and tidy tidings with bells on this xmas'n'newyear – from Tenby seaside, Sam Rob and Nansi Love. xxx \ 26-12-04 16:00:30 Hi lovely merry xmas to u. going to mam's tonight but will call in lynne's first. what time u there? \ 29-12-04 15:44:44 ...or a penny covered in birdshit under a ladder by which a black cat just walkeed when two magpies flew over. Luckily I stroked the cat then remembered stirring my tea with a knife only five minutes earlier!!??!

My text messages were coming in harder and faster now averaging 450 a month. Some were mundane, irritating, bizarre, others informative and many being placed within a specific time frame within my life and the outside world. The most irritating text I received in 2004 came from a friend called Danny Pockets, who had started texting me in the latter part of 2003, in which he invited me to start exhibiting with him on the theme of pizzas. He brought good wishes into the New Year festivities with a *Bo! Selecta* phrase and continued to text prolifically throughout the year. His most irritating, boring, and nothing text…

15-11-04 09:24:56
I've just met mr ferences's mum and dad. I've known terry for years, but it's the first time I've met terrence ference parents

I was still in constant touch with Elvis, Jesus & Co. Couture's Helen and Kurt. They were no longer working together. Kurt was in London and wanted a complete career change, when one day he said, 'I want to work in the porn industry, find me a job Tracey.' So I did. I have never worked in this industry but seem to have come across a lot of people who did. One person in particular I thought could help Kurt on his new career change was a friend who has been a regular at the Foundry. When I first moved to London, Jonathan and Little Mark had referred to him as 'Porno' Paul. However, no one told me this was not a direct name used to his face. The same went for Danny Pockets; his name is actually Danny Cuming. He had a joint show at the Foundry titled *Empty Your Pockets* which was a display of what had been in his and fellow exhibitor Lincoln's pockets for the last year. Again I spoke of him as Danny Pockets after the show; the name stuck.

I asked Porno Paul if he knew of any jobs going in the porn industry stressing that I didn't think Kurt wanted to act in any porn films, although I wasn't a hundred percent sure, but wondered if there were any vacancies in one of his Adult Shops. There was an opening, and I introduced them. Kurt began his new career, and several months later Porno Paul got his first mobile phone and I remember him asking if he could text me, as few of his friends were texting then. And so began a non-stop journey of texts with Porno Paul:

13-10-04 14:50:42
2.35pm standing outside k.f.c. Farringdon

road in the rain. How I despise the chicken eating filfth

Porno Paul and 'Dirty Kurty' would both become responsible for a section in the next of the Text Message series of shows, which would begin again in 2005 with *Text-Me-Up! Just a Little Bit More...*

At the same time as Porno Paul acquired his first mobile phone and started to text me, I noticed that sex text adverts were becoming more frequent (by pure coincidence of course). Random texts would come into people's phones and ask the recipient to text back quoting certain numbers. 'Dogging Sites' were a favourite for this method of texting. I'd mentioned mobile sex ads to Banksy one evening. He told me the story of one of our mutual friend's texting a hasty reply to one of the 'Dogging Sites' as people were stood about laughing and egging him on. Once the initial reply had been sent, he started receiving texts at all times of the day and night and these texts were charged at high premium rates of £1.50 or more per text. Following his first text giving permission for them, the costs incurred were phenomenal and our friend had to change his network after trying to deal with the embarrassment of explaining the story to his phone company.

I found chain texts more invasive and wondered if they worked on a similar level making revenue from texts for the phone companies. Did they employ someone in their marketing division to put out empathising chain texts as soon as a tragedy and in some cases, when something happened in the mass media that could have a sick or humorous joke extracted from it? Chain texting can appear to be very empowering along with everyday texting which has been instrumental in the shift away from centralised hierarchical modes of organisation towards a decentralised network, putting communicative power back in the hands of the people.

The Philippines is probably the text capital of the world, with an agricultural Catholic population in a country where the extended family is important. In 2000, with increasing industrialisation drawing the young to the cities for more income and a social allure, mobile phones and texting were necessary to keep in touch. One could be bought with a two-month lifespan for US$5, and pre-paid top-up cards purchased with free texts. The number of chain texts that passed between people was extremely high reaching over one million texts a day in 2000. The resignation of President Estrada was reported to have been hastened by chain texts accusing him of corruption. A classic hoax text in the Philippines was circulated announcing the death of the Pope, and although false, millions sent and received it.

Somebody has to have written these texts in the first place, and phone companies must surely make great profits from them. As I typed the last sentence I received a text from Porno Paul. The news headlines over the last few days focused on a manhunt for a fugitive in North East England, who, after a string of betrayals, shot and injured the mother of his child, killed her new boyfriend, and shot a policeman. He was eventually caught and after six hours took his own

TM > Porno Paul
9 Jul 2010 05:21 PM
Did you get your first mobile phone in 2004? The first text I got from you was at 2.55pm on 13/10/04. Had you just begun to text then? Can you remember the date you got your first mobile phone?

Porno Paul > TM
9 Jul 2010 05:30 PM
I think I had just recently got it and for the next few years went into 'Hyper text fiend' mode. Sending 100s of texts weekly. x

TM > Porno Paul
I know, I have just started writing about you first it was the introduction to dirty kurty then the mobile... The chapter after this is 'text me up just a little bit more...' where people were asked to copy out and leave their last mobile texts received. I have a strange feeling a certain dirty kurty & porno paul contributed significantly to this body of work... Ding!

Porno Paul > TM
Carry On! x

Dong!

life. No disrespect is meant to any of his victims friends or family members, but here is an example of what I am illustrating:

> Porno Paul > TM
> 11 Jul 2010 08:58 PM
> **I tried to give raoul moat a lesson in gun safety it went in one ear and out the other..**

> TM > Porno Paul
> **Tut! Tut! Is that your creation?**

> TM > Porno Paul
> **Only asking as I'm writing about joke texts, chain texts etc when national news stuff happens**

> Porno Paul > TM
> **Someone sent it to me. Actually it wasn't even Raoulmotely funny…**

> TM > Porno Paul
> **How many people did you send it to? I'm seriously writing a chapter on this now**

> Porno Paul > TM
> **About 12. x**

> TM > Porno Paul
> **Great thanks x**

The chilling school hostage crisis in the town of Belsan North Ossetia where at least 334 hostages were killed including 186 children, was followed by a text I received multiple times:

> 07-09-04 22:48:49
> **The whole world is lighting a candle in the window for the Russian children. Pass it on.**

The whole world was already engulfed in this awful tragedy and did not necessarily need a text message to heighten emotions that were already in the worlds consciousness. On a far lighter note, one of the better chain texts I received:

> 08-03-02 10:23:00
> **Hello, i need 2 speak 2 u urgently (need a favor) can you call me on 0207 9304832 battery is low, ask for Elizabeth + she will pass u on 2 me**

When the recipient of this text rang the above number they were put straight through to an answer phone message at Buckingham Palace saying that a hoax text had been sent around with the number. I rang it again just now to see if it is was still in operation and the phone was answered immediately by a friendly voice saying, 'Hello, Buckingham Palace…' I'd always thought that this text was a genius money-making hoax that someone had devised, when in fact, as I've just found out, it really is Buckingham Palace.

From the beginning of 2004, I had a steady program of exhibitions which included *Field; Sell-Out; Coca-Cola's Nazi Adverts, Beyond Porn, A Fundamental Truth* and *Star Spangled Sinners*. The first one, *Field*, began in May 2004 and was curated by artist Paul Caton. I selected various TV programs, films and news snippets that I'd appeared in and had archived on videotape for my piece in the show. I then took the actual

tape out of the videocassette and knitted it together and mounted it on to a canvas. Both sets of imagery were displayed next to each other, one playing the film on a monitor, the other displaying it on a canvas. The second show I was involved in, *Sell Out*, was held at the Foundry. I was one of ten invited artists who each sold 10 artworks for £9.99, raising a total of £999 as a fundraiser for radio station Resonance FM. The ten artists were: Francis Uprichard; Gavin Turk; Bill Drummond; Rebecca Hale; Jason Synott (the organiser); Jo Syz; Daedalus; Richard Niman, Kirsty Whiten and myself with my then name Tracey Sanders-Wood. My work for the show was voice portraits in the form of sonograms that I had then just started working on with former MP Tony Benn. The night was an immediate 'Sell-Out' and I felt each artist could have sold a hundred pieces such was the demand from art buyers at the exhibition. Moira made a special edition 'Sale Ale' beer wih Pitfield Brewery which sold out, raising more for the campaign.

Things were continually evolving, changing and spiralling in a multitude of directions. My parents had begun texting but didn't progress beyond a few words per text; but the messages they sent me, I hold dear. My friendship with Mark Thomas had blossomed and he asked me to work with him. He had just started a piece of work about Coca-Cola and we decided to put on an exhibition entitled *Coca Cola's Nazi Adverts*.

During the 1930s and into the War, Coca-Cola GmbH (Germany) collaborated

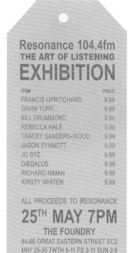

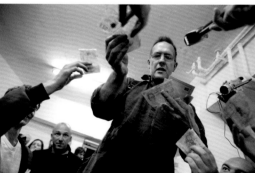

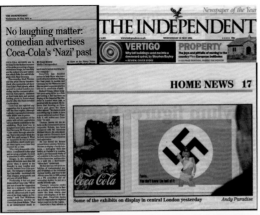

THE INDEPENDENT

No laughing matter: comedian advertises Coca-Cola's 'Nazi' past

HOME NEWS 17

Some of the exhibits on display in central London yesterday *Andy Paradise*

Coca Cola's Nazi Adverts
Mark Thomas and Tracey Sanders Wood

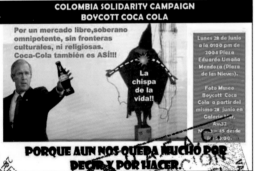

COLOMBIA SOLIDARITY CAMPAIGN
BOYCOTT COCA COLA

Por un mercado libre, soberano
omnipotente, sin fronteras
culturales, ni religiosas.
Coca-Cola también es ASí!!!

La chispa de la vida!!

Lunes 28 de junio
a la 0100 pm de
2004 Plaza
Eduardo Umaña
Mendoza (Plaza
de las Nieves).

Foto Museo
Boycott Coca
Cola a partir del
mismo 28 junio en
Galería Mar.

PORQUE AUN NOS QUEDA MUCHO POR
DECIR Y POR HACER

with the Nazis. The company advertised in Nazi newspapers, financially assisting the regime. Participants of the exhibition were invited to re-imagine and recreate these adverts. The exhibition was done without the consent of Coca-Cola as we weren't presenting the original artworks. The exhibition was devised in support of workers at the Coca-Cola bottling plant in Colombia, where eight trade union workers had been killed by paramilitaries.

Mark and I invited different friends, colleagues, ex-students, artists, designers, and filmmakers to take part in the exhibition. The response was phenomenal and hundreds of people took part in the show which opened first at the Nancy Victor Gallery in Fitzrovia, London, followed by a show at the Foundry and then in June on my birthday we took it out to the Galería Mar in Bogotá, Colombia. I had a bodyguard/translator who met me at Heathrow airport and a wonderful 'trolly dolly' on the flight kept serving champagne to celebrate my birthday. Midway through the flight, the bodyguard made me feel uneasy and proved to be untrustworthy. I'd had my eyes closed for a few minutes and when I opened them his hands were hovering over my bag. As the week progressed I would watch him steal from the Colombian Union. I was desperate to get away from him, and glad that Mark Thomas was meeting me at the other end. I had been advised not to use the taxis without speaking the language due to the danger of the date rape drug used in them for robberies.

When the plane touched down I was in a lovely champagne haze only to find that there was NO Mark nor his trusty friend and side-kick Sam there to meet me. The body guard/translator said I could squeeze into the car with five of his male

'cousins' who had to do a few 'drops' first, but they would take me to the hotel. I accepted this more readily than the taxi options as I cursed Mark now, being sat across two of the 'cousins' laps. I eventually arrived at the hotel safely and in one piece, grateful for the lift. There was still no sign of Mark and I was starting to feel the champagne dizziness lower to a yawn. Mark bounded into my hotel room two hours later like an over excited puppy telling me of all of the news from the week. I couldn't be cross for more than thirty seconds as he and Sam whisked me off through the empty Bogotá streets to the bar/gallery where we would be exhibiting the *Coca Cola's Nazi Adverts* exhibition. While we walked, they explained that a tramp on the next corner had been cleaned off the streets, quite literally. A motorbike courier had stopped to give him a package – the tramp opened it thinking it was food when it was in fact a bomb. I made a mental note never to accept packages from anyone.

When I walked into the gallery I felt like I was entering the Colombian equivalent of the Foundry. I was greeted with the news that both mine and Mark's full names were now on the front page of the website of the Colombian Guerilla organisation FARC. Only when I saw two Colombian DJs who had previously played at the Foundry did I begin to relax and my birthday continued there with a bonus extra six hours added to it.

Two days after my arrival, I was picked up early one morning and whisked off on an hour-long flight and then a very long car journey over the mountains as we made our way to the outskirts of Bucaramanga. That evening I found myself dancing salsa at a party in a huge house where the windows stretched up to three stories high with no glass in them. The windows overlooked a vast uninhabited area. I had known all the people I was with for less than twelve hours and I couldn't speak the language. Mark and Sam were hundreds of miles away. This marked a clear turning point in my life. Back in Bogotá the following day, Mark and I put up the exhibition which, as a visual tool, brought in much publicity for the union workers who fought for justice for those killed in the Coca-Cola bottling plant in Colombia.

When we left Colombia the exhibition travelled to Ecuador and I took it to Venezuela, then Mexico (where it toured substantially) and Russia. In Mexico I found myself on the trail of Subcomandante Insurgente Marcos of the

Zapatistas, finding him and fronting his 'Sexta' march. The Mexican section of the exhibition had come later when I teamed up with hostile environment trained photographer Jess Hurd on a different project. Jess had become an active part of my texting community and then frequent radio show guest.

This was the year that I received my first mobile phone photo. My phone didn't hold the right technology to view photos but the phone network gave instructions how to access your photos through the internet. It was an image of Jonathan, Nitin (a Foundry artist) and Anthony – whom we employed behind the Foundry bar (Anthony sadly died in a climbing accident a few years later). The photo inspired me to get a mobile phone with a camera the following year and begin another body of artwork under the banner of 'Mobilography', the project titled *Parallel Lives* (http://www.sanderswood.com/parallel_lives/). The line from the *We Breathe Each Other's Breath* brick poem that covered this work was: 'The biometric heiress collects, processes and stores,' which the mobile phone camera with its film and photographic facilities enabled me to do. I've run a daily mobilography blog since 2005 with the first image coming from a MMS text sent to me by Porno Paul from his Soho Sex Shop.

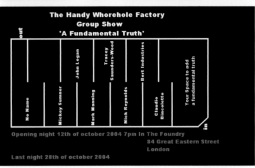

11-06-05 16:21:16
Naked cyclists in west end.
Hundreds of them ! :-l

When I stepped out of the mobile phone shop in London's Oxford Street after signing my new contract, I was greeted by the same naked cyclists that Porno Paul had just texted me about. A few button clicks on the phone and they were the images that I began my two-image-a-day blog with. I also started collecting groups of images – from plugholes to vomit in the street – and have had a number of exhibitions with them from Victoria, Australia to Kansk, Eastern Siberia.

As the year drew to a close *Beyond Porn* the exhibition re-opened at the Nancy Victor Gallery in London, followed by a huge installation show in the Foundry called *A Fundamental Truth*. This was conceived and built by John Logan and the participating artists were Bert Industries, No Name, Drew Barr, Nick Reynolds, John Logan, Micky Sumner, Jason Synott, Claudio Bincolette, and myself. I was working on issues related to domestic violence in a piece titled *Mental Abuse Part 1*. It proved a successful show and my installation within it went on to be exhibited at London's City Hall followed by a commis-

sion from the Women's Committee of Seville, Spain which was produced by Diavolo Produccion Cultural, Victoria Rodriguez Cruz and Laura Jamieson-Black.

The final exhibition of the year was a joint project with Gordon McHarg called *Star Spangled Sinners* at the Nancy Victor Gallery. It was advertised as the ultimate in decadence or addiction – taking an extreme look into the arts, music, performance and media worlds of decadent excess. My focus

within this show was to heighten awareness of the 'silent epidemic' of hepatitis C (HCV) as it was then officially estimated (in 2004) to have infected 200,000 people in the UK. In conjunction with the rise in popularity of cocaine, hepatitis C was increasingly being spread by social drug use. I made a series of short silver straws, each with their own line of poetry and when the full set of straws were seen together the poem illustrated the many ways of contracting hepatitis C. I also made long engraved champagne straws and produced a performance diary for 'Ladies What Luncheon'. Gordon produced a life-size waxwork of Charles Saatchi along with prototype solid silver joint. He also included a replica of the toilet on which Elvis Presley died. And the year ended with a final text:

31-12-04 23:56:32

Ooo arrhh, O sally can wait, she knows oi be late, an all that up north...In the meantime wurzel says 'appy noodles cocker!x

Annual SMS total: 2004 – 26 billion.

01-01-05 01:37:27 Here's to the New Year! May all your troubles be at the bottom of the glass. Drew \ 03-01-05 18:20:48 An acorn at the window will keep the lightening at bay. \ 03-01-05 20:03:43 crossing fingers believed to come from a belief that by causing a blockage, ie crossing digits, one stopped bad vibes escaping the body and causing fuckery \ 07-01-05 03:05:05 sorry 4 bugin u. I'm just lonely thats all, i went 2 charlotte st 2day u need a bigger stage. Like it a though. P xxx \ 07-01-05 20:34:43 Hi Tracey hope things are good with you guys – dunno if you can help me but im trying to locate the blair.mp3 by chumbawumba and i know they are your mate ... (tim smiles cheekily) also im looking for recordings of blairs speaches to cut up & use in a project ... Any suggestions ? Love peace & happiness tim \ 08-01-05 16:11:50 Excellent. I'm cleaning pennies (after boiling them in persil of course) and have a bowl of brasso on the floor to dip me rag in, and pockets is transfixed by the smell of it, just sits there wondering why it doesn't smell edible. It's in a bowl for fucks sake! he's thinking. \ 13-01-05 09:30:03 morning! Well what a lovely morning it is in Glossopdale! Well the wind has stopped and the press have not been around 2day. Back soon u int Ladys wat! Cant pick up straight away as Bez's phone cut off! *0! xLaw \ 16-01-05 16:03:21 Excellent. Dennis Skinner: "I don't want Harry to apologise, I want him to carry on the same way. The more they show themselves up, the sooner we're rid of them." \ 19-01-05 09:44:42 Tis very quiet. Have you lost your thumbs? \ 20-01-05 22:36:16 It's very quiet since you got a proper job, have you hung up your cowboy boots in favour of a slingback espedrile, hanging out pret a manager and laughing at things men with pink ties say. OR WHAT? \ 20-01-05 20:01:59 Had a diet of guinness, peanuts and chips for a while. Same thing. Listless. Great wind tho'. \ 27-01-05 14:46:19 2.34p.m. Location: lovecraft. Currently wearing bright green water wings over suit. \ 01-02-05 15:04:35 the proposed bill threatening freedom of speech and rights to protest at p/square will be debated next MON 7th FEB. Protest has been organized at parliament sq between 2-8pm. Please support urgent! pass on message thank you. \ 08-02-05 14:02:05 Porno/Paul 'jonathan in page 16 evening standard quote' scandal!! \ 10-02-05 15:05:03 14.44p.m location: lovecraft. Some filthy rascal has just had the tumerity to askwhere he might find 'hairy prostitute ladies'Good lord !! \ 11-02-04 10:57:39 Haha! Isit!.... Taffy ho! I'll drag grandad moodie by the scruff of his balls!x \ 12-02-04 17:05:32 Seth Armstrong's just snuffed it !

Please recycle your last mobile text /s

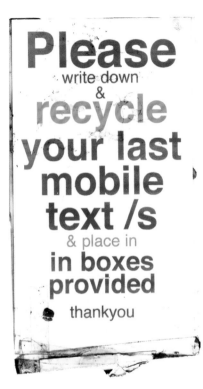

Please write down & recycle your last mobile text /s & place in in boxes provided

thankyou

It had been over five years since I had started saving my text messages and working with them. Over the last two years the texts I'd received had not only become more prolific but longer. It had also been over two years since I had held my last *Text-Me-Up!* exhibition. I began wondering if all peoples' text message inboxes were similar to mine. I wanted more and I wanted random, as neither my mundane nor salacious textual appetite was being satisfied. I decided to put on a basic interactive exhibition at the Foundry titled *Text-Me-Up! Just a Little Bit More...* It consisted of several large framed photographs of pink balloons taking off with individual text messages attached. At the opposite end of the room a concrete pillar divided the bar into two sections: on the outer side of the concrete pillar I placed a wooden box painted red with a slit in the top. A pile of notes were stored on top of the box and a few pens on long thread attached to it. Laminated instructions on the box read:

Please write down and recycle your last mobile text/s & place in boxes provided by you

People wrote down and posted their last text messages which I then collected, emptying the boxes every few days. I was trying to evaluate how the texts would in some way reflect the demographic of text messaging in a specific area.

Visitors to the Foundry would be coming to see exhibitions, performances, poetry or musical events. It was apparent when I gathered the texts from the boxes that a few were from regulars. I detected this from some texts referring to specific occupations, others by handwriting. At the same time as doing *Text-Me-Up! Just a Little Bit More...* I had also organised an event which included a cucumber-growing competition. It culminated in a village fête inside the Foundry with tombolas and stalls ranging from shooting to coconut shies. The winning cucumber was then auctioned on e-Bay and sold to Jeff Jenkins for £50, who came onto our radio show and kindly donated it to the Foundry art collection. I found a text in the box referring to that cucumber.

Mark Stringer > TM
21 Jul 2010 03:48 PM
I have been reading a lot of old texts for some reason and it suddenly occurred to me that it might be time to send some more......

TM > Mark Stringer
I am writing about old texts at the moment x

Mark Stringer > TM
I think I am writing about new ones or maybe just writing them, it's hard to tell sometimes, are your email addresses still the same?

TM > Mark Stringer
Yes they are still the same

Mark Stringer > TM
Things are fine and I shall send more details of anything I can think of whenever I have thought of it. I don't think we ever finished that conker tournament. Oh yes, hang on, Paul cheated and I burst his space hopper. Oh well never mind

TM > Mark Stringer
We need to do a conker tournament live on radio show

I have randomly selected approximately three hundred of the anonymously recycled text messages from *Text-Me-Up! Just a Little Bit More...*

We must do Nag Nag Nag again soon. Hope you're both well. Rave on etc. Carey x x (Kudos skiver speedfreak division).

Today I'm happy. Tomorrow who knows?

Yeah but couriers do it in the wet, He hee xx

OKLA HOMA CITY!! QUE BONITO!!

Fuk- it's ruining me_ like a school kid! Want you out of my mind but you won't get out of it! Captain Boubou

We might be late too - we're just getting nice food

(Notice 4 dots. important)

"THE WORLD WAS SO RECENT THAT MANY THINGS LACKED NAMES, AND IN ORDER TO INDICATE THEM IT WAS NECESSARY TO POINT."

Drunk. Everyone is empty. I love you. You're full.

So me and Jack are meeting in a while and heading out into hoxtonia to consume copious amounts of alcohol. Let me know your movements. will have keys.x

TYOUR MARK SAID: "I'M TOO DRUNK TO REMEMBER HOW MY PHONE WORKS, BUT I LOVE YOU."

Baby - you are L8 :(- oh well. call me - I still want to suck your cock

I love our mornings together... It's always like meeting a special friend for a quick cup of tea! I love you beautiful and feel so super lucky to wake up with you every morning. xxx

OK. But I'm gonna have 2 play with myself tho... Thinkin about u in my mouth in Canada just gets me so wet I can't help it ... want you ;-)

I'VE GOT GOOD NEWS TO!!

Please could you stop wanking in our living room? It's not nice to clean upafterwards. thank you for your understanding

SENT TOO QUICK LOVE HELEN

Yes martha 2 cups of sugar please. and the cake I like. the one with barbie pink icing and cherries

the is wearing a smelly green t-shirt and smoking in the shop.

Smoking kills

Calling planet earth

Whats that squidge? Its not squidge! Its cucumber art!

DON'T TEXT ME! I'LL TEXT YOU!!!

Do i scare you?

Do you want Green Day or Black sabbath?

Thought you ought to know that Helen + mark's baby died yesterday - only a week old - inquest to follow... Sorry to be the bringer of such bad news. Luv Erica x

Hi off to bed - shattered. Hope the test goes well tomz. Been watching Kill Bill thanks for that

Blll o o dy 'ell, that was a good night! See you guys@ the next shindig. Keep peace free. was lovely to see you!

Hi babe just got home from dropping u off. Spent 2 hrs in work trying to download a file then went to Sainsbury's got back no washing up done + Mike drunk: where are u?

Politics of Saturday night

Weckmich auf wnn du kommst, ich vermisse dich

'May the wind at your back Necer be your own!'

Are you back from holiday now? Can you give me a call when u get a minute? Cheers hun, xx

Sorry you did not win the Walkers i pod draw this time. Did you know Tina turner's real name is Annie Mae Bullock

Sorry phis de sous. Je suis mara contentie pre toi. Embrasse ja pour moi et jesse li ki ta tiou a vous deux! Bisons

Sorry didn't get it. Kitchen plastered like me been to the Swan luvu u ok xxx

How was the interview? Hope you didn't pee yr pants.

Did u really have to force it in Jeremy?

Not only are there a lot of cocks in Holland but I just had the pleasure of talking to a Mr. Dickman!

HIYA

No one puts baby in the corner!

I've just seen. on Trafalgar Square, a woman who appeared to have a brown tongue. On closer inspection she just had a bourbon in her mouth

this avo maybe better.not such a drag. Voicemail has 1 new message. Pls call 121. Thanks for the oysters x

Yes

Leave now and meet us in L.Square Times running out. We'll decide then.

that thing you like... the thing your husband does... I taught him that

I've run out of credit!

We are already closed I will be at home

Hey Kim how's the kitchen party going?

No aapol nec - u is mad ho ho ho - speak later x

I'm on the bus will be at the Foundry in 20 min.

I just got in a nd the cauliflower was all over the floor. I love you x x x

>Guest who's taken to sleeping on the bread board...<

Black PVC catsuit £27. Yeeeehah!

Her>Me: nightmares. you don't even know. I'm off to Shoreditch I just had bad news. Going 2 hospital 2moro.

I LOVE YOU

If I was lezbanian I'd fuck you

Maybe when I finissh. Now I feel like I'm walking on the moon. I need a rest! Cu x

Id habe es esen nod mit niernem laptop getrreben und falle num ins bett, leido ohne did.

NARRATOPHILIA CUNNILALIA – TALK ABOUT FEMALE GENITALS

Restricted to be supplied only to licensed Tracey M of not less than 18 years.

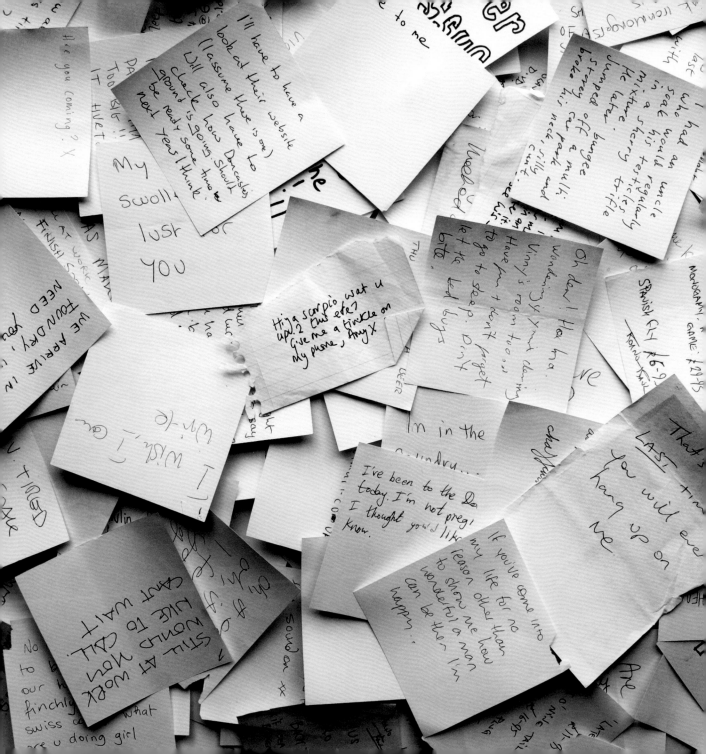

Great

Hi Madita! Shall we leave it for next week? Enjoy weekend!

What?! I don't believe it. What a toss bag. Email me when u get to work xx

Ok! ;) it's 75 Chiltern st, W1... Nearest tuibe = Baker St .. Definitely a nite time deal and pretty risky but worth it? Possibly thru rear-Sherlock Mews?

Sweetheart, if sleep is slow to come, know that i'm holding you in my heart. However, if sleep is your already, wake with the knowledge that you are in my daimoku - unless this wakes you now, in which case call me a cunt and try to forgive me.

Don't forget the soya milk

Message from the kingdom. The queen miss the king and say I love him more than a cheese cake

Ha ha, you're fucked! Remember, the only option for morning is to keep drinking and try to avoid talking to the boss.

Sounds cool, feeling bit better 2day. Work is so slow and boring tho. England need rain in the cricket!

Pig capitalist scumbags

Was the cucumber race fixed vicar?

Hello people, it's my last day chugging! Yay!

2 legit 2 quit

Bollocks. they've just realised I'm not really German. I used the accusative instead of the dative.

Delivered to: +44786677****
date and time: 17:30:50 18-09-2005

I'm coming don't worry. Paula - be buddhist with your desire...

What sort of a man goes out with a woman wearin fairy wings??? Lmk if there is an after party :)

Tomorrow maybe?

Like birds, lets leave behind what we don't need to carry, grudges, sadness, hate, suspicion, fear + regrets. Fly light. life is beautiful

Hey! its claire, soz 4got2mail u bak. uv got my number nw, u lucky boy! Moo!

Pasta and salad with the girls tonight xx

Nice for Barnet. Not so impressed with Gillingham for Doncaster. We'll have to play you in the next round.

Leaving work will pedal as fast as poss, so should be there at 6

Attention account holder: Please call now on 08700736736 regarding your mobile phone

been getting wasted with babyshambles (delphine) Too wasted I'll speak soon. Psychic sex in the fifth dimension. Take care xxx

Why do you want my txt's? Don't you have your own friends 2 txt u?

10.53am 23rd September Location: Old St. I think I have just seen a camel

Hur mycket thor du att du kom 27 sep 2005 12:11:47

KILL KILL KILL

Var finns dina skattesedlar har fatt fran fredrika b meo det var yit eklibake en du skulle soka fran var finns ansoknninbesblanjetten hur mycket tror duatt du kum. 27 sep 2005 22:11:47

Venus Penis Vibrator£22.95 Oro Simulator £8.95 back Door bouncer £18.95 * If seal on box broken ckeck contents

Finger Rabbit Vibrator £11.95 'Black pussy' £29.95 Black Latex Strap -On £63.95

Latex duo balls £4.95 'Love Ewe' Inflatable Sheep £13.95 'Woman On Top' by Nancy Friday £7.

Jill Kelly Love Doll £239.95 Sister strap on £63.95 'Poppers' £4.50 each or 3 for £10.00

Fuckin shit Fuckin cunt bollox cunt bucket arse anal fucker clit bleedin arse puss blood cunt clottin shit fuckin. I've maade my point...

Skin two Oagazine £10.00 'Crvella' (Fem Dom Mag) £10.00 'Janus' Spanking Magazine £10.00

what's wrong with the scooter? On my way home speak soon gorgeous

Could go for u and me, don't fancy the dukes

So when should I get back 4? Roll some joints 4 later

Stop worrying about that. everyone is allowed to rant. it was a minor mishap. instead think about the major contreibution you made to the company. we love you

Come to murder s. mile tonite @ the biddle bros, 88 clapton road. I'll play some records and have drinks with you from 6-11. See you later! Anna x

Male 'Stop stop' cream £5.95 Female climax cream £5.95 'Stud' action spray £7.95

Get off at la R'tness (on your right) ... walk down red lion street. the enterprise

16-02-05 13:19:33 Camilla happy 2 marry but turns down queens offer of a weekend in Paris with her own car and driver \ 20-02-05 12:55:58 Aye lass, i'll get ON wi' it reet away! \ 24-02-05 15:27:30 He's got a rotweiller tattood on his head, who's interested in his cock. \ 28-02-05 19:30:56 AAAAARRRRGGGGHHH ! Just engaging in a spot of text 'shouting' ! ! ! \ 25-02-05 22:26:47 it's good to have a fear filled paranoid day full of self loathing and nausea once in a while. \ 25-02-05 23:14:45 Maybe. But at a price, I've had to pull all the hairs out of my ears and nose. Bath. Shave. Fold numerous objects. Forget a couple of really good ideas and listen to the first madness album as a form of aural security blanket. Got a few eyebrow hairs too. What the fuck did they put in their beer. \ 03-03-05 17:51:22 Once again it looks like Babyshambles isnt happenin this sunday. Back down the foundry then! \ 09-03-05 13:46:48 Shop here sells halal toothpaste. (i wasn't aware that toothpaste had meat in it, in fact I was rather expecting it not to.) \ 09-03-05 14:37:29 in what capacity are you with bowie. Be clear woman for christs sake... \ 11-03-05 19:32:28 Saw norman evans today he looked u old took great pleasure in telling him

"You're raped just like a cunt" [sic]

Hola volvi de Sudamerica hos vemos para unosmates silii

Vibrating nipple clamps (lavender) £17.95 Julie Ashton's Anal teaser £25.95 Steel handcuffs £7.95

[Edit]##### Today I'm happy tomorrow i'm not

Still at work would you like to call. Can't wait

Good on yer!!!

Hi Posh, So u'v moved - that's y you weren't answerin landline! wot's nu address? R's wil b : 8 xxxxx Rd, Risinglust, OX OX3 8HZ, Tel: xxxx xxxx, as of Nov 1st, Jo xxx

Of course, I was forgetting? out of interest what involvement do FC Manchester have in cup competitions?

She's a bit of a cunt to say the least. Poor old nice steady job

Hey baby I'd like to invite u 4 my bday, sat 24 Sept, Leicieter Square, Yates @ 6 if u r free! Friends welcome. Love Cx

Would I stay at macs 2 long! I don't think so they r all 5p looking freaks

Where's my sugar puffs

Im on my way

Thanks for the meal and thoroughly nice evening. Waiting for train which is a few minutes late: Sleep well. M x

Hey rose Kerry gave me your number here is mine sweetie gem xxx

Well ?!

Fantastic! - will call when in

Fucker! May her vaginal worms + crab crawlin eyebrows find themselves in ur most secure dream ... Tsk

2+2=5 (archived.)

Darren, I will be 5 mins late for work. Cheers, M.

Dvdes. Can't make it 2 nite. Not much fun @ the m'ment. Will c u soon x

Im still at work will finish soon call you when im near

Let me know what time I should at at the foundasy

I hope for your sake that's not true. No worries mate.

I'm going to play in the rain

Are you coming? X

Vazhi!

Got to show on time!

I'm in the foundry... where are you?

NO NO NO u need to be escorted to our houses its finchly road near swiss cottage what are u doing girl cu here

I'll have to have a look at their website (I assume there is one) Will also have to check how Doncaster ground is going. Should be ready some time next year I think

I had an uncle who would regularly soak his testicles in a sherry trifle mixture. He later bungee jumped off a multi storey car park and broke his kneck, silly cunt.

Que bonita la estrella!

Translated (That pretty the star!)

11.31am. Currently skulking behind dustbins disguised as a large chaffinch

Oh, if ever Oh, if ever I felt your garden grow

You up for a beer Thu or Fri?

Ohdear! Ha ha. wondering if your cleaning Vinny's room... have fun and don't forget to go to sleep. Don't let the bed bugs bite.

Stud spray: Reduces male sensitivity £7.95, Monogamy: adult board game: £29.95, Spanish fly £6.95

Location Leicester Square 7.03pm. I have just seen a tramp that has puked his guts up, and the pigeons are eating his vomit.

Remember at 00:00 in the ladies! Pink pants I'm waiting

What is your alaias on 32 red and ill put you down as oz referer :-)

No she didn't swallow. but she did gurgle...

'Pocket Pal' mini vibrating vagina £22.95, Selection of clitoral stimulators (4types) £4.95 each, British escort guide no.1 £10.00

Well rechenzentouin so far but that's only out of that and 1sg ... need more time for listening! Did you go to multi - vitamins? Food?

Hi ime at stanstead airport flying to Isreal keep in touch

I actually feel abused, yuk! I'll leave the keys under the mat. from caroline mob 9.27 25-sep-05

Sorry to keep you waiting. Would be really nice to see you and C.

Ladies & Gents Sebo's bike is on display in the city, for wrong reasons. Grose abuse by met police. Police complaints 0207-601-2203

my job he was with some of his pupils and cheeky bugger said to the girls i used to teach her and look how well she has done \ 14-03-05 14:58:07 And the ability to see bags in trees wherever you go is my gift to you. Treasure it, and use it well my child. \ 17-03-05 20:08:06 Honey, you can take the girl out of the valley ... \ 19-03-05 17:13:11 We have just won the glad slam the 6 nations in rugby come on wales \ 21-03-05 17:32:05 I'm chillin'. Like bob dylan. \ 22-03-05 00:28:17 In this week. I'm expecting a stitch up. She asked me if I thought I was mad to take old bags out of trees and put new ones in. I said that it seemed perfectly logical to me. I told her the full truth: That emaciated old torn and tattered bags are the shredded dreams and hopes of mankind and by replacing them we give new strength to those ideals and offer the dawn of a new age in a world beset by an unfortunate malaise. \ 25-03-05 14:10:10 Yeah. Dry. Dry. Dry. Hey! I met someone the other day who said they didn't like pizza! what+a+fucking+cunt! ...or a liar. \ 26-03-05 09:42:11 Forgot to mention that last thursday I had to eject some weirdo from the shop for making twittering noises akin to that of a tropical bird ! !

My friend mr jones told me bonnie tyler welsh susper star has no vagina. Mrs M says its true. I wonder how she knows?

Paul has given up lurking for the night. He has decided to take up doing charlie instead.

Red + Black bondage tape £10.00, Leather spanking jarness £59.95, 'Intruder' vibrator £59.95

Any porn dvds for a fiver mate? I'm a cheap filthy scumster

watch the wettest T drip until she is soaked with gooey love liquid. Splash!

'Fore Play' massage mitt £29.95, 'edible undies' male female £6.95, Fishnet stockings black, white or red £4.95

No she got a huge northern bloke called Roy. Will keep an ear out tho.

What Watt?

Are you still coming for a drink before Cargo?

Crawley Rd Health Centre is on 02085391880. Brought to you by 118500 the UK directory enquiries

Brilliant! 1145 ok, sort captions after? words interestin, gues we can do somethin wth tht! How ru feelin? I flaked out 4 couple of hrs & now can't get 2sleep xx

xxx ooo

Fucking hell, that was a wierd text you send me last Sunday. English, French? I'm really sorry, but I just can't remember when and where we met!? x

Are you being naughty tonight? If so I will join you

Cool - yes pls come this way if thats ok - its als bday on sat and hes too busy to organise his own friends, so hed love it if the three of us went out x

Enjoy it you'll only hav it till next time when we'll bury ya. Wavney man of the series, next best to a sarj african.

Fuck off and die

'No swallowing allowed' d.v.d £29.95, 'Anal kommando' D.v.d. £26.95, 'Cum guzzlers' (hash2)

Arde you alive

Hi John, - Katrina here congrats on the bar x

Good morning. There was no inf. of jumble sale on paper. must be next week. To eve

No dress code tonight geezer

Where are you, you fucking bollock brain.

Lie to me

That's the LAST time you will hang up on me

R U OK?

Si Podes Llamame, xxx Ana

Party reminder This Saturday 17th sept. address: Lane 1 1.5 Nimrod passage (No I'm not joking that is the name!) Just off Kingsland Rd. N1 HBU. Turn up at around b8. Middle buzzer ... Bring Grog. xC.

Club in Crouchy, drugs & girls on the house? C.

Sure! Thanx ... S.11

Wo is Frau Klinton?

Hello Fanny dear.

Just walking down Bond St. not sure where I'm going though!x

I saw! So exciting. Just wanted to check you hadn't asked anyone yet. We'll go ahead.

According to the Guiness book of hit singles it was bloody Roxette so we were actually joint second!

I love you. Please

I've been to the doctor today. I'm not pregnant. I thought you'd like to know.

If you've come into my life for no reason other than to show me how wonderful a man can be then I'm happy...

WE ARRIVE IN FOUNDRY, WE NEED YOU.

Ned Kelly, Clive James, Waltzing Matilda, Rolf harris, dame Edna Everage, Skippy, Germaine Greer, Eddie Charlton, Mel Gibson, your team took a hell of a beating!

Having drinks at mine then going out. Everyone will be there. Should be fun!X

Hiya scorpio wat u up 2 this eve? Give me a tinkle on my phone, Amy X

Ace, I'm glad you have it and its not lost. I don't have an ink colour match and am using it in an artwork please look after it. I will try and see his show! X

I think ironmongers row baths is the cheapest nicest, and we could afford 2 hav treatments too you don't have 2 book. Discuss 2nite? Sx

OK.

hey hun. Just thought I would text you to say good luck today! I dunno if u have this phone on you but nvm! Hugs and kisses soph x

where are you?

wowzer

HE RENE WHEN YOU BACK AT HOME. THE REASON FOR MY QUESTION IS THE LIDL TRIP

YOU HAVE 2 MISSED CALLS FROM THE ABOVE CALLER LAST CALL ON 16/09 15:02

ooo-er missus

she IS the girl in the std ads! I swear

LATEX OPEN CROTCH PANTIES £8-95 'DESIRE' BIKINI SET £17-95 DOUBLE DONG 12" £22-95 PORNO PAUL

Ok, see you I'm still sleepy

I'm sorry my phone was no battery. So I couldn't call you. What time do you go to the park tomorrow? If the weather is good well go there.

Hi how about 4? Am less tired then cu then?

AM V TIRED GONNA SOAK IN LAVENDER BATH – CU IN THE MORNING XX

You are down for thur 3 sal

01:03 Addlee Car on its way. Price: 12:00 Driver mob 07816246701 Job No: 406894 Reg no. LM05 KUJ BLACK VW SHARRAN

I can't this weekend but I'm peachy keen for next weekend safro

Voicemail has 1 message please call 121

K.Y. JELLY £3.00 NICOLE LOVE DOLL £84.95 PENIS ENLARGER £39.95 PORNO PAUL..

Are you home? I am staying up tonight for granmum. Because it's last night I can be with her. Xxx

Quelle horror at suggestion!

OK Sweetie have hit London and got lots of sleep

Yes I am your piece looks wicked but I don't know how to turn sound on xx

SMS 600-MALE PHEREMONE SPRAY £11-95 'CARLA' LOVE DOLL £46-95 MINI COLOURED VIBRATORS £4-95 EACH (7 COLOURS) PORNO PAUL

BRILLIANT ITS OK SORT CAPTIONS AFTER. WORDS INTERESTING GUESS. FIGS WE CAN DO SOMEHOW WITHOUT! I FLAKED OUT 4 COUPLE OF HRS NOW CANT GET 2SLEEP XX

A glass of red wine PLEASE!

I COME. I OUT. I WITH. I YOUR. I HANDS. I UP

See you later radio star.

of course u deserve it. I was bad before I met u. A terrorist with a bloody past and ugly face, even a big moustache. Life is a miracle! Xxx

YES YOU TOLD ME. SO I HAVE BOUGHT YOU BYCICLE SEAT FOR FIFTY PENCE

I HEAR THAT DONALD HAS HAD HIS TESTICLES SAVAGED BY A LARGE DOG PORNO PAUL

I THINK WE HAVE TO PAY IT NOW BECAUSE IT IS ABOUT THE LEASE AND NOT SOLICITORS FEE. NTASHA

Thanks 4 the call will check prices tomz. Have a great evening

ok don't need now might need life Braintree. But reckon u busy. Might get train. Sxx

KISS, TEQUILA, ROCK'N'ROLL XOX

Now have habitat catalogue! –am going classy so have thrown out argos one!!! Xxx

Best till him to leave the lion at home in case I can't find a lion taming friend! Any chance of different tim/place? Generally don't finish work in old * some text missing *

MWAMWAMWAMWA ¥

licklickpurrpurr
meowwmeoww
¥ xxxxx
xxxxx
xxxx
xxx

Hi belle. I'm already here. Cause don don needs the cd mixer, which was @ our place. When ru hit the road? Xoxox

YOU TALK TOO MUCH WHY NOT SHUT THE FUCK UP?

HEY BOYS + GIRLS. THIS ISNT ART ITS STOLEN WORDS. I DIDN'T PAY FOR. IM A TEXT RIPPER OFF'ER !!!!

my lucky numbers one

'DYKES OF PERVERSION' D.V.D. £21-95 'GODESS FREYA' TRAINING THE SLUT WIFE D.V.D £21-95 LASBIAN SLAVE TRAINING D.V.D. £21-95 PORNO PAUL..

CUNT

lady boy sex toy

oh my god. Eugene has nicked Blagger. Miska is in a K hole and accusing me of nicking some brass pot to sell at portabello. Jane's here and everythings a shambles. I'm so tired of it all. Rx

Fuck Im hank marvin and all – you dozy muppet!

From "s"
ahahahah
ahahahah
ahahah.

I hope you haven't dared leave the close without paying off your debts!

Estoi en 5 minu

Yes for the chicklet love

Printclub. 0207-729-1961

HAVE GOT VIDEO PROJECTOR 4 SAT NITE X

YEAH I'VE GOT THE MIDGETS SORES. DAVES COOL WHERE CAN I FIND AN OBVIOUSLY USED VIBRATOR? LATER MICK

I wish, I can write

'SLAM IT IN HARDER D.V.D. £29-95 'FAT CHICKS IN BONDAGE' D.V.D. £21-95 'CORRECTIVE PUNISHMENT' D.V.D. £21-95 PRONO PAUL..

Yeah, its possible :) x

Wicked See U There x

Okay cool how long u think ur going 2 be?

'IMPULSE' FANTASY KIT £79-95 COCK EAGLE (PENIS RING) £16-95 JELLY 'TWISTER' VIB (PINK) £11-95 PORNO PAUL..

BINKY BEAUMONT THINKS YOU ARE A CUNT.

How about 8th oct then? You might have to see our Egypt photos I'm afraiD

xx loved sucking your gorgeous 18 inches. Cok the back of my throat still bleeds and my tongue is covered in hair still. Kis

WHAT IS YOUR ALIAS ON 32 RED AND ILL PUT YOU DOWN AS OZ REFERER : -) MATT

Good to see you mate, sorry again about last week. You are a good friend. Will call you over weekend for a walk with the boy. He loves seeing you, you make him laugh

Hi Anna, I have passed your details onto that journalist mike gerber who might give you a call to talk about being a student &2& fundraiser thanks Rebecca

Don't be sad baby, next time :)

It was the bishop all along

Gd news, chat was a pleasure, cu sn

Giati den me til? Ti kaneis?

I'm across the road from the tube. Turn away from the London Dungeon towards the bus stop.

Think I'm ok 4 food. But can you grab some white wine?

Hows your day? I'm still having trouble walking a straight line.

WHY DON'T YOU SEND ME ONE AND I'LL WRITE YOU ALL THE BRUTAL POETRY YOU WANT 0779596****

How do pea head fancy a pinto

GOT BROKEN INTO LAST NIGHT SO HAVE GOT SOME STUFF TO SORT OUT. WILL CALL THE OFFICE IN THE MORNING.

U have been sent a PXT by 021415529**. View it at www.pxitworld.co.nz Use yr Vodafone website details to login.

Good luck – phone me with negotiation results

Are you sure you want to write me off?

Saxon Film Crew Oh! That's nice we thought we'd be able to party here and show highlights from our new film our beautiful barbers

You can take your poncy picnic and stuff it up your arse.

There is a club in Crouch end full of pussy. I would hate to waste money on my own?

Could you pick me up some tabacco on your way back. Posted letter.

Strange boy do you know what your doing yet?

You're welcomw ;)

I can see Pieterson's hair.

My lips are swollen with lust for you

Hello Rick just had a good sesh thinking about you

IT HAS NO GOAL IN THE FUTURE! BUT IT'LL BE FUN!

Happy new year to you too. THAT QUESTION IS TOO HARD! I have changed my question with one week to go. I AM AN IDIOT!

2nite or 2moro? I not home til 11 2nite. Where shall I send card? I'l call evey1 2moro morn

He

X (WILL)

Here nw and staying all nite. U shud cum in if u want! I got a contract phone so im incredibly happy. Haha.remind me 2tell smith nxt time I c u !

I'VE JUST SHAT MYSELF

What's your ADDRESS?

So So Sorry

Yohoo

Craig McGlauchlan & Check 1-2 are touring again – lets get tickets

Come back to me t leave your life. It was good wasn't it? X

www.cosmosis.cc falcon

Just about to head to the tube. Where should we be headed?

Hello, 7 deadly sins has landed Pablo Cambarotto

OK KIDS. WELCOME TO THE LAST STAND. 7PM AT THE FOUNDRY X MICHELLE

In my head I am touching you deep inside and feeling the warmth of you and taking you high and looking into your fat eyes as I do to do it I thrill on it......* missing text from Pablo to Liza

HELLO FANCY A XMAS SHAG TODAY :)

40 FINDS OUT WHO YOU ATLV; HOW ATLV YOU

I LIKE STING

SAM FARMER IS YOUR NEW NAME 55 OLD STWALK OFF XXX

'POCKET PAL' (MINI VIBRATING VAGINA) £22-95 SELECTION OF CLITORAL STIMULATORS (4 TYPES) £4-95 EACH BRITISH ESCORT GUIDE No1 £10-00 PORNO PAUL..

STRUNZ che si tu? (o io)

I hate fashion shit ideas

Hi I think I have 3 coming, maybe more. Really want to do a show this time! Gossip? Um Gazza is still on the booze D

I keep receiving porn from these people. And I haven't even ordered it. Please make it stop.

83121 Thankyou. Your payment of 150p has been received. Temped.co.uk PO Box 1013IG110JA

Tel: 02085076972

PUB & POSH?

Thanks for the flares. I enjoyed last night – should have gone to bed earlier!

02-04-05 12:06:36 Yes, now certified text maniac. Have great idea for installation. Must discuss at some point ! \ 06-04-05 14:43:25 I hacked a lump off and it was like a bit of a feast ice lolly, y-know, the crunchy bits on the outside, but made of weepy pus and snot not nuts. \ 06-04-05 19:50:40 Want to list contents of what one might find in a shed. Well thumbed copy of 'razzle', old moores almanac circa 1971, manual lawnmower in dire need of oiling... Half empty bottle of 'mackeson' milk stout, filled with paraffin, tobacco tin containing some rusting nails, a page from the 'racing post' circa 1974..... Clement freud's nasal hair clippings. (Secreted in rusting 'nesquick tin....rasberry flavour.) \ 12-04-05 00:33:18 His daughter. Please don't tell me about your cats bowels! night love.X \ 14-04-05 23:26:46 All very good. No deaths, assaults, unsolicited porn or bankruptcy. Today is a good day \ 18-04-05 17:44:14 PInk and blue. Blue like my eyes. Pink like your's. Rabbit head. \ 18-04-05 20:31:40 Wilbert will return... He got swept away by the tsunami... He was on a shopping trip 4 thai brides. He currently paddling this way back.. \ 18-04-05 22:15:53 Why? haven't you got a camera fone? \ 19-04-05 08:56:47 Hi tracey. do you want to speak about the nazi coke stuff at the boycott party 2nite? \ 20-04-05 09:06:43 Hmmm, I have a fencing lesson - but it's so long since we met up that I thinl I'll miss it x \ 21-04-05 12:09:28 But I've already got ur present. I've been saving all of pockets turds and I've built an igloo with the names of every I ever played chess with inside in bogeys. \ 21-04-05 22:24:17 Mark thomas says its the best invite he's ever had! \ 22-04-05 13:02:27 Heard the show .. It was great.. Well done. A man called andy who knows you from moss side was listening with me! X \ 26-04-05 00:03:49 I think she lived with john cuooper-clarke, at the time. When I see you next, remind me of this + I'll tell you a very amusing story ! \ 28-04-05 00:46:45 Hey Trace, just on the bus now - pickd up a scrap of newspaper off the floor to read...its only your page frm the Guardian. Mad innit! Ded proud of u girl! X \ 28-04-05 12:28:04 Hi tracey tam here Im doin a robert burns festival gig wi peter doherty and press up here want a photo of us together if poss. Is there one from the foundry? X \ 29-04-05 11:50:18 I heard u doin show topless 2day,careful with those nips!

02-05-05 15:26:40 Christ you don't half go on init. Am back from my ordeal by didgerydoo this eve. Will send this eve. I smell real tangy... \ 04-05-05 11:57:27 Just seen a picture of a pizza with bits of coriander on. I tell you now, if any fucker EVER puts coriander anywhere NEAR any pizza of mine THEY'RE FUCKING DEAD! \ 05-05-05 00:32:26 No im in the fuckin middle of deep pissin bloody R.E.fuckin.E.M sleep u twat bastard \ 12-05-05 17:22:00 Get this i am staying in a hut on Mt Elgon with a Ghanan Princess - how bizarre is that!? Still worried about the animals but..:-/ xx \ 17-05-05 22:07:00 U watchin pete doc doc? Do u know that fat bloke? \ 18-05-05 08:22:20 And Tracey, thanks for the stay strong text. Bill \ 20-05-05 11:01:38 Car service Should you need to contact your Lehman Brothers driver for your 11.30 pickup, the contact number is 4479563***17. Your job Ref:3007725 \ 20-05-05 18:17:57 Oi! If me + u r making gnomes, why r we not sorting it out 4 foundry fete? I want a stall a tombolla! AND a pin the muff on bonnie! Paul is so excited he is damp! \ 23-05-05 11:37:49 Good morning Madam! Are you going to seek, out 'old jack mathers' in holloway thisevening? I cant go due to work, so if you find him could you photograph the bugger and send it to my phone.Perhaps you could subject him to 'happy slappin' !! \ 30-05-05 16:37:29 T-Mobile (UK) welcomes you to Turkey. Make direct calls using international dialling code (e.g.+44 to UK), roaming rates apply. Have a pleasant stay. \ 30-05-05 19:40:00 Have just finished nurturing the future prize cucumber for the evening by way of ordering it to grow to the size of a zeppelin airship. \ 01-06-05 18:54:16 Saw u on tv - u looked fantastic - me and mark and jude and nick and his friend wachin! Wow! Hope u r havin fab time! Cx \ 01-06-05 21:02:02 Did you know that at the time of the bubonic plague, burial victims were given bells to ring in case they were still alive in their coffins. Hence when they were to be seen walking around after being presumed 'dead', they became known as 'dead ringers'. \ 06-06-05 12:16:37 Hi hope u had fab time! Was up at 5.30 2day after only 3.5 hrs sleep as j was cumin 2 get his stuf at 10 and cudn't sleep. Had 2 get out of house so am at mark's now. Took me and mark and 4 teenagers 2.5 hrs last nite 2 put his stuf in hall - didn't realise he had so much there. I cried on and off all efin nite and hav just bin sick in mark's new u posh b'room! I do hav gud days as well - the humour is stil there - it just cums and goes :) Speak soon. Cx \ 07-06-05 15:40:01 Sailing in Turkey? Is this moberly or emin? \ 11-06-05 16:21:16 Naked cyclists in west end. Hundreds of them ! :-I \ 13-06-05 09:17:58 Your top-up has been successful. Your balance is now 31.76

I was lying in my comfortable ex-Soviet issue style twin hotel room bed one brisk November evening in Moscow; the outside temperatures flickering between zero and minus three degrees. I was bickering with Bill Drummond, who was sharing the room and the other ex-Soviet issue twin bed, on the subject of whether the window should be opened or closed throughout the night. Following the onslaught of cramp in both feet and the possible onset of hypothermia at the beginning of the week due to being forced to sleep with the window open, I was now insistent on it being shut tight. We were in Moscow organising a joint art exhibition under the umbrella title of *Death and Desire*, and we were looking for a venue.

We laughed much for most of the time we were in Moscow sorting our respective work for the exhibition. Bill was dealing with the 'death' aspect, and I with 'desire'.

The show was a conceptual progression from an exhibition and body of work I had exhibited at the 340 Old Street Gallery in Shoreditch earlier in the year.

My supportive and participative subject for that exhibition had been former MP Tony Benn. He is a prolific diarist, having recorded on tape each day of his many long years in Parliament. I had constructed voice portraits (or sonograms) on canvas to celebrate his life's work, on the themes of missiles, miners and monarchy. I used sections of his diaries where these three topics, which he felt strongly about, were documented with much conviction. Scientists involved in

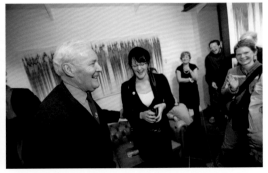

audio analysis, such as voice recognition or bird song, have used sonograms for decades. I used a similar technique to capture my favourite key moments from his words and render them as sonic visual artworks.

After the opening night of the exhibition, a few of us including Tony went for a meal. A long conversation on sonograms lead directly onto the work I would be exhibiting with Bill under the title *Desire* for the Russian exhibition.

For the *Death and Desire* exhibition, my work was split into three individual interweaving sections: The first, a triptych consisting of three large ink-on-canvas sonograms, produced from recordings of three different women's orgasms from three different countries. The next section was a poem made into an installation called *Pillow Talk* where each word of the poem is translated into Russian Cyrillic and individually crafted over 100 pillowcases. The poem contains an undertow with a twist intimating abuse, which leads the audience into the next section, a film called *V-day Until the Violence Stops* – a movement that grew out of *The Vagina Monologues*; I would be showing it in Russia for the first time. Russian actresses from *The Vagina Monologues* play would be doing a short performance in the gallery on the opening night.

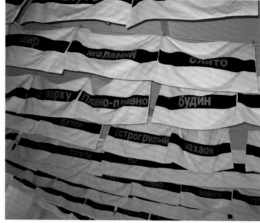

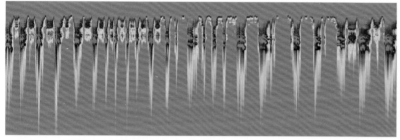

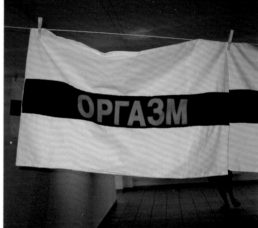

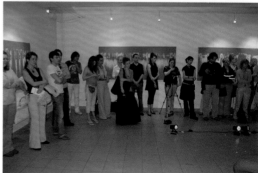

Bill's work for this exhibition began following the death of two close friends within months of each other. After one of the funerals he felt that the event did not reflect the man and wasn't a celebration of his dead friend's life. He therefore decided that he wanted to encourage people to think of their funeral as the last creative act they could give to their bereaved, the friends and family that they are leaving behind.

Following an intensely art-fuelled week and visiting the gallery taking our show, we took time out of our timetable for Bill to attend an interview with the Russian edition of Playboy magazine. I was fascinated with many of his responses to questions, some of which seemed to follow on from the debate we were having the previous evening. Beforehand, Bill had said he would probably be asked the same questions that came up in the majority of his interviews, such as, 'did you and Jimmy Cauty really burn the million pounds from the proceeds made by you as the band KLF in 1994?' 'Does KLF stand for Kopyright Liberation Front?' I'd heard most of the questions and the answers before, but this time Bill piped up on the naming of KLF and launched into a lengthy diatribe on names and the importance of names, masculine letterforms and how male strength can be symbolised by them. What ensued was a lengthy conversation which we continued long after the interview. Bill claimed that the capital letters K, L and F were strong male letters. 'K' when vocalised, made a strong masculine sound and the capital letter was reminiscent of a man with an erection. The argument developed with him suggesting that had I formed a band, as I was female, the name should obviously begin with a capital letter 'Q'. The feminine roundness of the form with a masculine stroke penetrating the 'O'. This obviously stoked the debate as I was starting to subvert the use of traditional feminine techniques in my text message work as a reaction to these kinds of attitudes…

I digressed from lying in the warmth of my comfortable ex-Soviet issue style twin hotel room bed, relishing the ensuing dream world I was about to enter, as a text message came stomping through the ether with a violent outburst on Bill's

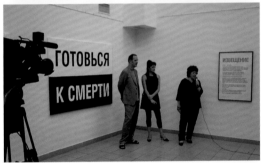

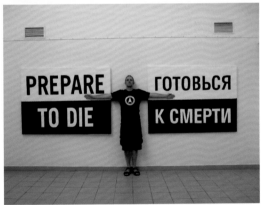

14-06-05 07:54:52 Are u ok? Y cant u stay, i really want to see you taffy….I will be back as soon as i have got the wheel replaced….Prob around 4 ish…Stay!x \ 29-06-05 10:37:06 Richard Whitely has died of pneumonia. On the up side he got extra points for having a nine letter word and using all the vowels! \ 01-07-05 12:42:43 In a certain book dealing with various forms of erotic impulses, there is a condition known as 'HARPAXOPHILIA', whereby the miscreant derives sexual pleasure from being robbed ! Perhaps he/she should consider moving south of the river ! \ 07-07-05 11:03:40 U manage 2 dodge the bombs? \ 07-07-05 17:01:08 I am on train now.. Thank god. Say hi to people. I cant believe i was right near it all this mornin. Thanks for your concern darlin and i will be in touch soon.Luv m x \ 08-07-05 11:59:27 'Dendrophilia' : Refers to those who are sexually aroused by trees !' \ 14-07-05 21:09:36 U shud do my thai kick box class! I'm sooo gay! \ 15-07-05 21:38:11 So sorry i haven't been in contact – sabbaticals, bombs etc. I'll give u a call nxt week, if that's ok? Hope u well. X \ 18-07-05 13:42:54 They say that everybody has a book in

them, and this is the working title of mine. 'Memoirs of a no good porn peddling louse. \ 19-07-05 21:56:12 We are around for coupla weeks then off on northern road trip. Need you bad, got withdrawal over you, we are at maximo park gig, ring you soon babe x \ 21-07-05 10:01:10 Sheep in yorkshire have learned to roll over cattlegrids and raid gardens...A tory counciller said it was 'soul destroying...We need more fencing'. \ 21-07-05 10:02:24 Did ya know hedgehogs lick creosote fencing to get off their faces? \ 21-07-05 13:32:10 There r 3 suspectd bombs on undergr-Warren st, oval, shepherds bush. Just to let u know. X \ 21-07-05 14:24:00 Baby u ok? \ 22-07-05 10:00:06 Pheromone spray not in stock untill next tuesday, shall I bring onto show next friday ? I shall endeavour to do just that. 'Never fear, Porno Paul is here'! \ 22-07-05 16:34:53 verse in the new zealand anthem says 'god defend our free land, guide her in the nations van...' do wot...? \ 25-07-05 00:03:26 have just seen somebody dressed up as a rabbit in old st. I can only hope that they were on their way to a fancy dress party.....

old relic of a mobile. Bill laughed out loud. He read out the text which was from a mutual friend, John Hirst: 'Start making work about the self, childbirth, form and texture. And then fuck off with the rest of them moaning about how their work is never appreciated.' John knew we were away together and this was sent to wind me up, which of course it did. I went off on a seemingly never-ending monologue on the imbalance in representation of the male and female throughout time within art and in society and how the representation of the feminine and femininity is a social and psychological product, and how the text message that was just sent was clear proof of this. I emphasised a classic example within the field of textiles: the practice of embroidery from medieval to current times with examples of work including 'birth and 'mourning' samplers. I also talked about Victorian educational samplers.

I was very aware of the types of texts I had received as a woman from male friends. Even though my personal situation had been constantly changing, the text messages and the way I texted had not really altered in content or context in parallel with this. Following *Text-Me-Up! Just a Little Bit More...* I knew that a random section of the general public with similar interests to me also received text messages akin to mine. I also felt that I had recorded a significant slice of socio-political history with my own rigorous text message collection.

The conversation with Bill had meandered onto a slightly different course as we spoke about growing up in industrialised working class communities. Bill was talking about his youth as a male in Corby with the steel industry, and I relayed my childhood in the mining community of the South Wales Valleys. I spoke about the fact that there are still men-only bars in the area and others which don't allow women in on Sunday mornings. Some of these provide

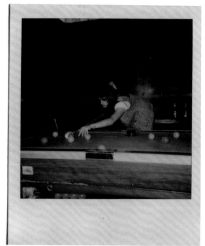

female strip acts for the men, whilst their wives and girlfriends are at home in the kitchen preparing the traditional Sunday roast. Growing up, I was forbidden to enter the snooker halls where all my male friends played. This Victorian attitude had a profound effect on me which manifested itself in a number of ways. The most important being my compulsion to walk into any bar or club with a pool table on my own, win a game and play on undefeated through the evening.

Ideas started formulating around the perceived implications and changing roles I currently felt developing in society from the invention and continual developments in mobile phone technology. The Representation of People Act

Bill Drummond > TM
24 Jul 2010 10:37 PM
Full day: Lots to report. But next to no battery left. More when I get back home. But bed making going well. Hope your weekend is progressing.

TM > Bill Drummond
Looking forward to hearing about it all... Hope the accosting wasn't too painful?!? Xx

Rob from Alabama Three accosted me.

Bill Drummond > TM
All very good natured. X

TM > Bill Drummond
I'm just finishing off the words in his sampler to/from/time/date etc. I won't text you anymore if bat low, call me when you get back xx

Porno Paul > TM
25 Jul 2010 01:27 PM
As an airplane is about to crash, a female passenger jumps up frantically and announces, "If I'm going to die, I want to die feeling like a woman." She removes all her clothing and asks, "Is there someone on this plane who is man enough to make me feel like a woman?" A man stands up, removes his shirt and says, "Here, iron this!"

TM > Porno Paul
What a daft man he was... they don't have irons on planes...!!

1928 in the UK (where women were granted the right to vote) wasn't really very long ago. I had always been intrigued by the art and content of Victorian sampler making and the sewing circles formed by women, as I have few female friends. I knew that my text message work would now take a new direction and would be illustrated in the medium of embroidery. I wanted to compare and contrast female Victorian samplers and the values illustrated and worked into them with current-day female values. These would be illustrated by texts received and used as a comment on male friends' interactions with women.

While teaching from pre-school up to masters degree level, I have always stated my clear-cut perceptions on the art of 'making'. As an interdisciplinary artist, I work in an abundance of mediums. I have always taught that the acts of making a brick and constructing a brick wall are analogous to those of spinning thread and knitting a jumper. The only differences being the ingredients and tools used. The same could be applied to cooking and icing a cake or constructing an iron gate. The tool used to create the art of embroidery is a needle. I view the needle as a tool, which not only creates and makes, but one which mends and repairs. If it wasn't for this basic tool or component, Manchester at the time of the Industrial Revolution, along with other cities across the world whose industry involved the use of fibre, would never have developed and the world's history would have been re-written.

I started working on my text messages as soon as we returned to the UK, becoming increasingly more interested in the comparisons between embroidery samplers throughout history and sampler making society. The earliest dated British sampler to have survived was made in 1598 by Jane Bostocke. In the 16th century, samplers served as a reference piece for a more or less experienced embroiderer and were usually worked on a linen ground with silk threads, sometimes including gold and silver. In the 17th century, they would become a method of measuring and recording the maker's skill. The Bostocke sampler now hangs in the Victoria and Albert Museum in London. By the mid 17th century needlework became an established part of the school curriculum, with sampler making incorporating the alphabet becoming an increasingly significant school exercise. During the 19th Century in Britain under the reign of Queen

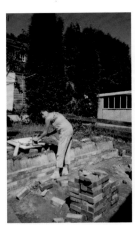

Victoria rigid standards of decency and morality dominated the country. With a vast majority of the population poor, education was neglected until the introduction of state schools, where samplers were developed to teach reading and writing skills. Furthermore, the children would gain skills in mending, darning, fabric marking and stitching to gain employment either in service to a family or in the many mills and factories that were the backbone of the Industrial Revolution and the Victorian economy. The production of mourning samplers had become more creative, with black thread being used in some and human hair of the deceased in others increasing the air of sentimentality.

For the millennium I had created a centre feature for Victoria Park in Miles Platting, Manchester made of recycled glass and glass mosaic. The park was next to Victoria Mill, and I based the centre feature on a local story from the mill about a ghost called Annabella who would come back and haunt the building. It was the story of a woman who had worked in the mill and had died as a result of getting her hair entangled and caught up in the machinery. Every Manchester mill seemed to have stories of this happening to women workers and I wondered how mourning samplers were made for these women and if they would use the departed person's human hair within this sampler tradition.

In the Victorian era, young girls were also encouraged to stitch to prepare themselves as future wives. Their age ranged from six to fifteen years of age. As wives in middle class families held dinner parties, they would lead the way into another room after the meal with their female guests to sew their samplers and embroider together. The men, on the other hand, would retire to another room where they would smoke, play billiards, gamble and drink whilst talking about the day's business. Sewing circles were commonly formed by women, comprising of relatives and neighbours who would gather at a particular house and work collectively on sewing chores. Sometimes they would swap and share sections of their work with other mem-

bers of the sewing circle if one was especially proficient in a particular sewing skill. The sewing circle merged the former isolation of sewing chores, creating a pleasurable social gathering. These groups would also form political discussion groups although this was rarely documented historically. Sewing skills passed between mother and daughter were also a great bonding exercise during this period, enhancing Victorian teachings on morality and decency. Examples of samplers produced read:

* Behold the daughter of innocence how beautiful is the mildness of her countenance
* God Bless Our Home
* Home Sweet Home
* Be thoughtful until death and I will give thee a crown of life
* A real friend is a great pleasure
* Things without remedy should be without regard
* Cease ye angels gaze no more but fall and silently adore
* Strive to cultivate your mind, and truest pleasure you shall find. All sandy shores shall fade away, beauty of mind never decay.

Start Making work about the self, child birth, form and texture. And then fuck off with the rest of them moaning about how their work is never appreciated. Thats the text john sent.

Date: 08.11.05
Time: 13.43.38
Sender: Bill Drummond

Big botty sausages and fugwuzles to u Shadwell. Love u xx

Date: 29.12.05
Time: 21.33.33
Sender: Nick Fry

My cucumber resembles some kind of giant tendril reaching into outer space, I have seen it touch many stars!

Date: 10.06.05
Time: 12.43.46
Sender: Porno Paul

LUVUX!

Date: 26.07.05
Time: 20.07.30
Sender: Aaj

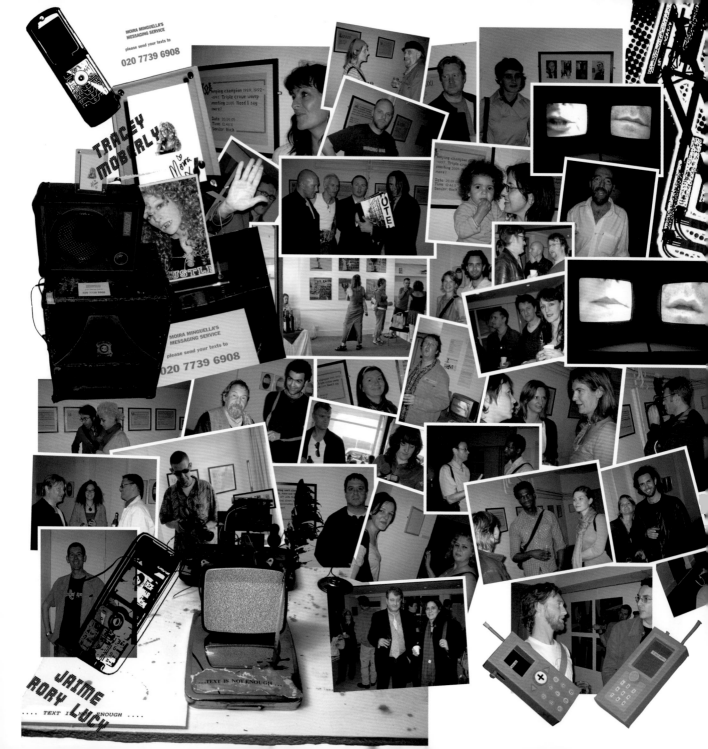

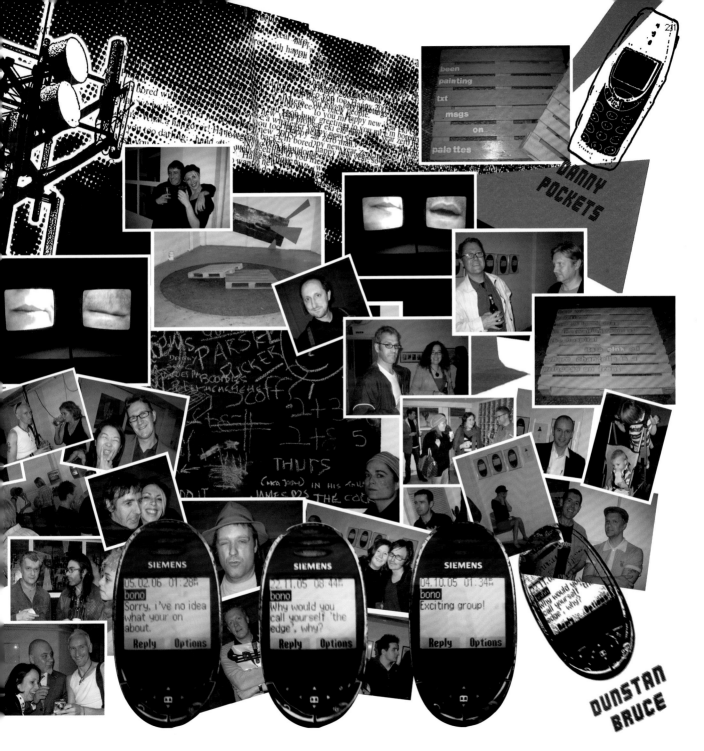

DANNY
POCKETS

been
painting
txt
msgs
on
palettes

SIEMENS
05.02.06 01:28ᴾᴹ
bono
Sorry, i've no idea
what your on
about.
Reply Options

SIEMENS
22.11.05 08:44ᴾᴹ
bono
Why would you
call yourself 'the
edge', why?
Reply Options

SIEMENS
04.10.05 01:34ᴾᴹ
bono
Exciting group!
Reply Options

DUNSTAN
BRUCE

As the Industrial Revolution progressed and a changing attitude in society developed, the production of the sampler declined. Following the tradition of French samplers, cross-stitch would become the sole survivor of what was once a huge repertoire of sampler stitches. This finally became known as the sampler stitch.

Having started work on my samplers, I began to plan *Text-Me-Up-Five*. I decided that the exhibition would be made up of five artists including myself: Dunstan Bruce (Chumbawumba vocalist on their number one hit *Tubthumping*); Jaime Rory Lucy, who had worked in film for many years; myself, producing my sampler work; my alter ego Moira Minguella producing her own body of work; and Danny Pockets who had started collecting and saving his texts following a serious relationship breakdown.

Dunstan Bruce continued his fascination with all things Bono, with his work entitled *Me and my mate Bono: Sage? Saviour? Puppet? Or prat?* A collection of intimate and illuminating text messages received from Bono Vox, lead singer of U2. Dunstan decided to show the world his many and varied text messages received from Bono Vox in an attempt to get to the bottom of what makes Bono tick. Would he be seen as pompous pious prick, a playful polymath, or both?

Jaime Rory Lucy presented his new work *From Plato to Nato*. Ms Minguella had also promised to make a personal appearance and would make herself available for a limited number of press interviews. Danny Pockets exhibited *Collapsing Sky* – a unique new painting venture. Danny and I also worked on a collaborative piece together. *Text-Me-Up-Five* was first exhibited in the Foundry. Then it was exhibited as part of the *Shot by the Sea* festival in Hastings, and also at Nancy Victor Gallery, London.

I used *Text-Me-Up-Five* to redefine the language and intimation of text between the sexes. *Stitch-Me-Up!* consisted of five Victorianesque samplers examining the language of intimation through mobile phones and texting – from a quintessential English dandy, a Soho sex shop proprietor, a gallery proprietor, and banter between two male artists; all of whom I have shared close friendships with. A parallel is drawn between the disposable instantaneity of the text message and the meditative, solitary, ponderous, intricate art of cross-stitching. The authors of these texts and creators of the narratives had long forgotten their disposable words.

The making of the text samplers also took me on another journey. Each

Bill Drummond > TM
27 Jul 2010 11:41 PM
As well as killing birds is there a good time to catch up?

TM > Bill Drummond
I can speak now is that good for you?

Bill Drummond > TM
I am now witnessing one of the greatest sunsets I have ever seen in my life.

TM > Bill Drummond
Send me a photo of it, I can see a blip of it in your direction but nothing really

Bill Drummond > TM
I took a photo but it was not worthy.

TM > Bill Drummond
It doesn't matter if it wasn't worthy I would still like to see it... Or you could take another?

Bill Drummond > TM
It has now faded. Like those snow flakes on the river. They last for a moment then gone forever. To sort of quote Robert Burns

BONO VOX

born billingham bangs in a bilious backwater. I got out quick. ran away to join the spastic anarcho cabaret. a master of nothing but a dedicated bon viveur nonetheless. an outreé non-orthodoxon. a bon motson in fact and in fiction. a fan of diction. nary a word left unturned with twitchy thumbs off key and off kilter. my raison d'etre: a desire to text lyrical using the written vehicle without due care and attention. no mention of convention. firing off apercus and overblown opinionated opuses banging on about the good and the bad the beautiful and the ugly with passion and devotion. mobile prosetry in motion. Never a fan of speaking telephonically. the text message is a godsend. [oh but the acronym, the emoticon, the numbers; oh how I h8 'em. Reviled and rejected, I tie myself to the trad-mast].

\ Falling in love; what a traumatic business. Who knew? Not me. And anyway, knew what exactly? knew about us? a question. Or a statement. Of joy. Or of dismay. Accusatory? Celebratory? Panic stricken. What the fuck in fact. Ohmygod even. Or just plain odd. I lost the plot. Two words. That's all it took. To throw me pell mell. But then what the hell. That vibration in Manchester and then the ping. There goes my heart. Pulled apart. Then put back together again. Perfectly. The doctor was in the house.

\ Brixton. At this Loughborough juncture. Second floor flat. Trains trundle past. A constant stream of copcar cacophony. Biding time whilst my baby works from nine till five. My thumbs hurt. Proximal phalange or first metacarpal. It's weird. No it is. Totally weird. It's been weeks now. Neither accident nor emergency. But one hospital trip later. Tendonitis. That's all. Or repetitive strain injury. Or repetive strain injury. A sling and a paracetamol. And a red face. Ridiculous. It's the modern malaise. It's beyond me. I can't keep up.

\ So daisy says you've got to meet my friend tracey. In so much to answer for Manchester. Where you can't not fall in love with her. She turns the double negative into the double positive. Kinetic, frenetic, endlessly energetic. Texpert, optimist, kick-up-the-artist. Diarist and diligent digital documenteer. A catalytic converter, uber networker and of course the arch collaborator whether bill or benn or the flower power pot man she's always thinking, always thinking dreaming scheming probing poking. A furiously curious cat amongst the pigeons. She's barnstorming bonkers of course and just a minute is just an hour [she can't half converse]. The irrepressible passion wagon has me reeling. I'm dazed and confused courtesy of the counter cultural explorer around the world campaigner, fund-raiser artmaker. From the far flung to the foreboding; Siberia, Haiti Mexico to deepest, darkest Wales. Don't touch that dial resident resonator she's the glue she's the stick she's the champion, the foundry flag bearer. That T in the window stands for tracey not tenants. Her hand's on her big pink heart, her heart's on her sleeve [and she's currently collaborating with captain beefheart I believe]

\ Then along came Gethyn. Opinionated, provocative, sharp and smart. I dug his chutzpah, his impudence, his haranguing and his humour. He's another prober and poker. He could and would become my project. He knew nowt about it. He would be my bono vox of the irish rock group U2. I carry on as normal. Bantering, bitching but not baiting. responses in my intray; they are bono's own scriptures. Making the normal abnormal. Text as pronouncement from high. Or confessional. Or just plain prickery. Whatever or whichever we commune with bono. To trivialise. To knock the pompous prick off his perch. To ridicule. And then out of the blue he takes me to the edge. A coincidence. Pure happenstance so I blow my cover and it's game over...

DUNSTAN BRUCE

TM > Bill Drummond
27 Jul 2010 09:47 PM
I've just had to eat curly cale the most disgusting vegetable known to woman. I even drowned it in garlic to steam

Bill Drummond > TM
Just one look at you and you can tell what you need. A diet of curly Kale for a month. And none of those takeaways. You need some fresh fruit and veg in you woman.

TM > Bill Drummond
You calling me fat arse face?

Bill Drummond > TM
Sorry. It was the full moon that made me do it. Over and out.

TM > Bill Drummond
That was the day before yesterday

Bill Drummond > TM
I have always been slow

piece became an artwork in progress that compared to the making of a painting or the developing of a photo. Unlike a painting where people comment as it is being made – for example on the strokes or colours – in the case of the sampler people seem to not see beyond the needle, thread and fabric. They don't want to look or ask questions because they assume that it is something that it is not. On a seven hour flight from London to New York en route to Venezuela I was the only female sitting in the middle of a large group of Hasidic Jewish men. I was virtually ignored until I got my text message sampler out. This seemed to break the ice with everyone around me, despite numerous unsuccessful attempts to instigate conversations with the group earlier. No one was interested in what I was sewing, just in the action of my sewing. I'm sure if they had taken note of the 'Wumping Champion' text I'd been sewing they would have completely blanked me.

A similar experience followed when I sat with a group of women including a prominent female MP and her elderly mother. They spoke about the sampler and the act of sewing; I explained it was a text message I was giving permanence to and they were still not interested in the content. I was once again somewhat grateful that they weren't as this sampler read 'Big Botty Sausages…'.

26-07-05 22:26:06 Egg and chips? \ 27-07-05 10:50:24 Mucophagy : sexual pleasure from the eating of snot ! \ 27-07-05 21:37:36 Head engaged. Crikey. Here we go! \ 29-07-05 12:21:30 Engelbert humperdinck was actually the first choice for the role of 'rigsby' in rising damp, but was pipped at the post by the great Leonard Rossiter ! \ 29-07-05 12:59:45 Taser stands for 'thomas a swifts electric rifle' and a taser hit tends to make the target vent their bowels and bladder…Snap crackle plop! \ 30-07-05 11:12:49 I'd rather the man i love loved me back and i had a cleavage like yours! \ 01-08-05 21:57:00 (u missed off 'hag, slut, hussy')xx \ 02-08-05 18:21:11 Can u bring a glitter ball \ 03-08-05 21:37:20 Formicophilia : sexual arousal from ants ! I kid you not. \ 04-08-05 12:29:58 Hi gorge. Am hiding and covered with psoriasis. Can you send me your email? Hope all good with you x \ 05-08-05 16:55:13 ave u seen banksy p8 of the guardian? FAB. Would u tell him id love 4 him add to the theme in the Big Room if he in town – massive fan :-) X \ 06-08-05 11:30:58 Do we have any advances on 50.00 for this delightful selecection of cucumbers ? ? \ 11-08-05 14:56:37 Ha ! They dont call me 'porno pool' for nothing ! (Wait till you see my cue !) \ 11-08-05 16:50:15 Fly back tomorrow into norwich airport.tackl aching from the wanking. Could do with a hand of pool myself. \ 13-08-05 17:19:06 Unfortunately i haven't seen twenty people from leek. All mancs. Bloke in pub didnt know though. Sting heard the wallabys were in stoke! \ 14-08-05 12:29:40 Mb Cynoemetomammagymnophilia – sexual arousal from the sight of a dog vomiting on a topless woman. No joke. \ 16-08-05 20:05:51 I'm in Heathrow departure lounge waiting for my flight to Melbourne. Goodbye! Au Revoir! Auf Wiedersein!

01-09-05 23:54:59 Tardis' final party is tomorrow knight – u able to come? \ 04-09-05 20:19:21 Heye eye wayeye man! Ha wey mardy shitbag ur too fat u'd sink my wakeboard anyway! \ 05-09-05 17:02:42 With paul! We think moira shud go on xfactor! \ 07-09-05 19:36:01 That boyfriend of hers, you know... The one who used to smoke the marrijoona or what ever you call it. Got himself a job in the local bakery so he did the cheeky beggar. God only knows what he uses to put the holes in the doughnuts...... \ 10-09-05 10:34:57 Good morning Tracey. In on the train back from Bristol. I had a shit night hope you have a great day spinning and dying. \ 14-09-05 23:17:09 Myself + dirty Kurty will be filling your inbox (ooh !!) With text smut as from tomorrow. Actually we started last night ! Prepare yourself Mrs Moberly ! \ 15-09-05 10:22:55 N00000! The snails! The snails have nuked my cuke! \ 17-09-05 15:24:57 T-Mobile (UK) welcomes you to Jersey. Make direct calls using international dialling code (e.g.+44 to UK), roaming rates apply. Have a pleasant stay. \ 18-09-05 19:48:04 Or perhaps you simply dissolved on contact with water...like a great big welsh alka seltzer? \ 19-09-05 08:14:53 Can!t open/access whatever it is you're trying to send me, instead of wasting your money on going to old st holiday inn and pretending you're somewhere exciting, why not purchase a decent fucking telephone. Eh? \ 20-09-05 12:37:57 Used for 'Wumping Flumpets', usually. \ 23-09-05 09:02:00 What's an ethnomethodologist? \ 23-09-05 12:03:49 I got an INSATIABLE desire for insane skinheads X XX! \ 29-09-05 17:30:00 I have dreamt lots of things Tracey but i didn't dream that. \ 30-09-05 11:51:05 Thats right , fuck the company , you will be sitting in a puddle next time you come to jersey with a cardboard box for a house and people will say how did this happen and ill say because of some fucking commie radio programmerking like good capitalists do \ 02-10-05 22:45:58 41. Egg fried rice. 42. Shrimp fried rice. 43. Egg foo yong. 44. Steamed mixed vegetables with oyster sauce. 45. Stir fried tofu with beansprouts. \ 04-10-05 16:37:07 Remind me, what wierdness are you weaving at the moment madame medici?

On 11th June 2005 I purchased my first camera phone. It was a Nokia 6230i. The minute my sim card was in my new phone, Porno Paul sent me his text about the naked cyclists in Soho. As I received it they cycled past the phone shop and I took my first mobile phone photos.

My mobile now took on the form of a surveillance tool. The ease of taking photos with a mobile phone soon became apparent, especially in places where photography had been absolutely forbidden. I kept seeing everyday objects inside and outside buildings – noticing aspects of them I had never absorbed properly before. The various objects that serve functions that we think of as generic are all unique with different quirks. I began to explore this with my phone camera. The first things I started photographing were plugholes, followed by manholes and drain covers; leading on to kisses, hearts, abandoned fridges, dead Christmas trees and vomit in the street. Things we see up to several times a day that we don't actually absorb when we are looking at them. It was easy to remain inconspicuous taking them on the phone. I started building up a lovely archive of these low-resolution mobile phone images and decided I would exhibit them as huge blown up prints in all their grainy splendour.

A few months later, I was invited by Deej Fabyc and Joanna Callaghan to take part in KISSS meta-performance at the Whitechapel Gallery in London, responding to political, social and personal issues around surveillance and suppression. It incorporated the individual and collaborative practices of artists, writers and curators in a live, inter-media combination of performance, video, interventions and working sessions. I was then invited to take part in KISSS at the Conical Gallery in Australia the following October.

Using my mobile phone images, I looked at private surveillance becoming public space. I set up *Parallel Lives – 'The biometric heiress collects processes and stores'* in which I developed a section of my website as a public gallery space. I started a blog called *Everyday* consisting of two images per day that documented my personal and public environment.

For the exhibition at the Conical Gallery in Melbourne, I selected the new work I was developing in *Parallel Lives* entitled *Plugholes*. I was fascinated by the plughole being the entry-point of the pipe net-work which connects each house in the street to each street in the neighbourhood as they lead into one vast system of waste and sewage pipes that travel and interconnect below our feet; towns meeting cities and then oceans of the world. The plugholes in the exhibition included those of pensioners, multi-millionaires, rock stars, artists, students, vicars, health professionals, social workers, investment banks, leisure centres, clubs, bars, trains, restaurants and so on. The art work showed the plughole as a personal and intimate object taken for granted and never studied despite being viewed many times throughout a day.

Tim Beckinsdale, a former employee of the Foundry, had emigrated to Australia with his wife Jenny, and lived literally just around the corner from

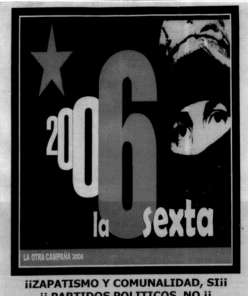

the Conical Gallery. They represented me on the opening night of the show there. As an intriguing addition to my section of the exhibition Tim and Jenny discovered that one of the gallery staff collected bath and sink plugs – I wish I'd followed this up. I continue to collect mobile phone images of plugholes and have amassed an archive, many with stories attached, from Trotsky's in the house where he was assassinated; Frida Kahlo's in her Mexican home; a full set from the last party I attended at Lehman Brothers before the bank collapsed; one which contained a severed thumb when I was on a successful mission to find and front a march by Subcomandante Insurgente Marcos and the Zapatistas in Mexico and many from across Russia including Siberia. It is surprising how many people cannot recognise their own plugholes considering how many times

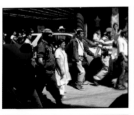
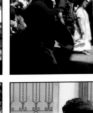
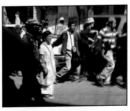

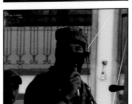
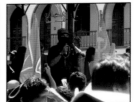
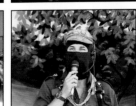

TM > Bill Drummond
28 Jul 2010 09:57 AM
Are you already hurtling up the motorway? … I see why you thought I may have been fed up at the weekend now. It was your battery being low I was commenting on!

Bill Drummond > TM
I'm going by train. Not left yet. But I am about to walk out the door.

TM > Bill Drummond
Why you going by train?

Bill Drummond > TM
It's cheaper and faster and I can get writing done on train. But also because I do not need to take anything with me but my mind. Mind you that is pretty heavy

TM > Bill Drummond
Heavy with everything? Or good things or bad things? Leave half of it on the kitchen table until you come back, metaphorically of course so you'll be light all day & have a spring in your step. What you writing about? I'm hoping to get a good chunk done today xx

Bill Drummond > TM
Went for a shave before I headed for Euston. I feel lighter already. I have put the new photo of the bed up on the Penkiln Burn EVENTS page. I look forward to photographing it with you somewhere. Top of a mountain? Middle of a motorway? Hope your book goes well today.

TM > Bill Drummond
I know… Was thinking that when you sent the phone pic & thought a series of them in random places would look good. You nearly there yet? Send me some pics of interesting tunnels & other places around manc today if you can?

Bill Drummond > TM
Stuck up a dead tree. Or even a pylon

TM > Bill Drummond
What one is on the track or did it crash into it?

they look at them during a day. The show demonstrated a facet of the rich and inescapable culture of the plughole in which we are all immersed but seldom recognise.

04-10-05 16:45:29 I going this fri tho, representing jersey on the world stage of paintabll , from shooting birds as a kid to idle to millions of paintabll fans worldwide , what a fucking hero \ 05-10-05 09:53:38 I draw the line at fishing around pulling puberic hair and old skin out of plug holes. Call me old fashioned if you like, but that's just the way it is. \ 07-10-05 21:24:19 Im with 5 lads having a ruby and a few beers , do you know trac, fucking heaven , she has been a right pain again this month with her p mt and sex,well what is that? \ 07-10-05 23:40:16 No! Actually I'm in a seedy bar, not a million miles away from my place of work, in the company of a certain Cedric 'the tweezers' Middleton. 'Cigar' Tony is also present. \ 08-10-05 22:33:33 No. I'm watching a dvd of mice yawning. \ 14-10-05 10:28:58 I'm wearing a polo-neck mum. It's okay, I'm wearing crotchless knickers. Prepared for everything! \ 14-10-05 12:02:00 My unicorns horn popped out of my uniform while I was headbanging to uriah heep. \ 15-10-05 20:34:44 Can u check womens toilets for loo roll... There is more on top shelf by the dj discoteque booth \ 16-10-05 11:52:00 Great basques in marks for 35 pounds, would be perfect under a fur coat! \ 23-10-05 15:59:24 3.55p.m. Location : Lovecraft. 'do you have a pink leather spanking paddle'? 'No sir, we do not.' 'Do you know where I can get one '? 'No sir, I do not'! \ 23-10-05 16:15:19 Ooh – will talk later – launderette makes me moody! Xxxxxx \ 23-10-05 17:32:21 Just walked past a little alleyway in green park called milkmaid's passage and it made me think of you..... \ 28-10-05 12:47:00 'idi nyuhai plauki' is a common russian term of dismissal which means 'go away and smell some pants'...honest! its on the internet! \ 28-10-05 21:34:40 Do u fancy working on a project undercover in the City with me? Operation Spike is TOP SECRET! ..with the obvious exceptions, for the duration of the mission.Jx \ 29-10-05 21:40:14 Have a great time in Russia – bring me back some Siberian salt..X \ 30-10-05 20:48:15 Bon voyageski. Find me some russian pickled eggs please. I may take one to peru and staple it to the marmite tree. Safe travels yous twos. \ 01-11-05 04:09:46 I need a bit more sleep. See you in a while. Bill.

I had begun using the name 'Mobilography'* when I was in Moscow on my prior visit with Bill. I was introduced to it in a conversation with my friend Yuri Bakhchiev, whose dacha we had spent time in when we were all in Moscow for the Foundry visit in 2000. I had, however, been pipped to the post in officially coining it as a phrase by a person called Dima Rezvan who had started up a brilliant project in Russia under the same name.

When I met up with Dima in Moscow, it transpired that we had met several years previously. We

*Mobilography (from 'mobilis' (lat.) - movable and 'grapho' (gr.) - to write) institutes a visual language which captures symbols and works of art in your immediate environment. It is a branch of photography that creates pictures using such devices with built-in cameras, as cellular phones, palm pilots, compasses, binoculars, lighters, etc, not originally intended to be used for professional photography.

were now both working on exactly the same projects with new phone technology. On this occasion we met in a new Italian bar and restaurant in a fast-developing Moscow, along with several other Russian friends including Nadya

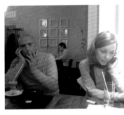

Bakuradze and Olga from the Dom along with Yuri Bakhchiev. I clearly remember this first taster of how I now use my mobile phone to gain access to the internet, websites, email and other applications. I had mentioned the Mobilography site *Parallel Lives* that I had up and running on my website and immediately there were seven phones on the table, all displaying my live website. I had internet access on my mobile phone then, but didn't use it and didn't really know anyone in the UK who did. Calls, texts and photos were then the main priority on my mobile. The experience of the seven phones on the table displaying the website I had been talking about didn't happen to me again for another a few years in the UK. Dima gave me a signed print of one of his Mobilography shots to take home of a beautiful Russian ballet dancer, with her hand ungraciously lost up her magnificent ballet gown.

Following this meeting, I really started thinking about the full potential of a mobile phone. It was apparent that Russia was either more technologically advanced than the UK or that different strands of the technology were developing in different time frames. When I did start to look into it, I learnt

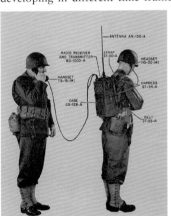

that it was in the USA that a detailed concept of the mobile phone first emerged. In 1947 engineers at Bell Labs proposed the use of a hexagonal cellular network to enable mobile radio telephony applications. Radio towers would be positioned at the corners of the hexagons so that they could transmit equally into three adjacent cells. A year later another team of engineers in the same building announced the invention of the transistor. These were two of the key principles on which the mobile phone operates. In 1957 in a development largely unknown to the West, Russian inventor Leonid Kupriyanovich demonstrated the LK-1, the first truly portable mobile phone which connected via its own base station to the regular telephone network. It had a range of 20-30km and a battery life of 30 hours. This appears not to have been developed further, perhaps a casualty of the Soviet system of top-down of government. It would be fifteen years later that Martin Cooper of Motorola would make the first analogue mobile phone call in the US. Meanwhile cellular networks were being successfully developed and implemented in Scandinavian countries.

As I was researching this I discovered that Russia is by far the largest global producer of nickel which is essential to modern mobile battery technology: was the opening up of Soviet markets

TM > Bill Drummond
Sorry I'm being slow just caught that as the text was leaving. You mean the bed not the train…

Bill Drummond > TM
Yes, bed up a dead tree or pylon. But it could be on a single track rail line waiting to be smashed into.

Bill Drummond > TM
Or floating down the river or in the sea or on top of the Land Rover.

Bill Drummond > TM
It is now pissing down and I have only got a T-shirt on

TM > Bill Drummond
I like it all… Particularly the sea. Purchase an umbrella in the station unless it's the usual 8 degrees below London temps. I moved from Valley-Newport-Manchester all rainy cities how stupid!

TM > Bill Drummond
I think the bed should travel far & wide & accompany us on journeys. It can even have a quilt and pillow in some shots maybe

TM > Bill Drummond
It is cold up there today 14 degs

Bill Drummond > TM
Summer almost over!

TM > Bill Drummond
No that's just Manchester it's always like that! I'm out in my garden writing in my bikini. Lovely summers day here

Danny Pockets > TM
28 Jul 2010 05:02 PM
Put your tongue in your mouth mate.

TM > Danny Pockets
What have I done?

Danny Pockets > TM
When your concentrating like that, you let your tongue hang out....

TM > Danny Pockets
Can you see me?

Danny Pockets > TM
Always

TM > Danny Pockets
Haha! Good luck with tonight!

and free exchange of ideas after the fall of the USSR a catalyst that helped to get us to where we are today? Perhaps also the sudden shift away from a command-and-control society and economy accelerated Russia's embrace of a mobile and personal high-tech culture.

Russia's nickel output is concentrated in the Krasnoyarsk region of Siberia which is responsible for 80% of the country's output; that is 18% of the world supply from this area alone. In total, Russia supplies almost a quarter of the worlds nickel for batteries, and this all comes from Norilsk, the northernmost city in the world and one of the ten most polluted. It also housed the biggest gulag during Stalin's dictatorship where people were sent to mine nickel up until 1979. So it was to Krasnoyarsk I travelled to hold my next Mobilography exhibition. The exhibition I put on there is now housed in the Krasnoyarsk Gallery's permanent collection.

I first visited Krasnoyarsk and Kansk in 2007. I had been invited by festival directors Nadya Bakuradze, Pavel Labazov (Pasha) and Silvestrov Andrey to exhibit my Mobilography collection and to judge the Kansk International Video and Film Festival. I was also asked to invite a DJ to perform there, so I asked Vis the Spoon, who then hosted our poetry nights at the Foundry.

There was a big media presence there, both radio and TV. The theme of that year's festival was *Video Vodoo vs. Cinema Magic* and also the title of the Mobilography exhibition. I selected a number of my mobile images by focusing on the perceived western perception of Vodou, which all contained silent menacing factors: a large spider crawling on a woman's chest; a set of false teeth firmly lodged in a mince pie; a severed thumb in a Mexican plughole; 'The End' taken from the rolling credits of a film; a blood-stained white seagull on a road;

a pool of vomit; a stretched portrait of Amy Winehouse with pointy ears; a pig face coming out of the froth of a cappuccino and several Vodou sculptures. The film festival was amazing and I made up my mind then I would definitely return there one day to live for a period of time.

I also ran two Mobilography projects at Tate Britain that year. The first consisted of taking images and building a website for the Tate. The project was run as workshops with participants aged between sixteen and twenty-six. They

selected image categories and built an archive up from this. We began by having full run of the gallery when it was closed to the public with no curators. It was an amazing feeling, taking photos of historical art with my mobile. Especially *The Lady of Shallot* by John William Waterhouse inspired by the Victorian ballad by Alfred Lord Tennyson. It was my favourite painting as a child and it was lovely to focus on elements of it through my mobile phone lens. The Victorian narratives were also one of my favourite sections of the Tate. I wished I could always go to galleries like this at night without the bustle of the crowd.

I made a radio show to accompany the Tate Mobilography website. I learnt so much from my Young Tate guests on the show with a lot of in-depth knowledge on the flash mob culture and how to 'bluejack' in one minute. Several of the Young Tate members were active in the then fairly underground flash mob scene, (before advertising companies appropriated the phenomenon and made it corporate). A flash mob involves a large disparate group of people assembling in a public space to carry out a random task: organised through texting, social media, and chain emails. They will all carry out the same or similar action for a short burst of time unbeknown to the rest of the public.

Following the first Mobilography and radio project at The Tate I took part in my first flash mob in the Turbine Hall at Tate Modern, which was then housing Doris Salcedo's piece *Shibboleth*; a huge crack through the entire floor getting wider as it reached the back of the space. I went with my youngest son and met Bill there with two of his children. I was also trying to co-ordinate meeting up with Ellie Hirst, who had come down from Wakefield to do her work placement with me.

Ellie > TM
12-10-2007 09:33
Hey tracey its ellie,how are you?Im in london for frieze with some friends frm college.if ur going 2 itd b lovely to hav coffee or something?X

Ellie > TM
That sounds brilliant! Might see you there!X

Ellie > TM
Aw wer going 2 miss the tate thing.Jst by the river so we wnt hav time.Hav fun x

Ellie > TM
Ah made it!X

Ellie > TM
Yup v strange! im hear til tues

Bill's youngest son was told off by a gallery attendant for sitting on the floor with his foot over a large section of the concrete crack only minutes before the flash mob began. I wondered now how the attendant's power would serve when everyone descended on the hall for the flash mob. I checked my mobile phone and at the given time, the crowd began dancing to music on their phones and iPods. It was brilliant: everyone danced to their own particular tracks provoking

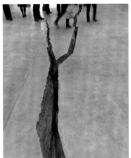 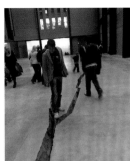

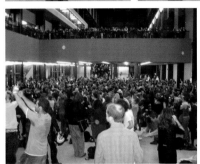 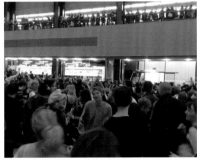

a huge club-like atmosphere. I danced to Peter Bjorn and John by Young Folk, and directly in front of me were an elderly couple each dancing to their own particular mobile tracks.

We set off for a meal and caught an almost full bus managing to get seats on the top deck. I was bluejacked for the first time. Bluejacking is the sending of unsolicited short messages through bluetooth. It's basically harmless, but it is surprising for the person receiving it and takes you a few minutes to work out what's happened. It made me slightly paranoid as I looked around at everyone on the bus. In one night I had experienced two variants of new technology made possible by the mobile phone as the bluejacker said:

12-10-2007 21:49:36
**See the girl with the Welsh eyes
talking with the moon. What in the
world can I do wait until the crowd goes?**

This did unnerve me and I turned my bluetooth device off immediately.

I did another Mobilography project at Tate Britain. This time, there were several groups and we randomly selected sentences that had been left in the Tate to create a Mobilography film board with the titles *On the Pavement of my Trampled Soul*, *Four Legs Bad Two Legs Good*, and *Through the Glass Darkly*. This was followed by another Mobilography project at Whitechapel Gallery in East London during a Sophie Calle exhibition, where we also focused in part on a woven replica of Picasso's *Guernica*; an exhibition put together as part of an

Bill Drummond > TM
28 Jul 2010 06:30 PM
Back on the train at Manchester Piccadilly and about to head South to sunshine and jellied eels.

Bill Drummond > TM
That is where I will be giving my presentation. It is part of Salfiord Station.

Bill Drummond > TM
There was just nobody there when I took the photo. I will be doing it on a Friday lunch time in October. Part of a thing called Un convention.

Bill Drummond > TM
I have to work all that out yet

Bill Drummond > TM
And I have hardly done a thousand. They rekon in five years time they are going to get it down to 1 hour 40. That is progress of some sort. Mind you I do not hold with the choice super markets are offering these days. It's just a con to make us buy more stuff and we get nothing in return. I say back to the curly Kale.

TM > Bill Drummond
Yay!! Hope you're not too soggy. Were you blown away by any specific spots in Salford & was it a productive day?

TM > Bill Drummond
I used to do that train journey 3, sometimes 4 times a week both ways when it was 3 1/2 hours long. Getting back in time to pick the children up from school back in the day … Coming up to 2,000 words today typed in, hope to doublre it by the evening

Summer 2009
Whitechapel Gallery

installation by Goshka Macuga for the reopening of the gallery. The mobilography images were printed out and attached to balloons with contact details of the project. This time one balloon landed in Luxembourg.

One of the most significant Mobilography projects I did was in 2009, when I was invited to participate in the Ghetto Biennale in Haiti, three weeks before the devastating earthquake struck. I gave out low-res camera phones to members of the community for a few days each and they were to photograph and record their everyday environment, ranging from newborn babies to Vodou ceremonies.

TM > Bill Drummond

Tonight my son cooked me seasoned duck with dauphinoise potatoes, asparagus & brocolli. I was fine with everything apart from the duck. He did a back up of same seasoned quorn fillets which were the same taste, nice. I am addicted to spinach & eat it almost every day. I just fkn hate curly bastard kale…

Bill Drummond > TM

It takes all sorts. I have just passed Tamworth. No pigs in sight.

Bill Drummond > TM

But I do like that weird shaped hill just south of Tamworth

Bill Drummond > TM

No Tamworth is where there were two pigs that escaped on their way to the slaughter house. They were on the run for days. They became known as the Tamworth Two. And when they were finally caught they were spared their fate as bacon between my butty to live out their days wallowing in the mud. Look it up on google. I may be wrong. Pigs like Curly Kale.

TM > Bill Drummond

How many people do you honestly think like curly kale? Do thy still make pigs in tamworth?

09-11-05 17:35:42 What are you going to downing st for ? \ 09-11-05 18:12:44 Looked, but it didnt flump my wumpet. Good effort tho!! \ 10-11-05 19:57:54 'yes officer, I realise it's very late and yes, appear to have put on my wife's clothes by mistake...I'm sorry.? 'dogging'? ... 'No......'what's that ? ? \ 14-11-05 18:03:17 Is it so wrong to want the Christmas tree up now? Damn, I bought a lovely pink tree today... and I'm sipping a chocolate martini. Christmas starts here. \ 14-11-05 23:47:56 I'm not sure if I'm doing the right thing, but, I'm thinking about Paul Gambuccinni's anus. \ 16-11-05 13:33:54 Having been turned, the stanier class 5 moves off the turntable with steam bursting out of the open cylinder drain valves and heads towards the points adjacent to the enginemans bothy. Here the points are changed, 45025 reverses and with a brisk exhaust accelerates fast, stopping at the points into the stabling yard. Christ! \ 16-11-05 13:55:53 My great uncle Silas was the first person ever to be caught wanking on a steam train. That would have been about 1901. They fined him 3 shillings, which was a lot of money in those days I can tell you ! \ 18-11-05 12:27:53 Did ya know about the pacific island where they worship an idol of prince phillip? \ 20-11-05 18:58:30 I trust you're not under the coffee table! \ 25-11-05 11:48:19 Put us a coupla guinness on love. \ 25-11-05 15:23:25 Tonite: JeanCharles de Menezes Solidarity Concert presented by Peace Not War. Asian Dub Foundation's Invasion Sound System, DJ Shodan & Lowqui, Ctrl-Z, MC Angel, Logic, Rhythms of Resistance. 9pm-3am at Jamm, 251 Brixton Rd. 6/5, or 3 Critical Mass cyclists \ 30-11-05 14:10:05 I have found 3 pennies 2dy. One of which was next to what can only be described as 'dried orange dog diahorrea.' i must remember not to pick my teeth. \ 01-12-05 16:55:10 Me + paul were wonderin how many mint imperials we could store in ur vaginal cavity b4 u dropped one. Mmmminty \ 02-12-05 11:02:15 Im runnin late but will be bringin the flak jacket in. \ 03-12-05 01:32:28 Just done Harry Potter again with flasks of mulled wine and talk of Mongolian wanking circles. Marvellous. \ 05-12-05 15:57:51 I need a favour, i'm at the police station, they've charged me with being the ugliest fucker in London.Can you come down and show them they've made a mistake!! \ 28-12-05 03:32:01 Mike foned 11:12 in th morning of 27-12-05 He'd tried 2 send a txt frm dai's fone but it wudnt wrk coz it dif one! They were putting flowers on jeff's grave including daisies x

\ 02-01-06 13:06:03 "Doctor, I keep singing 'the green green grass of home". Doc : "sounds like you've got Tom Jones disease". "Is that common ?" Doc : "Well it's not unusual ! " \ 04-01-06 23:32:20 Pearl necklaces-a-go-go... \ 05-01-06 21:16:33 read in paper that welsh are least funny britons. they raise 3 times fewer laughs than national daily average of 14. leo's – that's me! – are least funny star sign. \ 07-01-06 17:56:44 I'm at a deathbed I need you to get very drunk for me tonight. Hx. \ 07-01-06 19:36:18 Oi, medici, wot days you not cleaning bogs this week? \ 13-01-06 12:49:10 I bin to iraq and still think hes made an arse of himself...But on the other hand, he never voted to kill 100,000 people...So what does that make us? \ 13-01-06 15:33:32 i think my nipples are marmite-sensitive.. \ 14-01-06 00:06:55 Thanks, kid – you were superb, and a real joy to be with tonight, as always. You is top mate. Respect – Rathmell \ 19-01-06 20:05:02 Greetings from Caracas! People mucho raging here..Viva the Bolivarian Revolution!! Its Raw and Rampant in da Barrios! Bring ur Salsa flip-flops! We goin dancin in Caracas!! Jessx \ 21-01-06 20:01:29 Just done the tote! Cross ur fingers 4 me! Cx \ 21-01-06 22:21:21 andy will meet u defo. salsa with whole buncg a people, caracas not so scarey after all – cant wait to see u! bring some moisturiser!! Jxx \ 06-02-06 12:48:29 Your mum says are u showing off? I just told her about you eating horses... Can u send her a text? \ 18-02-06 19:56:02 fuck me, there"s a fucking foto of red elastic fucking bands in todays fucking guardian fucker \ 21-02-06 23:32:12 Okay, I've tried on cocktail frocks and heels and feel better. I recommend you do the same. Hx. \ 01-03-06 19:03:16 Going 2 a well posh film screenin do at a jewellers in mayfair. I'm the only one not a celeb or with a title. Wish i had wendys posh ball frock! \ 01-03-06 21:52:28 I just switched fone on been out 2 a film preview on dom violence in mayfair+i was the only non celeb or non titled woman, film sad+posh peopl wankers. Wil b in 2mz not home til late. Cud u do foundry+east end on that date? \ 01-03-06 22:50:28 I have found Putin's advisor's daughter+ive known her for 6 years, u never no whosd who init!

TM > Danny Pockets
1 Aug 2010 05:41 PM
What was Lincoln's surname fart breath? Also was it 12 cabinet tables in the empty your pockets exhibition? One for each month of the year?

Danny Pockets > TM
24 cabinets. Left pocket right pocket by month. Lincoln is A.Lincoln Taber. Shortest name in Guinness book of records. Sweaty minge

I woke up thinking about the opening night of *Text-Me-Up-Five*. I was encountering brief flashes of deep remorse due to the pounding of my head from passing liquid time at Charlie Wright's bar until the early morning. Liquid time is the best form of time clock when engaged in it, but the worst when having to recall it, especially once real time has been called on liquid time. It becomes worse after several hours when one's brain and head start ticking with regulated pain ticks which seem to match each second in every minute of real time. This I have concluded was for not living in real time the night before.

In Charlie Wright's, I'd enjoyed Mark Hammond and Jacqueline Geni's company: they had come with Gavin Turk to hear him play his regulatory tunes, as was now customary at a *Text-Me-Up!* exhibition opening night. Disco_r.dance also DJ'd for a large portion of the night. The alcohol had not clouded my judgment to the fact that Mark Hammond was in the wrong profession as an artist and should have been a typecast 1940's English 'spiv' actor in roles as a bus conductor or even government agent. He had told me that Kate Moss was the only other person who shared my views on this. I seemed to share other views with her at that time too, as she was now dating Pete Doherty. I was happy for him.

With my hangover, I began listening to the taped answerphone text messages from the previous night. I thought it was an ingenious breakthrough being able to text a landline, and then to have a robotic voice assimilate the message in the most perfect English accent which I'd set up as the Moira Minguella section of the show. Some of the messages were funny, others were clever and some were people's recycled text messages. Danny Pockets and I began collaborating on a piece for the exhibition called *Bermuda Blue Laps The Passion Pink Shore* and he had also included another interactive piece compiled from a short text conversation between us.

I first met Danny in 2003 when I was serving behind the bar in the Foundry. He approached the bar

and waited, beckoning my attention. He explained that he had exhibited in the Foundry before and was therefore entitled to book the large room downstairs. I was unsure of him so with a little white lie I directed him towards Jonathan, saying I wasn't doing anything with the booking system at the moment. He came back to me after speaking to Jonathan, said thank-you, and that it was all booked and sorted. Danny Cuming and Lincoln put on an exhibition in the large room the Foundry titled *Empty Your Pockets*. Wooden glass-topped tables housed the contents of both their pockets over the Millennium year. Everything from Pokemon cards, gloopy dried sweets, a collection of stones with holes in them, to snotty tissues were exhibited. It was the full content of their pockets for a year. They came on my radio show as guests, and were really nice. We had a good conversation with them before we opened up the Foundry one afternoon, sipping champagne as they dismantled their exhibition. I kept forgetting their names as I do with the majority of people: every detail of someone's life story I remember forever and recall it in detail in an instant, but names I cannot seem to remember at all. Lincoln became Lionel and Danny Cuming became Danny

Pockets, collectively they were the Pocket Boys following the title of their show. As my friendship with Danny strengthened, he adopted one of our kittens, a white tomcat that he called Pockets. Danny's wife became known as Mrs. Pockets. They became known as the Pocket family. Danny's business cards, website and other work related information now all bear the name Danny Pockets.

When Danny appeared as a guest on another of my radio shows, he noticed me transcribing some text messages. He told me that he too had saved all of his text messages, which started after a painful break-up. I explained how pink (prior to it being the new black at the time) was a prominent colour and theme running through many of my early texts following my obsession with the colour. Texts would range from 'in the pink' or 'to pinky' and several months worth of texts were totally dedicated to my acquisition of a pink leather jacket as I was coming out of my tumultuous relationship. He said that he had a similar theme running through his with the colour blue. Danny suggested that we should work on a joint show at some stage. In Danny's eagerness to enthuse me, he told me a story about a friend of his, a journalist who worked in editorial at the Independent newspaper. He told me that she had read the article that Rod Stanley had written in The Face on my *T3X3-Me-up-3!* exhibition and texted him about it.

When The Face article came out Danny and I had lived in two different parts of the country and I had never met him; I wouldn't meet him for another two years. I was now totally focused on what he was telling me and wanting to reiterate his last couple of sentences.

I said, 'how random, when we hadn't even met back then.' I continued, 'can you remember what it said?'

TM > Danny Pockets
Really? I am just writing how I never remember names… How come I didn't know Lincoln was called A & it was the shortest name in the Guinness Book of Records? Are there any other people with this name?

Danny Pockets > TM
Well he mentioned it on your radio show…

TM > Danny Pockets
I have such a problem with names. Hope you got your uber heamerroids sorted now & they've stopped swinging in the wind on the beach…and thanks for info.

Danny Pockets > TM
That's ok my piscine friend x

TM > Danny Pockets
You're piscine obsessed… Fish supper tonight is it? Before laying out a few of your ginger curly ones on the living room rug? I hear it's become a real craze in Hastings from a tradition of Hasting crab-catching men…

Danny Pockets > TM
I bet in this heat you've got all the windows open, eh?

TM > Danny Pockets
Did the head lice cum genital crab-killer lotion from the chemist work for you? I forgot to ask after you'd mentioned it. Did it remove them out of your eyelashes & eyebrows? Complete horror story...

Danny Pockets > TM

TM > Danny Pockets
It should be pink

Danny Pockets > TM
How's your tooth? Still hanging in there?

Danny Pockets > TM
It is.

TM > Danny Pockets
It's red & I have lovely teeth... Did you know teeth were actually supposed to be brilliant white in shade like mine... Not a greenish yellow like yours? I think you can buy bleach to help you with it. It's called domestos & if you brush 8 or 9 times in a day they should at least get to a creamish colour within a year. Don't forget to swallow it after brushing too ...x

Danny Pockets > TM
Pink like your eyes.

TM > Danny Pockets
My eyes are green... If you knew your colours you could become an artist. I could help you... Show you how to draw & paint

TM > Danny Pockets 1 Aug 2010 06:51 PM
I'm going to cook tea now... Try practicing your colours & phonetically sound them out. It will help. x

Danny Pockets > TM
X

Danny replied, 'yeah, I remember exactly what it said.'
'Well?'
'"Some Welsh bitch nicked your idea".'
'Seriously, what did she say?'
'"Some Welsh bitch nicked your idea".' He repeated.
I laughed, 'But you'd be aware of my work, I had the press – I want to meet this woman who called me some Welsh bitch...'
Danny said, 'okay, I'll text her and see when we can go and meet her.'
Johny Brown was presenting a radio show on New Year's Eve in 2005 called *Where Are We Now?* and asked if I would contribute to it. Danny and I decided to do a short series of shows where we would read texts from the same dates on different parts of our lives in a conversation format. We used our individually received text messages from when we both first started collecting them. We made seven pieces, which were about ten minutes long with this accompanying text going out on various websites advertising the night of radio shows Johny Brown was hosting:

Tracey Moberly and Danny Pockets (Foundry text team). Music: Mark Rathmell. The year is 1999... two people, two different cities and the break-up of two long term relationships. Independently, they both find the same new religion ... TEXTING ... NYE05 they join texts and look back at their new beginnings, reading their religion, in a series of short text dialogues, titled *Out With The Old and In With The New* throughout the New Years Eve 2005 radio show *Where Are We Now?*

This really seemed to work, as though one were listening to a narrative about two people and their life together. However it was many different people's words, sentences and sentiments in text messages directed at two different individuals. Within the actual texts, the colours pink and blue also resonated well in the text narratives and we decided at some point in the future that we would incorporate this into the work we did together.

Following this I had been in a hospital waiting room when Danny texted me, and we were in a dialogue about the day:

been painting txt msgs on palettes

how many palettes? saw us in ok mag in the waiting room of the hospital its a pink ed where chantelle is a princess on the front

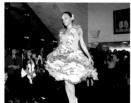

I happened to pick up a past copy of OK magazine and I was in there, taking a photo of a fashion show that I had asked Danny to make a dress for which was being modelled by a presenter on GMTV. This had all developed from Helen Littler, co-founder of the Elvis, Jesus & Co.Couture label and another friend Maxine Wrigley. They had asked if I wanted to get involved in a London show and if so, would I also invite some of my artist, designer and fashion friends to get involved. So along with Danny, I asked artist Abigail Fallis and Damien Hirst's girlfriend Maia Norman with her fashion label Mother of Pearl. The costumes for the fashion show were all made out of plastic bags. Students at the London College of Fashion also worked hard on producing amazing garments for the show. The event was called *This is* NOT *a Suitcase* and was a campaign against using bin bags to move childrens belongings when they leave one care home to another and instead to provide them with suitcases. Young people in foster care modelled for the show, along with TV presenters.

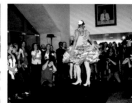

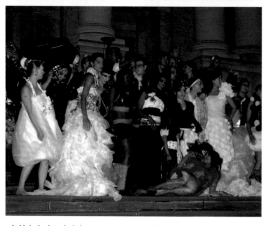

05-03-06 22:54:56 Hi T, duppy is about human fallibility an urban fear. How we relate 2 our environment. Jamaica history of handlin strggle through stories humr an folklore. Dwntown duppy, uptwn dppy, Dppy City. Indie kids an rude boys do they understd or heard of Duppy. End of all wrk cld b anythin from vid instl 2 pnting \ 06-03-06 21:13:33 Just saw a fellow wearing 3 baseball caps at once, all at different angles and all with the price tags on. Please help me understand.... \ 06-03-06 21:15:08 Bird flu has just arrived in uk and is attacking all wild and rough old birds – are you ok? \ 06-03-06 23:44:22 Just been watching trevor mc donald. They never showed you. We only get half hour show here. I was pissed off when you were'nt on. They did'nt put much emphasis on the colombia aspect. There should have information about whats going on there. Still, i bet a few million people are being woken up! Talk to you soon. I think i might go on your site and read up for a while. Bye. Fran. \ 10-03-06 15:15:02 Steve is going on alo presidente! \ 14-03-06 18:51:49 Latest craze with clubbers is to fill young womens vaginas with vodka & drink it out with a straw, experts are now warning about the dangers of minge drinking. \ 16-03-06 21:10:56 We r doin a toast 2 each othr + you on our 8th anniversary! Xxx \ 23-03-06 12:33:57 I'M PAINTING PALLETES BLUE AND PINK FOR THE SHOW THEN I'LL WRITE ON THEM, YOU LIKE? BET U WISH U COULD BE A PINK PRINCESS ON THE COVER OF OK INIT. \ 30-03-06 10:18:12 Dani Pox Mb Passion Pink Vs Waterfall Blue. I just like the names alone. They sum all that up me tinx. Don't wanna give too much up init. \ 31-03-06 11:38:49 In a cemetery \ 02-04-06 14:17:36 T-Mobile (UK) welcomes you to Mexico. To use your phone, call #33*1234# on Telecel and answer the ring back, roaming rates apply. Have a pleasant stay. \ 05-04-06 16:54:09 Hi tracey, working on a human rights freedom special. Really like mark to write a piece about his kids and arms venture, got a contact? Also, think penny would be interested in doing an essay on the meaning of freedom? Can you ask them for me please. Would be great to catch up at some point now i'm a bit more settled at dazed and have some time r x \ 10-04-06 19:10:05 Im in crobar poppin valium.....xk \ 18-04-06 15:21:30 Do not pass 'Go'and do not collect You naughty girl! "Go straight to jail !" \ 21-04-06 14:33:51 i cant believe u have my orgasm in ur bag. \ 26-04-06 21:17:42 I'm in london this Sun. wae paddy,he's hosting Alabama 3 clubnite Outlaws at Jamm Brixton it would be nice to catch up,spread the word n keep the faith– john \ 29-04-06 07:04:20 Just sent you my first picture with my mobile. It was taken while lying in bed a few mins ago.

I had mentioned the fashion show to Danny as he was doing a project based on blue plastic bags, where he painted them in rural and urban landscapes entwined in trees. He became fed up of viewing all the torn supermarket bags hanging and left to erode in trees like the slaughtered people of Roman times who were left to decay where they were killed. He got them all out of these trees and replaced them with brand new bermuda blue carrier bags. The words 'Bermuda Blue' became synonymous with Danny. We'd been working on the joint piece for *Text-Me-Up-Five* and one morning a text came through saying: 'Passion Pink vs Waterfall Blue'. This evolved into *Bermuda Blue Laps The Passion Pink Shore* which incorporated the blue of his work and the pink of mine. It was going to be a much longer and visual version of the radio shows we put out for New Years Eve. We received great responses from it. BBC Radio Wales suggested it should be turned into a radio play; BBC Radio Ulster regarded it as a present day response to Samuel Beckett's *Not I* (a quote I will cherish and use forever) and – as it was being shown in Hackney – people were perceiving the

influence of Harold Pinter on our work. Danny and I could not have been happier. Two TV screens next to each other were in conversation. Two pairs of lips spoke the recycled words, Danny vocalising chronologically my received texts while I did the same with his. Our lips filled the screen; mine bright pink and Danny's blue, highlighted with the dark blue stubble grown especially for the filming on his face.

Following the three *Text-Me-Up-Five* exhibitions, we were invited by Rebecca Marshall to take part in the *Shot by the Sea* film festival in Hastings. Mine and Danny's lips were projected to span three storeys of a building each. It was outside and programmed to start after dark. The next invite we received was from Jan Woolf, who was organising the launch of The Pinter Residency for new writers in residence at The Hackney Empire. This time, our exhibition was shown on two large flatscreen televisions. The residency program was named in honour of Harold Pinter, described as 'the famous son of Hackney and champion of the Hackney Empire'. Along with our installation, accompanying artworks were by Peter Kennard and eastlondonphotographers.com.

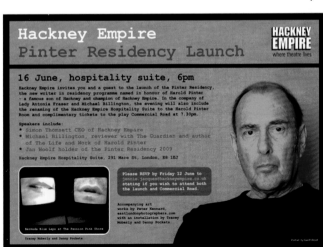

I was quite inspired by the Pocket Boys' *Empty Your Pockets* exhibition on a number of levels, but overall it made me think about and question my own actions and habits, whilst adopting a philosophical approach to them. From an early age when I first started using purses, then progressing onto handbags over the years, the bags got bigger and fuller. It got to a point where I seemed to be carrying around so much useless stuff that I had to wean myself off both the purse and the bag. I would discard them, but upon relocating them they would always be part of my life from a past long forgotten era, whether spanning a period of ten years ago or just a month. It has also followed a pattern that would include old bus tickets, redundant club flyers, phone numbers and emails of people I don't know and no matter how much I tried to associate these to a person in my brain it would never

work; wrong-coloured lipsticks; eyeliners that I thought I could never live without when I had been using them; train tickets to long-forgotten destinations, some kept for the conductors quirky hole punch; unidentifiable money from foreign climates bearing presidents and rulers that could belong to any nationality; books of postage stamps; money that would have come in handy long after the bag had been put away on a shelf and listed under 'unused items'. The bags and purses were always full of lives past, but they were my lives. I began associating the contents of my discarded bags to the culture of the different periods they were used in. Old bags in Wales would be full of Valleys culture from differing periods, the same of the discarded Manchester, London and holiday bags. This was also true of the Pocket Boys' exhibition containing their right and left pockets throughout the Millennium year.

A culture's values can be ascertained from what is in its handbag or pocket. In 2010, it would be safe to conclude that the majority of all men and women with bags and pockets would have credit cards and money, keys, hair accessories from a comb, hair tie or grip and maybe an odd lipstick even if the owner doesn't wear lipstick. And a mobile phone. In cultural terms this equates to a society's values being trade, property, appearance and communication. This would not have been true of the culture a decade and a half ago. No one would have had a mobile phone in their pocket or handbag then as very few people had seen one let alone own one. With the advent of smartphones a new cultural divide has occurred which defines a person by phone type: Blackberry, iPhone or Android.

I drew a direct analogy between the *Empty Your Pockets* show and our current mobile culture and speculated on what would define past cultures. I thought of my father and then my grandfather and the inscribed pocket watches that are passed down through predominantly male members of families. Early 'pocket' watches only had one hand, were big and worn around the neck. It wasn't until a century later that they would be kept in the pocket. The British were leading watchmakers in the eighteenth and early nineteenth centuries having surpassed the French after the Industrial Revolution. They in turn would be superseded by American watchmakers who in turn were overtaken by the Swiss. During the eighteenth and nineteenth century the pocket watch conveyed specific cultural values which could define their owners much in the way that the mobile phone we carry in our bag or pocket does today. Time was an important entity to the factory owner, mill owner, and businessman of that era. As industries and businesses began to thrive and develop, people became busier as more hours were needed to accommodate the booming Industrial Revolution: this became represented by the pocket watch. The watch appeared to symbolise freedom from the town hall or town square clock, just as the mobile phone symbolised emancipation from the wired landline. However, both of these pocket implements were tying their owners into much larger conformed systems. For example, with the development of the mobile phone and the incorporation of 3G, texting, emails, internet, and social networking sites we are tied more tightly to other systems and we are rarely unable to make contact. The internet houses features such as GSM and map applications which can pinpoint one's location at any given time down to the street, house and postcode. Any answer is available at our fingertips through internet applications such as Wikipedia; there are even mobile applications which, when held up in the air to music playing in a room, will tell you the

name of the song, album, band, genre and label. Social networking sites such as Twitter and Facebook constantly put out to the world various tweets or status updates stating emotions, locations, news items, social events and so many other things, keeping the person owning the mobile phone not only in constant touch, but in a powerful position to those who do not have this knowledge at their disposal. The pocket watch owner held similar power whilst stitching himself into the seam of the greater system of the world clock. The power was given to the person literally with time in his hands: stating when the working day began and ended, even when it was time for workers to eat or take breaks within the working day. The pocket watch became another time-telling commodity that represented Capitalism, just as the church clock with their tolling bells represented control of religion and it's congregation and as the Town Hall clock in turn represented political governance over the town its bells peeled in. Everyone and everything were ordered within this system, which was further revolutionised by the pocket watch. The mobile phone occupies the same role in a similar system, but on a much grander scale, from keeping us constantly in touch to giving and receiving orders or directions. From the working day into the social night, appearing to give more freedom, the data collects, processes and stores almost like a surveillance camera. The adverts we are subjected to through this collection of data seemingly fit many aspects of our wants, desires and personalities, all formulated from the data collected from our use of the mobile phone.

Danny and I have an ongoing *Bermuda Blue Laps the Passion Pink Shore* dialogue which presents itself in the form of pink and blue photos. Over a period of time we have been building up an archive to present as a Mobilography exhibition, printed on a large scale. The only important factor in the imagery are the juxtaposed colours of pink and blue within each individual frame.

I still wanted to meet the woman who worked at the Independent. True to his word Danny texted her and organised a meeting at the newspaper offices where she worked as an editor. She was called Lena Corner. It was all very humorous; as we told her about the combined pink and blue thread that ran in our work, she pointed out that Danny was wearing a blue checked shirt and I a pink-striped top. Neither Danny nor I had realised this. She laughed and took a photo of us.

05-05-06 18:50:27 I'm in the middle of counting a very large sack of sprouts. 1,531, 1,532, 1,533, 1,534, 1,535, 1,536, 1,537, 1,538, 1,539, 1,540, 1,541....... \ 07-05-06 11:27:29 It would appear that 'Macca' has had a furious bust-up with Heather. \ 07-05-06 14:31:20 Ok – seen the sultans elephant. Now i'm in park with the girl who is asleep in a deck chair she has vile shoes i don't like her. \ 09-05-06 13:55:51 I'm each and all. I'm all and none. I'm everything and nothing. I'm all you ever dreamed of and nothing you ever hoped for. I'm both conceited and conceiving, considerate and controlling. Content in my malcontentedness. \ 10-05-06 17:19:46 I been thinking bout you loads today. Ran out of bog roll this morning. \ 13-05-06 19:16:30 Marvellous, my pole dancing starts Wednesday! My customised nipple tassles won't be ready until mid-July, can I wait until then? \ 18-05-06 23:18:17 Mr Cadbury met Ms Rowntree in a room on Quality Street. It was After Eight. He turned out the light for a bit of Black Magic! He slipped his hand in her Snickers & showed her his CurlyWurly. Not keen to have any Jelly Babies she let him take a trip up Bourneville boulevard. She screamed with Turkish Delight! As he took out his fun sized Mars Bar it felt a bit Crunchie. She wanted some Time Out but he did a Twirl & had a Picnic in her Pink Wafers! \ 19-05-06 17:03:50 What date were you in that town in umexico with Sub commondante marcos do you know? Xr \ 03-06-06 11:04:41 Cant make parliament sq due to hellish hayfever symptoms + earlier work start. Have a great day, speak soon. X \ 03-06-06 16:05:32 Embroider this BITCH \ 05-06-06 14:59:53 Naked cyclists converging on west end this Saturday! \ 10-06-06 13:54:41 My front door is now bermuda cocktail blue \ 18-06-06 19:30:04 U r going 2 hate me. The newstatesman have asked 4 the article early.i can't meet 2moro.might be able to come 2 foundry in the evening.sorry .mark \ 21-06-06 18:52:58 Hey Tracey – in a wierd synchrostic twist I may have a job co-curating a commission of haitian artists for the liverpool museum of slavery – meet them tod the press section.. Got scared a minute then. The world is fallin out wi me left right+centre at the mo. It makes a change \ 22-06-06 16:35:58 I'm going to Haiti! \ 28-06-06 20:41:22 have a good time in russia. i going sand bar tonight! Jx \ 02-07-06 12:16:13 Dis is ma numba 4 skool n da trip. Missin u loads not much is happenin in bb since da new ppl came in. Luvu loads

04-07-06 11:51:40 all ok – jus dtails 4 wknd. Arr sat 1pm suggest meal, then day out sun. R the gipsy punks known out there? \ 05-07-06 17:16:57 Hope you're having fun here and lots of shashliki . Sorry for silence have been working till 1am all week and am shattered. But really want to try and make it this pm. Is there am invite policy? Can i bring a couple of mates? Ps i look like shit so dont get a shock when you see me. X good luck. \ 06-07-06 17:03:32 Wha u up 2 2nite?There's Strummer,foundation Opening-ladbroke grove/do u fancie it?Rob got gig wi nik,zoe at 11.X \ 09-07-06 10:36:54 The cops will be ringing.phone charing x police station and ask to speak to pc paul mcnally in special events,on monday.markx \ 09-07-06 20:49:37 I am now dazd n confusd n ta Trace . Well I'm mor likely 2 pik up my guns n tek t't'hills . wel i ope e dont tink e can wear is spndx shorts tinkin e getin conciousness xpansion \ 10-07-06 21:49:36 Apparently all 70's footballers had twinkie perms. \ 12-07-06 14:22:45 Is that a gun in your pocket or are you just glad to see me? Neither actually, it's a turd I did earlier, it's such a beauty I thought I'd take it down the pub and show the barmaid... \ 12-07-06 14:30:44 After looking at a picture of the princess royal's buck teeth, I unleash my sexy wee-wee! \ 16-07-06 14:29:50 Lots of pumper schinitzall and sourkraut not enough lard. \ 18-07-06 12:32:49 Morning love. Any chance you can get me Lily Allens dress size and agents address? \ 19-07-06 11:42:46 Moombadesprlllyyw. Thats Moberly! Im on to something here... \ 19-07-06 16:13:01 HANDS OFF LEBANON.ISRAEL OUT OF GAZA. DON'T ATTACK IRAN/SYRIA.Emergency demo in London this Saturday 12noon Embankment. Pass it on.0207278**** www.stopwar.org. uk \ 27-07-06 15:12:02 Spent the morning teabagging the milkman \ 28-07-06 11:46:47 the guy who invented post it notes actually trying to come up with a reusable merkin glue... Xj \ 01-08-06 23:26:14 Y haven't russians got their own fannies? \ 06-08-06 22:10:40 Hope you are well. One day we may meet again. You never know. X \ 07-08-06 13:36:47 Reading you loud and clear Big Momma Ape...

Bermuda Blue Laps The Passion Pink Shore had taken off in its own direction and *Text-Me-Up-Five* had been exhibited in in London and Hastings. The five embroidery samplers of my text messages had been well received. 'Big botty sausages', 'Wumping champion', 'Giant cucumbers' and the like had been captured in the brains of the audience and I was getting a lot of orders for similar work. I began formulating ideas for the next instalment of *Text-Me-Up!*

The 'fabric epitaph of the unknown embroidery sampler' was a story relayed to me by designer Bert Gilbert about a Victorian cross stitch sampler she had once come across in a museum. The sampler had left an impression on her and once she told me the story, it left the same impression on me. It had been created by a woman during the Victorian era of rigid morality in a period in history where verbal or written communication of emotion or sexual feelings was often proscribed. The female embroiderer had seemingly been living a repressed and abusive life at the hands of her middle class husband, dominated by him and society's virtues and values of that period. She poured her thoughts and emotions into her embroidery sampler. At this time, the woman's place was in the home. The Victorian age was highlighted by Tennyson who wrote of women staying by the hearth with their needles whilst men wielded their swords. The embroiderer's anguish, problems and sadness were poured directly through her needle and thread, creating the letters and words of her embroidery sampler. The accepted career for women during this period was marriage, and middle class women would be groomed like racehorses in order to be selected by their husbands. The Victorian gentlewoman needed to be able play an instrument, sing, be innocent, virtuous and express a diligent lack of neither political nor intellectual thoughts. Married and single Victorian women alike were expected to be delicate, helpless and weak, bear a large family and run a calm household in order that the husband could be domesticity-free, able to concentrate on the work that earned money in an industrialising economy. Despite the moral nature of the period, husbands would often keep mistresses, expecting both wife and mistress to remain faithful to him alone. If a woman took a lover and it became public knowledge, she would usually be cast out of society. This never happened to the man who would in most instances be revered for his affairs in the gentlemen's clubs he would attend.

It wasn't until the Married Woman's Property Act 1887 came into force in Britain that women gained the right to own their own property. Prior to this, all her belongings and family inheritances belonged to the husband. The wife was also the chattel of the husband and should she choose to separate she relinquished any rights to see her own children. A divorced woman had no chance of

acceptance in society again. This was a hypocritical period abundant with artificial relationships; a society where it was deemed to be improper in mixed company to even say the word 'leg' (the common substitute used was often 'limb'). This instigated the possible myth over the use of embroideries and cloths covering tables in order that the table 'legs' were morally hidden from the prudish viewer.

I had empathised with the woman who could only release her words through her needle and thread, wondering how many people at the time would have noticed or actually read the words in her sampler which may have been a cry for help. I suspected none, as even in our sponge-like high-tech visually absorbent world, people don't really take in the whole story or see the whole picture of what they are looking at. I had experienced this often whilst creating and stitching around the globe for *Text-Me-Up-Five*, finding myself with a needle, thread and growing imagery in many extreme socially interactive contexts where my activity was not fully observed by others. I've always been interested in ways of seeing, for example, how new something appears when we see it for the first time, but how after we grow accustomed to it, it almost becomes transparent. We are, in effect, looking but not seeing it anymore. I feel the same with all the visual information and words that are available to us that we choose to ignore. In contrast, I enjoy the words we also see, view and ingest, the sentences we construct with them and most importantly what we read between the lines. There are all the many invisible words being carried through the airwaves; simultaneously penetrating, passing through and surrounding us. The text messages, telephone calls and radio broadcasts along with music and films, speed through the interlocking information highway.

I'd began comparing elements of the cultures from both eras – Victorian and current – including the words and sentiments that appeared on the embroidery samplers produced then in comparison to my own. The samplers I had completed for *Text-Me-Up-Five* highlighted a small and personal aspect of this new century's popular culture, and I wanted to expand the next show to include a broader comment on our culture at a more generally understood level using texts I had received. It was therefore important that the work also held shared cultural references. I began to focus on the evolution of new technologies from the cinema screen to the development of television; the progression of the computer and internet, leading into the significant developments of the mobile phone and its ability to receive data from around the world into the hands of the nation's population in seconds. It was easy to focus on the vast cultural changes wrought by the communications revolution of the late nineteenth century and early twentieth centuries where there followed a nation's need for self-definition. And within that, exploring how we had began the cultural journey that lead us into a period that so defines us in relation to celebrity culture. It is a stark contrast to the not too distant Victorian era.

This development arose as we shifted from an industrialised nation into a nation of consumers. The early cultural icons that had been spawned by the development of the silver screen cinema had been replaced by the new heroes and heroines of television. In turn, these TV stars had undergone a metamorphosis into personalities of celebrity. As more joined this entourage, they became icons not for achievement, but simply for being famous. This process was accelerated by new technologies which made the mechanical reproduction of still and moving imagery seamless, and facilitated the speedy distribution of images and

news through cinema, radio, television, internet and mobile phone.

Soon culture became preoccupied with personality as it shifted away from 'character': in turn 'celebrity' became the measure of success. Personality depicts a change in social order. From its early big screen beginnings, the Hollywood dream machine represented its stars using the tools of chic and glamour. The packaging of these icons began in the form of still images (which continues today – the booming industry of DVDs and merchandise on an individual celeb now supplies a huge market). Following the big screen, radio became the archetypal medium for the cultivation of celebrity, as many people could buy into the idea and own a receiver. This was superseded by television, bringing celebrities into our

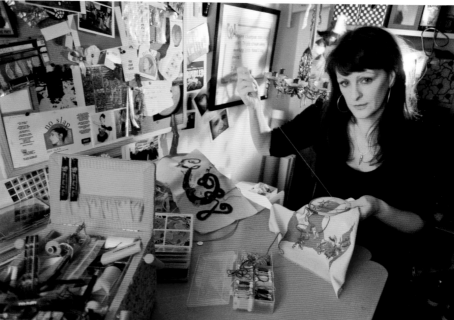

homes in an expansive simulation of reality. One of the defining features of celebrities is their capacity to sustain our interest in their private lives. It is this, over the activities that made them prominent in the first place, that elevates their persona to celebrity status. The symbiotic business relationship of celebrity culture wherein a sense of intimacy is sold to the audience accrues to its performers social power, honours and wealth. They are incessantly highlighted in tabloid papers and magazines to feed the members of our cultural consumer market. This, in turn, depends on the consumer culture selling us a vision of ourselves.

The phrase 'parasocial relation' describes the connection between the celebrity consumer or fan and their celebrity, posing a surrogate for 'real' social situations. Princess Diana was a huge international celebrity but it was her death that dramatically established her actual reality. It is difficult to measure the social power accruing to celebrities, examples such as John Lennon's controversial assertion that 'The Beatles are more popular than Jesus,' highlights the type of grandiosity that celebrity culture fosters. Other examples of this include Arnold Schwarzenegger, the Austrian-American bodybuilder, actor, model, businessman, and politician, who is currently serving as the 38th Governor of California. Even recently Hip-hop artist and singer Wyclef Jean tried to run for the Haitian presidency. For the fan, celebrity culture can produce intense identification at football stadiums, rock concerts, and athletic arenas. John Lennon's assassin Mark David Chapman thought he was the real Beatle and Lennon the imposter. Andy Warhol in 1968 proclaimed, 'Everyone will be famous for fifteen minutes.' Many people wanted their fifteen minutes of fame. The television companies tapped into this and soon a large majority of the nation developed a mindset suggesting that acquisition of status, notoriety and fame were in the grasp of everyone without working towards, producing or achieving anything.

Currently within this culture there are two types of celebrity. There are those who still hold their character, producing and working to earn their fame and

there are the other kind. Vocal critic Damon Albarn (from the bands Blur and Gorillaz) stated, 'Celebrity culture provokes a mindset that suggests you can get something for nothing and that it's easy to acquire status and fame.' People are elevated for reason of notoriety rather than for notable content in what they do, whether they have worked towards mastering a talent or have none at all. If society deems any slight attribute as exceptional the person is popularised. Reality TV shows are a good example of this and it is something everyone buys into, in one form or another, even by simply reading a newspaper or magazine.

In the earlier chapters of this book I have included text messages that were received from reality TV show Big Brother. The house member contestants were gradually voted out until a winner remains. They were assessed on their performance within the house (by selected editorial cuts highlighting exaggerated personality traits). Keen viewers could receive regular updates by text message. Jade Goody, a previous contestant, gained notoriety and celebrity status on the Big Brother show. After leaving the house the media followed her first marriage, birth of her two sons, relationship break-ups and new beginnings, fronting her own reality TV shows and launching her own fragrances She appeared regularly in celebrity, trivia, and gossip-oriented women's magazines throughout a terminal illness up until her untimely death and funeral.

07-08-06 15:33:26 My god that is the hugest coincidence – when my mobile bleeped I was standing on a stool pruning my books & wondering if I'd lent 'The Serpent & the Rainbow' to you – not going to Jess's party – shall I pick it up at the Foundry sometime – when's good? \ 09-08-06 20:02:55 Got u.exited to see a poster for 'Quim, Live!' alas, Quim is a moustachiod 50 something fat man singer. Lovely pair of tonsils though... \ 10-08-06 08:51:06 You've given me ocd picking up red elastic bands \ 10-08-06 16:42:46 Hello darling How's the straws? Champagne 50 a case of 6 How many you want? Love Ax \ 15-08-06 18:56:37 Next Tuesday I'm having a fridge delivered that can fit a case of champagne in the door alone. If that doesn't tempt you to visit... xh \ 16-08-06 21:19:40 spent the last five hours attempting to beat the world record for the number of Quavers that can fit under the foreskin. Perhaps I should take them out of the bag... \ 16-08-06 22:48:56 Not sure yet, will know tomorrow. P.s. Check out prosthetic testicles nailed to foundry bar! \ 18-08-06 18:31:19 T-Mobile (UK) welcomes you to Switzerland. Dial #33*1234# and answer ring back to make calls, roaming rates apply. Our direct dial partner is Sunrise. \ 19-08-06 20:03:03 U in london? Wanna come kick up hoof? \ 22-08-06 20:01:04 No! No! It's 'milk, milk, lemonade, round the corner chocolate's made!:-) \ 22-08-06 23:33:39 Hi msw tracey, in moscow Having beautiful cold curry and thought u needed 2 know . C u soon x x x sarahjailola \ 24-08-06 14:53:52 It is Spams birfday – she is 27 again and is sad. \ 24-08-06 15:34:15 It was lush being on tour with you again, boys lovely and gorgeous. They are little gorgeous genius babies and you are the fairy queen x \ 24-08-06 22:06:45 Hi treacy. Tell the boys i said congrats! Thats great news! What have they planned for september? How are you? I am a wreck lately. Been snoring for the last hour. I need a holiday! Got pissed two weeks ago at home with sinead and ellen, michaels sister-in-law. Whiskey! Fell on top of the leg of the mirror. Ass-bone killing me! Talk soon. Love F \ 09-09-06 18:32:25 CAN'T BLIEVE IT! JUST SAW A RAT! XX \ 12-09-06 21:31:33 Doing well. Charlie having placenta this week. V healthy. \ 13-09-06 15:33:11 Ha ha. Have just found out that alistair anusmouth and val vilevulva had the preview and launch at his space on the thursday! With booze, canapes, the lot! It was heaving apparantly!

Celebrity culture is continually raising issues: alcohol, drug abuse and other controversial activities which are on the increase are being blamed on the un-monitored images of these people featured daily on our TVs, internet sites and magazines. At the very heart (or liver) of our celebrity culture, money appears to equal controversy in the form of sex, drugs and rock 'n' roll.

 In March 2008, BBC news reports stated that pupils' obsessions with foot-ballers, pop stars and actors were affecting their progress at school and limiting their career aspirations. 'Some 32% of the 304 teachers quizzed said their pupils modelled themselves on heiress Paris Hilton,' whilst the Association of Teach-ers and Lecturers' general secretary Mary Bousted said, 'celebrities could raise pupils' aspirations and ambitions for the future,' but also warned, 'we are deeply concerned that many pupils believe that celebrity status is available to everyone.'

Throughout time, humans will seek out the alpha of any group whether male or female in our society. However now modern media entices us to seek and emulate them on screen or in magazines and through the internet which acts as a Biblical tome for celebrity culture. The hunter-gatherer tribes of our ancestors gravitated around strong, powerful people with well-developed qualities for sur-vival. Others would work their way into the company of these alpha figures and by observing and imitating their ways develop a stronger strategy for survival for themselves. Group alphas would in effect become celebrities based on the survival benefits they could provide to themselves and impute to the community. Celebrity worship has in this way existed across history, for example the gladi-ators of ancient Rome alongside the Christian martyrs that were maimed by them. In our current cultural climate we have experienced the likes of Madonna and Brad Pitt.

Flatscreen televisions have become the new main window in people's homes, some houses positioning the television in front of the room's actual window. Now a vast majority of people substitute the screen for the window and world outside, living out their lives complete with emotions, dreams and hopes through the fictional characters of soaps, dramas and reality TV. In the lyrics of a Marina and the Diamonds track: 'TV taught me how to feel, now real life has no appeal. Oh No!' Whilst consuming further, we are producing little.

 As I just pressed a button to exit Twitter, being left wondering why I needed to know what one particular product of celebrity culture had in their sandwich for lunch, a text update has pinged into one of my son's mobile phones. He com-plains there is little info on the band that regularly sends him updates and how all they ever do is ask him to buy things. I delete the celebrity I'm following and my son texts a request for no more updates from the band. My thoughts back on track, I'm focusing on a sentence I wrote a few paragraphs ago: 'At the very heart or liver of our celebrity culture, money appears to equal controversy in the form of sex, drugs and rock 'n' roll.'

My sixth *Text-me-Up!* would be titled *Text-Me-Up-Sex Drugs & Rock'n'Roll*. I wanted to make a socio-political comment in the work where I would focus on texts sent to me by friends who had also acquired high profiles in the media. All of these people exist to some extent in the celebrity arena, and also have earned reputations through impressive (sometimes infamous) bodies of work. Their treatment by the celebrity machine has been quite varied. These are all people who I know well and who regularly text me: Pete Doherty, Bill Drummond, Larry Love, Howard Marks, Aiden Shaw, John Sinclair and Mark Thomas.

Bill Drummond > TM
22 Aug 2010 10:02
I have been informed that BBC 6 Music are broadcasting an hour long "Bill Drummond" program today at noon. I have no idea what the program is or what it might feature. At the time of it's broadcast I will be driving up the M1 heading for Otley, there is no working radio in the Land Rover. Thus will not hear it or be none the wiser to the content of the program. Hope all is going well.

TM > Bill Drummond
I will listen & text you. Al going well here, writing slowly but qualitatively inbetween organizing the builder & painting my mum's living room & the like. Have a good journey & say hello to Kate & her boyfriend

TM > Bill Drummond
My mum enjoyed the radio program & thought you'd done a lot in your career, but was glad you preferred making art. It finished with the saddest song! Hope you've arrived safe...xx

PETE DOHERTY

Lead singer with Carl Barat of the band The Libertines and lead singer of Babyshambles. He is no stranger to celebrity culture with his well-documented experiences with UK drug laws and his engagement to supermodel Kate Moss. In 2008 he was awarded NME hero of the year award and in 2009 won NME solo artist of the year award.

Pete was a large part of Foundry culture before he formed the Libertines. For a time he hosted our regular Foundry poetry nights and he took part in our Russian cultural exchange.

Pete's Text:

Eels slip down a treat

I've used this for it's seemingly sexual connotations, where in fact he sent me this text whilst being a guest on my radio show and teaching me how to eat the traditional London meal of pie, mash and jellied eels (I couldn't eat the eels; they tasted like cold, wet, dead dog). Incidentally this is what I believe King Henry VIII's diet had been when his stomach exploded before burial after his death.

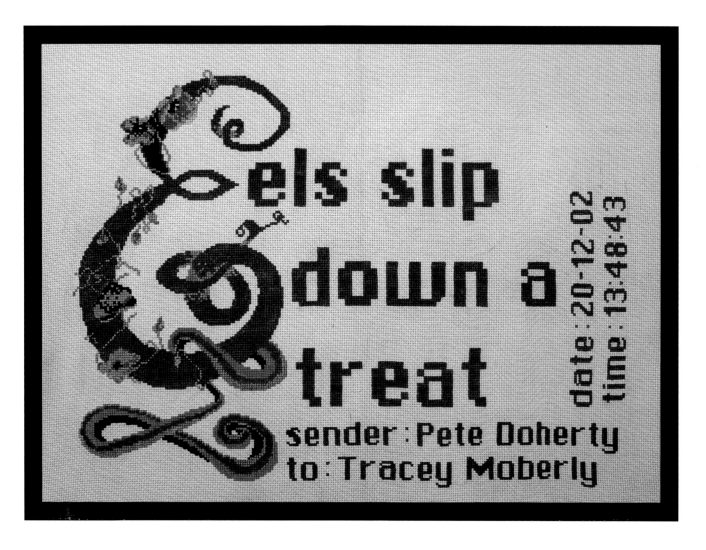

els slip down a treat

date:20-12-02
time:13:48:43

sender:Pete Doherty
to:Tracey Moberly

BILL DRUMMOND

Bill uses various ways to converse with the world. These conversations have found expression via the written word and pop music, actions and The17. His written works include *The Manual*, *Bad Wisdom* and *How To Be An Artist*.

The pop music (1977 – 1992) comprised of various projects from Big In Japan to The KLF. The 1992 Brit awards was the finale of the KLF. Bill fired an AK47 loaded with blanks at the music award ceremony after performing on stage whereupon it was then announced that KLF had now left the music industry. Deleting their entire back catalogue they went on to form the K Foundation – an art group which, amongst other projects, burned a million pounds in cash, costing them in the region of £1,350,000 to do so.

The actions have been the one constant in his practice. Over the past decade Drummond's activities have included the production of a pack of cards titled 'Silent Protest', the making of The Soupline, the construction of the London Cake Circle and setting up the websites. Since 2006 Drummond has focused his energies on The17, a choir. He is currently in the middle of an extended but sporadic world tour with The17. Bill's father was a Scottish Minister and he has recorded a version of 'Son of a Preacher Man'.

Bill and I collaborate on various projects. The text I sent Bill read:

Friendship is like pissing your pants, everyone can see it, but only you can feel the true warmth. Thanks for being the piss in my pants!

Bill's reply:

The piss in your pants? I am the cum stains on my own T shirt. Still in Liverpool and will have to be for the night to pick my new passport up first thing in the morning. Do not have enough juice to make calls.

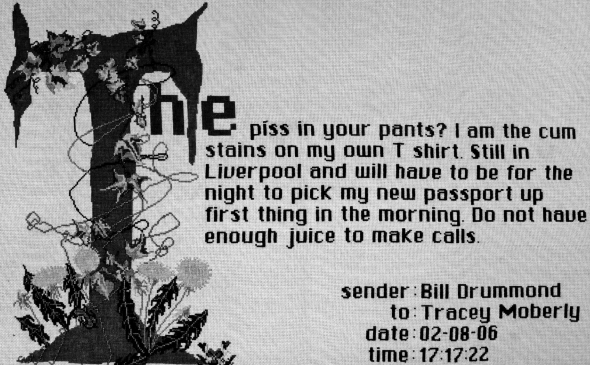

The piss in your pants? I am the cum stains on my own T shirt. Still in Liverpool and will have to be for the night to pick my new passport up first thing in the morning. Do not have enough juice to make calls.

sender: Bill Drummond
to: Tracey Moberly
date: 02-08-06
time: 17:17:22

LARRY LOVE

Lead singer of Alabama 3. Formed in Brixton in the 90's they pioneered a unique fusion of country, blues and acid house. Their song *Woke Up This Morning* is the theme tune to The Sopranos. Larry is a brilliant lyricist and all-round rock'n'roll genius. He comes from a religious fundamentalist background – his family are Mormons and so also considers himself to be an authentic son of a preacher man. Larry comes from the same village in Wales as myself. My favourite album of his is *Exit on Cold Harbour Lane.*

When hearing about my subject title for the new *Text-Me-Up!* show, he sent this tongue-in-cheek text:

Sex on rock is as bad as drugs without no roll (ing papers) x

Sex on rock is as bad as drugs without no roll(ing) papers

sender: Larry Love A3
to: Tracey Moberly
date: 15-08-06
time: 17:36:59

HOWARD MARKS

Former teacher, drug smuggler, and author. He achieved notoriety as an international hashish smuggler through high-profile court cases, supposed connections with groups such as the IRA and the Mafia. At the height of his drug career, he allegedly controlled 10% of the world's hashish trade. He spent seven years imprisoned in the Federal Correctional Complex, Terre Haute, Indiana. During his smuggling career, he claims not to have used violence and to have refused to deal with hard drugs.

Howard comes from the same part of Wales as myself. His film Mr. Nice was released in October 2010. Mr. Nice is a British comedy and drama film directed by Bernard Rose, and starring Rhys Ifans and Chloë Sevigny. The film tells the story of Howard Marks, 'Mr. Nice'.

Howard's text:

I wish my first experiences of sex, drugs and rock'n'roll had come at precisely the same orgasmic instant

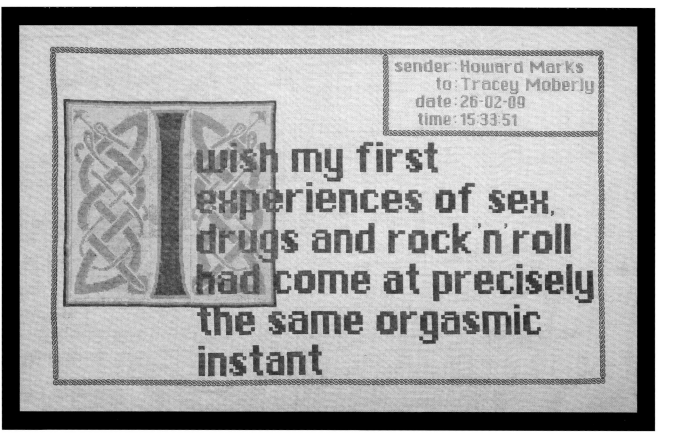

JOHN SINCLAIR

A Detroit poet, former manager of the band MC5 and chairman of the White Panther Party, a militantly anti-racist group of white cultural revolutionaries organised around the MC5 to support the Black Panther Party and the black liberation movement from November 1968 to July 1969. After a series of convictions for possession of marijuana, Sinclair was sentenced to ten years in prison in 1969 after giving two joints of marijuana to an undercover narcotics officer. This sentence inspired Abbie Hoffman to jump on the stage during The Who's performance at Woodstock to protest. It also sparked the landmark 'Free John Now Rally' at Ann Arbor's Crisler Arena in December 1971. The event brought together a who's who of left-wing luminaries, including pop musicians John Lennon (who recorded the song, *John Sinclair* on his *Some Time in New York City* album), Yoko Ono, David Peel, Stevie Wonder, Phil Ochs and Bob Seger; jazz artists Archie Shepp and Roswell Rudd, and speakers Allen Ginsberg, Abbie Hoffman, Rennie Davis, David Dellinger, Jerry Rubin, and Bobby Seale. Three days after the rally, Sinclair was released from prison when the Michigan Supreme Court ruled that the state's marijuana statutes were unconstitutional. Now based in Amsterdam, he remains active in the marijuana legalisation movement in the USA and travels the world as a poet and performer with the many editions of the band he calls the Blues Scholars. John and I are planning some joint projects together.

John's text for the project read:

Tracey the original slogan advanced by the white panther party was 'rock and roll, dope and fucking in the streets,' not the bowdlerized version that's come down via ian dury et al. Love John

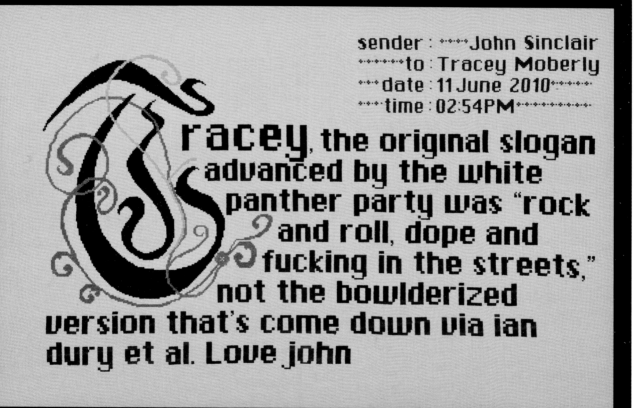

sender : ····John Sinclair
·······to : Tracey Moberly
···· date : 11 June 2010·······
····time : 02:54PM·············

Tracey, the original slogan advanced by the white panther party was "rock and roll, dope and fucking in the streets," not the bowlderized version that's come down via ian dury et al. Love john

AIDEN SHAW

A writer and pornographic actor who appears in American pornographic movies aimed at male homosexual audiences.

He has starred in over fifty porn movies, many directed by porn industry sensation Chi Chi LaRue. He has worked for Falcon Studios, Catalina Video, Studio 2000 and Hothouse. In 1991 he won 'Best Newcomer' at the Adult Erotic Gay Video Awards. In 1994 he won 'Best Sex Scene' for his scene in Grease Guns.

In 1996 Shaw wrote his semi-autobiographical novel, *Brutal*. Also in 1996 The Bad Press released a collection of his poetry, *If Language at the Same Time Shapes and Distorts Our Ideas and Emotions, How Do We Communicate Love?* Other published works include *Boundaries*, *Wasted*, *My Undoing* and *Sordid Truths*.

Aiden's text addresses numerous issues around the exhibition title:

Sex fills me with germs
Drugs fill me with doubt
Rock'n'Roll fills me with hope x

MARK THOMAS

A performer, writer, political comedian and activist. His most renowned vehicle has been his political comedy show, The Mark Thomas Comedy Product, of which there have been seven series produced for Channel Four. Mark has also presented the highly successful BBC Radio 1 talk show Loose Talk and is also a founding member of the London Comedy Store's hard hitting Cutting Edge show. Between 2001 and 2007 he wrote a regular column for the New Statesman. He has also published three books – *As Used On The Famous Nelson Mandela* on the international arms trade; *Belching out the Devil*, an expose of the Coca-Cola Company and *Extreme Rambling: Walking Israel's Separation Barrier. For Fun*. Mark's father was a lay preacher in the Nazarene Church.

I have collaborated on numerous projects with Mark, including *Coca-Cola's Nazi Adverts* exhibition and McDemos.

Mark's text was sent in response to a text I sent him. I was being hassled by a man with a God complex in a joint show Mark and I had co-curated, where Mark was not present:

Always trust a man who says he is an angel of the Lord unless he wants sex. Always run from angels with erections m x

15-09-06 12:07:07 Contents of bedroom airing cupboard: 1. An owl. 2. A book entitled '300,000 things to do with spinach. 3. An inflatable Dennis Thatcher love doll. 4. Packet of tulip seeds. 5. One 'Rover's assorted biscuit tin containing a set of rusty keys and some stoat and/ or weasel droppings. \ 20-09-06 13:33:52 Ah yes, the Matisse sketch. The Matisse sketch was a gift from my friend Eric Clapton, he gave it to me about ten years ago and it's very special to me... \ 22-09-06 20:36:01 Just on 55 up 2 walthamstow now. Keep u updated. X \ 24-09-06 23:30:00 Thanku darln 4 thinkn of me!ur a top bird x n lovely friendxx \ 27-09-06 17:46:53 Lets be the Duke and Duchess of Text! \ 30-09-06 12:38:33 Marvellous! I expect gossip-a-go-go from today. Do try to text me from a busy toilet cubicle! Hx \ 04-10-06 09:51:58 Well im not buying Lloyd Grossman jars again – Tory Bastard! \ 04-10-06 11:01:05 Battle of cable st celebration festival this sunday. Noon-four. Cable st. E-1 \ 07-10-06 22:56:25 Welcome to Russian network MegaFon! Enjoy your stay here! To get the information, please call 0500 \ 09-10-06 00:51:00 Sorry about bags- what a bugger. Just got in are you around tomorrow? I have to go to tyumen on 10th so will miss opening - bum. \ 11-10-06 15:48:09 Keep seeing this Russian journalist on the news, do take care of yourself love. Thinking of you, hx. \ 11-10-06 20:51:41 We have problems with the hotel. The only one I've found for the moment is 6380 rubles. \ 12-10-06 21:55:47 Hi tracey antoine de la plague calling! \ 16-10-06 12:14:41 Howd'it go on russian tv? \ 20-10-06 21:26:43 As a special treat, I'll be putting bogeys in the Tomato Chutney this year. \ 25-10-06 21:16:02 Had 2 go 2 Caterick 2 get J off miltry police, him n army mate took warrior tank an drove over a car?-got videod- on utube, think he wont get charged. Havnt been able 2 c ur pic yet, x \ 27-10-06 22:53:01 You will be my herd again one day tracey only you can rock me on every corner come on back now lets do it again. All of a sudden twenty years! Always thought about you tracey is that bad of me

I first met Tracey when I wrote a small article about her for The Face magazine in 2001, one of the first pieces I managed to get published. I was living in Brixton, having moved to London the previous year, but I had recently discovered the Foundry and had happily ascertained it to be a thriving hotbed of anarchy, madness and art. I was also just starting to try my hand at writing, and this seemed to me a productive well of possible stories, so I started hanging around and talking to people, and it wasn't long before I found myself undertaking several assignments potentially hazardous to life and limb, with at least one involving explosives. Less immediately life-threatening was the story of the lady who had decided to keep every text message she had ever been sent, and create an art exhibition out of them. The Face liked the idea for an article in their 'Hype' section, and soon I was in the back stairwell of the Foundry with a pre-fame Pete Doherty, helping an enormous net of pink helium-filled balloons to make their way out on to the street, and from there to stream out in a colourful ribbon across the London sky.

ROD STANLEY It's been almost a decade since we first spoke about your work with text messages, but you'd already been working with them for a while even then… How long have you been keeping all of your text messages and making them into art, and where did the idea for that first come from?

TRACEY MOBERLY I've saved every single text message I've been sent since 1999, and I've been putting on different exhibitions all under the banner of *Text-Me-Up!*. The one I'm working on at the minute is *Text-Me-Up-Sex Drugs & Rock 'n' Roll*; it's all about celebrity culture.

RS So, how do you decide on the theme for each show? Do you respond to what's contained in the text messages?

TM I sent a text to Bill (Drummond) that said, 'Friendship's like pissing your pants. Everyone can see it but only you can feel the true warmth', which was just like a stupid text. But he responded in an equally gross manner, and that embodied the whole 'Sex Drugs and Rock 'n' Roll' bit for me.

RS How has your own relationship with text communication changed, from the first shows up to this one?

TM The first *Text-Me-Up!* was when I was coming out of a disastrous relationship. I was saving all the messages, because they were like these little sugar rushes, little snippets of niceness. When you're on a bus going to a job you don't like, and you feel your whole life is falling apart around you, and then people come into your world through your phone with these nice three-word messages,

well, they were really uplifting and something I didn't want to throw away. I love looking back at them even now.

RD Text messaging has obviously changed the way we live and communicate in the last decade or so… but beyond your own experience, why have you remained fascinated with it as a medium?

TM In the last century, when Kiki de Montparnasse and Man Ray would eat and drink in the Left Bank, they used to go to a pub called Le Dome for their Kir Royales… all very decadent. But for their messaging, they used to just leave a message on the blackboard on the back of the door. That's the next best thing I've found to texting. That's why I started writing them all down, these little journals of millions of text messages, and decided this was a lovely thing, a really good social interaction to pick up on.

My first exhibition was in Castlefield Gallery in Manchester, where I made loads of pink silk cushions for people to sit in the middle and lie down, and observe all the texts going on. It was like a journey into my world. When I moved to London, it had expanded… I was launching a thousand helium balloons with my recycled text messages attached, and I got something like 350 replies from the first 500. They'd crossed the Pennines. I was getting stuff back from men in sewers, and kids and teachers in classrooms. I had people saying, 'I've got to meet you, we need a date'. There was one that said, 'I need to meet the person whose red heart just floated in through my door'. This was *Text-Me-Up-3* … with the second one, there were scrolls everywhere, and I've got this image in my head of Pete Doherty playing mouth organ, and then hand-springing in what felt like my living room.

RS Wasn't he there, helping release the balloons at the third one at the Foundry?

TM I've got this photo in the living room with all these pink balloons rising behind me, and The Libertines are there, and Suede, and all these other people. And because it's all their texts, it's nice to have documents like that. It's all to do with social interaction, really. All these single text messages go on to become part of something big. Yes you were there.

RS As it evolved, did you find it started pulling people in who were not originally part of it?

TM By releasing those balloons, I got people that I didn't even know involved. One said, 'some people paint on canvas, other people paint on cameras, you painted on the sky', and it was a really lovely thing. With all those responses, I put up another exhibition, which became *Text-Me-Up-4*. *Text-Me-Up-5* then went all over the country. I invited four other artists one of which was Danny Pockets. We sussed out that he'd been collecting text messages from about a year after me and he'd also come out of a disastrous relationship. At that point in time, a friend of his who just so happens to be an editor of the Independent Magazine texted him and said, 'some Welsh bitch has nicked your idea!' I didn't meet him until about three years later, when we started collaborating. She texted that to him after that article you wrote about me came out in The Face – 'Texty Lady'.

RS How funny. Did you find it productive creatively to meet someone else who was involved in similar work?

TM We did a film called *Bermuda Blue Laps At The Passion Pink Shore*, because all the messages have all sorts of flirty, sexual connotations, and because his are all blue and mine all pink. Basically, we're taking turns reading out all our

early messages, and all you see is a mouth – Radio Ulster likened it to Samuel Beckett's *Not I*. It forms a dialogue sometimes... you make your own stories. But none of them are our words – they're all words from other people to me, or other people to Danny. It's like the messages are now recycling themselves. The messages are becoming new messages, new words, new events, and new responses.

RS Text messages are something that everyone can relate to, but they are also something that is usually intensely private, so it's disconcerting to see them bared in this way. Do you ever see people directly moved to contribute, or get involved, having been encouraged to think about texts in a different way?

TM One day, I put up a box so people could recycle their text messages. I didn't think it would get a response, but the box kept getting full! I've now got this as another potential body of work. I want to divide those up and get eight different authors to write a chapter each, involving one hundred of these texts, and the story then gets handed on to the next author.

RS Have you noticed any changes in people's responses to your work since you started in 1999?

TM A lot of people get really engrossed reading someone else's texts. But the medium changed while I was working in Russia, and Bill and I were putting together a joint exhibition called *Death and Desire*. Our friend sent this really sexist text, going on about women artists, and how they should just have babies and fuck off. Bill was laughing, knowing that this guy had sent it because of the arguments we would have and the reaction he would get, but it was that which changed my thoughts about the medium. Following that text, I thought about this sewing 'sampler' (small pieces of fabric to sew patterns on) at the V&A Museum – they're from when men would go off and smoke and talk, and the women used to sit and sew their needlework samplers. There's a fantastic one in there where this woman was obviously unable to express what she felt, and obviously had some quite bad mental health issues and it all comes out in this sampler, which no one would ever have bothered to look at! I've sewed samplers in front of people and they don't look at it at all – they just don't look at what's on there. You expect a sampler to have 'Home Sweet Home' instead of the word 'Piss' on it.

RS So, subverting a historical form like that came from thinking about text messages from more of a political angle

TM Yes, but also looking at what's happening now, and what a woman can do with technology. Also, what interests me is the ease and quickness of everything with a mobile phone, but on a political level; it's how movements and marches can be organised.

RS Has any of your work addressed that yet?

TM I'm thinking about writing about that, because it is part of it.

RS The perfect example of text messaging in that context was the co-ordinating of all the big May Day and anti-G8 protest riots, round the time of the Millennium – it was amazing to see how quickly people adapted and subverted mobile phone technology for causes it was never meant to facilitate.

TM I'm really interested in that, but also in different cultures – like how significant a mobile phone is in Darfur, and the gender politics that go with that. It's not something I've yet researched but I'd like to.

RS You can also see how people's language has evolved and been influenced

since people were just getting to grips with it.

TM I think I'm quite good at how I shorten things, but one of my boys calls me a 'chav texter'.

RS That's interesting how someone could assume you can infer something about someone's social class without knowing anything else about them other than the slang they use in a text message. And you never know who's reading them, after all surveillance has become such an intrinsic part of our lives these days, do you ever wonder if there are government systems tracking and storing our text messages? It would be like a mirror image of your project, but on a huge scale and with different intentions. What do you think your decade-long archive would reveal if someone like that were to look at it?

TM Well, I'm known as a socio-political artist, and when I was involved with ISEA in 1998 in a show about Terror and Revolution, you could sometimes hear a click on the phone. My friends would be saying, 'why are you getting so paranoid?' But it happened to others, too. And with the nature of the other work I do now, and my anti-Coca-Cola work, and all the stuff challenging the government – well yes, I do think that periodically phones must be tapped, messages must be looked at, and I think they must have a field day with me! Because I have all these messages from so many different people – and if someone like that were to look at them, they wouldn't believe it if you said you've just gone from Howard Marks to some gangster to some pop star to my child's teacher! Facebook freaks me out, though.

29-10-06 17:17:12 I met the ghost of fossy jaw. I ll read that, her + Pankhurst proper heros \ 31-10-06 20:18:37 Youtube.com/moiraming \ 02-11-06 10:27:55 Three days it's been under my pillow and still the turd fairy hasn't left any money... \ 02-11-06 20:30:33 Hey hon – u eating dinner with goregous george now? Xx \ 06-11-06 10:15:28 On the way to Glastonbury Tor, splendid misty conditions, ideal for lurking. \ 08-11-06 14:53:54 You are my favourite Welsh woman artist that comes from the valleys and now lives in London that knows me. X \ 11-11-06 23:46:45 Ah! Pop liver in the washing machine on a wool cycle. Lovely and fresh! Do let's meet up for chocolate martini's love hx \ 13-11-06 15:40:05 talk about it in a fern curl ? \ 15-11-06 15:22:22 Do u remember when we were on the train......And i put my arse out the window, and u put your face out the window, and people thought we were twins! \ 20-11-06 10:17:02 Indeed madam the national guild of pornographers xmas extravaganza will be taking place on friday the 23rd Dec. The venue has yet to be decided. Your good self + Dirty kurty are most welcome. I shall keep you informed. \ 20-11-06 15:05:57 Maybe, dont really know, will there b crispy duck 2 eat? And bloody mary 2 drink? Free gifts? Midgets? Other welsh people + goats? Xk \ 25-11-06 19:51:54 Hi. It was ok thanks. Very boozy and very blokey! A real northern lads on the lash affair. In leeds now, off to meet harry chumba then on to back to basics 15 party. Think howard and bez will be there. Maggot is with me. Take care see you soon x \ 25-11-06 20:25:44 When you look at louis we are just to his left. I'm in jeans, mustard top with patterns. Not allowed to wave x factor rules. I'll mouth your name. \ 26-11-06 00:47:39 Sharon had major tears after show right in front of me. Was cuddled and consoled by ben and eton rd. \ 26-11-06 21:00:27 in the crowds my Chavez action man broke his legs ;-(\ 28-11-06 18:05:04 Haha we in Bar Roach now eating arepas in ur hönour! Toilets even worse unbelievably..R from Petare asked where u were.. had pizza last nite, wish you here im sure G is a spy haha X \ 01-12-06 23:55:09 Tracy are you there i love you for gods sake i am not drunk

I was invited as an artist to contribute to the first Ghetto Biennale in Haiti. The exhibition of work and performance would take place on Wednesday 16th December 2009 in the Grand Rue, downtown Port-au-Prince, Haiti. I would be staying there for two weeks to produce the work and exhibit it. I had first met the sculptors of the Grand Rue in 2007 just prior to the 200th anniversary of the abolition of slavery (when Britain had outlawed the slave trade with the Slave Trade Act in 1807). A sculpture by the artists was commissioned by the charity Christian Aid and National Museums Liverpool, which was first exhibited at Merseyside Maritime Museum. It was then toured before coming back to the International Slavery Museum in Liverpool when the venue opened on Slavery Remembrance Day.

The Grand Rue Artists came to London after they had been working with the installation of their sculpture in Liverpool. They visited the Foundry and Jonathan offered them free space to exhibit with us in London. At that time, the Foundry's landlords had constructed an unwelcome 15 x 20 metre advertising billboard which covered the entire building above ground floor level. The structure extended several feet in front of the building and was supported by a scaffolding structure. The scaffolding poles in turn were enclosed in wooden boxes at ground level in order to deter vandalism and prevent people climbing onto the structure. The Grand Rue artists exhibiting inside the Foundry happily took on the challenge of using their art to adorn several of these plinths in full view of the passing heavy traffic.

As well as being the 200th anniversary of Britain's abolition of slavery, within the next week and a half it would be Easter. The anniversary was marked in the Foundry with the Haitian artists and others creating a drum ensemble on the day. The huge billboard advertisement at the time featured a massive portrait of Madonna advertising a clothing range. The street artist Zevs decided one evening that Madonna needed to be seen crying and added a huge luminous green tear to her eye, which flowed straight down the length of the advert, hitting and

bouncing along the pavement. The blue, black and white of the Haitian's vodou art was now supporting a crying Madonna with a luminous green tear. It was quite impressive – defining, in a tongue in cheek manner, an interesting aspect of Haitian culture. There is a common saying which describes the population of Haiti as 90% Catholic but 100% Vodou.

The Easter miracle of the crying Madonna was reported in many newspapers and magazines, from Heat to The Times of India. However, not one journalist observed the irony of Madonna being supported by Vodou art. That week the artists took part in our radio show. During our conversation, I spoke about dancing in a remote place in Colombia, in an area close to the Caribbean Islands. The dancing there had thrown me; fast, rhythmical and intimate. Eugene, one of the Haitian artists, suggested that I should sample the dancing in Haiti, which he said was far better than that of Colombia or that of any of the other Caribbean Islands. I told him I would go to Haiti to dance. At the end of the show, still live on air, John Chris Jones (an academic and author who is a regular guest on our radio show) said, 'You shouldn't say things like that to Tracey because if she says it, she'll do it you know'. So I knew I would be making the journey to Haiti somehow, someday in the not too distant future and I would dance there. The artists of the Grand Rue visited several more times over the next year exhibiting and appearing on our radio show.

Leah Gordon, Eugene's UK partner and Myron M. Beasley an American colleague of hers collaborated with the artists in Port-au-Prince to devise and organise the first Haiti Ghetto Biennale. The idea of an arts Biennale interested me in what was historically a socio-politically extreme country. In 1803, Jean Jacques Dessalines led the Haitian Revolution becoming the first ruler of an independent Haiti. On 4 December of that year, the French colonial army of Napoleon Bonaparte surrendered its last remaining territory to Dessalines' forces. This officially concluded the only slave rebellion in world history to have successfully resulted in establishing an independent nation. Ripping apart the French flag and tearing the white section out, Dessalines asked Catherine Flon, a young girl of the area, to sew the remaining blue and red sections together, thus creating the Haitian flag.

I had written and submitted two detailed proposals for the Ghetto Biennale, both mobile phone related. One involving Mobilography and the other on the translation of text messages and the craft of Haitian vodou flagmaking.

The time had come to book my ticket. As there are no direct flights to Haiti to or from the UK I had two options – going via New York or Miami. It was December, New York was cold and Miami was hot so there was no pause for thought, the decisi0on was instantly made. I chose Miami. At this point I only knew two people there whom I could contact to see if they would want to meet up for a drink, a meal or a night out. They were Irvine Welsh and his wife Beth. I immediately emailed Irvine, who replied saying he was unsure if he was going to be there at that period as he may be filming in South Wales – coincidentally the place where I was born and brought up! I then contacted another American friend, International Vogue photographer David Mushegain, not entirely sure where

in America he lived and knowing that it is a BIG place and he would probably would be shooting photographs in a far off land. I texted him:

> David Mushegain -> TM
> 26 Nov 2009 15:42:45
> **Hi Tracey!...I won't be there. But call my friend Linley! 78624***** , he's really nice and he's my roomate in NY. He runs Miami nightlife, so at least you will get a good perspective. Wish we could hang!!...you have to come to LA or NY one day. And I want to come to London soon...but safe travels and big hug...I'm off to Hawaii Sunday for a couple weeks to work.....:) D**

He didn't know what country he would be taking photographs in on the dates I gave him and suggested I contact him nearer the time, whether Irvine and Beth were in Miami or not. As the time came Irvine confirmed he wouldn't be in Miami but that I should definitely visit two clubs there: one of them was The White Room and he gave me the contact name of one of his friends there. I then texted David who would be on an assignment shooting in Hawaii. He gave me the name and number of his New York flat mate who lives mostly in Miami and who did seem to run a lot of the nightlife there, he told me he would be expecting me to get in touch. I got a further text from David with the name and number of his oldest friend who also lives there:

> David Mushegain -> TM
> 26 Nov 2009 19:58:34
> **Hey my friend cassiano is there too...64654*****...he's my oldest friend in NY and moved to Miami**

After my initial thank you text, a few hours later I started fretting. I texted David again and tell him to mention to his friends whose doors I was going to knock on during my three day Miami stay that I was actually a woman and unlike the gorgeous models that he usually socialises and works with. He seemed to find this funny, but I just imagined the shock on their faces as they would be expecting a beautiful twenty one year old model knocking on their door to dance through the Miami nightlife with were they not warned! With that sorted another suggestion came in from a friend who had a friend with an apartment above a Haitian restaurant in Miami which she described as a half way to Haiti house.

Problems were occurring for me in the UK which meant I had to postpone my journey for a few days, I tried to change my flight out to Miami – there were none. I eventually found another flight incurring extra costs which left several days later but it had to be to New York. The few days adventure in Miami before touching down in Haiti was now a memory, but a fictional memory full of all cocktails, glitter balls, white carpets, dances on podiums and an overdose of Miami night-life and cultural days, which I had mentally indulged in before it had all changed.

> TM > Aiden Shaw
> 27 Aug 2010 14:53 PM
> **Great... Hope alls good with you? Do or did you know Darren Star the creator of sex & the city? I saw a reference once of Aidan Shaw in the series being named after you? Xx**

> Aiden Shaw> TM
> 27 Aug 2010 21:41 PM
> **A couple of New York papers contacted me asking. I was invited to one of the end of season rap parties. X**

I started focusing on my New York adventure wondering who would be there that I knew. The only person I could think of was my friend Aiden Shaw who was doing a book and whoring tour of America. Once again, knowing that America is a very big place, there could be only a slim chance of him being in New York when I arrived there. He replied to a message I sent him on Twitter saying that he would indeed be there when I stop over. We started making arrangements on where to meet and what to do. This was the first time I had used Twitter to contact someone in the same manner as I would text. Aiden is a larger than life character, with a look of Richard Gere only more rugged and handsome. He is extremely sensual and sexual and his body pours out pheromones and testosterone from up to eight metres away. Aiden Shaw is a gay porn star and icon of that industry. He has appeared in over fifty porn movies, with many directed by porn industry sensation Chi Chi LaRue. He is also an author, poet and spoken word performance artist. Aiden was at the end of doing an American tour to launch his new book *Sordid Truths: Selling my Innocence for a Taste of Stardom*. Coincidentally at the time I travelled to New York the American gay porn magazine Unzipped would be featuring a photograph I had taken of Aiden in their December Christmas edition. I thought about starting off my Haiti excursion by doing an interview with Aiden Shaw. He is one of the subjects of my forthcoming *Text-Me-Up-Sex Drugs & Rock 'n' Roll* exhibition, and I was hoping to do work related to Aiden for the exhibition in Haiti.

Sex and the City fans will remember that the character Carrie Bradshaw was engaged to Manhattan furniture designer Aidan Shaw. Author and critic Camille Paglia has said that the series was a victory for 'the huge wing of us pro-sex feminists' over the '1980s anti-porn, anti-sex wing of feminists'. I have always felt differently: the formula seemed to me to be written for gay males and cast with straight

TM > Aiden Shaw
Brilliant! When would be a good time to meet? I am writing the section on you when we meet up that night in New York & I was Carrie Bradshaw. I just have a few random questions? I may text you some others too xx

Aiden Shaw> TM
No prob. Sounds fun. I'm away until Tues. Going to a wedding in Devon. I've written something about love to read during the ceremony. It has taken me a year to write. The subject has been done to death. Also it's going to be kind of stressful reciting it, especially because I'm straight after Ringo Star. Quite an act to follow. X

TM > Aiden Shaw
You both have sexy voices so lucky bride & groom & lucky wedding reception. Have fun and let me know as soon after Tuesday that you can meet. Looking forward to seeing you & we should do more pix at some point xxx

TM > Aiden Shaw
I'm writing about unzipped mag in this chapter x

Aiden Shaw> TM
Yes. More pics. I'm shooting for Arena Homme Plus over next couple of weeks. An article about icons apparently. Get me!

females, by gay creator Darren Star. The plot also seemed to be formed around male relationships, if the males were taken out of the narrative, there would be no story. I was pleased in an episode of The Simpsons when Marge initially recognised this saying, 'that's the show about four women acting like gay guys.' I have seen a few references about my friend Aiden Shaw being the inspiration for Carrie Bradshaw's 'Aidan Shaw', but as I've just gone to the Wikipedia entry I last saw it on, it has since been removed. I would do the interview with Aiden Shaw, Carrie Bradshaw style when I flew out. We would meet in one of the restaurants they went to in the series.

01-01-07 21:41:21 Always remember for 2007. Life is short, break the rules, forgive quickly, kiss slowly, love truly, laugh out loud & never regret anything that made you smile... Send to all the people you love, care for & don't want to lose, even me! \ 02-01-07 19:08:12 Hi Brian, Just a quick message 2 wish you & Joan a Happy Easter & all the best 4 1982,from all of us @ the Alzhiemers Society. \ 03-01-07 23:18:33 Just been passed some potatoes and am thinking of you... \ 06-01-07 21:37:37 In Monmouth, a man was recently arrested for being 'welsh after dark'...Theres still a curfew dating back from the 12th century anti imperialist insurgency... \ 07-01-07 00:10:39 S grows blue fluff out his belly button can we flog that? a seemingly endless supply.. Its always blue, i can never harvest nothing \ 09-01-07 00:59:35 I dont talk 2 kylie. Nite x \ 15-01-07 04:33:45 Yeah, I think I pay and you pay!...man its hot here...I'm 8 hrs ahead,and very hungover. Just had a meeting with the first factory.. went well. I think my arse is going to fall out in a minute! \ 26-01-07 17:29:44 Hi tracey, forgot 2 ask u if u can bring in work again- the sets of hairy underwear or any new ones u have done to show fashion students on monday. thanx. Jade \ 29-01-07 07:28:01 You like fuck dumb a is who person thicko another to it send now, this read to trying time fuckin your took you. (now read it backwards) \ 29-01-07 09:16:22 On for Thursday evening. You said you were booking the table at the Ivy. Have a lovely day in Brighton. X \ 29-01-07 09:20:24 Thanks lard-arse.x \ 01-02-07 08:22:52 Penny Rimbaud: "We were on the prow of a ship cutting through a sea of turd." \ 01-02-07 12:07:17 Its about time fashion became more amusingly political and welsh and female-don't you think?hope u not wearhng the hairy knickers.will look up hair metaphors \ 01-02-07 18:59:37 Hi Tracey, weve got hair from richard and judy and nick ferrari- see you tomorrow, cheers Ben \ 03-02-07 19:52:58 I've got a bag of hair with your name on it... What you doing this evening crazy legs ? X j \ 04-02-07 21:31:50 He's fat and scant of breath \ 08-02-07 19:57:54 Hi Tracey. I'm off to Pakistan for a week this Saturday so unfortunately can't make it. Good luck and please stay in touch. X H

I caught a cab straight from JFK airport to the cafeteria where Aiden was waiting for me. He greeted me with a long hug. There was a Wild Berry Mojito waiting for me. Aiden joined me with a mocktail of berry lemonade, as he doesn't drink alcohol. I twizzled the fresh raspberries on the long cocktail stick around the sugary sides of the glass. I stared into the dark pink cocktail thinking of John Cooper Clarke, the Manchester poet, who drinks Martini's with olives and stirs them around his glass in a similar way. I banished that thought and the couple of decades it has taken me to educate my palette to liking olives. I started shrinking in size, my hair curling and turning blonde; I became Carrie Bradshaw and I was sitting opposite Aidan Shaw as he finished his mocktail and ordered a

sparkling water. He leaned back on his chair in a crisp, flawless white cotton shirt, his muscles defined and contoured even through the loose sleeves of the shirt. I ingested the strong pheromone-like substance that exudes from his pores. A synapse quickly triggers my brain, bringing me back to reality; I'm not Carrie Bradshaw and this Aiden Shaw is gay.

I began the interview by asking how the book tour was going.

He told me, 'fantastically. It's going great. I was surprised by the turnout at my readings and signings. Actually, I'm surprised by how many gay people read books, because none of the ones I know do!'

I asked him about the whoring part of the tour and how this is going and simply replies, 'Very profitable, much more so than writing.'

I asked him will he write another book based on the tour and he replied simply: 'Not specifically, but it'll probably all come in some book at some point.'

I ordered another Wild Berry Mojito as Aiden tells me about his favourite drinks from when he used to drink alcohol. I wondered if they did espresso martinis there as it would've been great if I could've stayed awake for my early morning flight. He pointed to the next table where I thought he said Erich Conrad was sitting with transsexual model Amanda Lepore, along with what looked like a very grown-up Macaulay Culkin. The waiters circulated ready to take our order, when Aiden commented on their tight trousers saying, 'these guys know how to work a tip.'

There were a lot of questions I wanted to ask him, some based around his text messages that I was using within my artwork. I asked him when he found out he was HIV Positive and he replied

Aiden Shaw> TM
Look at my new pics on facebook. My fourties.

Aiden Shaw> TM
When you have time. X

TM > Aiden Shaw
Yey! Get you indeed! That's good, let me know when it's out I will get it. I'll check facebook out. Have you got any of the ones I've taken of you up, the red briefs or the footy socks I love them. No worries if not I have a web link to your unzipped mag page. Shall I send that to you? I'll be back by computer in half an hour x

Aiden Shaw> TM
I'll tag you. I've credited the pics to you though. Can't access my computer till tomorrow. X

Aiden Shaw> TM
Fab. I just managed to tag you through my phone. Technology! Fantastic. X

TM > Aiden Shaw
27 Aug 2010 22:15 PM
Cool thanks are there a few on there? Looking forward to seeing your new ones, new pics have had a few double page spreads in the broadsheets recently, which is great xx

Aiden Shaw> TM
There's two of yours.X

Aiden Shaw> TM
Miss getting really famous lady so you are!

TM > Aiden Shaw
Ha! No I'm not... But I'm so into my work it's mental. I don't want to do anything else xx

Aiden Shaw> TM
Jus the way it shud B

TM > Aiden Shaw
Look forward to seeing you & creating xxx

Aiden Shaw> TM
Yes

TM > Aiden Shaw
I'm putting a comment on the tartan one now with the mag link your willy is blotted out on the nude pic next to it.

Aiden Shaw> TM
Thanks. I don't want facebook to delete my profile again. X

TM > Aiden Shaw
It's on a link aswell so should be ok xx

Aiden Shaw> TM
Does that mean porn links are allowed?

TM > Aiden Shaw
It's on my website as part of photographic & media section so it goes straight to that not into a real porn link I think? Should I take it off? You aren't showing anything http://www.sanderswood.com/photography/

Aiden Shaw> TM
No. I want to link to a porn piece I put on twitter. Love it

TM > Aiden Shaw
Cool I'll re tweet it now

Aiden Shaw> TM
X

Aiden Shaw> TM
Watch it. Let me know what you think of my work. X

Aiden Shaw> TM
X

TM > Aiden Shaw
Ok I will do. Is it there now?

Aiden Shaw> TM
Yes. 2 tweets ago.

TM > Aiden Shaw
Good stuff... Like the way that is shot. As a woman I should get the erotic fix of 2 men but don't. You are getting the female phwoar! On my facebook profile page xx

TM > Aiden Shaw
It's the blue one in the footy socks that's getting the thumbs up!

Aiden Shaw> TM
X

'not sure; it was somewhere between '92 and '96.'

I asked him about *Sex and The City* and if there were any real life merges.

'I write about the sex I have in the cities.'

'Do you see yourself like any of the characters?'

'No.'

When I mentioned unprotected sex within the porn film industry, he quickly retorts, 'I have NEVER done unprotected sex in the gay porn industry EVER. Back in the day they were always really strict about it, unlike the straight porn industry. Of course things have changed now, with the emergence of bareback movies, but I haven't done any of them.'

The conversation moved on to the gay porn industry and he begins to tell me about Chuck Holmes of Falcon Studios, who left the business to a board of trustees ensuring all profits from the company went to charity after he died.

I asked him how he reacted when he was told he was HIV Positive.

'I laughed – I guess I'd been expecting it. Perhaps it was nervous laughter but I can't be certain. Maybe it was the gravity of the voice with which the nurse used to tell me. Alternatively it might have been a relief, knowing you'll have to protect yourself by wearing condoms for the rest of your life. It's like you're being sentenced. It's kind of depressing.

'What's the medication like?

'Different colours and shapes. They keep me alive. I'm guessing they're hard on the body, but not as hard as AIDS!'

'If you were to have unprotected sex now, whilst on the medication would the HIV virus be more difficult to transfer?'

'To put it simply, the med makes you less infectious.'

He told me a story about bug chasers and gift givers – a phenomenon which of late has been becoming more prevalent in the USA. I later researched this and found an article by Daniel Hill: 'In private sex clubs across the U.S. men gather to participate in what is called Russian Roulette. Ten men are invited, nine are HIV negative, and one is HIV positive. The men have agreed not to speak of AIDS or HIV. They participate in as many unsafe sexual encounters with each other as possible, thus increasing their chances to receive "the bug". These men are known as Bug Chasers.' He had written this for Alternatives Magazine in 2000. Of course it is not confined to sex parties – people also meet one-on-one in pursuit of this activity. I started firing more questions at Aiden who said that he really didn't know too much about it. He pointed out that the practice may have come about because HIV is a more manageable disease now and not life-threatening anymore.

The conversation wove its way into my early morning flight. The country I was heading to held another extreme story about HIV/AIDS. For Haiti, the history of HIV/AIDS represented stigma, discrimination, and racism. For a period it was referred to as the "4H Disease", affecting homosexuals, heroin addicts, hemophiliacs, and Haitians. The stigma that this put on the country was catastrophic, not only did it decimate the country's tourist industry, but the economic, social and psychological implications of it were vast. Three years later the US Centers for Disease Control dropped the Haitian association admitting that Haitians shared the same risk factors as any other groups. It was all too late as HIV and Haiti were inextricably linked in the world's mind and the country's economy has never recovered.

We decided to order desert. For me, it had to be the Red Velvet Layer Cake for its name alone. We started talking about Aiden's tour again and remembering I'm in Carrie Bradshaw guise – reporting on *Sex and the City* – I ask him if there were any funny incidents and/or nice men on his tour. He became embroiled in his thoughts as he related another tour highlight:

'A Jewish guy got me to sign a book for him in Atlanta. He was gorgeous so I suggested we get together afterwards and he tells me that we had done it before and had an amazing time in 1992 when I had first started doing porn. After meeting in a sauna, really liking each other, we went home together. I was pleased that my taste hadn't changed over that period in time. I've started seeing him and he's coming over to London to see me. The sex though is much better now because I wasn't high – sex is so much better sober – why did no-one ever tell me!' He continued to reagle more tales.

We talked more about *Sex and the City*, both in his life, the TV program and film and I ask him if he had to be one of the female characters, which one would he be? He answered, 'None! I couldn't imagine myself as a woman.'

So I asked him if he were the straight Aidan Shaw which character he would want to be with and he quickly replied, 'Carrie Bradshaw!' with a wink – I laughed and blushed.

I concluded my evening as Carrie Bradshaw on a night out with Aiden Shaw, and returned to my hotel. The alarm clock blared out along with my early morning alarm call from the hotel reception desk. It was 6 am and I needed to leave within half an hour. As I skipped breakfast I thought about last night's dream meal, then of my double page spread photo of Aiden Shaw in the current Unzipped magazine, planning how I could pick up a few copies from the newsagents. Then I thought, 'Um, No!' I can't go into the airport newsagent, travelling as a lone woman and ask for a few gay porn magazines; they could well be hardcore porn for all I know, having never seen a copy of Unzipped magazine. It would be more embarrassing if I got stopped and searched at customs with male gay paraphernalia in my possession. I successfully board the 9.30 am departure from New York to Haiti, unsure of what will be in store for me there in the coming weeks and excited by the unknown adventure. I was looking forward to setting my two art projects with the local community into motion for the Ghetto Biennale ; seeing downtown Port-au-Prince and the Grand Rue artists in their home environment, along with meeting the many other artists, writers and academics taking part in the first Ghetto Biennale in Haiti.

09-02-07 23:08:44 curry or what tres belle tu as mon belle vache \ 14-02-07 14:35:18 I got the paper, great article! The bra's look fab. You should see my naturally hairy belly!it rocks \ 14-02-07 15:14:19 Just bought the wife a new bag and belt for valentines day.The hoover works a treat now. \ 16-02-07 00:11:02 mmm ... Thought u didnt do affection? :-@ x \ 16-02-07 10:53:30 Bath is getting cold! \ 25-02-07 13:19:40 I'm going to buy some very long socks and join the Freemasons. \ 26-02-07 19:39:45 Not sure if you're back yet honey. Just letting you know I won't be around this weekend. Let me know if you want the flat, hx. \ 05-03-07 20:17:09 I believe that they tried to get her into re- hab but she repeated emphatically "No! No! No! \ 06-03-07 16:37:47 The show looks great! You are displayed excellently and I'm very well hung. \ 07-03-07 19:06:11 Just got in + read yr Indy feature - fab :-) maybe you could've worn higher heels + brandished a whip for yr press shot? I'm thinking tits out Amazonia too... \ 09-03-07 13:12:01 Sorry I've gone a bit awol again. \ 09-03-07 13:22:02 Can you come to my afternoon tea party for 'the oldest people in the world' ? It is on wednesday 14th 2pm at channel 4! Please let me know today if poss x \ 27-02-07 23:15:06 By the way, I've just pulled a hair out of my left nostril over an inch long! \ 09-03-07 20:54:08 Good evening Madam. Did you by any chance get the two mobile phones back? Dropped mine last night and it has been 'misbehaving' all day! I can definitley get them unlocked by the china man so I'll get one of them back to you! \ 10-03-07 21:34:58 Loads of shit gone off in Shadwell, heard anything? \ 14-03-07 10:07:03 reel news 5 out now - uprising in oaxaca, cuts in nhs, esol and voluntary sector, plus full video of g8 protests in italy 2001 - genoua libera! Text me 4 copy \ 18-03-07 09:53:04 Riverside studios . Hammersmith. 7 for 7.15pm. U Plus 1 on guestlist. Love mark

32 New York to Haiti

21-03-07 08:08:37 Morning shadwell, what is your postcode is it? \ 25-03-07 00:28:34 Nelly turd farto! X \ 04-04-07 10:21:18 I been without heating or water for over 10 days had to go for a swim every day just to get clean \ 09-04-07 15:38:24 Up a mountain en france my little welsh plum...back saturday.x \ 14-04-07 23:00:07 Thanks for using TrainTracker Call back on 08712004950 anytime for a fast update or new enquiry Pls add to your phonebook now! nationalrail.co.uk/traintracker \ 15-04-07 13:19:32 No u have an old ass! Cross stitch me don't bitch me. \ 15-04-07 15:05:52 I got a text from Brian. Something bad seems to be happening at Parliament square. Can anyone find out. My phones acting up. \ 17-04-07 12:12:28 Still in bed. Looks like the only protest I'll be doing this weekend is lennon style. Sorry. \ 26-04-07 16:31:00 Female 101 years old seeks cabbage. \ 25-03-07 22:01:22 I just saw ad on tv 4 fuck off i'm hairy. \ 28-03-07 11:50:32 Hey neighbour fancy going for that drink sometime? Hope spain was fun sdx (dave's mate) \ 29-03-07 09:46:30 Im in le louvre. My feet ache. \ 29-03-07 22:16:28 A flyer... POWER...missiles, miners & monarchy fell from a book yestaday. 2day Iturned R4 on &MarkT was talkin bout u. 2nite I put tv on and there u wur wiv d'hairy women. A trinity of Moberly. I'm standin in local election in Accrington as THE ONLY GREEN candidate! 1loVe 2 ya sista x x x Kerry \ 30-03-07 17:05:19 I quite fancy the girl with the beard. Is that wrong? \ 30-04-07 20:08:02 Hey – good 2 c u ... Quick wash question – where do i put powder 4 quick wash??? Help! Ho ho ho x \ 03-05-07 11:10:45 Fat, bald, drunk, suit wearing cunt bumps into me on his way into a strip club. Surely, on morals alone, i have right of way? Xmark \ 04-05-07 11:46:28 I loved your subversive activity and that one of my staff got involved! I promise I'll mail him today x oh and congrats on your fab new company.

When I boarded the plane for Haiti, my flight companion, in the front exit seat next to me, was a light-skinned Asian man. I turned around noticing the many bags being brought on board and squeezed past people sat either sides of the aisle. Each bag looked like it was going to pop like a blown-up empty crisp packet, only these bags looked full and heavy. I didn't initially notice as the white cabin crew scurried back and forth that there were few white passengers seated on board. I turned again and there was only one. I took another look around and became completely focussed on the number of people that were wearing at least three hats, one on top of each other. My gaze settled on a rotund woman with a silk-like complexion, her third, topmost hat was a trilby with a magnificent pheasant plume fanning out from the brim. I wondered why three hats per person as another bag tried to squeeze it's way past me and I felt like this time I was going to pop. I settled myself in, took out my writing and started on it even before the plane took off, before the slightest hint of boredom could creep up on me. And I look forward to the four and a half hours of flight time I have set myself aside to write. The light-skinned Asian man starts talking to me, he tells me he is from Kansas and a lecturer in IT business modules. However he tells me that his role began today, as it had before on subsequent visits to Haiti as a missionary, selling finance to remote villages there. His selling of finance in a poor country coupled with the role of missionary left me with a lingering sourness. I put my pen to paper again and the new acquaintance at my side read over and over the same article in the New York Post newspaper. He somehow seemed anything but academic. I was soon grilled as to why I was going to Haiti:

'What POSSIBLE reason could be taking you there?'

Followed by each response,

'Do you know what it's like and you're travelling alone.'

I explain, 'Yes I am aware of the country, although I have never travelled there before I have friends from there who are from Port-au-Prince and they live in the Grand Rue area.'

He chats off and on still reading the same New York Post article over and over. The only other white passenger, who is seated on the other side of the plane, comes over several times throughout the journey, gives my fellow passenger a printout each time and says on every occasion with the same laugh, 'have you seen this one'. Hands it to the man and goes back to his seat, all strikingly odd. My thoughts are distracted from my writing, as I cannot reconcile my acquaintance's dual roles of financial salesman and missionary, a combination which conjures up powerful images of control and exploitation.

I continue with my writing as we come towards the end of the plane journey when the conversation picks up. Again he says how the villages in the more rural areas of Haiti are very sad, children starving, going without food for days. Part of the staple diet for children he tells me are dirt cookies, literally made out of dirt and a small percentage of food, he tells me how it fills the stomach, this would not be the only time I heard this. He continues to comment on the problems and trouble there, interjecting with how travelling alone I need to be very aware and careful, as Haiti is a very dangerous place and full of kidnappings. He mentions the kidnappings once more telling me that they had died down in the last couple of years but that I did need to be on my guard as a woman on my own. He seemed very concerned that someone was meeting me at the airport and warns me that I must not make eye contact with anyone... and so he went on.

'Always look like you know where you are going and what you are doing', he says.

I do not want to heed this man's words, as I had been feeling comfortable and confident and full of strength as I embarked on this journey. He was starting to make me feel unsure and nervous of myself. Then the air hostess leaned over my shoulder and said in a broad American accent with an emphasis on the words 'why' and 'what':

'WHY are you going to Haiti?'

'WHAT!? are you going THERE for?'

I explained once more, proudly, that I was going to a ghetto in downtown Port-au-Prince as I had been invited to partake in an arts biennale there. I was however mortified and extremely embarrassed as she was saying this in her loud white American accent, extremely scathing of Haiti whilst being surrounded by Haitians. It was racist and embarrassing. As she moved up the aeroplane aisle a fight almost erupted in the seat behind me. Voices were raised but as I don't speak Creole or French I was oblivious to its content, although I hoped it hadn't been sparked by the racist air stewardess. The gentleman causing much of the fracas had asked is there any duty free to be sold on board whereupon he was promptly told that he should have purchased it at the airport and that he should have known to do so by now. The man in the next seat to me had made me feel very uneasy and I tried to dismiss all his warning words coming as they had from a man claiming to be a missionary selling finance to the poorest people of a nation. Make sure you are being met, he had overstated. Don't make eye contact, stand your ground.

We landed in Haiti and made our way to customs and baggage reclaim. I was sure that my suitcases would not be there, which usually happens to me when I

04-05-07 16:40:20 Thankyou, 25 eh! hope u all well. Will see j n i at end of the month. Me'n lisa off away campin this weekend. Take care loue Ben x \ 08-05-07 23:20:58 R u go'n jo strummer prem 2mor-we r.at hm in bed nw.listen ,wha eva U did-was cool,u got off u arse flew there 2 do sum gud an au sum fun- so fuk um alll.u go gal!xx \ 13-05-07 11:45:56 No problem. I woke up in my suit. Take care. \ 13-05-07 15:45:47 Hola missy...ope you good. do feel free to join mygoodself and mark for a drink at big chill house.near scala.5pm onwards. barney x \ 14-05-07 16:41:01 wel cool ! - and wen the cherry blossom blew past my window i remembered x \ 15-05-07 15:46:56 Hi how u doin? Hau u got any alabama 3 footage on film or old promo stuff we can hau 4 website? Or do u know the whereabouts of any? Wantd asap! X \ 05-07-07 18:54:29 What time big bro mouth?just emailed u-did u c?now behave yourselves on tele!and get me russel's number...x \ 05-07-07 22:12:08 Tracy, what the eck are you doing on big brother's little brother?! I saw you sat next to older guy who left the house and did a double take \ 10-07-07 11:49:41 Projection going on two facing walls in the heart of it all. Outside. BIG. Will look great. Saturday night highlight. Festival opens friday. GET PRESSING! \ 10-07-07 15:25:17 Gilbert or george just walked past our house \ 12-07-07 04:02:01 Wooo! In china! Missin u already x \ 12-07-07 19:09:33 I made a mistake. It was his brother Barry Ryan that had the hit with Eloise. Paul wrote it. \ 13-07-07 05:07:00 Im on da great wall surrounded by cicadas n kumquat trees. Forbidden city was awesum n so was teneman sq. luv u n miss u lots. X \ 13-07-07 23:16:59 The vomit encrusted half eaten orange that I have just found on the kerb by the Strand, London. W.c.2. Has proven itself to be nothing short of a very tasty morsel indeed! \ 16-07-07 07:39:02 I never truly believed that trains discharged their wc's straight onto the track. However, I have just seen what can only be described as a 'ginger forearm' reclining majestic betwixt the sleepers at Eastbourne... \ 23-07-07 18:07:24 I think that might have been George Haig, The acid bath murderer. Can I see photos some time?? \ 26-07-07 08:03:08 Hi. Sorry was bit pissed last night. Was horrible about paul getting upset. Hadn been with him for weeks. Told him was seeing someone else and he really angry. Aggresive too. Kept all threatening texts in case. Living out of car but i think in long run this may be worth it. We will see. Thanks for caring. Loveux

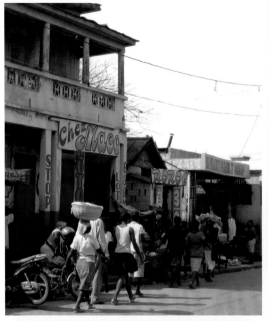

travel particularly in Siberia and Moscow. A Haitian band welcomed the passengers coming into Haiti.

I walked to passport control and the immigration officer spoke to me in Creole. Sorry, I speak no Creole, I told him. 'French?' he asked. 'No', I said. Then he asked, 'what French do you know?' I told him, 'voici le chat, le chat est dans le jardin'. He laughed, stamped me through, and wished me a happy time in Haiti. Heavily ladened with two suitcases and a full rucksack, I tried to leave the airport. I couldn't easily identify the exit. I asked a woman who said:

'Sprecken die Deutsch.'

I gave up.

I eventually found the exit. The heat was incredible. Rows of men held placards and pieces of paper in their hands. I looked for the familiar face of a white woman amongst the black males. I was suffering in my high waisted spandex leggings, knee boots and leather jacket that had protected me from the invasive cold of the winter in London and New York. I couldn't see anyone I knew.

A guy called me with a cream uni-formed shirt and shiny badge. He said that he was a taxi man and did I want his service. I explained to him that I didn't and that someone would be meeting me. I had to think on my feet, and I was standing out like a sore thumb (even more so) because I was in thick leather with too much luggage, streaming with sweat. Ten minutes eas-ily went by. The man with the badges came over to me again.

'I am a taxi. Where are you going?'

'The Oloffson, how much?'

'$30', he told me which I knew was excessive for the journey as I had been told prior to this it would be $25 maxi-mum. He took my bags and trundled them off to his car. We were going down an alleyway of cars to the boot of his vehicle. A uniformed official rushed over and grabbed the bags, shouting. Heavy-heated words were exchanged as he pulled me towards another vehicle. Men stood around the trees in the back-ground, shouting and moving closer towards me. The first man with the badges was yelling, 'you owe me as you promised me my cab'. The uniformed official was shouting and getting very aggressive, when a man appeared with a sheet of crumpled paper saying 'Tracey Moberly'. I finally felt safe as he put the bags into his car, bundled me in and locked the doors, directed by the uniformed official. I tipped the official and my journey into Haiti began. As we drove into Port-au-Prince we came to a huge flagpole but it was not flying the flag that was reminis-cent of Haiti's past and future. We drove past barrows carrying sugar cane on nearly every corner. Rubbish was piled high on street intersections. Drains leaked into the streets; manholes and sewers were left uncovered. A sweet smell like bread and cake mixture was perforated by the acrid, sharp aroma of sewage. This came and went, seemingly when in the direct rays of the sun. There were people everywhere, all active, all busy, all doing something, all going somewhere. I had

arrived in Haiti and I was happy as I started to absorb the abundance of graffiti everywhere, much of which said 'vote' followed by words in Creole.

We arrived at the Oloffson Hotel where I met people taking part in the Biennale. The hotel is famed as the real-life inspiration for the fictional Trianon in Graham Greene's 1966 novel *The Comedians,* and the place where Jacqueline Kennedy Onassis and Mick Jagger were once regular guests. This old ramshackle piece of colonial architecture had been declared part of the Red Zone no-go area by the UN (considered too dangerous for UN and diplomatic staff to enter without a security escort). I went to meet the owner by the reception: Richard A. Morse, who formed and fronts a band called RAM. Famed for their protest music during the Raoul Cédras military dictatorship (1991-1994), they performed in the hotel every Thursday night. That particular Thursday was no exception, kicking off (musically) after UN red-zone curfew time. I was in the company of artists, military, paramilitary attachés, former Tonton Macoutes and many local people. I was then taken to my very basic room with a leaking toilet. Luscious plants and trees obscured the scenic views out across Haiti. I would be sharing with an acquaintance from London called John Cussans.

It was time to meet Eugene and Celeur. Guyodo, the third of the Haitian artists I'd met in London, was not taking part in the Ghetto Biennale . We had been invited to what was termed a 'bourgeois exhibition' in one of the bigger galleries in Port-au-Prince. I became intoxicated by this new, strange country. Lots of men on motorbikes were nearby the hustle and bustle of street vendors. Aromatic food smells curdled in the heat. We ended up at the wrong gallery and got another cab to a large triangular monument of Jean-Bertrand Aristide, the Haitian politician and former priest who served as Haiti's first democratically-elected president. I was told that the statue was built for him, by him, to commemorate him. We finally made it to the correct gallery now and as we made our way into the entrance, we were met by Eugene, Celeur, and I was introduced to Chebby and Louco, two more Grand Rue artists. There were a collection of young Haitian artists dressed in white having their photos taken. I began taking photos of the exhibition. The queues for cold beers near the entrance were long and I thought I would rather not drink and have to go to the toilet than go to the toilet on the street. We sampled some gorgeous spicy canapés. We sat down outside taking in the full heat of the lovely night and I was introduced to people such as Saradia, Eugene's daughter and her friend Camesuze. We moved on from the gallery to a local bar through an expansive open park space. I was commenting that the testosterone-fuelled aroma of urine was at its most pungent, just as a man proceeded to wee in front of me on a tree; everyone laughed, as I thought it must have been the heat making it smell more. I walked over a sharp object, it lodged in my flip-flop and I realised how impractically I'd packed, with no proper footwear. Louco immediately took my flip-flop and got the object out for me, and then we proceeded through another graffiti-heavy area. Eugene led us to a street bar past

water streams from open drains where sewage spilled directly over the roads. He spoke to the bar owner as they prepared a table and more seats. We checked that there was a toilet we could use – there was and I felt happy to sit drinking in that knowledge. I was looking out onto the street, sat next to Celeur, who I obviously knew from London but I kept forgetting I cannot speak Creole or French and that he speaks no English. This didn't stop me chattering on to him as I felt so comfortable in the bar. I explained this to Eugene who told Celeur.

We all drank and talked for hours, watching the business of the street and the world go by. There seemed to be very few women out. The night was great and we left with Louco for the hotel, to see Marcia perform followed by RAM. Marcia was the mother of one of the Biennale artists. I would get on fabulously with her for the duration of the stay, as would Bill Drummond and John Hirst who would both be arriving later in the week.

26-07-07 19:22:48 Should scare them out of town though. A close up of your gnashers that fucking big. Wooh! Thank christ it's not in smell o vision. \ 28-07-07 12:06:14 I was the bucking bronco queen last night. I suspect footage will be on youtube iminently! \ 28-07-07 07:34:15 jules just dropped his iPod down a drain in central kunming... how surreal x \ 30-07-07 16:42:50 cn u plz do ur very best to bring it to public atenshun dat jk rowling implies that the holocaust nva happened n that it was all wizards killing muggles x \ 03-08-07 15:12:42 This is it, tonights the night... The last ECFOP gig ever. On stage 10.45pm @333 Old Street, opp Shoreditch Town Hall. Man Like Me r also playin. Txt me back for half price entry (if u havent already,) or meet in Foundry about 10pm and grab a flyer from me (or from myspace/ecfop) ! SPOON x \ 06-08-07 16:44:25 Just done Pete D. He said yes 2 everything. I passed your number on 2 him. Said he wants 2seeu? \ 07-08-07 15:54:23 Roadhouse Katie I want Johnny Depp to come into my club. I am very jealous. Did you speak with him much? \ 14-08-07 01:13:55 Is there any chance of getting an extra technics turntable for the siberia gig? Happy to lose one cd-j for it... \ 17-08-07 16:40:14 with friend pippa. You did protest for her anti only getting goats cheese as veg option! J x \ 19-08-07 20:08:01 In france two weeks ago in south lovely. How was paris? Yes mcdemo, iv gt photo of u and Mark holding sign saying Time is Art. Just driving back from devon. Been surfing. Xx \ 25-08-07 00:19:29 Wil there b problems with playin records with drug references ? How closely wil the kgb b listening ? \ 25-08-07 13:06:20 Generally speaking when I go into my local charity shop I don't expect to see a picture of YOU! \ 25-08-07 21:35:01 Hey ma. Can u tape reading highlights 2nite? Might be on, got right 2 front for arcade fire x \ 26-08-07 15:33:12 i had to get a portrait of him without identifyin him cos of the case..not easy. Enjoy siberia! X \ 28-08-07 10:42:26 Hello, we're planning to have a farewell drinking do for Brian & Chizuru this Sat the 1st early/late afternoon at the Foundry as it's their last weekend in the UK before they move to the States. Please join us if you're available! Mark&Junkoxx \ 02-09-07 20:39:31 Its Cock hungry cum slut! \ 06-09-07 18:07:05 I can sympathise with the italians over the death of Pavarotti. I know what its like to lose a tenner!

33 Vodou Flags, Puffer Fish and Mr. Nice

08-09-07 14:27:57 Hi sorry for delayed response . . Hope siberia's treating you well. . Would love to see you mon pm and tues day are good for me in Moscow. Travel safely see you soon. X laura \ 14-09-07 21:24:14 Where the fuck are you know \ 14-09-07 22:03:29 Hi Tracey. Got your message. Glad to hear we're big in Siberia! Fine for the other screening too. I'm putting a copy of I'm A Boy Anorexic in the post. Speak soon. Alicia x \ 23-09-07 22:17:55 At end of show hang about for 5 mins then go to upstairs bar. No pass needed. See you there? Mark \ 24-09-07 23:46:01 You made me laugh – mother earth be fucked! Ha! Am going to set date for party soon to focus me to get house sorted so can you give me some dates asap. Cx \ 26-09-07 21:02:16 Just got out the hospital. All taken longer the i imagined. Did not in to the toilet there incase of the appearance of any unwanted heads. \ 01-10-07 08:54:23 Hi Tracey. Faisal is good. Couldn't get to London unfortunately – just about to start a full on uk tour. Love to c u soon. X X X H \ 02-10-07 16:03:35 Tracey, Can you please find a nice photo of me smiling or looking happy please my love.xxx.... \ 02-10-07 19:36:51 prebendary of eald street \ 04-10-07 09:31:30 Good luck with interview I'm on the bill Thats great about the straws Whats happening with the bullets? X \ 05-10-07 20:46:47 Yes east coast new york cant wait to see you what a laugh you always were a crazy bird Ok you were my herd more important we were strangers sharing a journey i will never forget that it is special thanks baby x \ 06-10-07 14:27:22 What time are the band onstage and where? X Mark \ 08-10-07 18:33:02 Got txt – all ok ! BOHJ was great, really busy n bands were wicked. Johnny sends his love x \ 11-10-07 23:54:03 It was great to be with you this evening. But whatever there were no foxes between me getting off the bus and getting home. Shame. X \ 19-10-07 15:13:04 i just interviewed shilpa shetty! \ 20-10-07 23:00:05 36inch black cock, covered in warm belgian chocolate...1inch erect nipples pierced with gold nipple rings topped with whipped cream....Clean Shaven minge framed by an open crotched leather thong...Moist salty clit smothered in Blackberry jam.....This is not ordinary porn... this is M & S porn!! \ 20-10-07 23:13:06 Well, I worked that pole this morning. I was glamorous and glittery tonight. And now I've left them to it... Hope you've had a good one, hx

Sex fills me with germs
Drugs fill me with doubt
Rock'n'Roll fills me with hope
Aiden Shaw

Mache konyen anvayim ak java
Dwòg fèm pèdi bonnaj mwen
Miizik plen kèm ak lespwa
– Creole translation

I set out for my first visit to Eugene, Celeur and the other artists' Grand Rue homes in downtown Port-au-Prince. I was greeted by Louco, whose sculptures adorned an entrance way. Louco had made a statue of one of the Vodou spirits dressed in a purple cloak with a phallus protruding outward from it. I knew it was one of the vodou families but was initially sidetracked by the phallus

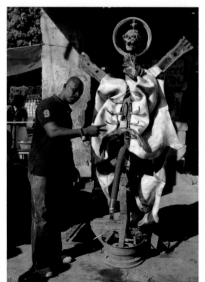

and its size on the street in the broad light of day and I couldn't remember which vodou spirit, god or family it was part of. Louco was very proud of it and stood with his arm locked firmly around its shoulders like it was a very dear friend, as he gestured to be photographed with him, which I duly did. My eyes gravitated to the horizon of the rectangular stone slab roof where children's faces were juxtaposed next to fleshless human skulls woven into metal body frames. Louco beckoned me to watch out for the coverless sewer hole as we swerved past it and into the walkway of the accommodation area. My feet clawed my flip-flops as the surface became a dust track with discarded sections of concrete, rubble and small stones touching base with the underside of the thin soles. We skirted past piles of neatly stacked

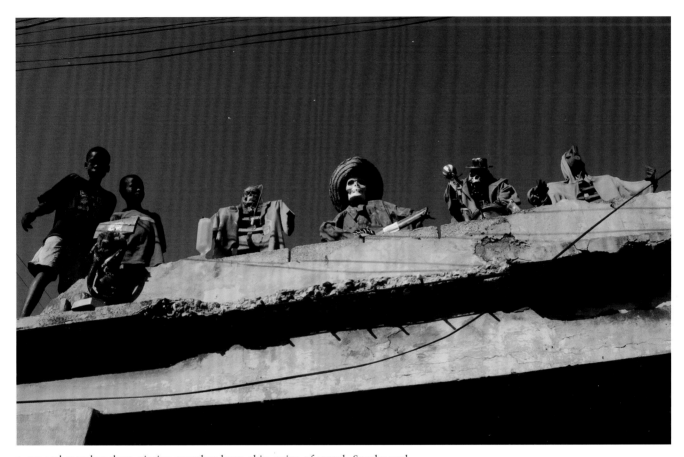

tyres and metalworkers piecing together long, thin strips of metal. Sparks and flames brushed past groups that were sat talking to the workers wearing no protective gloves or goggles. As I was directed up to Eugene's courtyard where the Grand Rue artists amassed I came to a sudden halt. Standing eight metres high directly in front of me I was greeted by a sculpture of the Vodou god Papa Legba; the same spirit that had greeted me with Louco, phased now by the even more gigantic phallus that protruded from the sculpture's groin. This must have been at least three quarters of a metre long. In Vodou tradition, Legba is a trickster, warrior, and messenger of destiny. There were already a number of reasons I liked Legba and none more than for the fact that fate could be deceived through this God. I already felt a close bond forming. Representing strife and change, Legba opens up the channel for all of the other Vodou deities to reach humans. Legba is always placed at the entrance to temples and the front of houses. Individuals also have their own personal Legba, which help them over-come the difficulties they endure in life. I wished this one was mine; I was more than attracted to it as it stood over eight metres high sporting its formidable

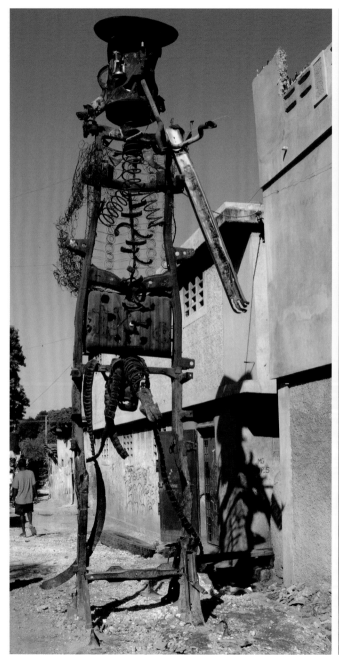

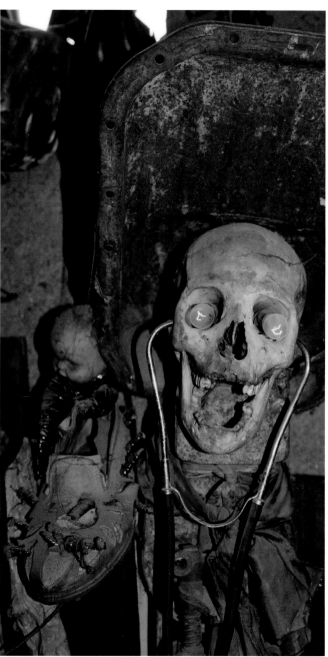

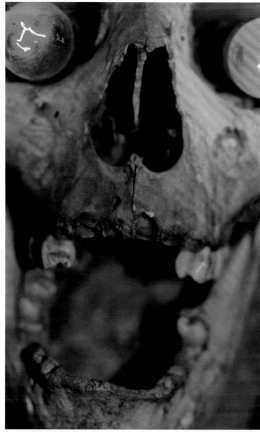

phallus. It was constructed from a car chassis, part of an old truck, a bed frame and scrap metal.

We weaved our way a short distance to sculptor Andre Eugene's studio which was full of Haitian Vodou art. My eyes scanned the rows of sculptures of all shapes and sizes, and I became drawn to the use of human skulls in many of the artworks of the Vodou spirits. I couldn't help but make a stark comparison to Damien Hirst's *For the Love of God* – a platinum cast of a human skull encrusted with diamonds, on sale for £50m. I was leaning and subconsciously stroking the sculpture next to me when I realised it was the top part of a human skull my fingers are interacting with. I wrenched my arm away, but not in time before Eugene noticed my horror at what I had been touching. He laughed and said, 'This man in his lifetime couldn't get a visa to leave Haiti, now he travels the world as art'. I wondered if he had been a good friend of his.

Digi Cell, the mobile phone company who operate in Haiti, had given me a couple of cheap mobile phones with cameras and I had brought others with me from the UK. I handed them out to people taking part in the project. I was

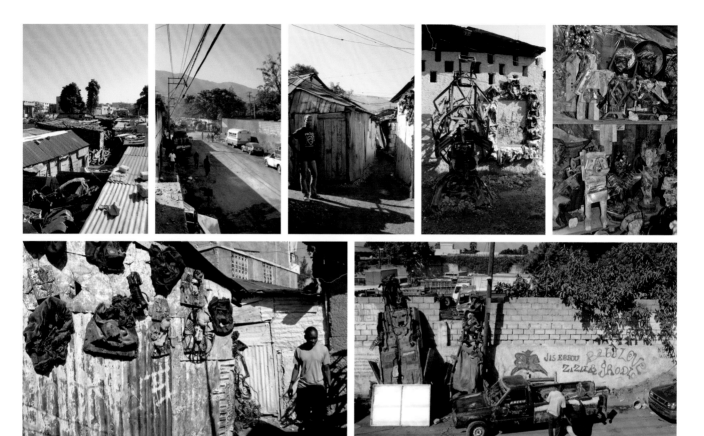

then taken on a tour of the area, guided past working craftsmen and a printing workshop into Celeur's studio which was full of his sculptures. Space was also given in his studio to younger members of the Grand Rue's artistic community. I spent some time there before the light diminished and total blackout gripped the neighbourhood.

The following morning I set off with Leah and Ebony (a Jamaican Biennale artist) to the Vodou flagmakers in Bel Air. Ebony's work dealt with gangster iconography and Hip-Hop in Jamaica, further delving into the gender of iconic figures within our culture. Her images dressed and adorned male subjects in nuns' regalia and lipstick: each was assigned a Vodou God.

I was trying to evaluate what would be right for me, how I could work with the flagmakers and hold onto every principle I felt. I really wanted to work with this traditional craft, that was being practised in Haiti. There were several of my texts for the *Text-Me-Up-Sex Drugs & Rock'n'Roll* exhibition that I wanted to work with in this medium. I knew I could incorporate images formed from my first initial impressions and fresh visual documentation of Haiti: there were

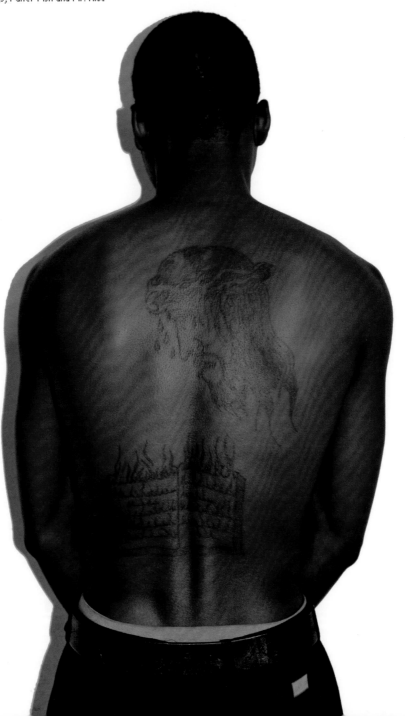

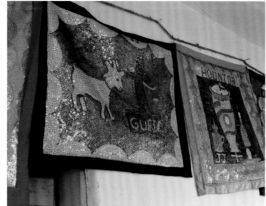
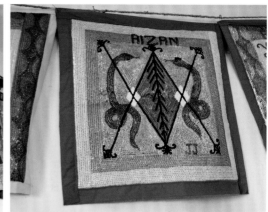

local customs and quirks that interrelated with themes of the text messages I was working with for the exhibition. Aiden Shaw's HIV text was highly significant, Legba reminded me of Aiden Shaw and the body part he is notorious for. Howard Marks and Mark Thomas' texts would work well in this artistic medium also. Cameron, one of the Biennale artists, said to me 'mobile phones are effectively satellite dishes for the Vodou world.' This short statement kept dancing in my thoughts.

As we entered the flagmakers' workshop, the whole space twinkled and sparkled with the vast array of coloured sequins that make up the medium of the Vodou flags which all hung around the bright workshop. A bare-chested flagmaker revealed a large tattoo on his back depicting Christ's weeping face with a garland of thorns placed on his head which was hung down, with blood dripping onto a burning Bible, worked in blue ink. It was one of the strongest and most interesting tattoos I have seen regarding the subject matter. After a short discussion Leah and I left to enter the Vodou temple next door. The walls were missing at the front and side as we walked off the street and into a thin, narrow room that

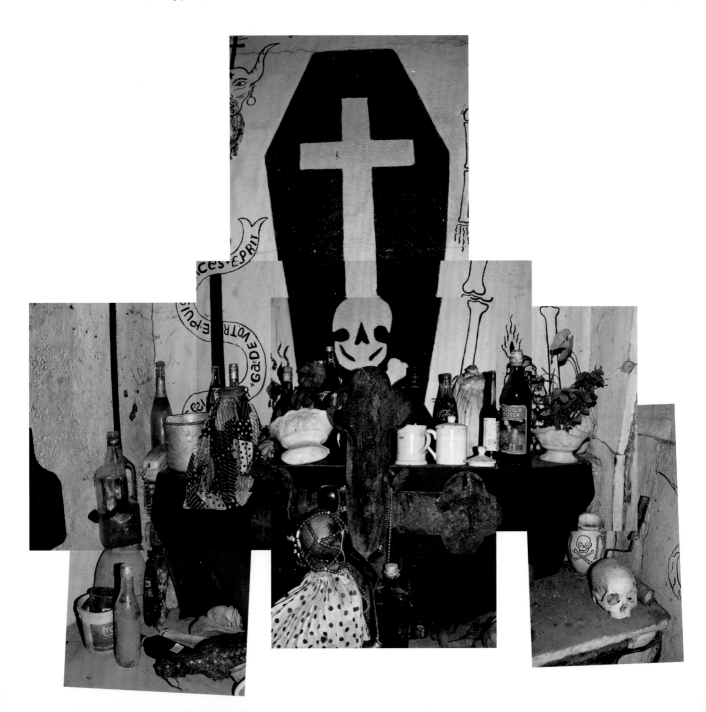

smelled of illness and decay. There was blue toilet roll on a metal hospital bed. A man with a wasting physique, frail with prominent knee joints protuding on his legs stood beside it. Leah spoke to him and introduced me to Silver Joseph. I said a warm hello and went to shake his hand, humble to be in his home, his room. I kept thinking of my father who died fourteen months ago in a hospital in the Welsh Valleys. He had been in a long room, slightly wider than that one, but illness and death seemed the same the world over. Silver Joseph ignored our introduction and ignored me. Leah explained that he was once a proud man and the Vodou priest, but his illness had taken away his pride and this is why he ignored me. I was told to leave an offering at the temple and at each of the altars. The atmosphere felt very tense. We went into the first room as the talk of an offering on the altar was being discussed. I was unsure what to expect, then suddenly the door fell heavily on my shoulder and in quick succession hit a bike that is leant against a wall before crashing to the floor. The bike went hurtling, heading for the direction of my groin. I successfully managed to stop it before it did any permanent damage to the lower part of my body. My shoulder ached terribly, but I tried to push the pain out as I learned that a person must always knock twice when entering a Vodou altar. I had learned my lesson and would always do this in the future.

My first sighting in the temple was a skull-and-crossbones painted on a black background. Next to this was Christ on a crucifix with a glowing heart, painted on the wall. There was a pot depicting Baron Samdi, leader of the spirits of the dead, next to a blue paint-roller and a skull. As I looked around I focused on an old metal crucifix on the floor, draped in beads with maracas hanging from it. Mugs, cups and pots with lids on; beer, rum and Cointreau and many Coca-Cola bottles; plastic flowers in an assortment of china pots and vases. There was a telephone in the corner almost out of sight and covered with various artefacts.

When we left the altar, I deposited a cash offering and we were guided down

an alleyway into the large assembly room of the temple. A woman who looked tired or unwell was hunched over two giant bowls washing clothes in soapy water. I was directed to a pole in the middle called a 'Poteau-mitan', which the Lwa used to come to earth. The Lwa are spirits and each spirit can be likened to a word in a language. A solitary Lwa has a narrow meaning: the spirit's importance is gained with others as a grouping of families who work to complement or oppose each other, together forming the Vodou pantheon. The Lwa are depicted as supernatural beings that enter the human body. They are thought to be present in all realms of nature such as in the streams, trees, mountains, air, water and fire. The Lwa of Vodou establish a web of links between human activities such as war, agriculture, relationships and various phenomena of the natural world. A structure of time and space is created and they take control of an individual's life, from birth to death. By listening carefully to their messages, the faithful can learn and realise their fates. The spirits provide a way of classifying the different provinces of the universe as well as of life in society. Order and chaos, life and death, good

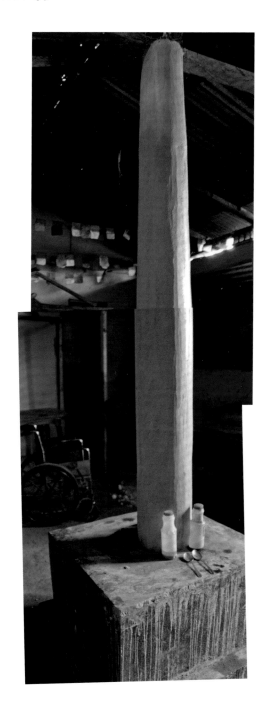

24-10-07 18:44 Yes – sounds good, it wont b all blokes tho will it? \ 25-10-07 16:28 ah mate thank you. catch up very soon love ya loads x yours nervously with wet nail varnish sx \ 29-10-07 11:54 Well mrs.Moberly i would like to meet up. But i am in bury till the 5th nov. I am committed as i have a machine booked to dig the garden. And am working with others. I would like to see you though.You could stay at my mum s if you'd like to. \ 31-10-07 00:14 Livin in crouch end...so so...miss ditch sometimes...how's u ? \ 05-11-07 23:31 I can smell a winkle licker on this train... \ 05-11-07 23:46 That would be bigamy! Or are you a mormon? Mormon Medici! \ 06-11-07 14:40 Dad just died \ 09-11-07 17:52 Can you text me back the photo of an ostritch biting me, i sent you about an hour ago as i no longer have it and i want to show it the others. \ 10-11-07 11:06 Hi tracy – what were those two girls called – they ended up staying here gone to meeting now – so wasted \ 12-11-07 19:24 Today is International Disadvantaged Peoples Day. Please send an encouraging message to a retarded friend, just as I've done. I don't care if you lick windows, interfere with farm animals, or occasionally shit yourself. You hang in there

and evil; they all take on meaning through the Lwa, leaving nothing to strike the faithful as absurd. They all act as links between the visible and invisible, explaining the origins of the world and representing it's hidden side – deep and shadowed, the very essence of life. All the Lwa have a mythical story that is tied to human history. I was hoping that the Mobilography project I had begun at the Grand Rue would illustrate some of the ceremonies of the temples and the Lwa.

The woman showing us around the three rooms and altars searched for the keys to the next room. I stood in front of the Poteau-mitan and directly behind it was a basic wheelchair. Feelings started welling up in me and my emotions

heightened considerably. It was as if spirits of the recently dead were speaking directly to my soul, my head filled with beautiful thoughts of my deceased father. It was like standing on an empty stage with the souls of people and their struggles sliding smoothly down the pole to re-enact scenes of life through a play. As they filed into the room, filling it up beyond its capacity, reducing the oxygen, I struggled for breath. I had not mourned my father's death, as I loved him very much; we had a wonderful relationship, much respect and good memories, so I had no regret for anything to mourn. My father had lived to a good age without illness until the last three and a half months of his life and it was then a relief for him that he was taken away from the pain that encapsulated his body. I'm not religious and I rarely cry, believing in life in the here and now, that we are each the creation of our forefather's genes and memes. But at this point I was so inexplicably overcome with emotion that I couldn't speak and couldn't stop the tears flowing. I was so embarrassed, I tried apologising, but Leah kept telling me it was ok, as the tears started to pour from her eyes. My father would have found this completely bizarre were he still alive, had I regaled him with a tale like this. The woman had reappeared and found the keys to open the second altar, and I still could not stop the tears flowing and the sobs choking my windpipe. This altar was brighter with red, yellow, pink and white satins covering some containers adding an air of mystery as to what lay beneath

sunshine, you're fucking special. \ 18-11-07 05:16 Im tryin 2 sleep. Cough kpin me up. Teeq is a shitarse. X \ 28-11-07 10:04 I know, im hesitating without a vest, cops got shotgun wounds.. \ 30-11-07 15:55 Meeting Lena at indi tues at 1.30. Can't get hold of Andy. Will keep tryin. \ 30-11-07 17:42 Am in country- no signal \ 01-12-07 17:04 With all the sadness and trauma going on in the world at the moment, it is worth reflecting on the death of a very important person, which almost went unnoticed last week. Larry LaPrise, the man that wrote 'The Hokey Kokey' died peacefully at the age of 93 The most traumatic part for his family was getting him in the coffin. They put his left leg in. And then the fucking trouble started. \ 03-12-07 19:20 If amy wino is running around bow in her bra, why the fuckery aint i seen she yet. The only fabulousness in this shitehole and i miss it! \ 05-12-07 18:40 Hi Tracey. Sorry to take so long to answer you, but yes, I am still up for straw portrait. I'm not yet 100% sure yet, but I should be in london overnight next tuesday. Will you be around? X H

them and what purpose they would serve in a Vodou ceremony. There was an abundance of alcoholic spirits arranged neatly at the four-tier altar. It was filled with dolls, crosses, a statue of the biblical Joseph holding a baby Jesus, and a large bunch of red plastic roses which surrounded a magnificent photo of Silver Joseph the Vodou priest in front of his altar wearing a cream suit of military design and matching cream hat with a cigarette drooping sexily from the corner of his mouth; a red satin cloth in one hand and a bottle of black rum in the other. Two conch shells were placed symmetrically on the bottom ledge and my red-rimmed eyes were drawn to the large colourful china fish which dominated the centre point of the altar. Seeing the fish, my grieving thoughts left my father and focused on another Welsh Valleys man – my friend, Howard Marks the author of Mr. Nice. The book was about his life as an international dope smuggler and his subsequent imprisonment.

The china fish that stared back at me propelled me into another train of thought away from the Lwa and the Vodou temple altars and offerings. The thought had begun with a text message, a reply which Howard had sent me. The text was probably one of my favourite in my eleventh year of saving them. Several months prior to this I had been given two small roles in Howard's biopic called Mr. Nice. I played a jury member in two scenes along with Francesca, one of his daughters, whilst another daughter, Amber (a friend of mine), played a clerk of court. When the first scene was finished, a group of us were eating lunch in the catering truck when I laughed out loud and quickly texted Howard:

TM > Howard Marks
7 Feb 2009 15:00
**Iv just found u not guilty as part of jury,
so u owe me a pint! X**

I read out the text as I sent it, but no one else had thought it remotely funny. Phones were switched off and we went on to do another couple of scenes where I played another jury member – again Howard Marks was acquitted.

Howard Marks > TM
8 Feb 2009 13:11
**Ok. It's a deal. That's immeasurably cheaper
than it cost me last time. Doing a gig in
Southampton tonight if you fancy it. I'll get you
dinner and 2 pints. xXx Howard**

TM > Howard Marks
**There is nothin i would love to do more,
unfortunately i'm stuck in the valleys with
no trains in or out until monday. Any others
happening let me no+i'l take you up on the
offer. It'l have be a nice red wine now though
as i let you off again in a 1970's trial too. Had
fantastic day doin extra stuf xx**

Howard Marks > TM
**I'm heading back to the valleys tomorrow.
Must stop missing each other this way. xXx**

TM > Howard Marks
Ha yes! I have to be in work in London/ Brighton monday to friday. Going to your film party saturdy, are you? You'l be swamped no doubt. Am going to be between wales+london a lot. Just got a good publishing deal so will use it to write. Are you in London anytime soon? X

Howard Marks > TM
No plans to visit London for at least a week but will be going to Cardiff on 14th. It's bound to be swampy I know. X

TM > Howard Marks
Ok just let me no + hopefully hook up soon. I'll cu nxt wk at the party, lookin 4wrd to it x

The following week was the wrap party for the scenes filmed in South Wales and the film crew were filming the next part in Spain. The party came and went with both Rhys Ifans and Howard Marks on full party form and it was a really good night. It was difficult to talk and I was looking forward to telling him about my forthcoming trip to Haiti. Howard is a great traveller and travel writer, he has experienced some of the worlds more obscure destinations. I enjoyed his travel tales and knew he had not yet been to Haiti.

Howard Marks > TM
13 Feb 2009 20:09
Hi Tracey. What time do you arrive in Cardiff tomorrow? X

TM > Howard Marks
I'd planned to be there by lunchtime. Ru able to speak if i call now?

Howard Marks > TM
Bit surrounded and noisy now. Can you text? X

TM > Howard Marks
Ok. Not sure what is the procedure for 2mz nite. Amber said she unwel, im cumin wi a friend. She said its in Mischiefs in the bay+starts at 8pm is this right? Do i need to do anything to get in, tickets/guestlist? Wil it all b ok?

Howard Marks > TM
That's right. In Mount Stuart Sq. Probably 9 pm rather than 8. I'll make sure you get in. X

TM > Howard Marks
Thanx. Im cumin with my friend stacey (we were in nursery school together) it rhymes well ha! Jona Lewie singer of (u'l always find me in the kitchen at parties song)+ (can you stop the cavalry song) askd me 2dy if he cud b an extra in spain for ur film. I said id mention to u, but it prob all workd out x

Howard Marks > TM
14 Feb 2009 11:04
It's possible to arrange your friend to be an extra. Will explain when I see you. xXx

TM > Howard Marks
Ok. Can u remember his songs? Im helpin him by doing photos for his new album. One of his houses is in Valencia x

Howard Marks > TM
I can't at the moment - you know what I'm like. But no worries. X

TM > Howard Marks
I'll sing them to you in the party (ha!) then you'l know x

Howard Marks > TM
It's a deal. X

TM > Howard Marks
I sing v.badly... Remind me to tell u bout Haiti aswel if u get a chance to speak x

Howard Marks > TM
We will for sure. X

Howard Marks > TM
We're at Mischiefs now

TM > Howard Marks
Ur startin really early! U said 9pm. Ru stayin there?

Howard Marks > TM
Yes

TM > Howard Marks
Ok, im in bristol now, goin 2 put my mum on valleys train frm cardif, get my friend frm the rugby, get changed+then get taxi there, so i'l b a couple of hours. Cu in a bit. Do i just give our names on the door? X

Howard Marks > TM
Say you are my guests and text me to come out

TM > Howard Marks
Ok im just going strait to my friends to get ready now, cu in a bit x

TM > Howard Marks
In taxi now txt u wen we get there

We met up again a couple of weeks later at London's Grouchos and went out for the meal honouring the 'text message'. It was great; we had a really good catch-up conversation initially about the filming, which was still in progress. We both agreed that Rhys Ifans was doing a good portrayal of a young Howard. He played me a stored voicemail from Rhys saying that this is why he is doing a good job, he has to have every detail correct. The voice message was about every aspect of how Howard used to sing a lullaby to his son Patrick as a baby. The conversation later changed course and we were talking about my intended trip to Haiti – covering myths and legends of the country.

Howard Marks > TM
26 Feb 2009 13:07
How many words?
I'm in London tonight.
xXx

TM > Howard Marks
As many as u like, it can fil txt message space or be few words. Do u want to meet up for dinner or for a drink this evening? If so what time?

Howard Marks > TM
Am in Acton doing some recording with Mick Jones. Should be finished in a few hours, then I'll be at Groucho's. X

TM > Howard Marks
Ok gud. Shal i meet u in there? Wat time?

Howard Marks > TM
Shall I text you when I finish at Acton?

TM > Howard Marks
Yes that'l be gud. I'm doin a foto shoot, shud be done in an hour then wil drop off my equipmnt+b with u wen u finish. U, on ur own+wil u wana eat?

Howard Marks > TM
Either on my own or with that German TV crew you met at Bernie's benefit. Still don't know what time we finish here, though. X

TM > Howard Marks
Ok text me with a time wen u no + i'l meet u in there. It'l take me half hr frm where i am x

Howard Marks > TM
Ok. I'll text when I'm about 20 minutes from Groucho. I will need to eat when we meet, if that's ok sorry this recording is taking so long, but it is important. X

TM > Howard Marks
I am hungry + havent eaten so thats gud. Luk 4wrd 2 hearing all about recording project. Iv had a gud day, cu in a bit x

Howard Marks > TM
Just finished at the studio now. I'll text once I'm in the cab. If it's getting too late, don't worry. We can meet another day. I can't do a late one either. But it would be nice to have dinner with you. I have to leave London tomorrow. X

TM > Howard Marks
Ok txt me wen ur in cab+i'l leave 2get one. Cu shortly x

Howard Marks > TM
In cab x

TM > Howard Marks
In cab x

The conversation changed to the religious practices in Haiti and the drugs consumed in particular areas. A long and intricate exchange ensued about the puffer fish, which I have always been interested in as it's the second most poisonous vertebrate in the world after the golden poison frog. We had both been to a party in Cardiff the previous year along with Pritchard and Dainton from *Dirty Sanchez*, who had just come back from a trip around the world filming one of their tours for a television series. Their tour consisted of experiencing natural highs across the world and Dainton explained that he had been licked by a poison arrow frog, sending him into anaphylactic shock. It was suggested that the golden poison frog would have killed him outright. It is well known that eating certain types of puffer fish can often cause intoxication, light-headedness and a numbness of the lips – a reason why it is often eaten in many countries. The puffer fish's poisoning causes many more symptoms including rapid heart rate, decreased blood pressure and muscle paralysis. Some people claim they have remained fully conscious throughout comas that can be brought on by it,

and others say they can recount all the incidents that occurred whilst they were in the coma. I mentioned the author Wade Davis, an ethnobotanist who wrote *The Serpent and the Rainbow* and *The Passage of Darkness*. We talked about the author's visit to Haiti in the early 1980's where he was looking at how a living person could be turned into a zombie. On his journey he had looked at two special powders being administered into the blood stream through an open wound. One of these had included tetrodotoxin (TTX), the neurotoxin found in the puffer fish. I mentioned to Howard that I thought it was in the puffer fish's ovaries or liver, but Howard said he thought it was in its skin.

Wade Davis had also written about Clairvius Narcisse, who was administered with the aforementioned powders and underwent a death-like state of suspended animation followed by a re-awakening after undergoing this procedure. When the person came out of this state they seemed to believe they were dead and with no other role to play in Haitian society. Our debate focused on hanging out in graveyards all day, as I suggested it wasn't too dissimilar to my youth in the Valleys, and we both nodded in agreement. The conversation switched back once again to the puffer fish with me saying that if I was right and the toxins were in the ovaries, the female fish would be more toxic. Howard was having none of it, saying he thought it was definitely in the skin. It was somehow agreed that I should bring a puffer fish back from Haiti (providing it was legal of course). I was pleased to be doing another mini-mission on my first visit there and the conversation went further into the debate on the puffer fish:

07-12-07 15:49 My colouring in birthday party next friday 14th at the foundry, old street, from 7.30pm. All pens and pencils will be suppled. Happy christmas. A x x x \ 11-12-07 19:52 No one . Just you an me swetardt. Mark \ 12-12-07 12:22 Have you heard, Tampax are replacing the string with tinsel.... Just for the Christmas period. \ 13-12-07 21:38 I would love to write something.:) i'd love come to Ruspia x pete \ 17-12-07 19:07 Glad you liked them and are feeling better. Would love to go out. Am off to India on 3 Jan so Let's put it in the diary for when I get back after 18th. X \ 19-12-07 16:58 Sending you shadows seems to be my thing. I did not plan it in be so. It is just the way it is working out. \ 20-12-07 12:40 I'm considered royalty around here. \ 21-12-07 15:46 Imagine my joy when getting out the christmas decorations i found a present i forgot to give kids last year. Their excited faces were a picture as they unwrapped it & opened the box. Unfortunately it was a puppy! \ 21-12-07 15:20 Please bless everyone's little cotton socks but I'm stuck on an enormous bus with half of Aerosmith.. \ 21-12-07 18:56 Red Balloon. Directed by Albert Lamorisse. 1956. French film. \ 23-12-07 19:25 Facebook is wrong x \ 25-12-07 20:46 Merry Cliterous Shadwell!. Hope you didn't get anything worth having and you burnt your turkey. Lots of love 'Well hung Nick from Bristol'.xx \ 29-12-07 23:39 Shoreditch looks busy 2nite \ 30-12-07 18:18 Wow! Chinese new yr is big date 4 u this yr then! \ 30-12-07 20:02 Hello darling how are you you royal fatcuntedness?.x \ 30-12-07 21:19 Just read that banksy book. Again . It was medicine for my heart and spirit. \ 31-12-07 17:26 B4 the sun sets on 2007, b4 the memories fade, before the networks get jammed & before i get drunk, naked & lose my phone, i am wishing you a very happy 2008 lots of love s,p and dx

TM > Howard Marks
4 Nov 2009 19:23:56
I have located this puffa fish stuff but it's mixed in powder form with a real stinky smelling thing used in high ceremonies. I'm trying to work out of it's ok to bring back or if I'd be better bringing the dried fish. So I'm doubly checking that you still want it?? & good to see you the other day & I'm also in Bridgend next Thursday with a street dance troupe from there if your around?

Howard Marks > TM
Just the fish I think please Tracey x

Howard Marks > TM
Possible but unlikely x x x

So I was now stood in front of a Vodou temple altar in the middle of Haiti after having one of the most intensely mournful experiences of my life. A china fish was staring at me and I knew what I would now be doing in the latter part of the day. I really hoped the smell of puffer fish wasn't too pungent as I had my new pink dress packed in the suitcase that I would be taking them back in.

01-01-08 11:23 Happy new year to you petal!xxx \ 02-01-08 19:19 Happy New Year to my favourite living artist \ 02-01-08 20:12 Sorry what i meant to say is - my favourite Welsh woman artist ever. \ 04-01-08 17:39 Our neils alison, came 2 mcr in t'early days - welly scrap n all that \ 08-01-08 16:44 Yeah, wot evah...ya know? Wot evah! I'm like...y' know?? I'm cool wiv dat.. or y' know...like...I dunno man..."WOT EVAH! Y' GET ME?? INNIT!?!?" \ 09-01-08 11:49 I've got a spot on the end of my nose. \ 11-01-08 00:39 I love how much you've embraced facebook. Off to kid's tomorrow, so will check it all then. Hx \ 13-01-08 00:32 Wish. I could take you away again into the night like a mad mentalist \ 24-01-08 17:38 Checked in, with one and a half hours before our flight was to leave. Time enough for an ice cream and a coke and a read of my book. It is now one and three quarter hours later and we have missed our plane. I blame the book. Or is it me that is the Great Tit. \ 28-01-08 18:40 It was the hair of Susan, my friend in Berlin. She was behind me. Her boyfriend Eoghan took the photo. \ 30-01-08 17:05 But i rejected his idea. Instead i had TRACEY across the back of my shoulders in the same way as i was going to have NOTICE across the back of my shoulders. I did not know having a tattoo done hurt so much. But it does look good. \ 01-02-08 18:07 Where did you in dancing when you were in your teens? Just one place, your favourite. And who did you go with? And how was the show today? Need this info now. \ 07-02-08 14:56 I saw 2 familiar faces in pelliccis. Noel supply teacher poet man and peaches geldof! \ 10-02-08 00:58 U got 2 b jerkin, but i do av a curdless fern now - i gorrit on rerd near British Erm Stairs \ 11-02-08 12:22 I am currently experiencing enormous difficulties attempting to avert my gaze away from the enormous breasts of the woman sitting opposite me. Hence the reason for this text message. \ 12-02-08 01:07 Still walking the mean streets of Hackney. Helicopters over head. Foxs making their screaming sound. \ 14-02-08 15:06 Yes he's a star. Heavy duty interviews and repeat death threats whilst we were there. But bizarrely we had a lot of laughs. Talked bout u often and ate mucho pizza! What u doing in NY? X

The photograph that stood on the second altar of Silver Joseph, taken a decade or so ago made me think of the power and strength the Vodou priests must hold in their communities throughout their lifetime. As we left I realised I was drained of most of my emotions. I walked straight back up past Silver Joseph, stopping on the steps beneath him. He had more visitors now as we bade him farewell entering back into the tattooed flagmaker's next door.

I had seen women represented very little in Haiti apart from as subjects in the previous night's exhibition. I had also been in Haiti for a short time making assumptions that women didn't seem to be equally represented there. It had seemed that there were very few women over teen years out in the bars last night. As we walked down the hill looking in all directions, activity up a long alleyway caught my eye. It was a naked woman taking a shower in full view of the street. I thought this odd. Within the next step I came across the first street cock fight I had seen in Haiti. Three young boys were coaxing the cocks to battle and they were already punch drunk. I thought of my younger son and how he would react to this. I had to look. I felt the excitement and adrenalin of the young perpetrators and identified completely with it and also with a part of my youth. I was no different: I had never put two birds together to fight at their age, but had blasted birds with air rifles, hanging the dead ones up by their claws to continue target practice.

We were heading in the direction of a female Vodou flagmaker. This was unusual as flagmaking was predominantly the trade of men here. She was called Ketty and we found her at the end of the street. Ketty got examples of her Vodou flags and mobile phone covers out. I liked the idea of the mobile phone case that she was making, which originated as a Vodou flag. We discussed design, size

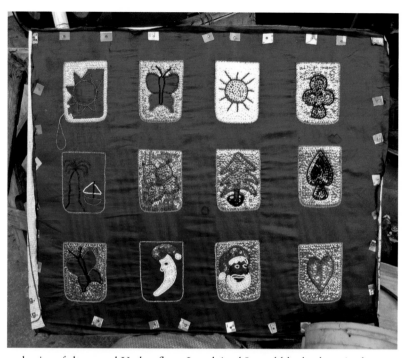

and price of the actual Vodou flags. I explained I would be back up in the next couple of days with the design and we all left in a taxi heading for the hotel. When we arrived, John Cussans had landed in Haiti and was sat on the veranda with his computer. We caught up on recent activities and events, later joining the rest of the Biennale crowd down at the New Friendship bar outside of the hotel. Earlier in the evening I had been sat chatting to Seitu Jones – an artist from Minneapolis and he joined us. A drunken guy, possibly affected by crack, performed on the street in front of us shouting, screaming and acting menacingly. In a pub-landlady moment, I thought he was going to be trouble, but he just started drinking in the bar with us. After asking directions to the toilet, I was directed up an alleyway. My friend had listened to the directions in Creole and I followed her up into an enclosed toilet. There was a short wall divide to which my friend gestured to use the toilet. Desperately in need of it, I followed her instruction. I released a brewery from a bladder that had become a full beer barrel. I was finding it difficult to focus in on an object a few centimetres in front of me. As my eyes blurred in and out I realised I was looking at the bottom and torso of a naked wet man, probably in his twenties. He held a plastic pot over his manhood as a shower poured down on him, splashing my head and face. It felt like another scene in a David Lynch film. I could not stop the action I had begun as the seconds went into minutes; at least the noise of the shower dulled the sound of my actions as I wondered what was going on in his mind. One minute he was having a shower then the next, two British women walk in and start using it as a toilet for an endless period of time, both with their faces stuck

centimetres away from his wet arse. What an intrusion, I wished I had seen him as we walked in and had realised this was not a toilet! In the Grand Rue I was told forty people shared the same toilet, obviously at separate times, but did this help? No! I feel mortified every time I think of this poor man.

We are just back from la gomera got your message. It is cold here. I was supposed to be going to uk on the 20th but am busy. But we are to go to Dafydd s wedding in april arriving london then on to cornwall. Enjoy yourself. By the way was it 15 or 12 burdith ave. We lived at? Love Andrew \ 22-02-08 21:24 Hotel says should be fine to pay on my card as they already have my authorisation....All your cards swallowed? How u getting on in brooklyn? Where u now? U got a nice email from a guy who runs a cafe in Brooklyn whom you've just left...?! \ 24-02-08 16:48 Are you still up for mekons tonight? X \ 29-02-08 18:29 Was just thinking about u! Was in howells and saw sandra bucket, she was spraying people with perfume but looked other way when saw me. Will call u tom \ 03-03-08 18:17 The fish was stolen from outside dhe foundry last night \ 04-03-08 17:06 Sitting on the bus with a hard on. Its the throbing engine that does it for me. \ 06-03-08 18:12 Don't tell anyone but i stamped a chocolate biscuit into the Downing St carpet ;-) \ 07-03-08 00:01 Hey honey. At Guy (elbow's) birthday. Hope all's good, available all day tomorrow, call me any time. Hx \ 08-03-08 12:21 Good morning all :-) well what a night and what a hangover ! ! It was great meeting up again after so long. I enjoyed myself :-) I'll see you all sooner rather than later next time . X wayne can someone send of lyn's number please ? \ 08-03-08 19:10 Happy International Women's Day. What's the diff between the G spot & a golf ball? Men are quite happy to spend 10mins looking for a golf ball! X \ 13-03-08 16:57 Come saturday to me party . Fancy dress pirates/ villains,. \ 15-03-08 11:59 'Gentlemen smoking pipes' on youtube now! Let me know what you think. \ 18-03-08 01:53 He did remember you and I asked him to drop by the Foundry. Nick asked me to try on inappropriate clothing and fondled my breasts. And have you seen Gavin and Stacey? Saw it for the first time last night and thought of you... \ 19-03-08 09:01 The new biog reads 'Life was empty meaningless before i knew Tracey' X Bill \ 20-03-08 03:58 If i could capture this moment/slice of time now, where everyones alive + everyone has hope i would. If we were born without emotions+tear ducts my eyes wud b wrinkle free+my heart wud stil flutter. \ 24-03-08 02:36 Darling, you're so bus shelter... \ 26-03-08 02:54 Hi sorry for late reply... Busy as ever. Many fingers many pies, none fully cooked ;-p i am too far down food chain to get an invite from pete but will come with you !

It was Sunday morning when artist Seitu Jones and I met up with local shop owner Milfort Bruno who would act as our guide. It felt and smelled the way a Sunday should as we set off to deliver the imagery for my text message piece which had now been translated into Creole. It was going to be delivered along with a payment to Ketty the Vodou flagmaker in Bel Air.

But first we had to find a person who would exchange money for a good rate. Milfort seemed to know where he was going and what he was doing. We were guided to an alleyway door and stepped behind it. Two chickens ran freely up and down the long concrete drain under the ledge as Seitu and Milfort sat down. Seitu started sketching. I shot some random photos from my small camera.

As we walked to Ketty's house, I recognised the area from the last visit and knew what twists and turns to make. Milfort was telling us stories about Bel Air

from the last few years: Seitu and I listened with intent. We got to Ketty's and she wasn't in, but was on the other side of the city. Her husband called her on his mobile. She would come to our hotel at 1pm to collect the fabric and sequins and to agree the colours and design.

I also needed to collect a book from Silver Joseph's flagmaking workshop so we made our way there. Milfort started telling us that a few years ago, even he could not set foot in this pro-Aristide area as people were being killed. Their bodies were left in the streets: it was probably the most dangerous area in Haiti. As we approached Silver Joseph's at the top of the hill a huge fight and a loud argument with a throng of people was in full swing. Milfort guided us directly through the middle of the fight to go into the Vodou temple to ask one of the sequin makers to come out and open the door to the flag workshop so I could collect the book. We had to walk right back through the middle of the street fight again, Milfort explaining that it was over a jealousy issue and a young man and woman fighting another person who had moved in on one of them. It all seemed very heated with so many people involved.

In the workshop Seitu was stressing how he felt unnerved by events but soon became visually engrossed in the sparkling arrangements of every twinkling sequin on the vodou flags surrounding us. He started asking Milfort about the different symbolic references as our eyes scanned around the different designs, which were all on display in the room. He asked about the mermaid and her significance. Milfort began with the story of the woman who became the siren on the front of a boat. 'In order to protect the boat and the crew from approaching pirates she takes down her knickers, bends over and shows her pussy to the other boat', he explained. As he was telling us the story he placed himself in the here

and the now doing the actions of the siren. Being told a story about a woman bending over having taken her knickers off showing her bits to the world was quite surreal in this context; after I had just walked back and forth through a large street fight; was next door to a Vodou temple where the door which one is supposed to knock on had fallen on me; where I had had a large emotional breakdown a day or two earlier and had been talking through a translator to a boy with a tattoo of a burning Bible and a crying Christ on his back. I was here it was now and I felt very alive but it still smelt and tasted of a Sunday over and above anything else.

Much later, back at the hotel, I waited for Ketty to sort out the Vodou flags. At 1pm she turned up and Milfort arrived to translate for us. She left with the sequins I had brought over and my design along with the drawing of the angel for the Mark Thomas text message. Bill and John had arrived and I met them downstairs on the veranda where they were hav-ing a few beers after coming straight from a Vodou ceremony. They had been up half the night and travel-ling nonstop since they left the UK. Bill having done a performance outside the Brill building in New York singing *Will You Still Love Me Tomorrow?*

Both John and Bill looked pale, drained, and very tired. The organisers were gathering together all the artists and scholars of the Grand Rue Ghetto Biennale for drinks and the film screening. I spoke to Flo McGarrell and Laura Teodosio who were making a film of Kathy Acker's book *Kathy Goes To Haiti*. The previous day John Cussans and I had played two small parts in it as scared white tourists.

Bill Drummond > TM
13 Dec 2010 06:35:55
Just done my performance now standing in middle of Times Square

Can you send that gay photo of me again. I deleted it and want to show people at the funeral. Thanksx Bill. \ 28-03-08 11:36 Tracey we're going to have to cancel,i'm staying at my brothers and can't get hole of Paddy n Gerry,i'm guessing that they're crashed as i know they're exhausted \ 02-04-08 12:46 Miriam, 54 years of age, 29 stone and apt to be mischevious. Gillingham area. \ 04-04-08 18:03 Can i phone. I need to hear your voice. \ 04-04-08 18:52 [C-u-s-t-o-m-e-r- j-u-s-t-e-j-c-t-e-d- f-r-o- m-s-h-o-p-f-o-r-a-t-t-e-m-p-t-i-n-g-t-o-w- e-e-w-e-e-o-n-f-l-o-o-r.] [E-n-d-o-f-t-e-l-e-x.] \ 04-04-08 19:03 Am number 10 amazon crime best sellers x \ 04-04-08 19:22 I'm in recovery from a private Elbow gig last night. Guinness is the only thing that's keeping me going. You? \ 15-04-08 15:33 I have raging pmt and want to bludgeon people to death. \ 27-04-08 17:37 Currently walking through a blizzard of cherry blossom. X \ 28-04-08 17:17 The Day The Penis Asked for a raise,I,hereby request a raise in salary 4 the followin reasons:I do physical labour,I work at great depths,I dont get weekends off,I work in a damp environment & a dark workplace that has poor ventilation,I work in high temperatures,my work exposes me 2 contagious diseases.Sincerely P.Niss Response:Dear P.Niss Aftr assessin yr request& considerin yr arguments,we reject ur request 4 the followin reasons:U dont wrk 8hrs straight,U fall asleep aftr brief wrk periods.U dont take initiative,u need 2 b pressured & stimulated in2 startin work,u leave the wrkplace rather messy at the end of ur shift,u dnt always observe necessary safety regulations,such as wearin correct protective clothin,Ur unable 2 work double shifts & as if that wasnt all,u constantly enter the workplace carryin 2 suspicious bags! Yours sincerely V.Gina. \ 29-04-08 21:06 I am home, i am glad i saw you. Isn't my daughter beautiful. I am so honoured to be her father. I still feel so close to you. XX \ 01-05-08 13:12 Just walked past Torvill and Dean! \ 04-05-08 19:16 I just blew my nose and some lettuce popped out. \ 09-05-08 19:50 Tracey!!! Whats occuring? Sorry 2 hear about parents. Is wales like gavin & stacey? Should i move there? Are u gonna hook up with cathy zeta jones? Are u behaving? X \ 12-05-08 14:48 Just waiting to hear off daint but it should be fine. Fri was a right laugh and i was right off my tit's haha. I'll let you know later when i hear off daint. I'll send you daint's number if he want's to do it somewhere else. You can sort it with him then. Look forward to it. I'll bring my make up hahaha. His name will be under 'white trash' when i send the business card. \ 18-05-08 20:19 Just seen a bloke with a packet of chips lick his fingers, get his knob out and continue eating whilst he pissed..and they say men aren't good at multi taskin? X \ 20-05-08 16:42 ...and I have a bottle of pink prosecco in my handbag...

35 The Art of Slavery

21-05-08 10:58 Ha ha. I'm taking my mate to Glastonbury who's never been before. He asked me if the showers were nice. \ 22-05-08 20:42 Mark T says he has called me a lesbian Tracey Beaker in his new book..:-| \ 23-05-08 12:36 People keep asking me if I saw the football...of course I did, I'm not blind, it's been on the lawn for nearly a month. \ 23-05-08 13:05 I'm standing in Nick's studio wearing a postage stamp over each breast and wondering were the cctv camera is. \ 23-05-08 23:41 11.27P.m. Location : Wetherspoons public house Kingsway W.c.2. Observations: Not only is the place choc a block with rabble, but the barmaid has teeth like a fucking donkey. \ 06-06-08 21:07 If i don't . There was a " wardrobe malfunction you are involved . You'll read about it in tomorrows paper. If it's rubbish i'll punch him soon crazy legs x \ 10-06-08 16:28 I lost my cherry to her remember \ 11-06-08 18:05 If u had painted it deep purple u could av had smoke on the water playin 2 help u along ha ha. Cant do 2nite doin carpet. Fuckin murder these carpet burns....! Apart 4rm the gripper stuck 2 your arse and all the shag pile stuckin ya pubes. \ 16-06-08 14:03 On the way to lourdes today. Be back sat. Wearing the nuns shoes. Good to hear from u. Wish the boys luck from me. Sinead in oz for a year. Patrick in tipp. Would love to see u. When u come to tipp? I will in london next year for sure. Talk to u when i get home. Got a lot of praying to do. With mother marian bernie eileen edel. Xx \ 16-06-08 20:17 Hi tracey love. Just about to see sex in the city! Catch up soon yes? Cx \ 27-07-08 19:14 Yea ok in the park hotel avin some cool beers wiv the lads. \ 28-07-08 15:25 Am nearly at kenfig.how is your dad and you? \ 31-07-08 08:47 Welcome to Namibia. It will cost you £1.40/min to make and £1.30/min to receive calls here. You can send a text for 40p a message and picture messages cost 20p each. To speak to T-Mobile Customer \ 31-07-08 14:49 Hi tracy. Hope you are all ok. Having a shit time. Past bad actions come back to haunt me. Will weather the storm but needed to tell you cos no one understands . \ 04-08-08 16:46 Bluuuurp! Rachel johnson what gave our text show a five star review in the times, wait for it....is BORIS JOHNSTON'S FUCKING SISTER! \ 05-08-08 09:52 At the Tower for the week with B, T and F. It was the shadow of the battlements that i sent you yesterday. The open day is tomorrow, today we get everything ready. F and i will spend the day collecting wood for the bombfire that we will be having. Give my love to the desert. X

Later that week John Hirst and I met up with two other Ghetto Biennale artists, Le Grace Benson and Toni. Le Grace wanted me to take photos with my professional camera of a painting she was using in her new book on Haitian art (*How the Sun Illuminates Under Cover of Darkness, Arts of Haiti*). She had taken some with her own camera and wasn't sure how they would come out.

Toni and Le Grace had been to the gallery yesterday and warned me of the cobbles on the hill which were so worn that they had turned the street into something which resembled a ski slope. I was wearing slippery flip-flops and Toni said if we walked towards the edge on the rougher compound we would find it easier. We set off up the hill and I saw what they meant by the glossy cobblestones which looked as if they were coated in icing sugar, but given the incline and their slipperiness were far more deadly. The journey seemed endless although we had in fact only walked a short distance. We got to the gates of the gallery and knocked on the door. Le Grace spoke to a young woman saying she had been there yesterday and had been invited back. We entered an unexpectedly sumptuous space. Our hostess was born in Israel and moved over to Haiti. The gallery had been her deceased artist father's place. He had owned the whole side of the street right up the hill, which had since become the family's following his death. The extreme dichotomy between the wealthy who tend to live on higher ground and the poor of the downtown slums is typical of Port-au-Prince and Haiti, where 1% of the French-speaking minority own 50% of the country's wealth.

Le Grace gave me a tour of the gallery and spoke of the artist who had owned and run it in her lifetime, how he had been a mentor. We went almost directly to the painting Le Grace wanted to photograph, *Colonial Games* by 20th-century Haitian artist Jacques Richard Chery. It turned my stomach; the roundness of the images in the painting and the brightness of the colours submerged the viewer immediately into the full story of the work. Then the horror hit. In the background in a semicircle sat three rows of white men and women in colourful colonial dress, waited on by black slaves carrying trays. On the trays there were rounded objects which looked like cakes.

Directly in front of them, a slave was tied up on all fours, stretched out, blood pouring from all areas of his body. I realised they were not cakes but stones. The happy gathering of colonial people were stoning the tied-up slave for recreational sport. It took me aback. Then I felt like I could vomit not knowing whether I was going to cry or be sick. Further forward was a row of slaves buried up to their necks in soil. Their faces were being stoned with rocks. The next row depicted slaves buried up to their chests, arms free to catch the stones being aimed at them. In the foreground a slave was tied up on all fours, his head pulled back while a white man forced flowing water into his mouth in a stream, not unlike the waterboarding practised now so close to Haiti, in Guantanamo Bay. I wiped the tears away from my eyes, trying to check the camera's focus. Artwork like that should be on show in public galleries across the world to show the horrific barbarity of the slave trade and the behaviour of Western civilisation. The second painting in the series depicted slaves arriving on the Benin trail across the water from places like Ghana and Senegal, dying en route. It depicted the slaves when they docked, having mouths opened and being checked before they were sold to their owner. Slaves who were taken from the same areas were all separated in order to prevent them speaking the same language and planning rebellion. The third painting was more optimistic, depicting Dessalains who was responsible for the slave uprising and the establishment of the Haitian republic. But it could not erase those other images from my mind. I hated the human race at this point.

06-08-08 11:13 Sun not shining, but things going well. Tower looking good. Give my love to the Skeleton Coast wrecks. X \ 09-08-08 23:08 In bed now feeling very strange because of medication. I swallowed a wasp today that then stung the inside of my throat, thus the medication. Give my love to the bugs. The kids here are wild. X \ 13-08-08 22:19 Welcome home honey. I do hope you killed that leopard with your bare hands, skinned it and that your winter wardrobe is now complete! Have just passed a woman struggling on a walking stick...in three inch stilleto mules... \ 19-08-08 18:31 Hi Tracey, Russell Brand here. Mark tells me that you fancy me! \ 22-08-08 18:49 Haven a clue who u r sorry if ur father il hope he gets better but i would appriciate it if u stop txtin C He been txt u and hiding it from me maybe inocent i dont know u wouldnt like it if it was ur husband hiding things \ 02-09-08 00:04 MTS welcomes you in Russia! With our premium quality mobile service your stay will be comfortable and safe. For roaming information please call 0890 (free). \ 02-09-08 16:46 Tracey if you get this can you tell Bill that I've got his texts and sent loads back. I don't think mine are getting through. His mate Ken Campbell has died. X \ 06-09-08 15:48 Blimey wot u shootin? Jx \ 08-09-08 13:28 Cool and damp.. We'vd had huge storms and flooding here all week \ 10-09-08 17:11 Sussex to play zombird and going to rap party – end of film party! Cx \ 10-09-08 21:21 Love the way bill d describes u in his 17 book changing topics mid sentence, thought it was just me not concentrating! How was dad \ 11-09-08 14:58 Hello Tracex , I have been thinking about you and your mum and dad for thepast2to3week.Isigned ontoan illustration course. Whilst there a meet a lovely young girl from donegal. She reminded me so much of you. X Andrew \ 13-09-08 12:00 Hi ya, im ok thanks, start treatment next weekend, cross fingers it works. Hope alls good with you, sending love xx \ 14-09-08 22:24 Hey, they start colliding particles tomorrow, let's hope they know what they're doing. Been beautiful knowing you, and hopefully see you again. Thanks for all the good times. May there be many more... \ 19-09-08 21:48 R u still with bill? Can u ask if he has amy idea how to contact Anthony Gormley? The Russians need to know.. \ 20-09-08 15:35 You salascious jezebel! You fucking Welsh are all the same. Pure filth! And is that Captain Faggot? \ 21-09-08 09:23 Thanks 4 last night love. I didn't want 2 burden you, but i feel so lost and confused x

We looked around more and moved on to an array of Vodou paintings. One in particular I adored of a Vodou ceremony with the Gede family out in force and numerous officials dressed in purple and black. The painting depicts them taking a deceased person through the stations of death into the other world. I had learnt that the painter Chery who had created the slavery paintings had gone blind and I thought that very sad for a painter.

I went downstairs to find John Hirst. He had bought some paintings from the money his new in-laws had given to him to buy souvenirs from Haiti. We went outside and stood on a plateau ledge looking down at the sea and the beauty just below. We were up higher than the Oloffson and I wondered if people thought John and I were an odd couple with matching white legs and puss-filled mosquito bites. I noticed that John had far more mosquito bites on his legs wrists and hands than me, and his looked to have reacted slightly (but not as much as mine). We left and walked back down the hill, the shiny cobbles like sheet ice on the downhill walk.

The hotel was fairly empty, as many people had gone to Jacmel for the day, which was about a two and a half hour drive from Port-au-Prince. Flo McGarrell had a studio and gallery there under the name of FOSAJ, a community arts space, and people were making art and films there. The group dynamic changed and dispersed a bit when Flo and Laura who were working on the *Kathy goes to Haiti* film had left a few days before for Jacmel. I was looking forward to seeing the rushes and thought that John Cussans and I probably did look like the scared white tourists we were playing in it.

Ketty turned up at the hotel with my text message Vodou flag. This was the image of Legba sporting his huge phallus and Aiden Shaw's text which read 'Sex fills me with germs, drugs fill me with doubt, rock n roll fills me with hope x'. I was in tears; she had creatively translated and worked my image perfectly using the sequin tradition unique to Haitian flagmakers. She was still working on the design for the Mark Thomas angel text design I had done for her. I would commission her to do the other two that went with the Aiden Shaw text and then a Howard Marks text as we had been texting a lot about the puffer fish before I left. I had taken a break from admiring the design and Aiden's text worked in Creole on the Vodou flag, when people started coming in with gossip about Bill.

Apparently he had almost started a riot after offering to pay money to each person who took part in the performance he was doing along a length of the Grand Rue. Bill and John had to be barricaded in Eugene's studio as the story went, with hordes of people coming after them for their dollar. Bill's version was different. He simply said 'oh you know what it's like, how people exaggerate any situation. It was all perfectly fine'. He went on to say that he had probably

achieved one of his best scores for the project he was working on with the people lined up in the Grand Rue.

People started to arrive back from Jacmel and all seemed to have had a nice day, but there were some oddities about their return journey. A person had been involved in a road accident from a village on the way, and no one had come to take the body away. People found this strange. Louco had been driving one of the cars rented for the Biennale and he had been involved in a small accident too.

It was Thursday again, the regular music night for the Oloffson house band, RAM. I was looking forward to hearing the band properly this time after being so tired last week. I got changed out of my day clothes, putting on my Spandex leggings, long winter boots and sixties circles hanging leatherette top. I was at last ready to dance. I hadn't imagined that it would be to a band once renowned in Haiti for its political music. RAM's music is known as *mizik rasin* ('roots music') a political style developed in the eighties when bands started combining traditional elements of Vodou music with rock 'n' roll (Morse has described his band as 'Vodou Rock'n'Roots'). The military government imposed a nationwide ban on one of their singles which it regarded as a song of support for former exiled president Jean-Bertrande Aristide. In spite of death threats (and an attempt to kidnap Morse from the hotel in 1994), the band continues to play their weekly concerts in the hotel, upsetting in equal measure all political factions. This is where I finally first danced in Haiti following Eugene's radio conversation with me in the Foundry nearly three years prior.

28-09-08 00:27 Petrol bombed it I recall! Hospital tonight, then Karl and I went for a curry and a pint and reminisced about a night in revolution on raspberry vodka and chocolate martini's. Thought of you... \ 03-10-08 14:43 Are you alive?you are def hardcore...let me know x \ 04-10-08 13:21 You are still coming Tuesday? If you and Carol fancy coming I'll put you on the list or walk in with me...one on each arm. U coming to play afterwards? Mark \ 04-10-08 18:12:11 Party to celebrate antonys life next sat. 4 oct at milton garden community centre, howard rd off. N16. From 3pm to 11pm. Plz forward on. Thanks. Sam \ 08-10-08 15:20 What did doctor say?your photo in elle-thank you.x \ 08-10-08 20:20 Would love to come on the radio show.... would be so rad!! Michele is here for another week or two.... Ok her# is +170... and her friend is here from Australia. Hes in this band called Sneaky Sound System. I think they r popular here. Maybe he will b around and can come with. Will give her your#. Big hug and i will say a prayer for you dad tonight :)d \ 09-10-08 11:27 Daimon Downey of sneaky soundsystem and he is also an artist. And annabelle wallis actress and currently on the tv show the tudors. I'm excited!!! \ 10-10-08 17:58 Ha ha that was me ! I've been building the sets for the skins film even weirder ! X \ 12-10-08 19:07 Its a boy! Beautiful bundle born today at 8.21 a.m weighing in at 8lbs 6oz. Sarah & baby doing v.well. No name yet. X \ 12-10-08 21:30 Stranraer, in Scotland. Will be visiting the Penkiln Burn in the morning before i get the ferry. \ 14-10-08 22:21 Dont forget im doing the cardiff marathon on sunday and am raising money for cancer research wales. I'd appreciate it if you could make a donation to www.justgiving.com/pritchardswyd......... this year im doing it with 4 months of partying inside me and no training as a challenge. Thank you. \ 15-10-08 21:35 Forgot william gibson.. He described the foundry like the insides of his brain (or something) \ 18-10-08 20:08 I is in Lourdes with my mum at the present. Will be back in Bantry tomorrow very late. I will say yes to your idea of meeting up next september. I will try to remember to say a prayer for him. I think of you. X Andrew \ 21-10-08 19:50 Nice little write up you have in the echo tonight. \ 25-10-08 12:08 Really sorry for u + ur mum. If theres anything icando,ask.X \ 25-10-08 12:43 I am so sorry – please send my love to your mum Lots of love 2 you all Thinking of you loads x \ 30-10-08 08:30 Lots of love for today Tracey. You can tell your Dad that he is an inspiration to me, I've never met anyone with such a peaceful soul as he had, and such devoted love to one women. Thinking of you.x

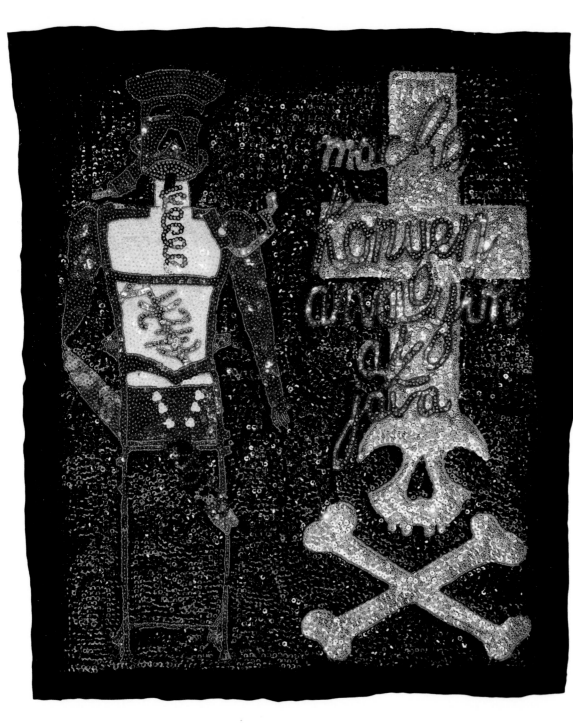

Vodou flags by Ketty and Tracey containing Creole translations of text messages

[left] part one of a three-part text from Aiden Shaw
– *Sex fills me with germs*

[above right] sketches for parts two and three
– *Drugs fill me with doubt*
– *Rock n roll fills me with hope*

[below right] sketch for Howard Marks
– *I wish my first experiences of sex, drugs and rock'n'roll had come at precisely the same orgasmic instant*

[far right] first letter of a text message from Mark Thomas

Dwòg fem pèdi bonnanj mwen

mizik plen kem ak lespua

Mwen swete premye eksperyans mwen ak seks, dwòg e jazz la

te vini nan jisteman an menm tan tankou yon orgasme

05-11-08 12:33 Piano party tonight at Gerry's,52 Dean St,10pm-2am.Text back for free guest list.Cliff Slapper \ 06-11-08 08:56 You going down to fundry tonight if so bring that magazine if you have it . You know the one with me shagging prince while contemplating outsider art from sao paulo and looking like a ponce. Cheers x \ 14-11-08 09:57 Really fucking sorry but taxi fuck up and train cancellation has meant I don't get to Paddington until 12:33, which makes Foundry impossible. Complete fuck up. X x x If at all possible, I will, but it's just getting worse trainwise down here. Best to assume no unless I call have to speak at hemp show in Shoreditch at 2 pm. X \ 18-11-08 11:54 Do not know how to send mobile photos to you on iPhone. Have a couple to send you from my drive back from Derry. Got the pics but all very difficult to view and not very satisfactory when I do. It does not have the instant hit factor that the Nokia had. X \ 21-11-08 00:47 Get rid of that tag and photo or i am out and deactivating.i will not be a cunt colouring doll \ 26-11-08 23:02 Hi amber and tracey. Hope your having a good one at the party. Rock on get smashed. Pritch x \ 27-11-08 19:22 btw cops said at a house of commons meeting that mark t is a 'bureaucratic burden on the police' haha x \ 28-11-08 12:35 Acrotomophilia is the Kink 4 sexual interest in amputees, whereas apotemnophilia is the name 4 sexual interest in being the amputee. AmourTobypretty armless.. \ 28-11-08 16:42 Ivans XTC 1 of best films of all time − and tell him i know what im talking about ! Not seen you in ages − mark and julie up 20 21 lets meet for dinner \ 28-11-08 17:30 Mike and claire from manumission. How do i find the photos? i will tell claire... You are the best x x \ 29-11-08 22:29 S Just saw britney. She was shit and she was miming. \ 01-12-08 23:38 Everyone going to letty's fancy dress shop in splott − rob's mum has gone. Wot hapenin with u? Cx \ 11-12-08 12:47 Man goes to Doctor with a hearing problem, Doc says, can you describe the symptoms? Man says Homer's a fat cunt and Marge has blue hair. \ 16-12-08 20:58 Once again Tracey, sorry to hear about your cousin. What a time of year for this to happen. X \ 23-12-08 10:01 This Israeli tear gas is proving to be a rather harsh exfoliant..x \ 31-12-08 07:34 2009 is at the door.... Remember, Life is short, break the rules, forgive quickly, kiss slowly, love truly, laugh uncontrollably, and never regret anything that made you smile. Send to all the people you love and don't want to lose in 2009, even me... If you get 3 back you're a great friend. X \ 31-12-08 21:40 To all my friends who sent me good luck for 2008, it did fuck all. So for 2009 could u please send either money, vodka or vouchers. (not woolworths) Wishing you all the best for 2009 !

I was chatting to a few Haitians with American accents, some of whom spoke little Creole. One of these was Reginald, who had been deported back to Haiti after committing a crime in the USA. A law was passed there in 1996 declaring that any Haitian committing an offence must be deported to Haiti following their sentence, even if the crime committed is minimal. This is extremely harsh for Haitians who may have moved away with their families when they were babies, as many do not speak Creole or French. Deportees arriving in Haiti are routinely placed in police station holding cells where prisoners do not receive food but depend on daily visits from family members. Many of the criminal deportees in Haiti don't have any family locally to do this. There is also no medical provision at these police stations. I was shocked at the severity of this American law.

A group of us were going to visit the cemetery. This included Marcia, Seitu and Jania, with Milfort as our guide. When we got there Milfort told us we would have to go around with guards and would need to pay them money as it was much safer this way. I felt uncomfortable as soon as we entered the cemetery. We were taken to a large black cross where people were giving offerings

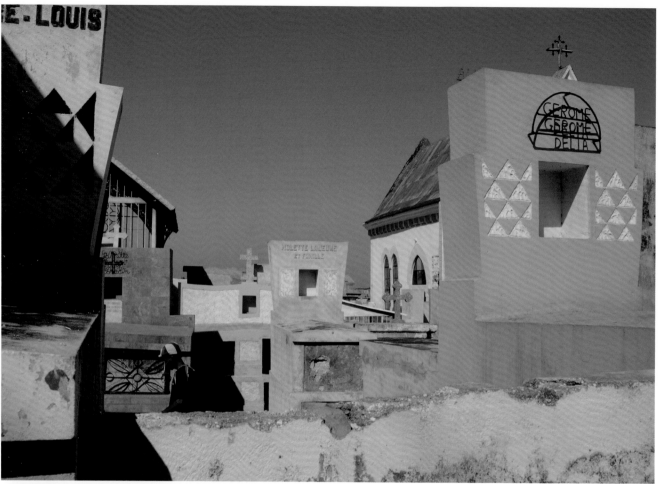

of food. Cinnamon was burning in a liquid form near the food. Flies swarmed and the smell was not pleasant. It felt wrong holding my camera as this was such an active place that commanded respect. People were making offerings and someone smiled encouragingly and beckoned for me to use the camera, which I did, and started taking photos and filming alternatively. Then I learned that the Vodou worshippers believed that cemeteries are controlled by the cross of Baron Samdi, the same black cross I was stood in front of at that point with the offerings. Baron Samdi is the leader of the spirits of the dead. Death in the vodou tradition is regarded as a source of regeneration for society when it is mediated by means of specific rites. These rites help to propel the dead by furnishing them with the strength of the living into the home of the Vodou spirits.

We were taken to two offering places within a short distance of each other. At the nearside corner of the graveyard we were shown the crosses which marked the graves of the first monks to come to Haiti and were then told that the first black cross we had come to which bore offerings marked the grave of the very first person to be buried in the Port-au-Prince cemetery. We were navigated

around graves and past tombs – some grand and French. Many were brightly painted in pale to mid blues and white.

There were gatherings of people who sat drinking and talking on most of the graves. I knew a community lived in the graveyard, but many were also well dressed and didn't seem as down on their luck. Others were begging and we were told not to give money, as this would set a precedent. People were selling food in small bags. I really wasn't sure what the rules of this cemetery were and the last thing I wanted to be was disrespectful in any way. People were mounted on tombs and slunk over graves swaying, dancing with arms in the air. Some people were sleeping across the raised-up grave tops and tombs. I filmed this but felt slightly self-conscious; once again I felt like I was intruding on people's personal space. Marcia was behind me every step of the way and she was on a mission being instructed by Nancy (her daughter) to take photos of anything interesting. Seitu was discussing the different seeds and fauna of the graveyard. My attention wandered to a plant with purple flowers and leaves.

An ex-boyfriend's mum had given me a cutting of the same plant in Stoke-on-Trent. I had always thought it was beautiful – at that point I wondered if it was a native of Haiti or the other Caribbean Islands. Purple is the colour symbolic of mourning in Haiti, with houses where an inhabitant has died sometimes displaying purple curtains after death: it is also the colour of the Vodou spirit Gede family Maybe it was a coincidence that this was the same colour as the purple plant in the graveyard or perhaps it was planted there deliberately as the colour represented death. I later found out that it is native to the Gulf Coast and known as 'Purple Heart' or 'Purple Queen' or by the negative name 'Wandering Jew'. Indoors, this plant is really effective at improving air quality by filtering out volatile organic compounds, a class of common pollutants and respiratory irritants.

Milfort told me that we were going to see where all the bodies are ultimately taken to after their grave rental time runs out. This is usually after a six month period. I was expecting a mound full of bones and decaying body parts. A grave worker wearing a white builder's dust-mask appeared with a brush in one hand and bones in the other. I kept coming across tombs with sides missing with views several feet down below. Some looked as if they had bones in others looked as if they had been cleared to act as beds for the night. I was told glue was the main drug here and a strong dark brown liquor made of fermented sugar cane called 'Clairin' which is illegal but the law is rarely enforced. As we walked further into the cemetery all was still neat and brightly coloured. I just happened to come across coffins that had their lids ripped off and shrouds bearing an image of Jesus that were

02-01-09 11:50 I thought it was leona 1st of all , shes beautiful , i think the lads will break a few hearts as well ,like me and jeff used to do,but in our defence we used to say to them " like us by all means but dont fall in love with us " your boys can borrow that one if they want ! \ 02-01-09 18:48 HANDS OFF GAZA: STOP THE BOMBING: FREE PALESTINE! Demonstration tomorrow, assenble embankment 12.30 march to trafalgar sq. PLEASE FORWARD. \ 03-01-09 00:49 Home safe and unsound as per... Love mark \ 07-01-09 23:10 No photos. No face book. Just good old fashioned text messaging. Except no text language. Is it already dead? Love from your man on the night bus. X \ 23-01-09 18:50 I will email my mate who does security work and get some guidance for you re haiti. Workin on a drilling rig off the coast of norway. Pays well if nothing else! Speak soon. S. \ 26-01-09 14:12 That would be good , i spoke to her dad today and he said they are all in shock , post mortem being done today . They still dont know why she died but i left my number so her brother can ring me tonight and find out more then ill give you a ring \ 30-01-09 12:16 I caught champagne corks in rula lenska's swimming pool @her wedding summer of '77 when she was making rock follies. She hasnt said i can come out yet... \ 01-02-09 17:42 I no! Never thort i'd end up on same website as russell brand! \ 06-02-09 12:11 Stik used the gap where the nicked Faile was downstairs \ 08-02-09 19:38 In hotel wrecked trying to convince the german to go out x \ 09-02-09 13:18 I am sorry I lied. There is no excuse but I will explain. Thank you for being my friend. X \ 10-02-09 09:33 Prog tonight C5 8pm about cheetah at amani lodge . . And their devastatingly handsome carer . . \ 10-02-09 18:03 Thanks Tracey. I got the photos and links nice one. Great news on the publishing deal, I'll get a text to you when I think of something amazing x Maggot \ 15-02-09 16:21 My girlfriend picked me up i was taken home ha. I didn't even know i was ready to leave. \ 16-02-09 11:30 Lips remain sealed \ 01-03-09 14:01 Oh gud! Happy st davids day,get sum extra gravey! Yep all gud here-lashings cumn up rathmell drive.. An get that welsh gal's costume on 4 jonathon!!te,he xx \ 01-03-09 19:56 Once i have a fridge i'll have a pink champaign nite. X

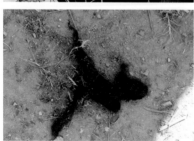

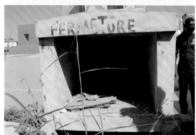

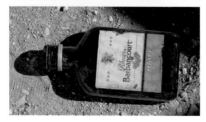

discarded nearby which had not even had time to fade or become threadbare. I wondered where the bodies were now, how relatives of the deceased would feel if they saw these coffins there now with the bodies ripped out and the cloths that lined the coffin on full view. Drag marks in the ground from where the body had been pulled out and left from the left-hand side of a grave were on display; long lines in thick bands where it had been dragged before it had been pulled up. Further into the cemetery discarded metal coffin handles were near to my feet, along with a strong iron coffin torn out from its tomb or grave. Bones with flesh were wrapped, encased or mummified as they leant outside with torn sections of shroud with thread hanging off. I was on a more central pathway now and wooden coffins were thrown aside onto rubbish piles. The underneath slats of one were splaying slightly apart while the lid was firmly fixed on. I wondered who was inside and what state of decay – what illness this person would have suffered in life and whether the germs were still dancing around inside the coffin to be given off in pockets of gaseous emissions. I wondered how large the pile of coffins would get until they were removed, taken and burnt.

As we walked, families were gathered together, sitting around the more open spaces that we entered. Milfort said he was taking us to the place where the exhumed graves were taken. I was expecting a horrific pile of rotting flesh and morbid degradation. We were taken into a more constricted area where the tombs were condensed and built nearer together. The atmosphere became claustrophobic, strangling as the smell of old death grew stronger. Then a sweeter fragrance sailed through the air and I was immediately transported back to the village where I was born and brought up. As a child, every year as the first flowers of the hawthorn bush came into bloom in May, I would pick a beautiful selection. My mother wouldn't let me bring the flowers into the house, saying that the hawthorn was bad luck and that it would bring illness and death to the house. I just put it down to an old wives tale or superstition until I found out in my teens that the hawthorn blossom contained trimethylamine, which is also one of the first chemicals formed in decaying human tissue. I started scanning the cemetery fauna for hawthorn trees but I couldn't see any and presumed it was variations of fresh death I smelt instead and maybe the bodies that were not incarcerated in the ground first, but due to costs had to forgo the burial phase and be put straight into the mass oven.

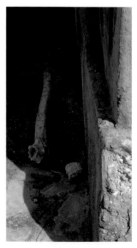

I noticed on a narrow shelf the remnants of a leg – well, a femur bone – just tucked away behind two tombs. I gave a nod to Marcia who was photographing close behind me. I thought of my Nan and Grandfather buried on the hill in the Valleys, thankful that their bones were still interned and in skeletal tact. I thought of all the bones and skulls the Haitian artists were using. In contrast I'd be happy to have mine incorporated in one of these works and I needed to balance different cultures, focusing on the different customs regarding death and how none of this was any different to the grave exhumation I had done in Manchester Cathedral.

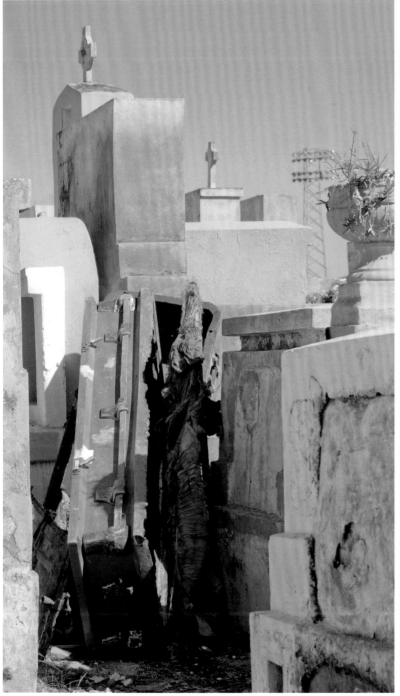

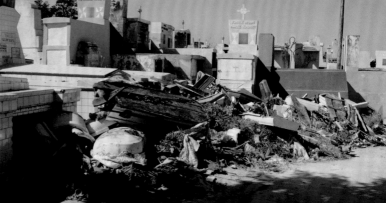
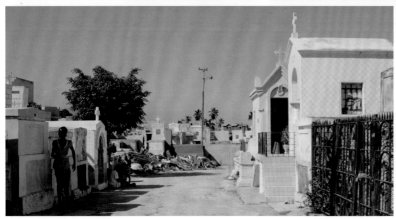
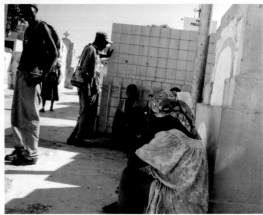

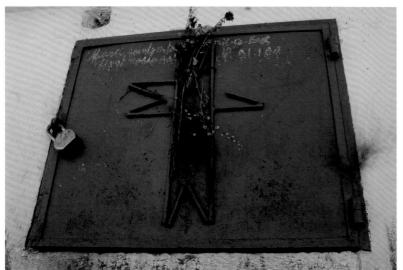

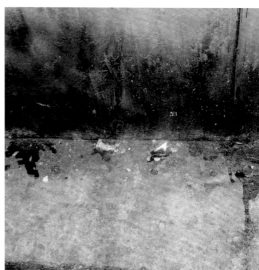

Two of the security guards we were with started shouting to a woman who was topless, only wearing a skirt. A couple of women behind her were doing their washing in the centre of the graveyard. She turned around quickly with wild eyes. The security guards were shouting loudly at her as she walked towards us. Her misshapen breasts drooped down, the left breast almost a quarter longer and larger than the right with its nipple taking up most of the flesh there. Stretch marks gouged into both. She looked quite young and I wondered how many children had fed on her breasts and what her life story was.

We walked on, turned a corner, and were in front of the oven door which dominated this section. The floor was littered and I was told the burning brown liquid was cinnamon. Grass crosses on the floor were also attached to the door

and something was written in Creole across it. I wondered what it was. To my horror I found two black headless cotton stuffed dolls exactly like the Vodou dolls I had seen in films. The stench of death was not masked in any way by the burning cinnamon but heightened in all its decay by the souring temperatures of the hot Haitian winter day. I had to get out of this spot. People were closing in on us and I felt fear and danger in the air. Maybe this was my inbuilt reaction to the pungent stench of death.

I couldn't wait to leave, but felt better as the area we were walking towards widened out. People had five-litre plastic containers full of Clairin, the brown moonshine liquid. I wanted to taste it but didn't know how I could buy it or ask for a taste as Milfort had now walked on in front and was lost in his own thoughts; respectfully I didn't want to disturb him.

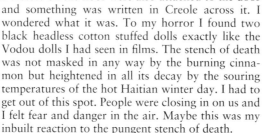

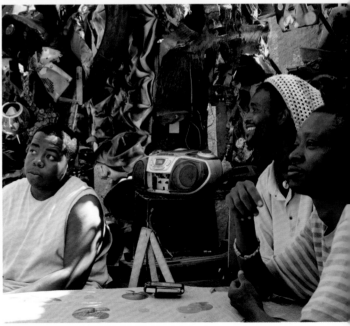

05-06-09 12:58 HI TRÄCEY. LISTENING TO SHOW FROM SUNNY TURKEY! LUV MARTYN'S MUSIC & BEF ALBUMS! X \ 07-06-09 16:10 Don't have Russian details with me as I'm on the road again. I'll email someone who knows who they are. I think only main cities would work. Back from Egypt by june 18th. Could send you Russian book then, if you want. X H \ 11-06-09 20:52 To dear Tracey HAPPY BIRTHDAY From Jona. :-) ! ! \ 14-06-09 11:49 Bloody pleasure to be able to write about you and the best pub in London! Xxxxx \ 14-06-09 14:26 Look at you two in the observer! ;) love yous x \ 15-06-09 11:19 Hey Love. This text's a bit bleak, but – disease, comedown, hangover. – i warned you. Maybe my head's in a dark place this morning, or maybe it's just the cold, but kind of warm light of day. Would love to see you soon. Did you read any of the books i gave you. I was thinking of sending you some of my recorded poetry. What say you Wonder Woman? X \ 15-06-09 12:29 Can we just have a blanket 'yes' to anything you ask me to do. It'll save time. In futre, just tell me where to be when, whatever the project. I trust you. X \ 17-06-09 12:54 Soon i'll be throwing things at you from balchony! X \ 23-06-09 10:36 Gig was good. I was amazing. Tearful at how much I miss you. \ 25-06-09 22:34 Apparantly jackson's had a heart attack. Not breathing upon ambulance men arrival \ 25-06-09 22:47 Jackson has died \ 25-06-09 23:23 The life of drugs sex & rock n' roll hangs In the balance. X \ 26-06-09 19:18 Tracey Tracey Tracey. I just like saying it while I am doing house work. Enjoyed my curry and with the bonus cockroach \ 08-07-09 16:42:21 Between you phoning me the first time and then phoning me back I had my phone stolen and then got it back. It was all very dramatic but I saw none of it. I stayed with my head wrapped up. I can phone now if you want. \ 09-07-09 14:09:53 Just jokin in army talk. Curry un chips un out instead of over and out. Just jokin about your love 4 gilfach curry and chips. \ 16-07-09 08:39:09 Keep your hands over the table missus x x \ 17-07-09 12:39:53 There is already a save the foundry campaign on facebook!

The day of the Biennale had arrived and people had gone to the show with Louco driving. A Ra Ra band played at the start. I wandered down to the opening and received a warm greeting from Marcia who was up at the top section near Eugene's studio where we all sat under a tarpaulin cover. I started handing out the Polaroid sticker photos I printed out of the Mobilography project. John Cussans put together a slideshow of photos that I had collected from the Port-au-Prince Grand Rue community. Edgar, another Biennale artist, put his collection of music to it from his iPod. We worked out the things we wanted to see, Nancy's performance being one of them.

Two UN guys walked in and were looking around complete with uniform, hats, and guns. I walked down with Marcia to watch Nancy's performance. Bill and I went for a stroll through the crowd, stopping to talk to people.

My slide show and the films were going to be on after Nancy's piece. Nancy led a group of young people with handmade musical instruments in a Pied Piper event through the length of the Grand Rue section in the area adjacent to Eugene's where everyone sat under tarpaulin. Before she set off, I became fixated with two young girls laughing so much at imagery of themselves through Polly's camera that I had to go over and photograph them. The police arrived carrying rifles. The policeman who seemed to be in charge wanted to have his photograph taken with Polly. I said that I would do it on my camera as I knew I would get the shot right using my own equipment. I took two. He wanted

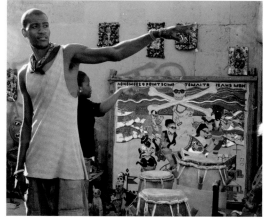

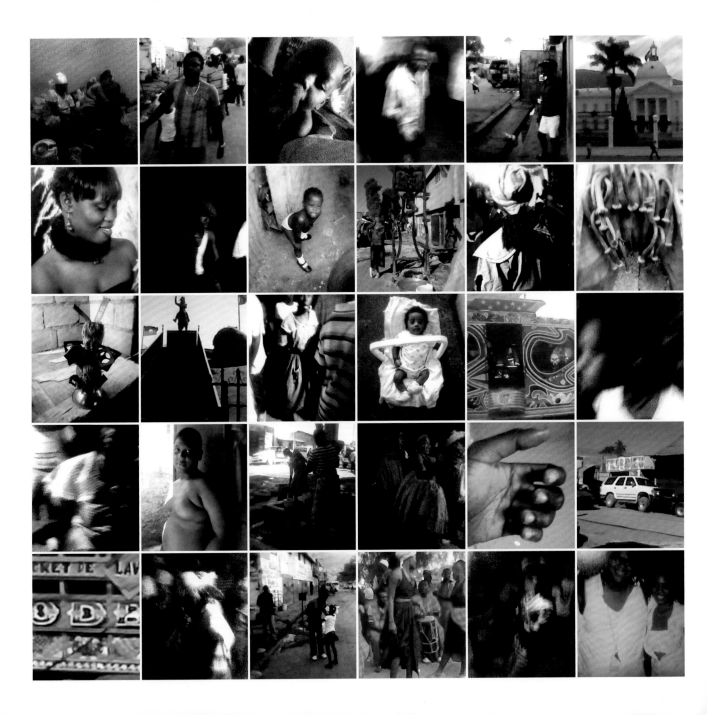

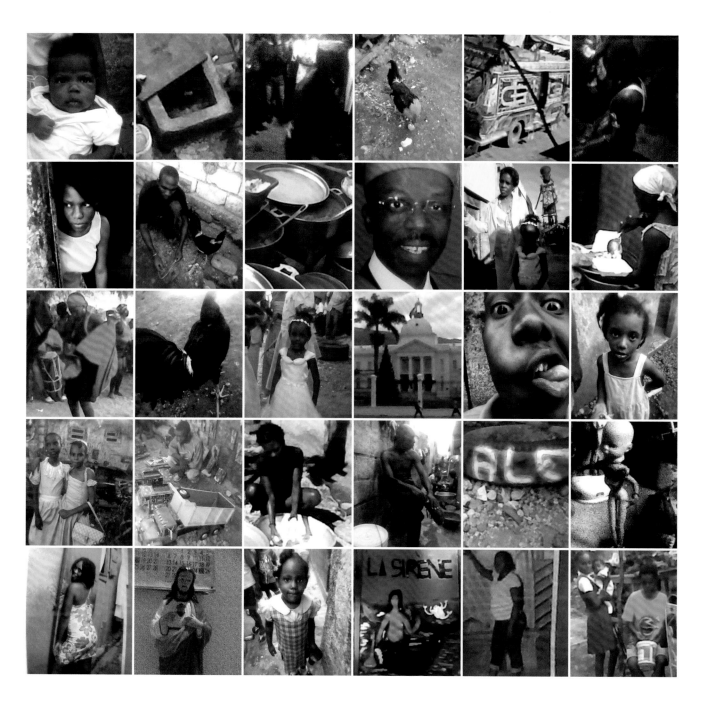

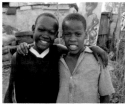

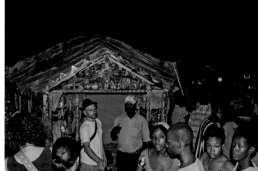

Polly's name and address asking her to send the photos to him. She obliged and I promised her I would send the photograph. Le Grace mingled in and out.

The younger artists of the Grand Rue (or 'Ti Moun Rezistans') filmed throughout the day and night, interviewing people. Their cameras were made of empty plastic bottles and their mike was a similar design. Both held no recording technology, but it was amazing to watch them in action and the reaction given by the people they interviewed.

The sun had started to go down. I knew as the dusk set in and it gradually started to get darker that I needed to be away from there. The air and atmosphere would change and in the Grand Rue there were no streetlights at all. A woman with a four-wheel drive open back truck who had been transporting people with Louco during the week was going back to the Oloffson. I asked if it was okay if Bill, Marcia, and myself got a lift back too. Darkness was falling quickly. From my position in the back of the open truck I took a couple of shots as we left the Grand Rue area and filmed as we came through downtown Port-au-Prince. Streetlights started to emerge and shoplights were in full glow. As we teemed out of the Biennale, so did many people in front and behind us. We spent the remainder of the night on the veranda of the Oloffson.

People were in and out of my room on the day we

were supposed to leave, and I only had time for a quick shower as I bade a big farewell to my plughole to the centre of the Earth. I got in a car with Le Grace and Seitu and we were off. As we made our way to the airport I recognised the streets and the route out and my now-familiar way towards Bel Air. As we passed through it I felt there was something about this area that I really liked with its strong sense of community. We were approaching Ketty's house. She was there with her family sat outside and was looking in the direction of the car. I waved really hard until she waved back. I felt like I had started to make friends outside of the Oloffson and Grand Rue community. I knew that I would be back with what business and orders I could find for Ketty once we had finished our project together. I was leaving Mark Thomas' Angel of the Erection – the next text message Vodou flag design – in her very capable hands and I was leaving Haiti happy after waving goodbye to my new friend.

18-07-09 23:04:45 And it was the blankie that made me think of you, in Moss Side! And your mad red-head fish...so odd... \ 19-07-09 17:35:32 I am off to Portugal but will meet on the evening of the 2nd . Can you organise as mnay folk as possible to come on the 2 nd in combats and shades if possible (banaclavas too) . You can say we are going to do the bay tree bring cameras and fun. I will be back onthe morning of the 2 nd . Have fun and can't wit to se you. Mark \ 24-07-09 12:46:31 Mark Stringer say's that after Xmas, the foundry is more than welcome to re locate to his flat. Hooray for Mark!!!!! \ 28-07-09 14:49:21 Your greediness is the thing I like best about you. X \ 28-07-09 20:49:22 I think it is Build A Fire. X Bill \ 30-07-09 02:39:00 Flying scud has gone \ 02-08-09 07:17:08 Hope your day as the Pink Terrorist goes well. Any more photos of you in costume to enliven the fact that our flight has been delayed by three hours. \ 02-08-09 19:50:52 You're stil being watched.. All surveillence cameras on u \ 02-08-09 20:00:27 Come 2 noodle king + sit on my lap. \ 05-08-09 18:12:35 Not going SHARM-EL-SHEIK as we dnt have enuf time. Hope ur enjoying ireland. Has my laptop been repaired yet? Back in cairo. Pyramidz, sphinxz n egyptian museum 2dai. Was gdgd. Citadel, shoppin 2moro then home! Cairo trafik iz crazay =o c u soon x \ 06-08-09 21:48:45 The rain is torrential like that night we met dean & iru except it has been constant for hours. Rivers running down the streets x x \ 07-08-09 14:48:56 Missed a nice pic for your sick collection.. Stale vomit from yesterday being pecked at by a pigeon \ 12-08-09 14:38:24 Cher is in all our internal juke boxes. That is what she is there for. \ 20-08-09 02:09:13 Clunge Pungtang Gash \ 20-08-09 02:30:50 Oh sorry if i woke you up! I'm on an adventure in Soho. Everywhere shuts at three though! If you know of anywhere after hours let me know, otherwise sleep tight! X \ 29-08-09 14:49:31 Jesus Darling, you do have the arse for it. And you know I'm worth it ;-) Hx \ 04-09-09 21:08:50 He not here! 2 of the waitress screamin + kungfuing

Marcia Flude > TM
18 Dec 2009 04:39:41

Hey Tracey, so good connecting with u again. It made my day. I call u next time xx marcia

Marcia Flude > TM
Yes I was just txting u xx

Marcia Flude > TM
Sitting by the pool at the Oloffoson wondering why am I here maybe

Marcia Flude > TM
Sorry about the txt pushed the wrong button. Yes , we have never had a normal chat have we? Even now it's all crazy still. You said exactly how it is. So I send u a Haiti txt that I can remember. X

Marcia Flude > TM
Very hot here at the Oloffoson and am wondering if I need a Rum Punch. Miss u already and strange and wonderful things still happening here at Oloffson .Three people left for the airport and have just arrived back at the hotel as the flight has been cancelled. And playing through the sound system is Hotel California. Wish you were still here. X Marcia

04-09-09 23:45:56 I have to go back to the cocktail bar tomorrow to see if they have my shoes & your liver. So wrong...? \ 06-09-09 18:17:55 I have just emailed you the itinerary. Now off to video shop for Wicker Man. \ 06-09-09 21:16:49 Echo and The Bunnymen by Alan McGee on www.zani.co.uk, in memory of their kexboard player Jake Brockman who sadly died last week. RIP JAKE \ 12-09-09 22:06:59 I'm ok love, not feeling so positive about future but know this is right for me now, will leave a hole in my life, could use a fraction me yr energy and zest for life Xxxx \ 13-09-09 01:50:47 Go bed! Be bk in few hours XJ \ 13-09-09 03:12:15 On way hm nw. bbk soon xiz \ 15-09-09 11:04:15 The trouble is you need to leave the card in for the power. But if you leave the card in you lock yourself out. I am sharpening my knife for you baby. Are you ready for breakfast? \ 19-09-09 14:19:23 Florence (and the machine) is the spitting image of you with my colouring. Do you think she's our love child? \ 20-09-09 21:52:03 I have just had a drink in your honour. And now you will soon be a grandmother. \ 20-09-09 22:48:55 John and I have just found him passed out on the pavement outside the Playhouse choking on his own vomit. We threw him in the river to clean him up a bit and then told him to get back to his

At this point or to be more precise at the end of the last page, as I am writing these words about the Ghetto Biennale in pen on paper before typing it into my computer – a text pings in…

Dave Sinclair > TM
12 Jan 2010 23:07:19
Have u heard there has been an earthquake in haiti

It's from my friend Dave Sinclair, informing me that Haiti (from where I have just returned, but where my head currently is along with the pen in my hand and words which have just flown forth with it) has experienced an earthquake 7.3 on the Richter scale

TM > Dave Sinclair
12 Jan 2010 23:10:37
No where? Which bit? I'm holed up in a blizzard in s.Wales not seen any news etc. If you hear any more info can you let me know? Thanks for texting me this. Know lots of people out there now & am writing about it as we speak

TM > Dave Sinclair
12 Jan 2010 23:10:50
Do you know if it's a bad one?

TM > Bill Drummond
12 Jan 2010 23:13:51
Someone just texted me a big earthquake has just hit port-au-prince

Dave Sinclair > TM
12 Jan 2010 23:12:20
7 on richter scale - big. Hope alls ok?

residency as he had to be up bright and early in the morning. As for his curtains being open the window was smashed. Hope you got back safely. \ 21-09-09 08:44:12 Hey tracey – its terence from the pam hogg show, how are you doing? I will attempt to find you on facebook later today. Have a good day love, terence \ 22-09-09 03:54:35 All going well. Im friends with all american hipsters. Love my 70s crack den accomo. Ring u 2mro x \ 23-09-09 10:51:35 Hey love. An American porn mag wants to use your red briefs image of me. Can they use it? XX \ 26-09-09 06:20:01 This photo was taken no more than 100 yards from R's flat bang in the middle of a city of 17,500,000 people. Jungle clearing village bang up against Vodaphone adverts. I am the only white man that I have seen since I have been here and still the tallest by a head. I am a walking one man freak show. No cockroaches or rats but lizards on the ceiling and crows on the windowsills. This will be the last text for sometime as the drums have started up again as they are about to take the goddes Durga and submerge her in the Ganges. All over the city Idols of Durga are being taken to the river. I am locked in my room while Ronita and her mum have a massage from a woman who has come to do it. It is night here so nothing can be seen from the window. Just the noise of the drums from the street below. \ 05-10-09 13:46:52 Hey trace, i know this is kinda random but do you know if you would be able to get me some tickets to capital fm jingle bell ball? Xxxxx \ 05-10-09 22:39:02 Are you tracey tracey now? \ 06-10-09 14:36:27 Yes, texted to tell you. And on the front page of Google!! Mine and your gobs on the front page! Hahaha. Something to talk about Friday..;-)

TM > Dave Sinclair
12 Jan 2010 23:16:52
That's big. I hope people I know are ok. They've not got much as it is. Just gone online & it doesn't sound good. If there's a tsunami deforestation has left nothing to stop massive flooding

I immediately left my writing, went downstairs and put on the BBC News. Very little news was coming through. I stayed up through the night, crying as l texted and called the numbers of the phones I had left with people that had taken part in the mobile phone photography project. All the lines seemed to be down and there was no way of communicating with the Port-au-Prince. If anyone had answered I don't know what I would have said as I don't speak Creole or French. I just wanted someone to answer and say it's not as bad as it seems. I texted people in the UK who were in constant touch with this area of Haiti via friends and loved ones; they had no information. I presumed that all communication lines were down, especially if no news was coming out of there. Richard Morse, proprietor of The Oloffson Hotel, had set up a Twitter account a few weeks before my stay there. The hotel was a popular spot for journalists – If it was still standing. The full coverage on every news TV channel was now given to Haiti repeating the same short fragments.

Bill Drummond > TM
12 Jan 2010 23:23:39
Just read about it on the BBC site.

I thought if the phone lines were down, then in all probability there would be no internet connection for Twitter to work. I was wrong and I realised then that the communication medium Twitter, although not as personal or as interactive as the text message, had significant power to disseminate short messages to many people very quickly. At the same time, I was texting people for any news at all. Once on the Twitter site I clicked the box to start following Richard Morse ('RAMhaiti') at the Oloffson. At 11.20pm UK time, about half an hour after the earthquake, his Tweets began:

Were ok at the Oloffson..internet is on!! No phones! Hope all are ok..a lot of big buildings in PAP are down!

There is a tsunami alert! Everyone stay safe!! Fires seem also to be burning in downtown PAP

Just about all the lights are out in Port au Prince.. people still screaming but the noise is dying as darkness sets.

Lot's of rumours about which buildings were toppled.. The Castel Haiti behind the Oloffson is a pile of rubble.. it was 8 stories high

Our guests are sitting out in the driveway.. no serious damage here at the Oloffson but many buildings nearby have collapsed

People are praying in groups..others are looking for relatives..no phone service..no electricity

A retweet from Richard's wife Isabelle says:

much destruction on Grand Rue (Ave Dessalines) Daniel Morel's ok. Police Sta, Cathedral, Downtown teleco, Church St Anne all destroyed

Richard's tweets continued:

I see people on Rue Capois and I see some cars but I think getting around is difficult@ tinoisette

We're ok.. a little freaked out but ok.. every one is hanging outside on the driveway@ mannysister

Phones are starting to work..got a call from some one who's house fell in, child hurt but ok. .

A few showing up @ Oloffson..roads are blocked by falling walls..much destruction on Grand Rue. I hear hospital General has collapsed

I can't confirm what I hear about different buildings which are said to have collapsed but all reflects intensity of situation

People are needing medical supplies..food, housing; I don't know the situation

Collapsed UNIBANK building is on NYTIMES.com

Another aftershock.. people are screaming and freaking out down towards the stadium..much singing and praying in large numbers

@CNN photomorel@yahoo.com has photos of Haiti earthquake

news agencies needing photos of Haiti earthquake can contact Daniel Morel at photomorel@yahoo.com much destruction many injured

There are still aftershocks

It was now 01:20AM on January 13th 2010, RAMhaiti was following 33 people and had 466 followers. The number of followers of his tweets rose steadily every few minutes as I refreshed. I contacted Jonathan who began following the same tweets. No real concrete news was coming from any news channels with information on the level that Twitter was delivering. Jonathan texted the BBC to inform them of the Haitian tweets and news being disseminated from them.. Fredo Dupoux had posted one of the first recorded tweets at 23.00 UK time:

Oh shiet [sic] heavy earthquake right now! In Haiti

Along with another Haitian tweeter FutureHaiti

Earthquake 7 Richter scale just happening #Haiti

A U.S. missionary, blogger and tweeter who lives in Haiti called Troy Livesay tweeted:

Church groups are singing all through the night in prayer. It is a beautiful sound in the middle of a horrible tragedy.

Another prominent voice through Twitter in Haiti at the same time was Carel Pedre:

TM > Leah
2010-01-12 23:39:53
Thinking of you & people in Port-au-prince. I hope you are able to make some contact & people ok

Leah > TM
23:41:30
No contact at all- all lines dead- do you know caroles number

TM > Leah
23:43:37
Sorry no I don't have it I'm in Wales but I do have one of her cards I will phone my son now to see if he can find it at home

TM > Leah
23:56:16
He's located her card but there is only an email on it but I presume you have that. Please text me as soon as you get news

Leah > TM
13 Jan 2010 00:36:45
No news at all

TM > Leah
13 Jan 2010 00:42:49
You must be beside yourself. I have BBC news 24 on & nothing at all. I hope news starts coming through soon

Leah > TM
00:45:21
Sky news is full on- we are oscillating between tears and despair

TM > Leah
00:51:48
I know, but they seem to know nothing yet so hold on to major hope. I hope you are with people & not on your own

Leah > TM
00:58:56
I am with Oceana & ZehraX

Leah > TM
00:59:45
Thank you for being such a loving & sensitive person X

**If you need to get in touch with friends
and family in Haiti. Send me a private
message with names and phone numbers.
I'll get back to U**

Facebook, Youtube, and Flickr were instrumental in getting news and the full
graphic horror of the disaster out to the world. Leah got word at 4am that her
partner Eugene was alive and OK and phoned me straight away.

 The first raw images started emerging on the BBC news painting a full and
graphic picture of the tragedy. I saw the sculpture of Legba which stood in the
Grand Rue. It was Eugene's studio, yard and community area. At the time of
the earthquake he had been doing an interview on child slavery in the coun-
try, when rural families sent their children off to what they thought would
be better lives for them away from the rural poverty. Eugene and the other
Grand Rue artists worked with children and teens
to educate them. Other children however, ended up
in abusive situations with constant beatings from
the people their parents had entrusted them with.
A photographer called Daniel Morel was present
at the interview when the earthquake struck and
started photographing immediately. These were the
first images the BBC started showing as they reported
the story and the only ones which the world saw
in the hours following. Emotionally, I have never
been so close to a tragedy on this scale in my life.
As the first images were displayed, the photographer
was walking out of Eugene's yard down onto the
Grand Rue. People I had been working with, rub-
bing shoulders and laughing with a few weeks before
were the subjects of these photos; some depicting appalling injuries. A man I
had photographed appeared in one of these images, lying on the ground wear-
ing a black shirt with his trousers missing and his underpants below his knees
in a pool of blood. The skin on his left leg was an open flap from his knee
to his bottom. I was horrified, sickened and the tears would not stop flow-
ing. More photographs and short film clips followed as I spotted Camsuze,
one of the girls who had taken part in the Mobilography project. The camera
only showed her back in her distinctive pink t-shirt with a hole cut out of the
back and edged in white. Happy to see that she was alive, the image remains
implanted in my memory. I wondered what sort of mental pain Camsuze must
have been enduring. Even the Palais National was a crumpled mess, as the true
horror was filtering through via these networks and websites. I couldn't sleep
and resigned myself to Twitter for any short updates on the situation. Richard
Morse was accruing many more followers as the hours ticked by and at 12:34
the following day, he was still only following 33 as the number following him
had risen to 6,812. Nine months later he is following 393 with 14,539 people
following him.

<div align="center">…</div>

TM > JM
13 Jan 2010 01:19:59
Got news coming through from
the Olloffson on Twitter... link
on my facebook

JM > TM
TM > JM 13 Jan 2010 02:04:45
02:09:52 I'm reading the twitter

We have to do something to
help. They have nothing as it is

JM > TM
02:10:00

TM > JM What? Money or other kind?
02:12:54

Anything we can think of. JM > TM
02:59:18

TM > JM Some video on the news now..
03:05:53 Bt i'm going to bed.. Lvvuxx

Yes iluvux I should go to bed
too, I can't stop crying & have
a headache x

06-10-09 18:31:51 Well actually I'm front page of whopingcock.com what hey hey!. So check it out there.. \ 11-10-09 18:55:17 Isn't she.... Pretty in pink! ;) Dx \ 14-10-09 15:12:11 This is the longest I have gone without sending or receiving a text to or from you in three years and 46 days. I am unable to view episode six on my iPhone thus will not see it until I am back home tomorrow evening. Also have only taken one photo on my iPhone over the past week. It was of the barber that I got my haircut in Northampton. And you? \ 16-10-09 12:16:25 sat in cool coffee bar in kemp town. have just discovered copy of dazed and confused available for our perusal! X \ 16-10-09 23:31:43 I will think about you and your rats when I wake up at about 4am and then if I fall back asleep I will dream about them in unision with you. It was good to see you as it always is whatever mood you are in with me or the moon. Love from your man heading for a Haitian divorce. X \ 20-10-09 15:43:52 Also. Might you come to Shoreditch House this Sunday. I'm guest DJ. You can meet some of my other friends. >˘ \ 20-10-09 17:21:27 I am aTLC free area. I give but do not take.I am that kinda guy. But fraid I am not going to book launch. I am on the top deck of bus stroking my blade. The sharp one that slices not the one in my jeans. Meeting R from work. "See you at the barracades babe" X \ 22-10-09 12:00:28 The site of my knob end poking out the bottom of my snug fitting lederhossen as I did my James Brown on the minute dance floor of the Somali Club in Upper Parliment Street, Liverpool in early 1973, was always a winner. I have visions of us doing a dance off on rival circular dance podiums in a far flung night. \ 24-10-09 11:41:18 This Sarah was a bit of a one. The invitation to dance in gay Berlin nightclub was not from someone I met in Zurich. It was a text message from a woman in Stokholm who makes radio plays and who I get on with but not in any sort of licking each others private parts sort of way. But she was in Berlin for a conference and I thought it strange I should get this text from her at the same time as you and I are making plans to have dance offs in nightclubs around the globe. By the way I will be wearing my kilt and not the lederhossen which I got rid of back in the days of the one eyed trouser snake making his appearance and winking at the prostitutes working the Somali Club. \ 26-10-09 14:33:35 Did you see news today about new police database of activists? The Standard says your friend Mark is on it! And they admit profiled individuals have not necessarily broken any law but are headed "domestic extremism"! Cliff x \ 02-11-09 16:29:12 Have you booked your flights and had your jabs done yet? I get my jabs done in the morning. \ 05-11-09 12:44:12 Just the fish I think please Tracey xH \ 13-11-09 07:48:16 Faster than fairies, Faster than witches. \ 18-11-09 10:12:44 Haha! Cause you fuckin texted..radio is not going out after that is!..I cant understand Bargoed sometimes, it's like Mandarin..! So I thought you were saying it's the last one cause the buildings going isn't it? \ 20-11-09 16:19:40 Inside Schindler's Lift again X \ 29-11-09 12:36:38 I sat through three films. And was the only person to vote on any of them. The winner was the first one. Ken Livingston has just walked past me. He is in the museum with his kids. It's weird accidently being at a film festival and being the only judge when you have spent the whole year failing to organise us going to one for us. Just been told off for taking photos with my camera. More later. \ 30-11-09 11:11:32 Ready to rock

Kirsteen Mcnish › TM
13 Jan 2010 09:37:36
Just heard what's happened in Haiti on the news. Devastating. Let me know if I can help organise funds or help in anyway via friends artists event donation as I know it must be very close yo your and Bills hearts. Xxx

TM › Kirsteen Mcnish
13 Jan 2010 10:20:50
Horrific... Watching it all unfold through the night & waiting on news from friends & their loved ones. Was getting all the news through Twitter but it seems to have stopped now, batteries on their computers died. Yes I will let you now re fundraising & events etc thankyou. They have so very little as it is x

The text message revolution paved the way for new technological developments with short messages, which include Facebook statuses and Twitter. Research has proved that young children who use more textisms when texting tend to be better at reading. Researchers think greater use of textisms in text message language may be a sign of increased phonological awareness; that is the awareness of the sounds that words are made of. There are, of course, many other factors affecting this. In texting it is acceptable to drop letters from words. On Twitter, however, it seems as though it isn't widely accepted and people tend to use fuller words along with the development of the newer mobile phones where many more characters can be written. When the first text message was sent by accident I wondered if anyone could have ever imagined that not only would it lead to a text revolution, but that it would also be responsible for the development of significant aspects of Twitter and Facebook along with developments in other social networking sites. People are questioning if Twitter is replacing texting. I am in favour of separating the two paradigms in this period of social media revolution. I think that although Twitter plays a vital role – text messaging is here to stay. Text messages maintain privacy between you and the recipient and (at least in theory) no one can view it when you send a personal message. In contrast you don't have one primary recipient with Twitter. It is good for making announcements to many friends or even nations which would be extremely time-consuming with a text. People are not alerted personally to a tweet and many are missed. 90% of SMS texts are read within 5 minutes. Twitter cannot claim this and many people see no reason to tweet as they have Facebook.

I wanted to leave the UK for Haiti straight away to help. However after much discussion I decided that, as I have little to no medical skills and no great strength to get involved in the physical tasks that they would be much in need of there, I would only be taking up someone else's food, water and air space who could be more immediately useful than myself. Instead I began a fundraising campaign with Jonathan and called it the Foundry Haiti Fund. All I could think of was everyone from Grand Rue to Bel Air from poor Silver Joseph, and Ketty and the woman taking the shower, and the children cock fighting, the jealous men fighting on the street, the woman they were fighting over, the young flagmakers, and the man with the tattoo of the burning Bible and weeping Christ on his back. I thought of Flo and all the FOSAJ people in Jacmel and everyone else in and around Grand Rue. I thought of all of them, every one.

We collected donations which were flown out and physically handed to disaster victims within three days of the earthquake. Subsequently money we have raised has been invested into computer equipment and training allowing many young and old people there to become part of social media networks such as Facebook and Twitter, reaching out to a wider community. People still continue texting there and the Mobilography project I did with the community receives many hits on my website from Haiti. CNN and other news channels also wanted

footage the following day of both the images produced by the community along with the photographic archive I had collected of what Haiti had looked like prior to the earthquake. The fund still continues to raise money which goes directly to the Grand Rue Community.

Kirsteen McNish sent a text out to her friends and colleagues.

Kirsteen McnIsh > TM
13 Jan 2010 23:33:46
Dear friends. I need your help. After the devastating earthquake hit Haiti today, thousands of people were left injured, homeless or dead. Haiti is the most impoverished nation in the Western hemisphere.The people there have so little already for basic needs so this earthquake has caused horrendous and heartbreaking suffering. Please, please, donate to the fund below to help the men women and children of Haiti get some way to finding their missing families, getting medical supplies, and being provided with the basic needs we all take for granted everyday. Please, dig deep and give whatever you can afford. Sacrifice a luxury or two to help others in desperate need. You only have to look at the pictures on the news to see what effect this has on the people there. A collective of artists that have recently worked in Port-au-Prince have set up this website to get funds directly to the people affected. www.foundry.tv/haiti Many thanks. Love, Kirsteen xx

JM > TM
13 Jan 2010 23:34:21
£185 .. 6 donors

As funds start to come in from our friends wanting to help we decide to set up a fundraising event at the Foundry.

TM > Dancon1
17 Jan 2010 13:35:47
Do you & pete want to dj the benefit night I'm just starting to organise for Haiti on Wed 27th jan? Just getting people to commit & do half hour slots & maybe get a sales thing going on with proceeds to the fund also? What do think?

Dancon1 > TM
17 Jan 2010 13:47:17
I'm up for it and sure pete will say yes x

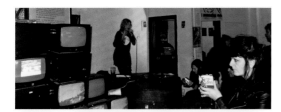

TM > Dancon1
17 Jan 2010 13:57:35
**Brilliant, I'll text him the same now
& If you want to help with organizing
part of it that good too?**

Pete Stormcrow > TM
17 Jan 2010 14:01:14
**Absolutely - dan's just told me. Very happy to
help in any way we can...**

TM > Pete Stormcrow
17 Jan 2010 14:08:01
**That's great. Now have just put a face book
page up so I can add derails to that text
me what you want to put on it. I don't know
about flyers or anything as I need people to
confirm. So far i'm waiting on... Viv albertine
ex slits, gaggle (20 odd women), mark
Thomas (comedian), Kirsty hawshaw (it's
a fine day song) daryl from (jean Cocteau
something?!?) they are good. Now have said
yes... There are others who have offered &
who I am seeing & I think they are a bit big
so maybe we could do another night in a
different venue after with them don't know**

Dancon1 > TM
17 Jan 2010 14:12:41
I'll get a flyer poster etc together if you fancy?

TM > Dancon1
17 Jan 2010 14:36:37
**Do you want me to send a couple of
good positive photos to you of Haiti/
people before the earthquake to work
with? I have some good ones x**

17 Jan 2010 14:38:13
Dancon1 > TM
Yes please about the pictures. X

TM > Dancon 1
17 Jan 2010 15:34:23
Just sent you an angel...Louco's angel

Pete Stormcrow > TM
17 Jan 2010 14:16:43
**That's all looking great... For
yr listings: "dancon1 + pete
stormcrow (disco_r.dance djs)**

TM > Pete Stormcrow
17 Jan 2010 14:39:01
**Ok that's all great... And fantastic
re posters re foundry/Haiti gig x**

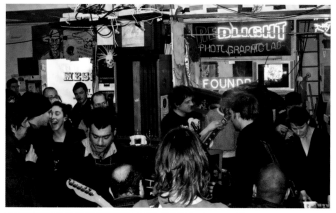

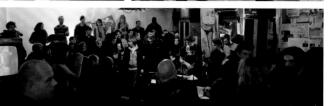

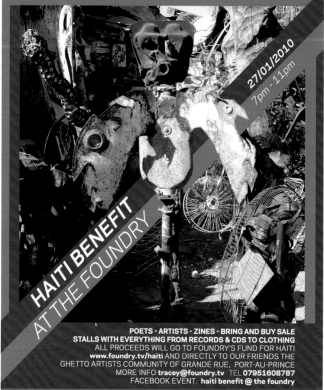

27/01/2010
7pm - 11pm

HAITI BENEFIT
AT THE FOUNDRY

POETS - ARTISTS - ZINES - BRING AND BUY SALE
STALLS WITH EVERYTHING FROM RECORDS & CDS TO CLOTHING
ALL PROCEEDS WILL GO TO FOUNDRY'S FUND FOR HAITI
www.foundry.tv/haiti AND DIRECTLY TO OUR FRIENDS THE
GHETTO ARTISTS COMMUNITY OF GRANDE RUE, PORT-AU-PRINCE
MORE INFO tracey@foundry.tv TEL **07951608787**
FACEBOOK EVENT: **haiti benefit @ the foundry**

LIVE MUSIC FROM **VIV ALBERTINE - KIRSTY HAWKSHAW - NOW -**
ANDREW BAILEY - CLUSTER FITS - LITTLE ERIS PLUS MORE...
DJS **SPIKE SPIEGEL - PETE STORMCROW & DANCON1**
THE FOUNDRY 84 - 86 GREAT EASTERN STREET
LONDON EC2A 3JL - OLD STREET TUBE (EXIT3)

SCULPTURE BY EUGENE ANDRE (PHOTO BY TRACEY MOBERLY)

Kirsteen > TM
17 Jan 2010 19:01:30
That's brilliant about the money. Well done T. Let me know if you need performers too. How will people buy stuff with the money if everything is gone tho? Let me know re: performers Xxx

Mark Thomas > TM
17 Jan 2010 20:05:47
Hey Tracey. Film was Ok , thanks. I am not up for the benefit on the 27th. I am filming all day on the 25 ,26,27 and frankly will be knackered. Also having done lots of benefits I also know they are the gigs most likely to go wrong as they aren't normally run by folk who do not run comedy nights . I am happy to do a bucket at Reading and have sorted that out. Lovely to see you. Mark

JM > TM
17 Jan 2010 21:45:35
£5077 raising rapidly

30-11-09 12:50:38 We're just leaving home... It's so sad... We've got a car full of memories and bellies full of love for lovely people though. Hope your Manchester trip goes well x x x \ 02-12-09 13:31:05 Hey tracey its Ciaran hope u are well..sorry not got back sooner..are u back from yr travels? Wil Be away till 2nd of jan on hols but if ya fancy comin into work after then let me kno wens good n we'll sort it out x \ 04-12-09 11:56:41 When do u leave for Haiti? There was an article on R4 this morn abt the huge number of disabled kids abandoned... Is that who u r working wiv? Whats a provo? Spk later xxx \ 04-12-09 23:47:12 Shadders do you realise I've watched your children grow from babies into real men..xx (I love that photo).xx \ 09-12-09 13:04:41 Have a good trip to Haiti – yoodoo that voodoo... \ 15-12-09 17:25:10 Is it very heaty in haiti ? \ 17-12-09 18:40:00 I am getting Tracey withdrawal symptoms. I take it you are up and nearly ready to go. I will be on the breakfast veranda. See you in a couple of minutes. \ 20-12-09 13:24:05 We were that last flight in that did not get diverted. Snowed up in Brooklyn for an indefinite time. Wishing I was back in Haiti already. Will be going for a shave at the barbers across the road from the Motel. Hope your toilet is pleased to have you back. Have a great evening in Miami. \ 24-12-09 08:02:14 Aiden NEW Shaw Happy everyday \ 25-12-09 20:52:37 Merry Christmas to you too Mrs Mellon. Let me know when is good for you to meet up in the new year. It would be good to cook you dinner. Off to Tapestry for New Year's eve if you fancy it! \ 01-01-10 00:40:23 And as for that text message with my full confession about my sex life with a skate that I was going to send you before the midnight hour never got sent. The thing about sex with a skate they always let you know what a great shag you are. And are willing to give up there life for you and you can eat there wings after wards with fresh chips. The lips are a special delciacy. Once you have fucked a skate no other fish will do XXXX \ 01-01-10 22:38:23 Just saw the bayleaf tree get cut on the gormley plinth, as a question on big fat quiz of the year! Happy New Year! X \ 02-01-10 13:00:13 Thanks :) did you intentionally send tht at the time i was born or was it chance? Xxx \ 02-01-10 13:04:58 Haha, have you seen my dads new iphone cover? Bright pink! So funny. Chose it himself "so he can see it easily", we're going to have to keep an eye on what he buys from now on :) Xxx \ 05-01-10 23:39:43 What are you doing early tomorrow evening? I need to deliver you a cake. \ 12-01-10 16:06:41 Gud gal... All gud wiv me re tex. Mid feb is cool. Rob.X Powder in the blood \ 12-01-10 23:07:19 Dave Sinc Nw Mb Have u heard there has been an earhquake in haiti...

RIP Destimare Pierre Isnel,
 aka Louco
RIP Flores McGarrell
RIP Laurence Wylie

Three members of the Ghetto Biennale who lost their lives in the Haiti earthquake
12th January 2010

As I'm typing the last words of the last *Text-Me-Up!* chapter, I had thought that I would be concluding this book with statements proclaiming: 'Text messaging is on the decline and Twitter on the up along with Facebook'. Although I regularly update my Facebook page, I decided against it. From July 2009 (when I purchased my iPhone) until July 2010, over half a million words have travelled through my phone in the form of text messaging. I wanted to state my wonderment as to what the next wave of short written or visual communication would be, as I reflected over the last decade of my life through text messages.

Eleven years later I am back in Manchester. I am there with Bill Drummond as part of Salford's Un-convention music conference.

I am finishing typing the last words of the book in a hotel room in Salford which looks directly onto the other side of the River Irwell. The panoramic view in front of me includes the places that are the opening chapters to *Text-Me-Up!* First and foremost is the river. With my passion for industrial rivers, the Irwell is at the top of my list and the opening subject to my favourite book – *The Manchester Man* by Mrs. G. Linnaeus Banks written in 1874. To the far right is Castlefield Bridge. As I scan across I see the junction where Liverpool Street begins and where the first passenger railway station still resides – now as a museum. I am looking at the very place the letter-writing communication boom began – the same place responsible for the one-time growing need for Valentine's Day verses in cards. At the top of the street is the Castlefield Gallery where I held the first *Text-Me-Up!* exhibition. I focus on the Haçienda, thinking about Tony Wilson and his early exit from life and the legacy he left behind, before averting my gaze to search for the nearby Roman fort. Long since landscaped over, I think of my stepson's wellington boots and all the other artefacts of ours that were buried beneath the Roman fort area after the archaeological dig was filled in. Briefly remembering some dresses in a suitcase, thinking they too are probably now decayed fragments far under the Castlefield ground. I'm not sure how much of my life exists below there in artifacts and fragments. The Roman broach that one of the archeology crew had found would probably be on exhibition in a museum along with the pornographic pot shards that my ex-husband had found. By the time the press had finished with commenting on this archaeological find, the pot shards had turned into 'hundreds of graphically crafted pots bearing obscene pornographic imagery'.

I start bumping into old faces in Manchester that are taking part in the conference – everything feels like it has suddenly started to come full circle. I meet Ed, who ran the Arc fashion shop on Oldham Street, who talked about the first

ELECTRIC CHAIR
SEPT. '99

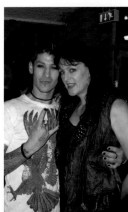

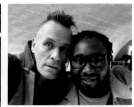

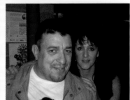

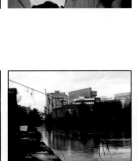

exhibitions there, *The Object* along with mine and Karl's *Scarcrush* show. He informs me of The Object's current whereabouts. He asks about Jai and Nick. I tell him Jai and Sarah are living happily in London with two beautiful children and that Nick had texted me last night to say he has just accepted a new job four minutes from the Foundry. I'm hoping he's going to get a flat in the next street to mine, where former Elvis & Jesus Kurt is also living. He laughs, saying it will be fully like Manchester if Nick adds to the London mix. The next people I see are John Robb (a musician, music journalist and TV presenter on pop culture) and Luke Unabomber. Luke immediately greets me with a warm hug saying that the last time he saw me was when I was setting off delivering a nuclear warhead in a Chevy to London a decade ago. Luke was responsible for one of my favourite Manchester club nights, *Electric Chair*, which was the place where I was taken to by friends on the very evening 'The End' had begun. The Unabombers began the night in 1995 when Manchester had become a 'sanitised, gangster run, cocaine-fuelled Madchester theme park'. Luke had also been obsessed with *Twin Towns*, a Welsh film he would often show at his flat. It stars, among others, Rhys Ifans. I tell him about the few parts I have in Mr. Nice where Rhys plays the lead role. I began drifting off into Manchester memories as if they were yesterday, when I was brought back around by John Robb stating in wonderment that he had seen a kingfisher bird near one of the houses where I used to live. As I leave, Luke says that he would be DJ'ing as part of the Un-Convention event so I said that I would see them there and see John soon.

I then meet my old motor-biking partner Julian Layfield whom I'd last seen when I was living there and whose friend Big Dave had sent me my first ever text message. Julian and I then talk about my book and he remarks on the synchronicity and serendipity within it as I tell him that his texts are in there dotted throughout the last eleven years.

Before leaving London, I had left my Facebook status saying 'Tracey Moberly … Salford … Unconvention' and suddenly texts started coming in from Manchester friends arranging possible meetings. A young fully tattooed male approaches me. I start thinking I've entered a Groundhog Day film of my own, which instead of repeating daily, runs an eleven year full circle. Then suddenly Bill appears jut like the shop keeper in Mr. Benn.

We move on to the next part of the working weekend. Bill's project is part of his practice where he is painting the same piece of graffiti under bridges in the UK and abroad. I help find and photograph these. I am instrumental with a couple of others in getting him across the wide berth of the River Irwell. It's a typical rainy Manchester day, the current is quite fierce and added to this, the sluice gates further up river have opened, increasing the river's current dramatically. I relinquish all responsibility of my friend's voyage in a dinghy, saying I need to document this event by moving and still image. I knew there was a

high probability that he was going to be swept away by the force of the current of the River Irwell, washing him into the River Mersey and out somewhere near to the source of the Manchester Ship canal if he was not drowned by this stage. Fate would take its course with my friend but I hoped he would live. As I documented it I lost myself in the fast sweeping flow of the river. My thoughts became one with it.

My text message journey would conclude here, ending where it had begun – at the end. I was anticipating a text message arriving now and this would begin a new book, which I would start with a beginning to this end along with this chapter preceded by a new body of artwork. I waited No text message pinged into my phone to instruct me into my new fate. Suddenly there was a flash of blue darting in a straight line along my line of vision. It was a kingfisher. Four times the flight of the kingfisher occurred in front of me. This was the symbol I had needed; whatever the kingfisher symbolised THIS WAS IT. The graffiti mission was aborted until the following day when the river would be calmer and I set off to research the symbolism of the kingfisher.

The kingfisher, or Halcyon bird, according to Greek mythology symbolises peace and calm. The bird in the legend is the European kingfisher. Traditionally Halcyon days fall between December 14th and December 27th, the weeks surrounding the winter solstice (the day with the fewest hours of daylight, the first day of winter). The term 'Halcyon Days' signifies days of calm, peace and tranquility – the attaining of our hearts' desire.

In the Greek myth Halcyone (or Alcyone) was the daughter of Aeolus, the god who controlled the winds. Deeply in love, Halcyone married Ceyx. Ceyx's brother died soon after their marriage, cutting short their happiness. Ceyx decided to sail to Ionia to consult the oracle of Apollo, god of prophecy, to find out if the gods had turned against him. Halcyone begged him not to leave, fearing that something terrible would happen. Determined, he set sail travelling only a short distance when a terrible storm on the Aegean Sea destroyed the ship drowning everyone on board. When Ceyx did not return Halcyone asked the gods for a dream to explain what had happened to him.

In the dream she was visited by a drowned Ceyx. Finding solace in the place she had last seen him, Halcyone wandered down to the shore, grief-stricken, whereupon the waves carried Ceyx's body to her. She hurled herself into the water; and the gods, witnessing her terrible grief, lifted the couple up and transformed them into kingfisher seabirds who would mate each year at the start of Winter. The female Halcyon bird is said to build a nest of fish bones that floats on the sea, where she tends to it for seven days before and after the Winter Solstice. During this time the god Aeolus keeps the winds away and the waters calm, ensuring the safekeeping of his grandchildren.

The calm and the peace I immediately interpreted as representative of the end of this particular journey

achieved through my text messages, as I end with a beginning. The corpus of text messages I have collated and stored from other people is a slice of social history: my social history through their words which initially helped me over a tough period in my life, but then were transcribed almost every hour of every day. I love reading them back, spotting the different texts that helped me take many different routes and directions whether walking down a road, driving in a car, or following my path through life. These would be otherwise throwaway words and sentiments, all lost in the ether.

If I had not collected them all they would have lingered, to be tripped over as I walked down a street, or bumped into when I turned a corner, without my ever fully seeing them or being able to recall them exactly. They were etched into my psyche and inscribed into my life's archive. Each text as important as the next, whether as a myriad of deep meaningful emotions or not – all beautiful short statements of the sentiments of others: words to me made up of love, lust and adventure; birthdays, pregnancies, births, deaths; flirtations; phone top-up successful; swearing; food, alcohol and hangovers; chain texts; low battery and credit; illness; weather; anniversaries; Easter, Christmas, New Years; St. David's Day; International Womens Day; top-up card numbers; pink in content; sexual and sensual; places directions and transport; time-referenced, days, nights, mornings, afternoon or sun- and moon-related; questions and statements; animals and insects; self-status updates from myself or friends; love and marriage; sorrys and thank-yous; happy and sad; how are you; yes and no; goodbyes and hellos... HELLOS...

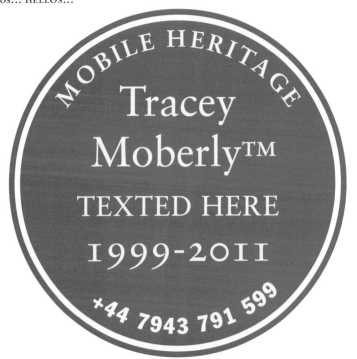

Photo Credits

16
Sue Shambrook
(nee Baxter)

19
Granada TV

22
Manchester
Evening News

23
Manchester
Evening News

22
Artwork
John Hyatt

34
video stills
Jaime Rory Lucy

38
Sion Touhig

45
Shiffer

47
Steven Haines

50
Mr Frank

50
Steven Haines

50
Steven Haines

50
Steven Haines

51
Steven Haines

51
Steven Haines

51
Steven Haines

51
Steven Haines

52
Good Morning
Channel One
[Russia TV]

53
Steven Haines

54
Daisy Asquith

55
Steven Haines

55
Steven Haines

58
Steven Haines

59
Steven Haines

59
Steven Haines

59
Steven Haines

59
Steven Haines

59
Steven Haines

60
Steven Haines

60
Steven Haines

60
Steven Haines

60-61
video stills
Daisy Asquith

61
Steven Haines

62
Steven Haines

63
video stills
Daisy Asquith
Jaime Rory Lucy

64
Steven Haines

66
Mr Frank

68
Daisy Asquith

70
Daisy Asquith

76-81
video stills
Jaime Rory Lucy

88
video stills
Jaime Rory Lucy

92
Kirsty Hawkshaw

99-101
video stills
Jaime Rory Lucy

111-113
video stills
Jaime Rory Lucy

120
Max Reeves

124-125
video stills
John Spencer

135
Max Reeves

135
Max Reeves

135
Max Reeves

137
Paul Mattson

143
Jess Hurd
reportdigital.co.uk

186
Jess Hurd
reportdigital.co.uk

236
Lena Corner

189
Sion Touhig

239
Jonathan Evans

147
Max Reeves

148
Max Reeves

200
Jess Hurd
reportdigital.co.uk

296
Alvesgaspar
http://commons.
wikimedia.org/wiki/e:
Mosquito_2007-2.jpg

333
Emanuel Brown
Mark Chilvers
Ruth Daniel
Bill Drummond
Helen Littler
Greg Matthews
Tracey Moberly
Dominic Penrose
Robert Pereno
Izaac Sanderswood
Aiden Shaw
Todd Steponick
Mark Thomas
Inga Tillere
Martyn Ware

148
Max Reeves

200
Jess Hurd
reportdigital.co.uk

297
John Hirst

148-149
video stills
Jaime Rory Lucy

203
Helen Littler

314-315
Community of the
Grand Rue,
Port-au-Prince, Haiti

155
BBC Wales

205
Manchester
Evening News

314-315
poster design
DanCon1

All other photographs
© Jonathan + Tracey Moberly

172
Nick Reynolds

218
Tim Beckinsdale

330
Helen Littler

185
Jess Hurd
reportdigital.co.uk

218
Tim Beckinsdale

186
Jess Hurd
reportdigital.co.uk

219
Jess Hurd
reportdigital.co.uk

186
Jess Hurd
reportdigital.co.uk

234-235
Danny Pockets +
Tracey Moberly

186
Jess Hurd
reportdigital.co.uk

331
Izaac Sanderswood